The Mass Image

The Mass Image

A Social History of Photomechanical Reproduction in Victorian London

Gerry Beegan

First published 2008 by
PALGRAVE MACMILLAN
Houndmills, Basingstoke, Hampshire RG21 6XS and
175 Fifth Avenue, New York, N.Y. 10010
Companies and representatives throughout the world

PALGRAVE MACMILLAN is the global academic imprint of the Palgrave Macmillan division of St. Martin's Press, LLC and of Palgrave Macmillan Ltd. Macmillan® is a registered trademark in the United States, United Kingdom and other countries. Palgrave is a registered trademark in the European Union and other countries.

ISBN-13: 978–0–230–55327–9 hardback
ISBN-10: 0–230–55327–3 hardback

This book is printed on paper suitable for recycling and made from fully managed and sustained forest sources. Logging, pulping and manufacturing processes are expected to conform to the environmental regulations of the country of origin.

A catalogue record for this book is available from the British Library.

A catalog record for this book is available from the Library of Congress.

10 9 8 7 6 5 4 3 2 1
17 16 15 14 13 12 11 10 09 08

Printed and bound in Great Britain by
CPI Antony Rowe, Chippenham and Eastbourne

To J, K, K, K and L

Contents

List of Illustrations

Acknowledgments

The inspiration for this book is most likely geographical. Growing up near Newcastle in the north of England I became aware of Thomas Bewick's beautiful jewel-like wood engravings of the birds, animals, and landscapes of Northumberland and Durham. Bewick's illustrations and tailpieces for his *General History of Quadrupeds* (1790) and *History of British Birds* (1804) were created in his workshop near Newcastle Cathedral. The dexterity of his networks of fine white lines carved out of black still seem astonishing. To this day I am also amazed by the level of skill that went into even the most commonplace commercial images in the nineteenth century. The other personal factor that has shaped my approach to the study of the printed image is my experience as a working graphic designer. Dealing with the economics and pragmatics involved in the creation and production of printed matter enabled me to understand more fully that representations are material objects shaped by groups of people working with each other, and sometimes against each other. This interest in the materiality of representation became the starting point of my postgraduate research in design history at Middlesex University. Judith Williamson, Tim Putnam, Fran Hannah, Lisa Tickner, Barry Curtis, and the other members of the faculty at Middlesex encouraged and nurtured my researches and asked all of the right questions. Judith Williamson supervised the thesis that was the basis of this book, and the clarity and accessibility of her own critical writing was an inspiration that I have attempted to put into practice. During my studies at Middlesex a seminar presentation by Raphael Samuel opened my eyes to the richness of the Victorian world of work.

The great inventor Joseph Swan, who, like Bewick, was a Northerner, said that there was no invention without a pedigree, and I am indebted to the work of many scholars. My interest in the halftone was shaped by Neil Harris' "Iconography and Intellectual History: The Halftone Effect," in which he ponders the lack of research on this important aspect of visual culture. This book is one attempt at addressing that gap, although there is clearly much more to be done. On the beginnings of press photography I am particularly indebted to Geoffrey Wright whose unpublished dissertation, "The Origins and Development of British Press Photography, 1884–1914," was an invaluable source of information. The American historians of early press photography, Ulrich Keller and Michael Carlebach also provided essential foundations for my research. The work over the last ten years of scholars of nineteenth century print media including Margaret Beetham, Brian Maidment, and Laurel Brake, has helped to shape my understanding of Victorian publishers, journalists, and their audiences. I have presented

elements of the book at conferences and seminars in London and in the United States, and the comments, questions, and conversations that have come from these events, in particular those of Bill McKelvy, Susan Canning, Minsoo Kang, and Amy Woodson-Boulton, have been essential. The advice and encouragement of Peter Hall, Barbara Usherwood, David Raizman, and Alison Nordstrom have also been critical. The insightful comments and constructive suggestions of Palgrave Macmillan's anonymous reader proved invaluable in focusing the final version of the book.

I am indebted to the staff and librarians at a number of outstanding institutions who have helped me locate materials and have shared their own insights with me. The St. Bride's Printing Library in London is a treasure trove of material on the Victorian printing industries. The immensely knowledgeable librarians in this tiny room, only yards from Fleet Street, provided me with numerous productive leads. At the other end of the library scale, the New York Public Library remains a potent symbol of democratic access to knowledge. I would like to particularly thank the staff and librarians of the Division of Art, Prints and Photographs who were indefatigable in tracking down materials. I also am indebted to the professionalism and dedication of the librarians and archivists whom I worked with at the Victoria and Albert Museum Prints and Drawings Study Room, the British Museum Department of Prints and Drawings, the Rare Book and Manuscript Library of Columbia University, and the *Punch* Archives. I cannot fully express my gratitude to Annette Hatton for her sensitivity and care in the copy-editing of the manuscript.

My researches were supported in many ways by my colleagues at Rutgers University. With the aid of a grant from the Mellon Foundation I was able to undertake research at the Zimmerli Museum with its rich collection of printed material from the 1890s assembled by Phillip Dennis Cate, a fount of knowledge on the printed image. Mason Gross School of the Arts provided support for the completion of the manuscript. I would like to thank Kate Flint of the English Department at Rutgers for her timely practical help and Tent Williams, also of Rutgers, for his unflagging research assistance.

This book is for my family. My parents have influenced me more than they knew. My wife Karolyn has been an invaluable critic of the project through its lengthy gestation. Her sense of what the book was has guided me toward its current form. My daughters Katia and Loïe, who were both born while the book was taking shape, have spurred me on toward its completion.

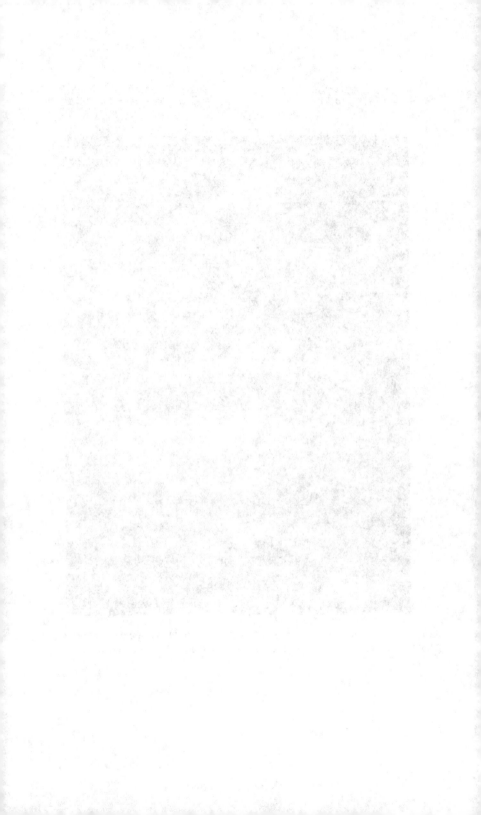

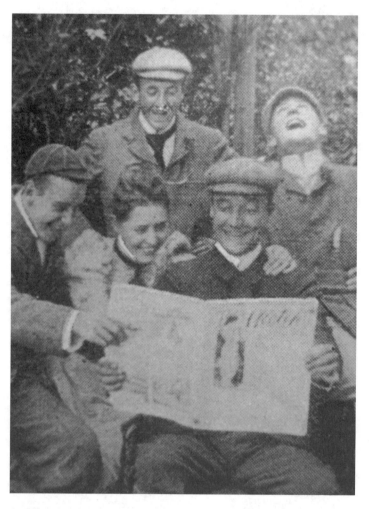

Figure 1 "They Know a Good Thing When They See it, Photo by Miss Gidley," *Sketch*, 24.300, October 26, 1898, 40. (Photorelief halftone print from retouched photograph, detail)

1
Introduction: Mass Reproduction and the Mass Audience

> We discovered and opened up the world of Illustration as connected
> with News, and the quick-sighted and sound-judging British public
> peopled it at once.
>
> – *The Illustrated London News*, January 6, 1843[1]

The masses and mass reproduction

This self-congratulatory text from an early issue of the *Illustrated London
News* speaks of the themes that I trace in this book. In it the magazine was
looking back over the seven months since its launch in May 1842 as the
first topical illustrated weekly. The sentence binds together the magazine
and its audience in a particularly intimate relationship as the readers rush to
become an integral part of the contemporary world that is delineated within
the magazine itself. By using the word *discovered*, the writer suggests that
the magazine simply revealed something that already existed, a world that
had been waiting for the *Illustrated London News*'s energetic and resourceful
coverage. In contrast to this concept of discovery my study looks at "the
world of Illustration" as an imagined place that helped its readers to create
a reality. Readers did undeniably insert themselves into the magazine in
complex and meaningful ways, as the quotation also suggests they "peopled
it," becoming at the same time the audience and the subjects of the illus-
trated press. This study examines how the mass-produced image enabled late
Victorian readers to conceptualize their society. In doing so I draw on ideas
of "the social" as a collective identity that has to be actively imagined, rather
than something that is pre-existing. I suggest that the illustrated magazine
was a form that allowed readers to make meaning of the city by creating what
Patrick Joyce terms an "imagined collectivity." Like the pubs, music-halls,
and theaters of the metropolis it provided a sense of a shared experience
and a guide for how one might behave. Reading a magazine, like attending
a theater, or strolling through the streets, was always in some sense a public
act, even when the reading occurred in private. In this study I will examine

the materiality of the ways in which Victorians read the photomechanically illustrated magazine with its diverse, fragmented content, so different from a book or a newspaper.[2]

By the 1890s, the period that this study covers, the illustrated press was able to envisage modern life on a much more intense scale than ever before. What does it mean, then, when tens of thousands, or hundreds of thousands of people could see the same image at the same time, particularly when this image was combined with text? What modes of reading and what types of public were made possible by the new illustrated periodicals?

This study looks at some of the complex relationships between the mass-produced illustrated magazine, the individual, and the late-Victorian masses. During this period the ownership of the print media became less diverse as large publishing conglomerates began to dominate the press. At the same time, the tone of the magazines these corporations produced focused increasingly on human interest material. While editorials addressed the reader in an intimate conversational manner, the magazine's purchasers were being positioned in groups defined by income, class, gender, or age. The reader became the target for the illustrated advertising for mass-produced products that magazines were now incorporating.[3] The methods that publications used to reproduce images were also moving toward systems of segmentation and industrialization. Yet, within this very broad picture there were many variations and adjustments. There was not just one category of image, one purpose for the image, one format of publication, or one monolithic audience. The masses did perceive themselves in the press, but not in a deterministic fashion. Mass reproduction provided not only a great number of images but also an increased variety of kinds of image. Although reproduction became more industrialized, it employed the engraver's and illustrator's hands to bring an individuality to mass-produced representation.

This study examines the struggle to depict the contemporary world during an anxious time of cultural and economic upheaval. I suggest that the spatially and socially fragmented urban culture of the 1890s could most usefully be grasped through its representations. New illustrated magazines both produced and reflected the visibility that was central to modernity. Pictorial journalism made the individual discernible in a new fashion and on a new scale. The press was able to provide its readers with up-to-date information on the surfaces of this modernity, vital to those attempting to navigate its complexities. It did this by using technologies of imaging, such as the sketch and the photograph, and technologies of reproduction, such as the halftone, that embodied that rapid and ephemeral nature of modernity. In consuming and understanding this material the reader became part of what Jennifer Green-Lewis has called an "interpretive community," that is, a cluster of individuals who are bonded together by the experience of common reading.[4] Benedict Anderson identifies the importance of mass-produced print in the creation of publics on a large scale, indeed on a national scale. In

Imagined Communities he suggests that the commuter seeing others reading the same paper with the same stories at the same time was reassured of the existence of an imagined national community far beyond his immediate locality.[5] The creation of a sense of recognition, inclusion, and belonging involves at the same time an exclusion. In the texts, drawings, and photographs of the illustrated magazine readers were able to comprehend who they were and also who they were not.

The press depicted the masses in a number of different ways using various techniques to image and identify the different groups and individuals within society. The pen-and-ink sketches of manners that became so popular in the 1890s showed recognizable "types" in everyday situations. These drawings separated the urban masses into classifiable upper-, middle-, and lower-class characters making them legible to the viewer. At the same time, large photographic halftones distinguished entertainers, authors, politicians, and sportsmen from their audiences. Yet these photographic halftones also widened the numbers of people who could be presented in the press. An American illustrator, Valerian Gribayédoff, complained in 1891 that anybody could now be portrayed in periodicals. Middle-class "merchants, lawyers, butchers and candlestick makers" wanted to see their likenesses reproduced in the press. Things had become so bad, Gribayédoff lamented, that even the portraits of the working classes appeared in the press.[6]

In other cases magazines portrayed the masses not as individuals or as "types" but as crowds, in particular well ordered and respectable ones.[7] As early as 1865 the pioneering editor and publisher Charles Knight had looked back over his bound copies of the *Illustrated London News* and noted the recurrence of the crowd in the magazine's coverage of topical events:

> If the whole outward manifestation of our present social life be not monotonous, their *sober* delineation in weekly pictures is decidedly so. . . . All these pictures are alike, with a difference. The scenery is varied, the actors are the same. . . . The staple materials for the steady going illustrator to work most attractively on are; Court and Fashion; Civic Processions and Banquets; Political and Religious Demonstrations in crowded halls; Theatrical Novelties; Musical Meetings; Races; Reviews; Ship Launches; – every scene, in short, where a crowd of great people and respectable people can be got together, but never, if possible, any exhibition of vulgar poverty.[8]

The crowd as presented and called into being in the images Knight lists is orderly and middle class and is taking part in the series of communal political and social events that helped to define the nation. As Knight complained, this process of visualization involved the exclusion and invisibility of the majority of the population that made up the "lower orders." Yet these groups did have a place in the *Illustrated London News's* depictions of the British social system. John Plunkett has examined the importance of the crowd

in the *Illustrated London News*'s coverage of royalty. In many of these images the loyal and enthusiastic crowds and not the queen and her consort are the focus of the picture. He claims that loyalty to the crown rather than the figure of the monarch herself is the theme of the engravings of royal visits to venues across the nation.[9] Although these crowds were too numerous to be entirely middle class, they were, nevertheless, coalescing around middle-class values.

The readers of the illustrated magazine wanted to see who they were, and who their fellow Britons were, a desire not limited to press images. In 1872 John Ruskin complained that the British public's wish to perceive themselves in visual form was the reason for the popularity of paintings of everyday contemporary scenes, rather than of the ideal or uplifting. Referring to the art of William Frith, Ruskin complained that its attraction was its imaging of the urban crowd. "You want essentially Ramsgate Sands and the Paddington Station, because there you can see yourself."[10] The media's ability to portray the modern crowd to itself was amplified in the second half of the 1890s by the application of photomechanical techniques as well as by film. The early "actuality films" of the Lumière brothers, Auguste and Louis, featuring subjects such as railway passengers at a station and workers leaving a factory were rapidly succeeded by the "newsreel" in the 1900s. Speaking of newsreel and film in the 1930s Walter Benjamin observed that "Mankind, which in Homer's time was an object of contemplation for the Olympian gods, now is one for itself."[11] The popular periodicals had already envisaged an "everyday" city in which the inhabitants could see their own surroundings and lives.[12] There were other places and other formats in which the modern audience could coalesce around the compelling presentation of their own environment. Vanessa Schwartz's study of entertainments in Paris during this period shows how the Parisian crowd became a collective audience for the spectacles of the city.

> Through the spectacularization of reality, urban dwellers could assume the pleasures of looking as the very means of constructing a new collectivity. Rather than subsist as alienated and detached individuals lost in the crowd, the urban mob happily assembled as a new collective in front of the spectacle of the real. In, and thus as, the audience, they became "Parisians."[13]

In the 1890s the magazines that depicted the urban scene were exponents of an illustrated new journalism that was related to wider changes in the press. In 1887 Matthew Arnold coined the phrase "new journalism" in his criticism of the *Pall Mall Gazette* and its editor W. T. Stead.[14] The long descriptive passages, verbatim reports of speeches, and detailed political analysis that had been the norm in the established press were now being replaced by short, varied paragraphs of gossip and opinion. Periodicals

adopted a lighter, more conversational tone, with an overall emphasis on personality and human interest. However, the new aestheticized and fragmented journalism was not, in fact, entirely new. This kind of material had been a feature of the working-class press since at least midcentury. In the 1880s George Newnes' *Tit-Bits* marketed short, miscellaneous, entertaining snippets of information and opinion to a lower-middle-class audience. What was novel in the 1890s was the bringing together of all of these elements for a broad middle-class audience in a lively visual format that incorporated more illustration.

So as not to deter potential readers or advertisers, contentious political content was excluded from most of the weekly magazines. Whereas daily papers were often openly partisan, in the depoliticized magazine personality rather than governmental policies or economic forces appeared to shape society. The photographically reproduced image fitted comfortably within this magazine as a means of depicting the world in an apparently impartial manner. One of the most important figures in the introduction of photographic reproduction was Clement Shorter, the pioneering editor of the *Sketch*, the *Illustrated London News*, and the *Sphere*. His assistant editor J. M. Bullock stated of Shorter: "He exercised a self-denying ordinance in excluding politics from his papers, for he held the sound view that an illustration is a neutral fact, and that it is foolish to deneutralise it by expressing opinions, at least of a political kind."[15] The photograph was the epitome of this neutrality, a neutrality that was in turn reinforced by the ostensible objectivity of photomechanical reproduction.

The photograph, in particular the photographic portrait, was used by magazines to support the emphasis on subjectivity that was one of the central characteristics of the new illustrated journalism. This focus on the personal applied to the content of the magazines, which concentrated on human interest and celebrity; it also embraced the way in which this content was communicated, both textually and visually. The editorial tone of the press became more intimate and conversational. The reader was no longer preached to or talked down to, but addressed as an equal. Through the familiar, conversational tone that the press adopted the personalities of journalists came to the fore. Magazines and newspapers featured wide-ranging columns of gossip and comment which emphasized the opinions and character of the individual writers who had gathered together these eclectic fragments.[16] The visual content of the magazines also drew attention to subjectivity and personality. Individuals of many types were depicted in the press: entertainers, sportsmen, writers, politicians, businessmen, and artists. Images of actresses and beauties had been popular throughout the century, but what was different in the 1890s was the press's ability to rapidly circulate the appearance, personal details and opinions of personalities on a huge scale. The new interview format, which was often accompanied by photographs, dramatically emphasized the individual qualities and thoughts

Figure 2 "Mr. Max Pemberton Reading the Sketch," *Sketch*, 20.249, November 3, 1897, 51. (Photorelief halftone print from retouched photograph, detail)

of the subject. Unlike the drawing reproduced by wood engraving, the halftone photograph appeared to offer viewers a direct trace of the individual it depicted. As such, it apparently represented them with an unmatched candor and intimacy. Photomechanical reproduction also allowed illustrators to become well known, as their distinctive styles and mannerisms were now ostensibly directly communicated. Photorelief techniques were highly suitable for magazines that were personal, informal, and conversational in tone and content.

Through its editorial and advertising content, the press helped to shape a collective, though by no means monolithic, consciousness of gender, class, and national identities. The illustrated periodicals and the advertisements they contained were targeted at different mass groupings. Raymond Williams points out that the periodicals in the 1890s were aimed at "masses" which he defines as "a particular kind of impersonal grouping, corresponding to

aspects of the social and industrial organization of our kind of capitalist and industrialized society."[17] Yet, these groups were very broadly defined as publishers who wished to appeal to as many purchasers as possible. The press did not merely address these groups, they had a stake in bringing them into being. Through their regular and timely appearance the illustrated magazines offered readers an apprehension of a public urban culture. In creating this group awareness the press formed and sustained a community, an audience of individuals which gained a sense of a collective identity via the mutual knowledge provided in the magazine. However, the relationships of individuals to these groups, how they saw the groups, and where they situated themselves in relation to the various classes were by no means simply determined by the magazines. Neither were they merely economically defined; social affiliations within a broadly defined middle class were shaped by religion, politics, geography, and education.[18]

Without a doubt, the magazine format, with its many diverse images and different authorial voices offered the reader choices.[19] Late-Victorian magazines were sites for multiple, sometimes contradictory, cultural messages that readers could draw on to make sense of the conflicts in their own lives. Readers made decisions about which magazines they read, what they read within the magazines they bought, and how they used the texts they consumed. Furthermore, in opposition to the magazine's intended meanings, the individual reader could also read across gender and class. Women read men's magazines, servants read their masters' periodicals. The magazine with its fragmentary structure and contradictory character offered a particularly extensive space in which readers could make leaps and connections. However, this is not to say that they were totally free to make just any reading they wished. The new emphasis on consumption within the magazine, for example, would be difficult for its audience to disregard. In addition, a reader's desire to subvert the messages within the magazine might well be limited.[20]

The hybrid image

The construction of the images in the press required considerable physical and material effort, and in this study I will look at the industries through which Victorians represented and reproduced their world and examine the emergence of the illustrated magazine within London's media networks. I describe the activities of the editors, journalists, publishers, writers, image makers, and reproduction firms who all congregated in the capital. London had a particularly rich and well-established print culture. However, similar developments in publishing were also occurring at around this time in Paris, New York, and Berlin. Indeed, many of the techniques of mechanical reproduction were imported into the British press from the United States, Germany, and France. Magazines had for many years bought or stolen images

from their overseas peers. Publications had produced foreign editions since the early days of the illustrated press; British journalists could see for themselves the high quality of the images in the European editions produced by American magazines such as *Harper's, the Century,* and *Munsey's*. This study concentrates mainly on developments in the English media in order to show the particular cultural and economic forces at work in the United Kingdom and how they resulted in very specific applications of reproduction technologies.[21]

Over the course of the 1890s, the amount of illustration in British periodicals and the number of illustrated magazines increased, allied to the adoption of mechanized reproduction techniques. A number of methods, known collectively as "process" used photography to transfer originals onto metal plates that were etched to produce raised surfaces that could be printed alongside letterpress type. These photorelief methods, sometimes called photomechanical processes, were broadly divided into line process, which could only reproduce linear originals, and halftone process that captured the continuous tones of paintings and photographs.

New institutions were organized to supply these images to the press. The first English photographic agency, the Illustrated Journals Photographic Supply Company, was founded in 1894. The first agency in the US, the Bain News Picture Agency, was established the following year. In 1897, the year of Queen Victoria's Diamond Jubilee, John Southward noted: "The leading illustrated journals now use process blocks, almost to the complete exclusion of wood-cuts. The popularity of the halftone is one of the facts of the present time. It has even brought into existence a new kind of literature, depending for its attractiveness upon the pictures."[22] By 1900 the director of the largest process reproduction firm, Carl Hentschel, estimated that the middle-class weeklies were using over 1000 blocks every week.[23]

Although the coming of photographic reproduction helped to transform the way in which the world was visualized, it is important to situate these technologies in relation to the established industries of image generation and hand reproduction.[24] The photorelief image fitted within the conventions of existing imagery, in the kinds of subjects it represented and in the ways they were depicted. Indeed, photographs traced or chemically transferred to woodblocks had been used by the press since the 1840s. There had been a dialogue between photography and engraving for half a century, as, in order to compete with the detail of the photograph, wood engraving had become increasingly fine and increasingly tonal in its aesthetic. Although photography produced some innovations in subject matter such as the introduction of snapshot imagery in the press, overall the photograph was one of a range of different kinds of image used. Line and halftone processes added to the imaging possibilities, making the visual content of periodicals more abundant, complex, and increasingly hybrid.

I follow Brian Maidment in insisting that the reproduction methods used played a large part in the meaning that these images had for their

audiences.[25] The wider variety of techniques available made editorial choices regarding imaging more complex in the 1890s. The magazine within its heterogeneous and fragmented structure incorporated diverse illustrations and photographs, reproduced via halftone, line process, and hand engraving. These images were deployed according to developing notions of appropriateness; moral considerations as well as aesthetic, economic, and practical factors governed magazines' imaging choices.[26] In some cases photographers were simply not allowed access to certain events, or they were unable to photograph a scene for technical reasons. In other cases the subject matter shown, particularly images of violence, poverty, or sex was too morally charged to be depicted photographically, but could be represented through illustration.

The most significant attribute of the photographic reproduction methods was that they heightened the nascent mass media's ability to mix and combine imagery. In effect, the introduction of photomechanical technologies destabilized reproduction and representation so that the discrete categories of photograph, wood engraving, and drawing took on a new fluidity. Imaging practices dissolved the boundaries of the image, melding wood engraving with process and photography with drawing. The illustrated periodicals of the 1890s contained a malleable flow of images. A typical magazine might contain wash drawings, line drawings, and photographs, all of which were reproduced by combinations of photographic and hand techniques. In many cases mechanical processes and hand techniques were merged together, not only on the same page but within the same image. Wood engravings were pirated, photographed, and printed by process. Halftone blocks and line process images were extensively retouched by hand. Pen-and-ink drawings were produced on top of photographs that were bleached out to produce an apparently handmade sketch. In photographic portraits the background and clothing might be completely re-engraved by hand. In some cases these mixtures were concealed, but many syncretic illustrations openly fused different systems of photographic and hand-drawn representation and reproduction. I suggest that these amalgamations were a means through which the press and the viewer negotiated anxieties regarding not only the visual image but the modernity that was portrayed in these images. For instance, the use of extensive retouching and re-engraving on photographic halftones allowed the viewer access to an image that communicated the intimacy and directness of photography while softening photography's association with mechanism and industry. These mixtures produced images that were fundamentally ambiguous.

Photomechanical reproduction was enthusiastically adopted by illustrated human-interest weekly and monthly periodicals. Halftones were also deployed in other kinds of publications such as books, but their commercial development was very much shaped by the economics of magazine production.[27] The refinement of the mass-produced image was very much

tied to the fortunes of these magazines. For instance, during the first six months of the Boer War, from January 1900 on, there was an intense media effort to image the conflict for a domestic audience eager for both photographic and hand-drawn pictures from the front. Many new photomechanically illustrated magazines were launched during these few short months, and the quality of magazine reproduction and printing improved dramatically as publishers competed for a lucrative market.

The publishing trade was one of the most highly industrialized sectors of British manufacturing. Using modern systems of production, communication, and distribution, publishers created a mass public for their products. This study locates reproduction processes as industrial techniques within this highly mechanized, bureaucratically organized sector of manufacturing. Charles Booth, in recording the dire economic situation of wood engravers in 1901, argued that engraving had been more adversely influenced by technological change than any other trade.[28] One of the themes of this study is the various ways in which these systems of production shaped the images that the magazines contained. In his "Notes of the Present State of Wood Engraving in England" written in 1876, John Ruskin linked the lines of facsimile wood engraving firmly to the industrial character of Victorian culture. The speed of production which magazines now demanded meant that the engraved lines had become meaningless, the result was merely a slavish copy rather than an intellectually directed translation of an original drawing. He connected the material qualities of these wood-engraved illustrations to the pace of contemporary life, and to a publishing industry driven by the debased tastes of the British public. He complained that the modern illustrated press was "enslaved to the ghastly service of catching the last gleams in the glued eyes of the daily more bestial English mob, – railroad born and bred, which drags itself about the black world it has withered under its breath ... incapable of reading, of hearing, of thinking, of looking, ... "[29] Ruskin's despair at the vulgarity of the nineteenth-century public in this passage was sparked off by the industrialization of image production which had resulted in the enslavement of the worker. As we shall see, Ruskin's portrayal of the mass audience with its shorted attention span, and its thirst for visual stimulation, and the press that served this audience became the norm in the critical discourse around mass reproduction.

The facsimile system that provoked Ruskin's rage involved the faithful cutting of lines that in many cases were photographically transferred onto the woodblock. This is one of the numerous ways in which photography intersected with hand-drawn and reproduced imagery. The constant merging of these two very different reproduction methods, I suggest, rendered images as essentially hybrids. This study queries the purity of the reproduction technologies themselves. All technologies are amalgamations, which draw on their predecessors. The development of photographic reproduction methods was not linear, but rather consisted of a complex series of overlapping

exchanges, shifts, and transfers of people, mechanisms, and above all, visual forms. This study suggests that through their amalgamation, both reproduction and representational practices straddled the old and the new in an attempt to negotiate an uncertain visual terrain.[30]

A message without a code?

The essential hybridity that emerges from an investigation of the early process industry is at odds with triumphalist accounts of the "photomechanical revolution" in which detailed and more accurate halftones sweep aside the existing hand-engraved methods. This view was most influentially expounded by William Ivins whose books *How Prints Look* (1943) and *Prints and Visual Communication* (1953) have shaped much of the subsequent understanding of these technologies. Ivins was curator of prints at the Metropolitan Museum of Art in New York, and his arguments were mainly based on the reproduction of works of art, which have always been a minute proportion of the images produced at any one time. Ivins ignores most of the photographic and drawn images which the illustrated press produced.

The halftone was, for Ivins, what all the previous technologies of reproduction would have liked to have been:

> The principal function of illustration has been the conveyance of information. The graphic processes and techniques have grown to the end of conveying information. The illustration that has contained the greatest amount of information, i.e. detail, has been the one most in demand. As a result of this, the graphic processes have shown an ever increasing fineness of texture.[31]

Ivins' version of events does not stand up to close examination and is at odds with what was actually occurring in reproduction and image making. His claim that image reproduction techniques invariably became increasingly detailed in a drive for greater amounts of information cannot be sustained. A photograph might include a lot of detail but not much information, whereas a pen-and-ink sketch or a diagram might well convey a great deal of information without containing much detail. Not all of the reproduction processes of the 1890s valued detail, but they worked toward communicating certain kinds of information. A bold wood cut might be more meaningful to a specific audience, than a photograph. Wood engravings certainly did become more photographic in their textures and moved toward facsimile rather than translation. Nevertheless, they retained their ability to clarify and edit imagery. Photographs themselves were retouched to achieve the same ends.[32] So, rather than a photographic hegemony based on informational clarity, the last decades of the nineteenth century saw the development and refinement of different conventions in illustration

and image making conforming to the expectations of particular audiences. Distinct types of illustration and reproduction methods were used for posters, for news images in the press, or for fiction. Photographic images, for instance, were rarely used for magazine advertisements, many of which retained a hand-drawn and wood-engraved aesthetic.[33]

In any case, throughout this period wood engraving was able to surpass the halftone in its ability to capture tone and detail for the printed page. But Ivins argued that no matter how fine hand engravings became, the lines of the engraving stood between the viewer and the object it depicted. Through their linear syntax, wood engravings attested to the presence of a translator or interpreter of the original. In contrast, the halftone enabled the viewer to have supposedly direct contact with an object and the artist. Ivins maintained that the halftone grid was below the level of vision, it had no discernable syntax, and it therefore operated as a neutral conduit of information. In order to position the photograph and halftone as immediate and factual forms of reproduction, Ivins cleansed them of human agency. He overlooked the role of individual choice and design in the making of photographs and saw them as the result of chemistry rather than human actions and subjective judgment. Similarly, he also ignored the considerable interpretive human element in the halftone process. In addition, as critics have argued since the 1890s, the halftone itself does have a syntax as the regular rows of dots are in themselves a visible and meaningful aesthetic element.[34]

Ivins' version of events does not account for the continued use, and indeed growth, of other methods of image making alongside the photograph. In his essay "Iconography and Intellectual History: The Halftone Effect," Neil Harris agrees with Ivins on the importance of the shift in the visual which occurred in the last decades of the nineteenth century. "In a period of ten to fifteen years the whole system of packaging visual information was transformed, made more appealing and persuadable, and assumed a form and adopted conventions that have persisted right through the present." Process, both line and halftone, did eventually replace the wood engraving as a standard method of reproduction in the press. However, Harris makes the point that the photograph did not oust the drawn or painted image and notes the "permanent continuity of non-photographic reproductions."[35]

The photograph and the halftone

In the illustrated magazines of the 1890s, halftone reproductions were often captioned "from a photograph." This might seem strange to us nowadays, for are these images not photographs? But, in asking the question we are reminded that they are not. Printed photographs in the press are reproductions, replicas, duplicates, copies of photographs. When we look at a photograph in a book, a magazine, or a newspaper our first reaction is to

think, if not that we are seeing an analogue of the thing that the photograph represents, that we are, at least, seeing the original photograph. But we are not. The difference between the original photograph and the reproduced image may seem at first glance subtle, but the distinction is, in fact, vital. This distinction was much clearer in the early days of illustrated journalism when the photographically derived illustration laid out within the textual matrix of the magazine was a novel visual form. At the time of its emergence, the halftone photograph was a strange new phenomenon that attracted a good deal of critical attention.

The photographic print and the halftone "from a photograph" are two objects with very different material qualities. The halftone detaches the photographic image from its material base and from the context of its photographic production and consumption. Once a negative image is printed on photographic paper, it has a three-dimensional materiality; it is not simply a surface but has a front and a back. Its face has certain physical properties, such as a glossy or mat coating. These characteristics are central aspects of its consumption; a certain kind of photograph is placed as a large individual object in a frame, another is inserted into an album, arranged alongside other photographs. The photograph is more than simply an image but is an object that is usually part of a personal collection connected to a personal narrative. By reproducing just the surface of the photograph, the halftone emphasizes the image at the expense of the photograph's other qualities.[36]

One key difference between the photograph and the halftone is the latter's multiplicity. The daguerreotype produced a single picture, and it was only with Fox Talbot's calotype process that the negative enabled multiple photographic prints to be made. Although the photograph had became a multiple, these were, nevertheless, discrete photographic objects. Furthermore, even if a number of prints are taken from a negative, in the vast majority of cases the photograph is a severely limited edition. Indeed, as Mary Warner Marien notes, nineteenth-century photographic discourse seems to have overlooked the implications of photographic multiplication.[37] It is true that in the nineteenth century, photographs and *cartes de visite* were produced in large numbers for those who wanted to possess images of royalty, beauties, topical events, and topographic scenes. However, purchasers would have selected a particular *carte* purposefully, and once these images were bought, they were carefully organized and saved. In contrast, multiplicity, miscellany, and ordinariness are inherent in the halftone image in the press. The mass-reproduced photograph is manufactured and consumed in relation to other images and written inscriptions. In the magazine it becomes just one ephemeral image among many contiguous texts. It is this representational multiplicity and hybridity that readers experienced for the first time in the photomechanically illustrated magazines of the 1890s.

Once it is printed in a magazine, the halftone is viewed, handled, and experienced in specific ways that are very different from the ways in which

photographic prints are consumed.[38] In the magazine the image is embedded in a very specific reading process, as the reader turns the pages backward and forward, glancing rather than studying. Unlike the comparatively linear and uniform consumption of the book, the magazine is often flipped through, that is, the reader is not consciously looking *for* anything in particular. Illustration fits within this fragmentary erratic mode of consumption, which the magazine format encourages. The reader may skip rapidly from text to image to caption to headline, but may then slow down to concentrate on the aspects of the magazine they find of particular interest. The structure of the magazine allows readers to construct their own order, starting and ending where they wish.

Whereas the photographic print is often a private and domestic object, the photographic halftone inhabits a commercial space.[39] It is for sale and is purchased, not for its own merits, but as part of a publication in which it is also surrounded by commercial messages. As part of its role within the periodical the halftone takes on a specific temporal arc. It is available for purchase at a certain point in time and may be discarded shortly after its acquisition. Our attention on a specific image may be relatively short as the layout of the periodical always invites us to move on. Victor Burgin writes, "It is not an arbitrary fact that photographs are deployed so that we do not look at them for long; we use them in such a manner that we may play with the coming and going of our command of the scene/(seen). . . . "[40] Halftones are essentially public, ephemeral, and part of the everyday.[41] Whereas the photograph is often singular, the halftone is essentially multiple, meant to be seen in relation to other images, whether those images are reporting the same story or are juxtaposed with it in the magazine. It becomes a text that potentially speaks to every other image in the publication in which it is printed and also to those in every other publication.

The cultural importance of the photorelief image was even more intense as its reproductive matrix was type compatible; images of photographs could be inexpensively printed at the same time as letterpress text, just as wood engraving allowed images to do in popular topical magazines from the 1840s. As Brian Maidment has pointed out, "The most profound revolution brought about by the massive use of wood engraved illustration was the way in which wood engraving presupposed an intense relationship between an image and a written text."[42] This opened up a vast series of relational possibilities. The written text could change the meaning of the image; the image could encourage the readers to see the text in new ways. The two could act to support, enrich, transform, or contradict each other. A dramatic and sensational textual account of a train wreck might be accompanied by a restrained image of the aftermath, thereby softening the impact of a disturbing event while still offering the reader a sensationalist thrill. These conflicts between diversely authored texts and images created fruitful spaces of meaning for the reader.[43]

The halftone of the 1890s allowed the photograph to occupy the same page as the printed word on an economically viable basis. Photomechanical reproduction and the increase in imagery unsettled and complicated the relationship between text and image in some respects. As photographs were deployed in greater numbers, they operated, in some cases, independently of texts. There was, for instance, an early vogue for photographic competitions as a means of filling editorial pages with freestanding images. In other respects, the intimate relationship that Maidment describes continued and even intensified as the text intersected with the comparatively enigmatic photographic image.

The transformation of a photographic print into a halftone involves a complex change between forms of representation. Subtle and not so subtle variations in tone, size, and color between different originals were homogenized as photographs became halftones. Through the reproduction process certain tonal qualities and elements were emphasized as others were discarded. In addition, through retouching the original image was visually modified according to specific criteria that varied according to the publication and the class of the viewer. The reproduced image could also be enlarged or reduced. It was in the 1890s, in fact, that, for the first time magazines began to crop photographic images in order to exclude content and alter their meanings. All of these interventions realigned the meaning of the image in a certain direction.

Whereas the surface of the printed photograph consists of continuous tones on a light sensitive metal coating, the printed halftone consists of dots of ink of varying sizes with more or less white space between them. Held at arm's length, these dots give the illusion of unbroken tone. Roland Barthes proposed that the photograph's status as a truthful trace of reality as a "message without a code" is dependent on the continuity of this surface.[44] Jennifer Green-Lewis suggests that, for mid-Victorian viewers, the photograph's lack of an "intrusive surface" bolstered its claims to be an unmediated view of reality. The unbroken nature of the photograph's tonal surface allowed the average Victorian reader – and still allows many of us, today – to overlook its mode of production. Photographic halftones that mimicked the aesthetic and the surface of the photograph suggested a similar veracity and credibility.[45] William Ivins' assertion of the halftone's superiority as a reproduction method rested on the fact that for him it had no visible syntax, and therefore no reproductive code. According to Ivins, this meant that the halftone offered the viewer a direct experience of an original work of art freed from the intrusive lines of the engraving. Yet, reproduction processes are never neutral, transparent, or direct as Ivins would have it. Each reproduction technique suggests a particular way of viewing the world while it closes off other possibilities. The halftone, through the suppression of its reproductive codes, signified rationality, candor, and directness. Halftones attempted to conceal the work of interpretation and selection inherent in the act of representation and clearly visible in the lines of the wood engraving. I suggest that

its application was part of a general move within the systems of the mass market to detach production from consumption, and work from leisure. The designer and illustrator Walter Crane observed this separation in describing the attractive displays of goods in shop windows. As the commodity became more visible, the labor that produced it became less tangible. Crane wrote of the commercial cityscape: "The shops too are not workshops. The goods appear in the windows as if by magic. Their producers are hidden away in distant factories."[46]

Visual advertising

The magazine also became a commodified space in the 1890s when large scale image-based advertising began to surround the editorial texts. The 1890s therefore signaled a new commercial alignment in which the product became an integral part of the periodical and the illustration was used as a means of mobilizing mass consumption. Up to this point advertising had been strictly controlled in the press, particularly in the dailies. Classified advertisements were placed on the outside of newspapers and periodicals, segregated from editorial matter, and most newspapers would not admit advertising with bold "display" type or illustrations. The visual appearance of advertisements was controlled by the papers that typeset and positioned them.[47] By the 1890s, however, the presses were opening up their editorial pages to illustrated advertisements that could appeal to the viewer on the basis of emotion, aspiration, and fantasy far more effectively than the typographic advertisement.

As with many other aspects of media innovation, illustrated magazines showed the way and, since the 1840s, advertisements had been incorporated among their articles and images. It was in the 1890s, though, that magazines became truly commodified spaces in which advertising matter was mixed within editorial pages. An article from 1897, entitled "The Encroachment of the Advertisement," complained that advertisements were actually appearing on the same page as editorials, not just facing them. It noted that even in respectable periodicals advertisements were "soaring higher and higher on the pages, until the [editorial] matter itself occupies but a narrow space at the top as though placed on a high shelf."[48] Advertisers were increasingly successful in their attempts to insert their material into the journalistic sections of the magazine, either as editorial plugs, advertisements disguised as editorial features, or overt advertisements. Publishers, for their part, were getting used to the idea of relinquishing space and visual control to others.

It was around 1895 that the position of advertising in the press changed. The depression in trade that had lasted for twenty years was coming to an end, and there was a renewed burst of commercial activity.[49] Manufacturers were now organized in larger corporations and associations and

were concerned about overproduction. They therefore strived to organize and control the distribution of their mass-produced goods. Advertising was beginning to shake off its association with dubious patent medicines, and mainstream manufacturers were increasingly convinced that it could be an effective and appropriate means of reaching respectable consumers. Through the weekly magazine, advertisers were able to reiterate their images and repeat their messages again and again, becoming a constant presence in everyday life. Most important, the magazine, unlike the poster on a billboard, could take the visualized product into the heart of the middle-class home. Once there it would then remain in the domestic space far longer than the daily newspaper. The modern advertising industry was born in the 1890s with the establishment of full service advertising agencies and the appointment of advertising managers by periodical publishers.[50]

In the 1880s and 1890s there were very important innovations and refinements across a range of imaging and reproduction technologies that were tied to the need to appeal to viewers in a more compelling fashion. The lithographic printing of intensely colorful designs for larger images such as for posters and packaging was as commercially important as the letterpress technologies in the periodicals. In 1896 the German intellectual Georg Simmel coined the term "aesthetic productivity" when he contrasted the attractions of the illustrated lithographic poster with the traditional typographic newspaper advertisement. These economically driven attempts to visually entice the city dweller he described as "the shop-window quality of things."[51] The French critic Arsene Alexandre writing in 1895 noted the increasing importance of visual appeal in book publishing. In the age of advertising, each book now had to be "its own sandwichman" enclosed in an illustrated cover so that it could make an impact in the bookseller's window.[52]

The magazine quickly became an essential link between the production of commodities and events and their consumption. Week by week the illustrated magazine created, traced, and maintained a culture of the mass-produced commodity. It did this not only through the advertising it now contained but also through its subject matter. Department store sales, theatrical performances, book publications, were all presented within the weekly magazine. Reports of new technologies, entertainments, and fashions enabled readers to keep abreast of the rapidly changing world of goods and become skilled modern consumers. With the integration of illustrated advertisements into the editorial sections of the magazine, both commercial and editorial material reinforced each other, each of them reflecting and shaping the reader's concerns. Consumption became the inescapable backdrop to the magazine.[53] Illustrated advertising addressed the viewer as an individual embodied subject, someone with fears and desires, someone who could feel both physical pain and pleasure.[54] The magazine and its advertisements offered consumers mass-produced goods and experiences through which they could express their individuality. Yet, at the same time that she

was spoken to as a discrete person by the advertiser, the reader was also being positioned as a consumer in a category based on her presumed class.

Hand-drawn illustration

Recalling the magazines of the 1890s, Holbrook Jackson stated, "Every phase of life found its pictorial exponents. . . . Where the camera could not operate, in for instance the realm of character study and humor, the modern genius for pen drawing produced surprising and masterly results."[55] Certainly, a wide range of handmade images appeared beside the photographs in the press. Some of these came from "cut agencies" which, since the middle of the century, had provided the press with formulaic images to order. Indeed, the words *cliché* and *stereotype* originally referred to the printing plates that these firms supplied. Complex wash paintings were imaged by halftone, while line process captured the bold graphic marks of pen-and-ink illustrators. Pen and ink was seen as the most innovative and contemporary of the modern methods of hand-drawn illustration. Pen-and-ink sketches were used for political and social caricature and also for the illustration of news. Its supporters argued that these lively, brief, autographic images surpassed the static and overdetailed photograph as a means of capturing modern life. These bold line sketches were perfect for the press: they were easier and cheaper to print than photographs, harmonized with the linear qualities of type, and provided a sharp visual contrast to the gray tints of the halftone.[56] These sketches reproduced by line process appeared to communicate the illustrator's vision directly to the viewer. The autographic marks of pen-and-ink drawings were an assertion of individuality in the face of the seriality and anonymity of the photograph.

Many of the sketches in the press dealt with everyday life in the city, with what Judith Wechsler calls "social caricature," that is, the "satirical presentation of typical characters in everyday situations."[57] The illustrators of *Punch* called these images of contemporary life and behavior "socials" to distinguish them from the political cartoons that the magazine also featured. In *Punch*, as in most of the illustrated magazines, these line images depicted the miscommunications and class confrontations of modern urban life. These sketches of the contemporary scene allowed middle-class readers to simplify and clarify the unpredictable and potentially overwhelming encounters that took place in the city. The drawings achieved this through their use of types – recognizable figures epitomizing aspects of race, class, and gender.

These standardized characters – bluestocking, do-gooder, teetotaler, drunk, toff, Jew, street urchin, cabbie, city clerk – were dependent for their meaning on other media portrayals. The illustrator's image was therefore always a representation based on other representations. Caricature alluded not only to other caricatures and other modes of graphic depiction but also to the

poses of theatrical performance, pantomime, and melodrama.[58] This is not to say that illustrators did not also base their images on observation, but that their image-making choices were filtered through existing representations. Phil May, the most brilliant and popular caricaturist of the 1890s posed models for his sketches. Yet his comments on his methods reveal the tensions between representation and reality that illustrators had to negotiate. He stated, "my types are all individuals. I am constantly on the look-out for the individual who embodies a type."[59]

The designer Charles Ashbee, who lived through this period, believed that May's drawings of city life marked a new phase in social caricature. He suggested that in the 1870s Charles Leech's drawings for *Punch* had shown "English bourgeois society in process of absorption into the great aristocratic tradition."[60] By the 1890s, the England that Leech and, later, Charles Keene traced had been transformed. According to Ashbee the caricaturists of the nineties, such as May, revealed a "new social order," the mixing of the classes in the "mechanistic democracy of Industrialism."[61] These heterogeneous spaces were a feature of the late-Victorian city, from the busy shopping thoroughfares to the entertainment venues that appealed to large diverse audiences. For the middle classes this experience was at the same time exciting and unsettling. As Julian Franklyn observed in his book, *The Cockney* (1953), Phil May's images showed class confrontations: "The blending of contrasts, the fraternization of the extremes of society that was so much a feature of the old music hall, is present throughout Phil May's work. . . . The well-dressed will be familiarly accosted by the ragged: the swell chipped by the coster."[62]

May's images visualized the disorientation and dislocation of modernity, in which everything and everyone were now in flux. The rapid growth of the Victorian city resulted in its inhabitants being unsure of their class positions. Sketches of manners established the city as a knowable place and, moreover, as a place that was defined by class. As Richard Terdiman notes, in time of rapid social change, small details of appearance become very important, not only in themselves but as means of establishing, maintaining, and reinforcing the structures of class differentiation. He suggests that "beyond any of their specific contents, such signs communicate and enforce the reality and the constitutive practices of a culture's internal differentiation."[63] Illustrators of the 1890s were no longer producing gentle comedies of manners but tracing the disruption inherent in the muddle of contemporary city life. By presenting these encounters and establishing these stereotypes caricaturists were identifying threats and problems and, simultaneously, making them less threatening. The depiction of types in the press suggested to the viewer that the urban masses were recognizable and categorizable. This comforting and partial knowledge allowed the magazine reader to operate effectively on the basis of prejudice and conjecture.

In 1855, Charles Baudelaire had argued that the sketch rather than the photograph was the best way of communicating the vital signs of class and

status in the fast moving contemporary metropolis. Baudelaire's subject in his seminal essay, "The Painter of Modern Life," was Constantine Guys, an illustrator who worked for the *Illustrated London News*. Baudelaire argued that the photograph was unable to capture the fast moving and complex surfaces of modernity and overwhelmed the viewer with too much unselective detail and at the same time gave too little specific information. The sketch artist, on the other hand, could distill the essential elements from the contemporary urban scene. Illustration could show the viewer only the important aspects of an event and not inundate them with photographic superfluities. The illustrator was a man of the world, intensely engaged with the visible surfaces of the modern city, and was therefore a cut above the Academic artist who was concerned with the historical and the ideal.[64] Baudelaire declared that every aspect of appearance – from the fall of draperies to gesture and posture – was specific to its own time and revealed to the astute observer differences of class and breeding. The illustrator's "eagle eye" was able to pick up on the slightest changes in the cut of garments or the styling of hair. Baudelaire advised that these details must be captured quickly, as "in the daily metamorphosis of external things, there is a rapidity of movement which calls for an equal speed of execution from the artist."[65] The illustrator was completely focused on the present, on everyday modernity.

Guys' images were reproduced in the *Illustrated London News* by wood engraving, and Baudelaire based his analysis on the artist's original drawings. Baudelaire's theories seemed to reach their fruition in the 1890s when illustrators no longer relied on wood engravers to translate drawn lines into reproducible form. Rather than using pencil as the illustrators of the past had done, Phil May and his contemporaries produced pen-and-ink originals. The apparent speed, fluidity, minimalism, and roughness of the sketch became tokens of artistic sincerity, of an honesty that set it apart from Academic gentility or photographic literalism. Black-and-white illustration celebrated the rapidly drawn line, in contrast to the Academy's valorization of highly finished tonal drawing and painting. In opposition to the detail and idealism of Academic orthodoxy and as a reaction to photography's mimetic surface, illustration renounced polish and refinement. This bold graphic style had developed partly because of the technical requirement of line process, which had initially demanded open work and strong, simple lines. Yet, even when process became more sensitive in the 1890s, pen-and-ink caricature still retained the rapid, sketchy aesthetic that evoked the rapidity of modern life.[66]

Following in Baudelaire's path, pen-and-ink illustration was discussed seriously by critics in the 1890s as an important new artistic development. The discourse around the contemporary illustration, contained in the writings of Joseph Pennell, Joseph Gleeson White, Charles Harper, and others, made claims for the sketch as an important modern art form. Its supporters

linked pen-and-ink drawing to other stylistic developments, including the Aesthetic Movement and Impressionism as well as avant-garde printmaking techniques such as etching. For its proponents the pen-and-ink sketch was a revolutionary affirmation of the artist's subjective vision in a new artistic arena that was outside of Academic control. The technological duplication of the pen-and-ink illustration defined it as a modern art form that was much more immediate, accessible, and democratic than the hidebound and distant Academy. Many of the new illustrators had no artistic training, the tools they used were inexpensive, their subject matter was often quotidian, and the images they produced were seen by huge audiences in relatively inexpensive, mass-produced, ephemeral periodicals.

The sketch fitted perfectly within the regime of abbreviation and segmentation in the press. It was confined within a page, defined by a caption, and could be rapidly scanned by the viewer. The press's fragmentation and diversity were seen at the time as being linked to the faster pace of modern life in which readers had little time for contemplation.[67] The world of journalism itself also seemed to epitomize the increasingly hectic pace of life. As Charles Harper put it in 1891: "This is a feverish age, the era of (amongst other evils) an unexampled race for wealth, for fame, for notoriety, and for news . . . in all the diverse fields of modern work it would, I feel, be difficult, if not impossible to find any department of labour more hurried than that of the journalist."[68] In some sectors of publishing the layout of texts and images seemed to visually celebrate speed, unpredictability, and transience. The paragraphs of the evening press were laid out with larger headings and illustrations in a format that could be easily scanned by commuters and busy office workers.[69] Monthly magazines such as the *Strand* had the time to produce elaborate integrations of text and image. Weeklies were more constrained in their production cycle and, on the whole, they relied on a fairly regular grid to enclose their varied editorial matter.

Knowingness

Although on one hand the layout of the magazine allowed the reader to trace his or her own path through its content, the periodical also functioned as a means of bringing its readers together as members of a group. It did this through the diffusion of a shared, superficial, contemporary knowledge that I term *knowingness*. The historian Peter Bailey's discussion of knowingness is extremely valuable in considering how the audience for mass culture might coalesce. He has analyzed how knowingness operated in the Victorian music-hall allowing the audience to "complete the circuit of meaning, thus flattering them in the sense of their own informed and superior worldliness."[70] He states "it was through knowingness that the skilled performer mobilized the latent collective identity of an audience." By presenting material that required some prior knowledge the performer turned a disparate and shifting

crowd into a communal audience. "This flattering sense of membership is the more so since music-hall performance suggested that such privileged status was not so much conferred as earned by the audience's own well-tested cultural and social competence." Bailey stresses that this knowingness addressed the uncertainties of life in the rapidly changing modern metropolis, where the individual needed to remain wary and alert in a mass of anonymous strangers. Indeed, he suggests that the knowingness of the music-hall can be seen as a new idiom linked to the hurried transformation of modernization.[71]

My use of knowingness, although informed by Bailey's characterization, is broader. Knowingness in the music-hall often related to sexual matters, and, moreover, was somewhat subversive, it "punctured official knowledges and preserved an independent popular voice." It is associated with that which is unsaid or only hinted at. The knowingness that was circulated in the press was less exclusionary than in Bailey's model of the music-hall, enabling a wide audience to feel they were "in the know." Knowingness in this sense was also not limited to the sexual, was certainly not subversive, and the information provided was not simply implied or hinted at. Rather, I use knowingness to describe the shared, up-to-date knowledge of a broad range of ephemeral, contemporary material. I argue that the readers of the late-Victorian press experienced a good deal of pleasure in assembling and using fragmentary information in order to feel that they knew what was happening at that moment. Like Bailey, I want to emphasize the communal and pleasurable aspects of knowingness. Knowingness was shared through conversation and through simultaneous consumption, it was active and it was social.[72]

In day-to-day matters, the knowledge required by city dwellers was diffuse rather than deep. Superficial categorization, based on surface appearance, allowed the inhabitants of the metropolis to navigate the fleeting, anonymous encounters of economic and social life.[73] In the rapidly shifting urban arena there were strong incentives to keep abreast of change, to be assured that one knew what was going on. In the 1890s, knowingness became increasingly important, and the illustrated magazine was a key site for the circulation of this broad, though shallow information. The magazine created a body of timely knowledge and also an awareness that this knowledge was shared.

The photograph and the sketch both depended on a relationship of knowingness. The minimal form of the pen-and-ink sketch involved the audience in its completion, in closing what Bailey terms the "circuit of meaning." The sketches of manners that Phil May and his peers produced depended on the viewer's existing knowledge of the types they presented. The key details the illustrator provided enabled the viewer to complete the picture, to fill in the gaps. Drawing on their experience of other textual and visual depictions readers could recognize the characters and get the joke. The humor of social

caricature was often derived from its characters' inability to understand a situation or to behave in an appropriate way. The reader who grasped the joke gained satisfaction from placing himself in a group more worldly than the characters in the sketch.

Whereas the rhetorical thrust of the social caricature might be relatively clear, the photograph was less easy to read. Viewers required even more external knowledge to make sense of the photographic images in the press. As Baudelaire had noted, unlike the selective sketch the photograph showed everything. Its messages were in the details of its surface, but which of these details were meaningful? In addition, these meanings were subject to increasingly rapid change. City dwellers required a constant updating on the ever more swiftly shifting signals of fashion. As well as this visual information they also needed reports on who the subject of the photograph was, on what the subject had done, his or her character, etc. In modern society this data is usually garnered from previous media encounters. This information does not need to be detailed or truthful, but the reader needs the assurance that he or she knows something, that he or she can connect somehow to the photographic surface which confronts them. The photograph in the magazine is therefore clarified and vivified by the knowledge that the contemporary viewer gathers from the surrounding visual and written texts as well as other media encounters, for example, with theater or cinema.[74]

The periodicals in which halftones were first deployed were sites that circulated the knowledge required to read the process photograph. The magazine's continual referencing of other media and contemporary urban culture, therefore, helped its readers to give meaning to its images and achieve a reassuring and enjoyable sense of knowingness.[75] The serial nature of the periodical was an important aspect within this structure as events, personalities, products, advertisements, and ideas recurred week after week. The illustrated periodical's unique power was that of visual and textual repetition. On a regular basis it was able to reproduce, reduplicate, reiterate, and recirculate apparently slight fragments of knowledge, which, through their accumulation became very significant. Like the dots of the screen these multiple shallow fragments provided a comprehensible picture of modernity.[76]

Knowingness was articulated and circulated through commercial channels, the publications that provided the information which they thought their audience wanted. However, this knowledge did not merely travel through the press, but circulated by means of interactions between people, whether intimate conversations between family members, or banter between a group of people in a workplace. As Patricia Anderson notes the members of the mass audience discussed the contents of magazines in shops, in homes, and in pubs.[77] Although in one sense the audiences for mass-produced magazines were addressed very much as individual consumers, in another sense these magazines could never be read individually. Each reader was always aware that many others were consuming the same material. The contemporary

French sociologist Gabriel Tarde identified the importance of the press in creating a continuous, simultaneous social interaction, which he described as the soul of the modern public. These shared opinions and scraps of gossip he spoke of as "the unification of the public mind."[78] Tarde noted the importance of celebrities as the subject matter for the social intercourse that was so important in maintaining cultural cohesion. In the new metropolis, these public personalities were the individuals that everyone knew. Gleeson White writing in 1895 noted the same phenomenon and saw the light material in the press as creating national connections within a more dispersed society:

> It is an age of the interview and the reporter, and the kodak has come to his aid, so that a new public take the old interest in scandal and tittle tattle; but thanks to increased opportunities, its scandal-loving and gossip concern a nation of celebrities and nobodies instead of being limited to a parish.[79]

Advertising also had a hand in producing and sustaining this sense of social connection. Jennifer Wicke suggests that in large complex societies there can be no common core. "A network of texts, of advertisements, 'floats' throughout the country and accomplishes the supreme task of creating a center where one has never existed. Ads provided a way of charting this unfathomable, centerless world, and the newspaper was their particular territorial domain."[80] She uses the term "social reading" to describe a situation where each reader is aware of the same slogans and advertisements at the same time.[81]

In 1896 the drama critic William Archer offered a fascinating glimpse of the transmedia operation of knowingness in his review of a performance of *The Gay Parisienne*. In Archer's review, the play and the topical publication became one. The show was an example of a new theatrical format, the musical comedy, in which the surfaces of contemporary life were presented on stage in heightened form. In pieces such as *The Typewriter* or *The Shop Girl* audiences would see a more colorful version of their own lives enacted on the stage. Like the illustrated periodical, the musical comedy contained a variety of material: prose, verse, music, dance, sentiment, and spectacle. Archer, whose writing appeared in the *Sketch* and the *Pall Mall Budget*, noted that the play was indeed a "close reproduction of the external phases of everyday life." He went on to comment on its topicality: "Such a piece as 'The Gay Parisienne,' far from resting on any substructure of mythology, history, or literature, seems rather to assume that the world was invented the day before yesterday." This picture of contemporary life was visually rich and meticulous with a great deal of attention given to sets and the actresses' fashionable costumes. Linking the play to images in illustrated periodicals, Archer urged readers to "Consider its charms as an animated fashion plate."

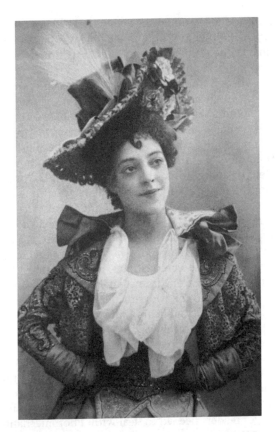

Figure 3 "Miss Ada Reeve as Julie Bon-Bon in 'The Gay Parisienne' From a Photograph by Hana, Strand," *Sketch*, 14.170, April 29, 1896, 1. (Photorelief halftone print from retouched photograph)

He noted the importance of up-to-date material to musical comedy's success, as the play was constantly revised in order to stay current. "It goes through a second and third edition, for all the world like an evening newspaper."

Archer mingled with the lower-middle-class audience of clerks and shop workers, who were drawn to the theater for relaxation after work. As in the popular press, these patrons were addressed informally, as equals, by the performers. He described in a bemused fashion the reactions of this audience: "They had picked up from the news papers and the scrap papers a very fair notion of what was going on in the world." However, Archer thought that "their interest in life is superficial, uncritical, unselective." Archer clearly wasn't as up-to-date as his companions and admitted that the audience caught references that he was unable to follow. "Any allusion, whatever its tone or its tendency, was sufficient to delight them. If only something was

mentioned that they knew something about, they did not care what was said on the subject, or whether anything intelligible was said at all." The appeal of the performance, he claimed was not due to sentiment but to "common knowingness on political and social matters."[82]

Just as in the theater, topical references in magazines served to create a bond between the publication and its audience. For the reader, they created a perception of communal knowledge and maintained a comforting, pleasurable sense of a shared, if swiftly changing present.[83] In times of rapid upheaval and uncertainty, the unique power of the illustrated magazine was its ability to quickly and continually circulate the knowledge that city dwellers needed. Its ability to do this came not from the image or the text alone, but from the magazine's hybridity, the fact that it could juxtapose a variety of texts and images and do so week after week. The serial nature of the magazine meant that material in any one issue related to previous and subsequent issues of the magazine. Periodicals offered readers "simultaneity," a cluster of texts to be consumed in relation to each other.[84] In addition, as Archer's experience demonstrates, an illustration in the magazine gained meaning not only from immediately proximate texts and images but from its relationship to the wider media field.[85] By the 1890s the emerging commercial realms of publishing and entertainment were becoming connected in rich and interesting ways.

The synthetic mixing of diverse imagery is, I suggest, a particularly modern way of apprehending the world. In *Suspensions of Perception* (1999) Jonathan Crary credits the invention of the halftone with a proliferation of imagery that demanded new forms of attentiveness from the modern viewer. Certainly photographic processes were involved in a huge increase in the amount of images readers needed to deal with. Photomechanical reproduction deployed within new magazines accelerated the circulation, mobility, and variety of repeatable images. Crary suggests that the logic of capitalism creates a visual regime of constant novelty and distraction in which attention cannot be sustained on one object for long. He notes that in order to gain a sense of a coherent, if contingent, reality the late-Victorian city dweller had to sort the continuous flow of stimuli into inevitably provisional forms. Resolution and coherence were no longer possible, and in their place the viewer performed a kind of synthesis, continually juxtaposing images in order to create a functioning whole. Knowingness was generated by this material, and at the same time, knowingness allowed the reader the pleasure of making sense of these fragments.

The following chapters trace in detail the ways in which the mass image was produced and positioned in the press of the 1890s. The chapters explore a number of different aspects of the relationships between the mass-produced image, the masses, and ideas of hybridity. They begin with an account of the fluid, exciting, and unsettling visual environment of late-Victorian London in which diverse social groups encountered each other. The modern city was

an essentially heterogeneous space that brought together the beautiful and the ugly, the fascinating and the terrifying.[86] I outline the range of periodicals that helped readers to see themselves within this arena of ambiguity, as well as the appeal of topical weekly illustrated magazines to the visually receptive middle classes.

The next two chapters trace the Victorian industries of reproduction, exploring the connections between wood engraving and photorelief line and tone processes. Chapter 3, "Wood Engraving: Facsimile and Fragmentation," examines the transformation of the wood-engraving trade from an interpretive craft to a mimetic assembly-line system. It discusses the various ways in which the photograph was involved in this move. Not only was photography used to transfer images for cutting and as reference for engravings, it caused wood engraving to shift from a linear syntax to a tonal aesthetic.

Chapter 4 gives an account of the development and application of both line and tonal processes and their emergence from the existing hand-reproduction methods. It explores the many links between the process industry and wood engraving, as techniques, tools, and workers migrated between the two trades. The chapter describes the organization of the main process firms of the nineties and the new work relations within them as they adopted modern production, accounting, and marketing systems. The chapter demonstrates that despite their rhetoric of facsimile, photographic halftones relied on hand interventions, including the use of engraving to focus their meaning.

I devote Chapter 5 to the *Sketch*, launched by the publishers of the *Illustrated London News* in 1893 as the first middle-class weekly to be entirely illustrated by photorelief technologies. Its editor Clement Shorter boasted that the publication marked the separation between the old and the new pictorial journalism and ushered in the modern era in the press.[87] The new photomechanical magazine visualized a spectacular city of individual consumption, entertainment, and leisure. I argue that what was particularly modern in the *Sketch* and its peers was that they showed readers how they might define themselves through the consumption of mass entertainments, goods, and fashions, rather than within the world of politics or work. The *Sketch* appealed to a broad audience, a mobile readership who were able to define themselves, less in terms of their employment or actual economic position, than in how they spent their time outside of work, in terms of what they might buy, experience, read, or discuss.

Chapter 6,"The Illustration of the Everyday," and Chapter 7, "The Photograph on the Page," look at the imaging methods used by the pictorial new journalism. The former discusses the photomechanically reproduced drawings that became hugely popular in the 1890s. The chapter uses the work of Phil May (1864–1903), the most popular sketch artist of his day, as a means of examining the key elements of nineties illustration. It looks at the way May's minimal aesthetic allowed him to depict

potentially disturbing contemporary subject matter, in particular, his typification of the cockney as a cheerful and nonthreatening figure. Sketch artists' seemingly rapid drawings operated as the antithesis to the detailed photograph but the chapter goes on to discuss the many ways in which illustrators incorporated photography into their practice both overtly and covertly.

Chapter 7 provides an account of the use of photographs in the illustrated magazine and discusses the new challenges that magazines had to deal with in commissioning, placing, reproducing, and printing photographic imagery. The chapter looks at the various sources from which art editors could acquire photographs, including amateur, commercial, and staff photographers and agencies. This section examines the emerging role of the professional press photographer in the context of the Boer War (1899–1902). The chapter also traces the ways in which the photograph was transformed by hand in order to produce an image that conformed to the standards established by wood engraving and examines the pervasive nature of the practices of retouching and re-engraving, which at the same time clarified and intensified the photographic message while complicating the halftone's status as a facsimile.

The book concludes with "Learning to Read the Halftone," a discussion of the critical reactions to photomechanical reproduction and the rise of the photographic image. Those who praised the mass-produced image characterized it as a means of exposing the middle and lower classes to high culture; some saw the image as a more effective means of capturing contemporary life than written text. However, process reproduction was regarded by many critics as an inartistic and mechanical technique, and this condemnation was linked to wider criticisms of mass production and popular culture. The commercial mass image was perceived as inherently challenging established cultural and aesthetic standards. Criticisms of these mass reproductions were connected to theories of cultural degeneration and an emerging mass culture that was threatening to corrupt and overwhelm society. Despite this condemnation, however, the halftone proved to be a very long-lived technology, I suggest, because of its hybrid ability to combine the real and ideal, art and actuality. Regardless of its promise of direct access to reality, it continued to be refocused and refined by hand retouching throughout the twentieth century. Technologies of retouching have continued and have, indeed, intensified with the recent disappearance of the halftone and the arrival of the endlessly malleable digital image.

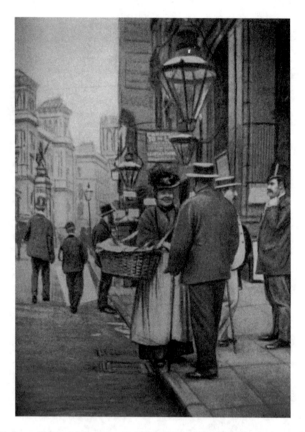

Figure 4 "A Snap-Shot at My Interviewee," "Out-of-the-way Interviews: 1. A Flower-Girl," *Sketch*, 3.36, October 4, 1893, 516. (Photorelief halftone print from extensively retouched photograph)

2
Imaging the City: London and the Media in the 1890s

> For one person gazing at the "Griffen" with sorrow or reverence, you shall see a dozen looking in at the office of a popular weekly paper; for one rapt in contemplation before the Law Courts, perhaps a hundred with their backs to it, studying the actuality of the sketches on the spot which are exhibited in the window of the *Daily Graphic*.
> – "The Lay Figure Speaks," *The Studio*, October 1893[1]

In 1893, Joseph Gleeson White, the editor of *The Studio* and the leading critic of contemporary illustration, commented on a familiar London phenomenon: the crowds that assembled outside of publishers' offices in the Strand and on Fleet Street. The great illustrated weekly magazines, including *Punch*, the *Illustrated London News*, and the *Graphic*, all displayed their latest issues in their windows, attracting spectators who lingered over the pictures they contained, engaging in a particularly public form of social reading. Gleeson White suggested that these groups found the printed depiction of events more compelling than the capital's ancient monuments and the grand official buildings that surrounded them. This chapter discusses the structure of the late-Victorian media and the differing ways in which daily, weekly, and monthly publications incorporated illustration. It also looks at the audience for the new pictorial press.

At the end of the nineteenth century London was by far the largest city in the world. Its population had grown from 4.7 million in 1881 to 6.5 million in 1901. It had three times the population of New York or Berlin and was twice the size of Paris. The French capital had, during the course of the century, been rocked by revolution and war; London, on the other hand, was the Imperial center of an industrial power that spanned the globe. It was the British Empire's legislative, administrative, and commercial hub and the focal point of a global communications network, linked to the rest of the United Kingdom, the Empire, and the world by telegraph, railway, telephone, and steamship.[2]

In the first half of the nineteenth century, the disparate social and economic groups that flocked to the city had lived cheek by jowl.

Shopkeepers lived above their businesses; workers had to be near their jobs. This all changed with the redevelopment of the center of London in the second half of the century. In a move that was even more dramatic than Hausmann's reshaping of Paris, the capital's poorer inhabitants were driven eastward to make way for more lucrative commercial and business users.[3] The East End became a gigantic working-class ghetto. At the same time many of the middle classes moved to new housing in the suburbs.[4] In order to enable Londoners to get from their distant homes to their work the city was crisscrossed by transportation systems, including the world's first underground railway. Public transport opened up the center of London, from the shopping and entertainment areas in the West End to the financial and business complex in the City. The capital's different social groups encountered each other on their way to work, to shop, or to spend their leisure. The city became the site of an intense public spectacle for these diverse crowds. Department stores, shops, exhibitions, museums, spectator sports all appealed to broad audiences, including many visitors from out of town and overseas. London's thoroughfares themselves, with their elaborate displays of goods in shop windows, advertising posters, sandwich men, and the city crowds, were open to all. These colorful and entertaining streets were also ambivalent spaces where the status and intent of the strangers one encountered were uncertain.[5]

The area around the Strand and Fleet Street, between the West End and the City, was the hub of media London. Here were the publishers' offices, newspaper and magazine headquarters, advertising agencies, the firms that supplied reproduction services, and the pubs and clubs where journalists congregated. The railway terminals, from which printed copies could be rapidly dispatched throughout the country, were close by. Getting by road to these terminals was not always any easy matter, as the busy streets were jammed with an chaotic procession of omnibuses, trams, carts, cabs, and carriages. Newsagents and street sellers came from all over the capital to this central location to buy their copies for sale to the public. By the 1890s this was said to be the busiest section of the busiest city in the world. In 1897, the *Illustrated London News*'s Diamond Jubilee celebration of British technological achievements boasted that "Fleet Street with its network of telephone and telegraph lines is the cradle of the world."[6] Until the 1980s this area remained the center of the British newspaper industry and "Fleet Street" still denotes the British press in the same way that "Wall Street" indicates the US financial industry.

The press was an important element in the creation and development of London as a city of consumption and pleasure. In the last decades of the century the metropolis was the site of a mass entertainment boom, supplying those with time and money with new ways of spending both. The regular working rhythms of capitalist production created standardized portions of empty nonwork time, and these newly demarcated leisure hours in the

evenings and on weekends were occupied by novel forms of commodified amusements.[7] The press was a vital link in creating and sustaining patrons for these entertainments. Mass theater needed to maintain a large audience composed of disparate social groups. The upper, middle, and lower classes all mingled at the new variety performances and musical comedies that developed in the 1890s. By 1892, a total of 550 places of amusement, including concert halls, music halls, and theaters, could accommodate half a million people nightly, around one twelfth of the capital's population. These venues varied considerably in their sophistication, but the staging of performances in London's West End was very elaborate and labor intensive. In 1899 the staff at the Lyceum Theatre consisted of 639 people, including 355 actors and musicians. In a city that had little heavy industry, the theater was the largest single employer. British journalists chauvinistically proclaimed that London had replaced Paris as the international center for pleasure and entertainment.[8] Patrick Joyce notes that London has an equal claim to Paris as defining the modern city as a site for the circulation of pleasure and consumption.[9]

Behind the excitement and bustle of metropolitan life, these were anxious times for many of its inhabitants. As the world's first industrialized nation, Britain had experienced the social upheavals of rapid economic expansion over the course of the nineteenth century. However, after attaining global preeminence as the workshop of the world, its economy underwent a long, slow decline throughout the late 1880s and 1890s. Britain's industrial might was being successfully challenged by Germany and the United States. Imperial expansion toward the end of the century was no longer a confident adventure but a desperate attempt to preserve economic influence and control markets.[10] Back at home agriculture was declining in the face of cheap American imports, and there was social unrest in the cities. Conservative critics were convinced that the rapid pace of urban life was leading to physical decline and cultural decadence.[11]

Change was sweeping through all of society, as every class grouping came under pressure. Even the aristocracy was seeing its political and economic power, based on land ownership, threatened by manufacturing and business interests. Nevertheless there was still a huge gulf between the small numbers of the well-to-do and the rest of society. Britain's social inequalities were at their most visible in London with the massive discrepancy in prosperity between the affluent residents of Knightsbridge and the often desperately poor inhabitants of the East End. Indeed, three quarters of London's population were working class.[12] Yet, not all of the working classes were indigent. Those members of the working class and the lower middle classes who received regular wages were now materially better off as industrialization had improved their lot and mass production had reduced the prices of commodities. Chains of butcher shops, groceries, and shoe and clothes shops that catered to these groups expanded during the nineties.[13]

The 20 percent of the population who were categorized as middle class owed their social status to education and personal effort rather than to inherited wealth or an artisanal trade, and they occupied a particularly unstable economic and cultural niche. Changes in political organization and industrial manufacture had created a large stratum of administrative positions, and the middle class filled these new bureaucracies of government and manufacturing as clerks, "typewriters," and managers. Economic forces continually remade the social and physical world, creating opportunity but also uncertainty. Middle-class workers had to be adaptable, willing to move to new areas and to new kinds of employment in order to better themselves.

The Victorian journalist and editor T. H. S. Escott remarked on the amorphous nature of a group that took on the characteristics of its upper and lower neighbors:

> The whole course of its history, the changing ideas and interests, the molding influence of the associations connected with it, in a word its affinities of all kinds, necessarily impart to the middle class, whether in England or elsewhere, an artificial and fluctuating character. Its boundaries are being constantly extended.... While the middle class at one end becomes every year less distinguishable from the aristocracy of birth or wealth, less prosperous middle class sections and individuals are constantly being depressed into what the polite world knows as the inferior orders.[14]

Indeed, many of the middle class hovered just within the financial bounds of respectability. An indication of solid, established bourgeois status was the employment of servants, and in 1891 only about a quarter of the middle-class households in London were able to do this.[15] At its lower levels, the sections of the middle class were liable to sink back into the abyss from which they had emerged. As Escott makes clear, the Victorian middle class was not a single entity; there were huge differences in income within its upper and lower borders. Despite material progress and political successes, this nebulous grouping was still unsure of its status and understandably anxious about cultural change.[16] Change had created the middle class but it could also sweep it away.

Membership of the middle class was asserted not so much by occupation as by appearance. Middle-class uncertainties were literally embodied in their concern regarding the minutiae of appearance, dress, posture, and behavior. Economic factors were subject to change, and often there was little one could do to control this, but appearance could be manipulated to maintain bourgeois respectability. For clerical workers, the regular purchase of decent ready-to-wear apparel was considered a necessity. In general, those in the new bureaucratic occupations were subject to heightened forms of discipline and self-regulation. Outside of work one also had to control one's own

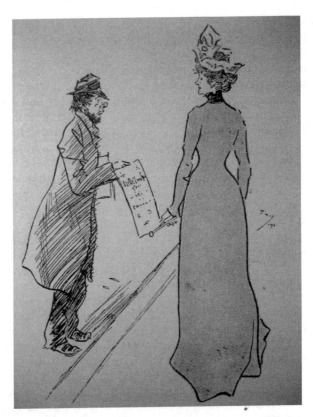

Figure 5 "Vendor of Cheap Music: 'Ere y' are, lidy! 'I'll be yer Sweet'art.' One Penny!,"
Phil May, *Mr. Punch's Life in London*, London, Educational Book Company, 1908?,
105. (Photorelief line print from pen-and-ink drawing)

appearance so as to make the right impression and at the same time to
accurately read the appearance of others. Patrick Joyce discusses the city as
a site for mutual observation, for the reciprocal presentation of the self to
others, and suggests "If many nineteenth century city centers took on the
quality of theatre, the people and the city themselves became like actors on
the stage."[17] In order to treat one's fellow "actors" appropriately one had to
assess their social standing, but in a fluid and fragmented urban arena this
assessment could no longer be based on personal knowledge. The problem
was not entirely new, and the visual classification of city dwellers into types
had been codified from the Enlightenment onward. Since the 1840s there
had been an increasing interest in the pseudoscience of physiognomy, the
reading of character through facial characteristics.[18] To add to the taxonomic
tensions in this intensely charged visual environment, appearances were

also subject to increasingly rapid changes in the flux of fashion.[19] Much of the new illustrated journalism targeted the anxious, uncertain, and visually sensitive middle class, helped their readers to negotiate the swiftly changing visual scene and to gain a sense of their place within it.[20] Although there was not a single homogenous middle class, institutions such as the press enabled this broad grouping gain a sense of a common identity and a shared set of values. Through the printed image readers could stay abreast of nuances in dress, hairstyle, expression, and stance. This group proved to be a fertile and receptive market for a different approach to mass communication. The middle classes were, by their nature, open to innovative ways of doing things, new ways of earning a living, new domestic and leisure arrangements. The magazine became an essential tool for the first generations of modern city dwellers, who were actively inventing their lives in a manner for which there was no precedent.[21]

Bourgeois concerns about their position within society made them receptive to the commercial messages that became a central feature of the illustrated press. Both in their editorial and advertising sections magazines encouraged their readers to spend money on mass-produced goods. Many of the middle classes now had some money to spare once they had provided for the necessities. Even the office and shop workers who earned no more than artisans had a predictable weekly income that enabled them to spend more freely than freelance workers.[22] When advertising began to increase dramatically in the 1890s, the kinds of product that were heavily advertised were those associated with new domestic arrangements and a "modern" way of life. These included convenience foods such as cereals, chocolate, soups, and sauces, as well as cleaning products for the body and the home. There were also entirely novel products such as cigarettes, soft drinks, typewriters, sewing machines, bicycles, and cameras.[23]

The illustrated magazine was itself a sign of modernity both to the reader and to others, as reading was a social act. Not only did the magazine help its readers imagine the social through its content it was something that was consumed communally. The reading of papers and magazines in public spaces such as coffee shops, pubs, and barbers' shops had been normal throughout the nineteenth century. However, this public role was tremendously increased by the coming of public transportation systems that were associated with a huge growth in the number and variety of printed material. Reading matter became an integral part of the suburbanite's journey to work from the outskirts of the city. W. H. Smith's network of railway station bookstalls, with the motto "All who ride may read," covered the country. Books, newspapers, and magazines could also be bought from newsagents while the latest editions of evening papers were hawked by street sellers to commuters on their journey home. Georg Simmel suggested that city dwellers, forced for the first time to make eye contact with complete strangers, used the newspaper both as a shield to protect themselves from fellow passengers and

as a cover from which to observe them. Yet the contents of the press also brought city dwellers together, providing the ingredients for social interaction. Mason Jackson, art editor of the *Illustrated London News*, writing in 1885, stated:

> In London, and in all our great centres of population, the newspaper has become the unfailing accompaniment of the City man's journey to business. At the railway stations journals of every kind tempt the loitering passenger, while illustrated papers appeal to him in a language of their own. Whether in the railway carriage, the omnibus, or the steam boat, the newspaper is eagerly conned, and its content forms the food of conversation.[24]

Although the magazine might be bought for commuting, it was also an important social and cultural artifact within the home, and again it was shared. Many middle-class readers bought a number of weeklies and monthlies.[25] After work and on weekends reading was a hugely popular leisure pursuit for all classes. Reading aloud in the home was a widespread recreational activity. The latest issues of magazines were displayed in the public areas of the middle-class residence as indicators of social status. Copies of periodicals were not only shared within the family but also with friends. Servants would often read their employers' magazines. In some cases, periodicals were resold opening up the readership of expensive weekly and monthly publications to a much wider audience. In other cases, magazines were preserved in binders and added to the domestic library. Whereas the daily newspaper was an ephemeral object and rarely kept until the following day, the magazine stayed in circulation much longer and was, as one enthusiastic advertiser put it, "a stranger to the waste basket."[26]

In the 1890s, the reason given by those in publishing for the explosion in magazine readership was an increase in literacy. The Foster Education Act of 1870, which set up School Boards, and the Mundella Education Act of 1880, which made school attendance compulsory, were cited as the main factors. Indeed, the education provided by the School Boards was blamed for the supposed inability of the lower classes to read extended text and their preference for the snippets that magazines like *Tit-Bits* provided. Journalists such as Edward Dicey of the *Daily Telegraph* and the *Observer* blamed the 1870 act for the new reader's supposed intellectual deficiencies.[27] The literacy explanation for the expansion of the press has now been largely discounted. There had, for example, been a very large market for working-class Sunday newspapers at midcentury, when workers' literacy rates were thought to be low.[28] In reality, many of the new magazines were aimed at middle-class audiences that, by 1900, had literacy levels of almost 100 percent. The prominent journalist George Sala rejected the conventional explanation for the growth of the press, arguing that literacy had long been much higher

than official estimates, particularly in urban areas. He thought that the rise in readership was due to two factors, the first being the reduction in the price of newspapers. The second was the change in content as periodicals became lighter and more entertaining. He suggested that people were more interested in the apparently inconsequential events of daily life than in politics.[29] Indeed, the magazines that prospered in the eighties and nineties dealt largely with the everyday, with "human interest" material rather than major political or social issues. This approach was not entirely new, but what was innovative, in addition to the huge commercial scale of their production, was the way in which this material was presented to the reader in lively layouts accompanied by more illustration.

Press expansion in the earlier part of the century had been hampered by "taxes on knowledge," which had been imposed on publications and which forced them to limit their size and the amount of space they devoted to illustration. These levies on paper, advertising, and on the number of pages a newspaper could contain were all abolished between 1853 and 1861. Up to this point publishers had typically been family-run concerns, producing one or two journals, in many cases as adjuncts to printing businesses. Papers were edited by proprietor/publishers whose concern was in the content of their periodicals rather than commercial expansion. After the removal of the advertising tax in 1853, periodical publishing started to become an attractive business proposition.[30] As a result chains and syndicates developed, and speculators and entrepreneurs built up empires through takeovers. One of the first media empires was Ingram Brothers, whose fortune grew out of the *Illustrated London News*. Capitalizing on the success of this magazine, the Ingram family bought up rivals and expanded their publishing interests through the rest of the century. In the 1890s, the Ingrams once again led the way in illustrated magazines with the launch of the *Sketch*, the first middle-class weekly to be illustrated entirely by photorelief processes.[31]

Other large publishing conglomerates emerged in the last two decades of the century. These organizations were run on modern managerial lines and depended for their success on the creation of a mass audience and on selling these large readerships to advertisers. The new publishers of the 1890s were of a different breed than their predecessors. They were not motivated by political belief or a desire to provide their audiences with "improving" reading matter; rather, they were dedicated to the commercial expansion of their businesses.[32] An efficient, rational, commercial structure of the press was a new phenomenon and had important repercussions for the character of publishing companies and for their products. As James Moran asserted in 1930, these magazines were above all products. "The great publishing houses – Harmsworth, Newnes, Pearson (and they were soon to have imitators) – threw off new publications, daily, weekly, or monthly, much as a great shop might take up a new line in boots or hosiery." Publishers were, he

suggested, simply industrial enterprises in which the power was entirely in the hands of the owners and in which there was a great distance between owners, editors, and journalists.[33]

The major British media empires of the twentieth century originated with a lower-middle-class weekly entitled *Tit-Bits*. Probably the most successful magazine of its time, *Tit-Bits* had been launched by George Newnes in 1881. Its pages were small, it was sixteen pages long, unillustrated, and printed on cheap paper. It cost one penny. However, its editorial structure of short, light snippets of miscellaneous information proved enormously popular and influential.[34] According to *The History of the Times*:

> In order to maintain the greatest possible variety all the constituent articles, stories, items, paragraphs and sentences were short. This penny paper of scraps, culled by Newnes from odd sources, was destined to modify in the most profound degree the intellectual, social and political tone of the Press as a whole.[35]

Newnes, who had been a fancy goods salesman and a successful restaurant owner, was an outsider in publishing. His experience in commerce, however, had given him a strong sense of his readership and a commitment to providing them with entertaining material that could be easily and rapidly scanned. Newnes was also able to use extensive and effective promotional strategies to build circulation. Two ambitious young men, Arthur Pearson and Alfred Harmsworth, both worked for Newnes before going on to found rival magazines that adopted and refined Newnes' approach to content and marketing. All of these publishers went on to develop innovative pictorial weeklies and monthlies, including many women's magazines before moving into daily journalism. There they applied the illustrative and editorial techniques developed in their periodicals to produce a new kind of daily paper. Harmsworth (later Lord Northcliffe) took over the *Evening News* in 1894 and launched the *Daily Mail* in 1896, followed by the *Daily Mirror* in 1903. Pearson founded the *Daily Express* in 1900.[36]

These figures were, as D. L. LeMahieu notes, outside British elite culture, and brought a business approach that openly embraced profit and which depended on new technologies for its success. Jean Chalaby has proposed that the rivalry between these highly efficient businesses lead to a new type of discourse in the press and the emergence of "the journalistic field." In what became a highly competitive field arenas reporting was intended to attract and entertain rather than inform, educate, or challenge, as had been the case earlier in the century. This situation led to a press that featured a diverse range of topics with an emphasis on light human-interest material.[37]

As they expanded their empires, these conglomerates were able to draw on their existing managerial and production resources as well as their leverage with suppliers and distributors. They were also able to duplicate material

across their publications. In book publishing, by contrast, each product meant undertaking a new gamble. However, once a periodical was established, the publisher could project a steady income from advertising and sales for a number of years to come. On the basis of these repetitive sales, proprietors were able to invest in the development and purchase of new printing equipment and imaging technologies.[38] Pearson, Newnes, Harmsworth, and the Ingram Brothers were the major forces in late-Victorian publishing, but there were many other firms involved in the rich and varied print media. Indeed, the cheapening of production costs, including process illustration, allowed other entrepreneurs to enter the market, although many of these ventures proved to be short lived as they were unable to compete with the economic might of the conglomerates.[39]

There was a flurry of press activity in the last decade of the nineteenth century that was driven by competition and powered by the advertising of products aimed at the creation of a mass market. As Chalaby observes, periodicals were always looking for a means of gaining competitive advantages over their rivals, and this led to rapid technological advancement in printing in the 1890s. Once a publisher had installed updated equipment their competitors had to follow suit.[40] Publishing required large investments in fast, powerful printing presses, which needed to be replaced as printing technologies improved. Periodical publishers relied on rapid and efficient systems of production and distribution for their timely magazines as they could not miss their weekly or monthly deadlines. By the 1870s, rotary presses were in common use, able to print on both sides of a roll of paper at once; presses were developed that could fold and cut paper as soon as it was printed. The large publishers invested heavily in these expensive new technologies that increased their ability to produce large numbers of periodicals in a short time. This enabled them to bring their costs down, but they continually had to improve their presses, for "the day was now over when the newspaper printing machinery could be installed and left in place for a quarter of a century." This heightened the intense competition between papers.[41] It was also essential that firms spend money on promoting their magazines through posters, competitions, and giveaways. In this increasingly crowded market, publishers came to rely on income from advertising to make their operations profitable. The publishing conglomerates reduced cover prices, built large circulations, and opened up their pages to the advertisers. Magazine publishers were able to sell their individual readers to manufacturers, who were now convinced that press advertising could be an effective tool in managing consumption. This incorporation of commerce into the heart of the magazine was a key element in the new media structures of the 1890s.[42]

The press of the 1890s consisted of a rapidly changing assortment of titles. Morning and evening papers and weekly and monthly magazines all attracted large readerships. Contemporary commentators applied the word

newspaper to both daily and weekly publications, although in this study I will use it to describe only the daily press.[43] Many of the new magazines were aimed at audiences that were roughly defined by gender, age, and class. Moreover, in the 1890s, both advertisers' and publishers' attempts to reach specific markets were somewhat haphazard. Although publications were directed at target audiences which tended to be quite broad, publishers had neither the desire nor the ability to fine-tune their products for specific market niches. Nevertheless, many periodicals addressed middle-class women in their new roles as managers of the household and as consumers. Harmsworth's *Daily Mirror* was the only attempt to produce a daily newspaper specifically for women. However, it did not survive for very long in this incarnation and was relaunched in 1904 for a general audience. Periodicals were also produced for young boys and girls. All of these publications were differentiated by price and content, as well as by size, layout, and the quality of the paper on which they were printed and, in addition, were also varied in the number and kinds of images they contained. Women's magazines tended to be leaders in the incorporation of illustration in both their editorial and advertising.

Most morning newspapers were broadsheets of eight pages that were dominated by text. Columns of classified ads on the front of the paper were followed by page after page of editorial matter set in diminutive and unvarying type. Headlines were small, and there were few illustrations. These layouts had been established in the days when papers had to economize on space for tax reasons. Newspapers were designed for simple and rapid production, rather than to visually attract or guide the reader. Indeed, the dense columns of unvarying type positioned the reader as someone who could devote a good deal of their time to progressing though these columns in a patient linear fashion. Within elite culture these columns had come to signify a sober and erudite approach to journalism.[44]

The presses used by the dailies were unwieldy and were designed to print these columns of text as opposed to images. Any time spent adjusting these machines in order to incorporate a picture would jeopardize the printing of the thousands of copies most papers produced each day. When the morning papers did use illustrations, these were in the main simple line images rather than photographs. It was in 1904 that the *Daily Mirror* staked its claim to be the first national photographically illustrated newspaper, although it was not until around 1914 that the dailies began to incorporate photographs on a regular basis.[45]

The only morning newspaper that made a feature of its illustrations was the *Daily Graphic*, which was launched in 1890 as a sister paper to the long-established weekly the *Graphic*. It employed a specially trained corps of illustrators who could work to its technical specifications. Unlike other dailies, it was a tabloid with news on its front page and small line illustrations incorporated into the text. Many of these images were based on

photographs translated manually into line images for reproduction. The techniques of photorelief line engraving had been developed in the 1870s by the Frenchman Charles Gillot and were well known by the 1890s. Images were first drawn in pen and ink, as only dark, clear lines could be reproduced. A negative was then made, and the image fixed onto a light-sensitive metal plate that was then etched, leaving a raised image that would be printed alongside type. Only linear drawings could be printed via this method, known in England as "zinco," as zinc was commonly used for the plates.

Morning papers such as the *Times* or the *Daily Telegraph* were delivered to the home through a system of child labor. In contrast, the evening papers relied on impulse purchases. Commuters bought them from street sellers or newsstands on their way back from work.[46] Evening papers therefore needed to market themselves more actively to these mobile consumers and so provided their customers with a lighter, more visually attractive product.[47] They incorporated a greater amount of illustration, usually line drawings, but two of the most forward looking evening papers – the *Pall Mall Gazette* and the *Westminster Gazette* – featured candid, informal snapshot images.[48] These papers capitalized on their illustrations by issuing weekly magazines known as "budgets" which gathered together much of the news and illustrations from the previous week.[49] Writing in 1894, Horace Townsend conjectured that these budgets must be highly profitable. Their "phenomenal success," he claimed, was entirely due to the public's desire for pictures, and he predicted that the thirst for images was so intense that the twentieth century's cultural achievements would be visual, whereas the nineteenth century's had been literary.[50]

In order to attract large readerships and, thereby advertisers, the new mass-market magazines had to deliver a highly varied, attractive product. Weekly magazines usually contained 48 pages in a small tabloid format, a format that was eventually applied to the daily press. They had many more pages to fill than newspapers and could not rely on political or dramatic events for their content. Magazines therefore printed numerous items that did not depend on unpredictable circumstances, but which were, nevertheless, topical, including comment, gossip, news of celebrities, entertainment coverage, sport reports, and fashion. These paragraphs were slotted into recurring sections through which readers could browse. Using these methods editors could rely on prearranged events and timely comment to fill much of their columns.[51] Illustration was an important element in this structure as it occupied a good deal of space and did not require lengthy accompanying texts. Sport, fashion, theater, and personalities were all relatively easily illustrated.

To a far greater extent than newspapers, magazines were able to provide their readers with a rich and varied visual experience by incorporating photographs, paintings, and drawings into their pages. Weekly magazines, in particular, were innovators in image production. Their fragmented and

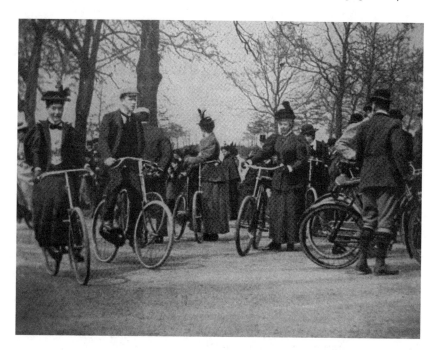

Figure 6 "In the Park, From a Photograph by Thiele and Co., Chancery Lane," *Sketch,* 20.248, October 27, 1897, 39. (Photorelief halftone print from retouched photograph)

miscellaneous structure was ideally suited to the insertion of a variety of illustrations. In addition, their production schedules gave these magazines time to reproduce tonal images. Since the 1840s, sixpenny weeklies had featured large wood engravings of what were deemed to be notable events and newsworthy people. The wood-engraving process had been refined into a rapid, highly effective method for printing images alongside text. Wood engraving was based on a straightforward hand technique: an image was drawn, painted, or photographically fixed onto a boxwood block. The smooth, hard surface of the block was then incised with a graver leaving a network of raised lines. Although the process was a line technique, the illusion of tone could be produced in wood engraving by the use of very fine webs of marks. As it was a relief technique, the finished woodblock could be inked and printed alongside letterpress type.[52] This "type compatibility" was essential in a mass press. Intaglio techniques such as metal engraving or planographic methods such as lithography required either an expensive and time consuming second pass through the printing machine or, alternatively, the images had to be printed separately and then inserted into the magazine. On short run publications, this was not necessarily a problem, but for magazines with many pages and circulations of hundreds

of thousands, simultaneous printing was essential. For fifty years, therefore, wood engraving had been the only commercially viable reproduction technique for the popular press. Weeklies including the *Graphic, Black and White*, and the *Illustrated London News* covered national and international events and current happenings. The first, and perhaps the most successful of these, was the *Illustrated London News* (from here on, referred to as *ILN*). Competitors and imitators had come and gone since its launch as the first illustrated topical weekly in 1842. These periodicals had, in many cases, been "crushed" by the aggressive business practices of its owners the Ingram Brothers. Founded in 1869, *ILN*'s chief rival, the *Graphic*, had made a feature of images depicting the socially disadvantaged. Its content was more artistic than *ILN*'s and the *Graphic*'s engravings were much admired by Vincent van Gogh who in his time in London joined the spectators gathered outside the publisher's windows. Most of the middle-class news weeklies cost sixpence, but the quality of its visual presentation justified the *Graphic*'s higher price tag of ninepence. Other weeklies such as the *Sporting and Dramatic News*, dealt with social and leisure events. Humorous weeklies included the long-established *Punch* and its rivals such as *Judy, Fun*, and *Ally Sloper's Half Holiday*, which featured an incorrigible, drunken cockney antihero.[53] There were also specialist illustrated weekly and monthly papers for women, including *Lady's Pictorial*, a leader in illustration and advertising.[54]

By the late 1880s, illustrated magazines were using line process as an adjunct to their wood engravings. A few also experimented with the new halftone-reproduction technologies which allowed them to print tonal images. In the halftone process, a sheet of glass covered with a grid of fine lines was used to transform the continuous tones of an image – either photographic or painted – into a pattern of minute dots. Then, using basically the same methods as line process, the image was fixed onto a sensitized metal plate and etched to produce a type compatible relief block. If the procedure was successful, the viewer interpreted the printed dots as a series of continuous tones; if not, the effect was grainy and gray. Since the early 1880s, experimenters such as Carl Meisenbach in Germany and Frederick Ives in the US had made some progress in refining halftone technologies. Sporadic experiments with halftones appeared in the *Graphic* as early as 1884; *ILN* printed its first halftone a year later, and by 1888, both magazines occasionally featured halftones alongside their wood engravings. The following year, a new illustrated weekly called *Black and White* was launched which enthusiastically embraced photomechanical techniques. By adopting the new technologies, *Black and White* was able to provide its readers with twice as many images per week as its established rivals.[55]

Monthly magazines also adopted the new imaging processes, and publications such as Newnes' *Strand*, were highly illustrated. Newnes' often reiterated aim was to have a "picture at every opening," and he made good on

this promise by scattering many small illustrations through the magazine.[56] However, the monthlies were unable to compete with the weeklies in their topicality. Monthlies would be prepared many weeks in advance of publication, and although there was space for the illustration of current events, they were not oriented toward the news. The *Strand*, for example, contained a good deal of fiction, including Conan Doyle's Sherlock Holmes stories, as well as a lot of factual material. Items on zoology and geography were printed side by side with photographs of curiosities such as potatoes shaped like human heads. Other monthlies were aimed at specialist audiences, such as those interested in the art world or in sports. These journals clearly served their readership in a different fashion from the weeklies by providing them with fiction and documentary material rather than up-to-date, ephemeral news.[57]

In *Life and Labour of the People in London* (1903) Charles Booth observed that whereas book printers were leaving London, magazine and newspaper printing remained in the city, and indeed he noted the particularly metropol-

A GLOOMY AND THOUGHTFUL AIR.

Figure 7 "A Gloomy and Thoughtful Air," E. S., *Sketch*, 3.31, August 30, 1893. (Photorelief line print from pen-and-ink original)

itan character of the magazine and newspaper printing industries and their enormous growth over the last twenty years.[58] The magazine was a metropolitan commodity not only in its production but also in its subject matter; as the city increasingly became a site for pleasure and the commodity, illustrated magazines provided a guide that encouraged the spectacular consumption of the modern metropolis. In its appeal to a broad urban market the press made the city legible and accessible to an extensive popular audience, the urban masses themselves. At the same time periodicals presented city dwellers with a means of classifying and differentiating their fellows. Patrick Joyce sees the various printed forms of categorizing and ordering the inhabitants of the city as one factor contributing to a modern sense of the social as dependent on individual observation and regulation rather than coercive power.[59] Popular illustrated magazines were an important agency through which city dwellers could apprehend their society and regulate their behavior in a manner appropriate to their imagined social position. Charles Booth's pioneering sociological study, undertaken over the turn of the nineteenth century, examined in minute detail the productive human labor involved in creating the everyday life of London. In the rest of this study I will trace the practicalities involved in one aspect of this vast struggle, the generation and reproduction of imagery in the capital's photomechanically illustrated magazines.

3
Wood Engraving: Facsimile and Fragmentation

> Now calculate – or think enough to feel the impossibility of
> calculating – the number of woodcuts used daily in our popular
> prints, and how many men are night and day cutting 1050 square
> holes to the square inch as the occupation of their manly life. And
> Mrs. Beecher Stowe and the North Americans fancy they have abol-
> ished slavery.
>
> – John Ruskin, *Ariadne Florentina*, 1872[1]

John Ruskin's reaction to the wood-engraving industry of the 1870s was a
response to a trade in which the movements of the engraver were increas-
ingly prescribed and surveyed by photographic technologies and by a move
to photographically influenced mimesis. In the 1860s, photography's use as
a means of fixing images onto woodblocks helped to speed up and trans-
form the production of engravings. This was allied to the growth of an
approach to engraving, in which engravers simply copied an image rather
than interpreting an original. This removal of individual control resulted,
for Ruskin, in a form of industrial serfdom. We will trace the transforma-
tion of wood engraving from the artisanal workshops in the 1840s to the
assembly line systems of the 1880s. Three factors helped to shape this shift.
Two reasons were the growth in the number of images printed by the press
and the demand for the faster production of these images. The third factor
was the move toward the facsimile system in which, rather than interpreting
and translating an original, engravers produced close copies. As the factu-
ality of the photography became the standard for reproduction, facsimile
became the norm in wood engraving. The move to a photographically based
facsimile assembly line by wood engravers was a revolution in image making
that prefigured and fed into the process industry.

This chapter examines the use and the meanings of engravings within
Victorian magazines and pays particular attention to the *Illustrated London
News*. Over a period of fifty years *ILN* refined and developed the techniques
of wood engraving in order to produce mass images that were suitable for

middle-class audiences. The magazine promoted its reproduction technology from its early days in articles such as "Wood-Engraving: Its History and Practice," a series written by William Chatto that ran from April to July of 1844. Through such strategies the magazine championed the beauty and excellence of its engravings, even when they were delineating sensational events. Indeed, the wood engraving was able to make the depiction of even the sensational acceptably artistic. Whether depicting royal visits, the triumphs of industrial progress, foreign wars, or train wrecks, wood engravings were able to situate these events as suitable for middle-class consumption.

The engravings in the *Illustrated London News* drew on such pictorial conventions as the picturesque and the sublime in their imaging of Britain's industrial progress and the natural world.[2] Brian Maidment has noted that wood engravings could at the same time appeal to the emotions as well as providing documentary information.[3] In the magazine, sensation was confined within a middle-class frame. Through its written text and images, the magazine defined its focus (and by implication, its audiences' interest) as rational and scientific. Its illustrations of topography, zoology, science, and the arts were situated as self-improving information, and it was also on this basis that sensational material could be covered. For instance, the weekly justified the publication of the portrait of a murderer in one of its early issues by stressing the usefulness of the image to students of phrenology. The wood engravings in *ILN* became finer and crisper as printing techniques and engraving methods improved. In this chapter I examine the ways in which the documentary and objective character of the wood engraving was challenged by the influence of photography. Anthony Hamber has demonstrated photography's growing use as a method of reproduction in the 1850s and its influence on ideas of reproductive veracity. Photography set a new standard for accuracy through the creation of what Hamber terms the "philosophy of facsimile."[4] This move from a subjective image to an apparently objective representation was in keeping with an industrial society that was increasingly organized along scientific, bureaucratic principles.

Photography, wood engraving, etching, and reproductive engraving were all intertwined and shared common languages, and aims and, in many cases, common aesthetics. Nicéphore Niépce's initial experiments in 1827 were aimed at creating a printing plate to reproduce engravings rather than making an independent photographic object. His technique was described in his agreement with Daguerre as "a process for engraving on metal." Many of the first photomechanical experiments were attempts at producing a more permanent form of photograph through the printed image.[5] It is therefore not surprising that, from the beginning of the illustrated magazines in the 1840s, wood engraving and photography were closely linked. Over the next fifty years wood engraving's aesthetic became increasingly tonal and its purpose increasingly mimetic under the influence of photography. At the same time, early halftone photorelief developments were inspired

by the way in which wood engraving achieved tone via dots and marks. When halftone images were eventually incorporated into magazines, their appearance was shaped by the aesthetic standards that had been established by the wood engraving. Many of those who practiced in these fields crossed over from one area to another, as engravers and draftsmen became photographers and process workers. In the end wood engraving merged with the photomechanical techniques which came to dominate mass reproduction.[6]

Wood engraving was developed in the 1780s in England by Thomas Bewick (1753–1828), who trained in Newcastle-upon-Tyne as a metal engraver. Metal engraving was at the top of the hierarchy of reproductive processes and was used to make large, framable reproductions of paintings. These expensive prints took months, even years, to complete. The craft had a well-established language of marks and textures used to translate the continuous tones of painting into printable lines. These marks were incised into the surface of a metal plate using a sharp graver. As this was an intaglio process these grooves acted like ditches, holding the ink which was then pressed onto paper to form the printed image. Bewick applied the techniques he had learned as a commercial copper engraver in order to transform the crude "wood cut" into the refined "wood engraving." The woodcut stood at the opposite end of the reproductive hierarchy from metal engraving and its speed and relative cheapness tied it to commerce rather than art.[7] Woodcuts were particularly associated with the crude images in vulgar, sensationalist lower-class broadsides and chapbooks. The woodcut was a relief process in which parts of the surface were cut from the soft long grain of wood using a knife leaving raised lines that could be inked. In an intaglio engraving the lines an engraver cuts are the lines that get printed; in a relief engraving the lines that are cut do not get printed. One major advantage of relief methods was that they were type compatible. Text was printed by letterpress techniques, which had not changed much since Gutenberg's days. Raised letters were assembled one at a time into lines, locked into frames, inked, and printed.

Bewick's innovation was to apply the precise graving tools of metal engraving to the hard endgrain of boxwood blocks. Boxwood, although expensive, had a very firm surface on which minute lines could be cut. The sharp burin produced a free-flowing line, which Bewick used to produce highly detailed, jewel-like illustrations and vignettes mainly for publication in book form. Because Bewick's images were defined by the "white lines" that he cut with the graver, he was essentially drawing an image using the negative spaces on the block. By holding the graver in the palm of his hand and varying the pressure, the experienced craftsman could quickly produce subtle changes in the width and character of his line. The technique was much quicker that cutting through steel or copper, and much finer than the woodcut.

Bewick's techniques, for the first time, enabled finely detailed images to be incorporated alongside letterpress text on the printed page. The linear, rather

than tonal, aesthetic of wood engraving was thought to complement text particularly well. Both type and image consisted of tiny but distinct black lines that contrasted crisply with the white of the paper. The wood engraving harmonized with printed text not only in its appearance but also in its scale; since box trees were fairly small in diameter, the finished blocks were usually around four inches by six inches, an ideal size for the book page. Unlike metal engraving or lithography, wood engraving was rarely used to produce a free-standing image in a frame or on a poster and was almost invariably allied to text.[8] By the 1830s engravers who had been apprenticed to Bewick or who had been taught by Bewick's apprentices had become established in London. They started to produce even more elaborate wood engravings that imitated the syntax and shared the genteel artistic connotations of metal engravings, but which were much cheaper to produce.[9]

Figure 8 "Queen Victoria," *Illustrated London News*, 1.1, May 14, 1842, 8. (Wood engraving)

These master engravers took on apprentices and pupils in their turn, and the trade spread with the increasing popularity of illustration. Wood engraving was typically organized on a system of small artisanal workshops, known as "offices" staffed by apprentices and journeymen working alongside the master. Although larger firms did develop, it was also common for small groups of engravers or individual freelancers to work from their homes.[10] Wood engravers based in offices typically worked a fifty-hour week with no paid holidays, although by the 1890s they were able to take Saturday afternoons off.[11] Very little was required in capital investment, as the basic tools and equipment were cheap; all the engraver needed was a range of cutting tools, a stand on which to place the block and a light source. Everything that was required could be bought for a couple of pounds.[12] The major expense was the woodblocks themselves. The trade was labor intensive rather than capital intensive and required an extended training period. Most of the London wood-engraving offices were in the Strand, Covent Garden, Clerkenwell, or Holborn, close to the periodical and communications hub of Fleet Street.[13] The areas adjoining Fleet Street were long-established centers for printing, book binding, and precision work, such as watchmaking and jewelry. A few larger firms such as the Dalziel Brothers, which needed extensive premises for their proofing presses and routing, trimming, and mounting equipment, were based in the north of the city.

London was unlike the other major English conurbations in its industrial structure. London-based manufacturing industries tended to be not only smaller but also more skilled and more specialized than in other cities. The manufacturing centers that had powered the British Empire, such as Manchester and Birmingham, housed vast factories that relied on an extensive semiskilled labor force. In London there was also a large amount of commercial production, but it was typically organized around small-scale firms and individuals, and carried out in thousands of workshops and homes. In the 1890s, most firms in the capital still had fewer than twenty employees. The metropolis attracted the best craftsmen from all around the country, as well as from mainland Europe. Wood engraving was a typical London industry with many small firms and individuals based close to their customers.

Although the trade's skills were not of a highly technical nature, they were dependent on practice, judgment, and manual dexterity, which could best be obtained by observation and through advice from a skilled engraver. Books were an unsatisfactory means of developing the hand-and-eye coordination needed in the trade, and in the entire nineteenth century only five English manuals were published on wood engraving.[14] There were a few classes, such the Queen's Square classes for women engravers in London, but the women who entered the craft by this route tended to be isolated outworkers who undertook low level commissions. In order to set up as a successful wood engraver, one had to develop a network of contacts within the trade. The

apprentice system, therefore, was the means of acquiring these skills and connections.[15]

In a traditional apprenticeship, parents would pay a premium to the master and their son would be taken on at the age of fourteen for up to seven years. The apprentice was not paid, but the master would supply him with clothing and board and would undertake to teach him the craft. Apprentices, who were invariably male, would learn the whole range of skills necessary to eventually become a journeyman, from cutting and preparing their own woodblocks to cutting the finished engraving. Apprentices were instructed in two methods, interpretive engraving and facsimile. Drawing was often an important part of the training. When William Linton was apprenticed to George Bonner from 1828 to 1832, he drew from casts and nature as well as worked on practice engravings. In the 1850s many engravers attended John Ruskin's drawing classes at the Working Men's College.[16] Through absorbing a range of skills the apprentice could work his way up and become a journeyman and might eventually become a master and take on his own apprentices and journeymen. The system aimed to turn the apprentice into a respectable member of a trade, with a sense of worth, independence and craft identity. Indenture was a way for individuals to advance in the trade, but it was also a method of controlling access to the craft, thereby ensuring that commercially valuable trade knowledge was not too widely dispersed.

The wood-engraved image was originated by an artist, illustrator, or draftsman, who made a drawing either on paper or directly on the block. Many of these images were produced by draftsmen who had been trained within the engraving office to prepare engravable designs. Wood engraving had specific requirements in terms of the scale of the images: the distance between lines and the character of those lines. Illustrators needed to learn to make drawings that could be easily and successfully engraved. The person who made the original image was part of a team of artisans involved in a production process. Outside artists whose education emphasized tonal drawing and easel painting were not well prepared for this type of work, since often they were unable to draw successfully in line or to work in the small scale the engravers demanded. In many cases the draftsman adjusted the originals provided by these artists to prepare them for cutting. It is important to realize that because these drawings were made with the intention of being reproduced and not as finished artworks, most illustrators were willing to adapt their styles to engraving's requirements as it produced excellent printed results.[17] Some draftsmen, such as Walter Crane, John Gilbert, and Charles Keene, went on to successful careers as illustrators or painters.[18]

In the 1830s and 1840s, the majority of wood engravers still worked in the delicate style that had been developed for book printing. The pace of production was slow and expensive, and weeks could be taken on the engraving of a single small block for a book.[19] But in this period some offices also began to modify the techniques of wood engraving for the production of

magazine illustrations. Master engravers, including Ebenezer Landells and Henry Vizetelly, developed a simpler, more open style of engraving that retained the elegance of book work but was quicker to engrave and withstood rapid printing. The type compatibility that wood engraving offered was essential in a high-volume production such as a magazine. Periodicals could afford neither the time nor the expense of passing sheets through the presses twice, as they would have to do with metal engravings or lithographs, and binding in images that had been printed separately, an alternative method, was also prohibitively expensive. Wood engravings, although still somewhat expensive to produce, could be printed cheaply and relatively easily on the same paper stock as the rest of the magazine.[20]

Landells and Vizetelly and their counterparts controlled the commissioning and reproducing of images that the new illustrated magazines of the 1840s needed. These master engravers became major figures in Victorian publishing as the demand increased for the reproduction technology they controlled.[21] Only they knew what kinds of image would print successfully on the fast, powerful, steam-driven presses that the magazines used. These masters had the connections to freelance illustrators and often they, rather than the periodical editors, commissioned the images. As we have seen already their draftsmen could also generate drawings and adjust outside artists' originals for engraving, so therefore the artist was by no means the major figure in image generation and reproduction; indeed engravers were often paid more than the artists who supplied the originals.[22] The engraver's expertise was in short supply, and in many cases the masters were involved with the launching of magazines, whether in collaboration with others or on their own.[23] George Stiff started as an engraver and founded the hugely successful *London Journal* in March 1845, and Ebenezer Landells co-founded *Punch* in 1841 and was the founder of the *Lady's Newspaper*. One of the major magazine publishers in the US was the English wood engraver Frank Leslie, who emigrated in 1848 when there were only 40 engravers in the entire country, and through the success of his *Frank Leslie's Illustrated Newspaper*, he built up a hugely profitable stable of magazines.

Leslie, Vizetelly, Landells, and Stiff were all associated with the *Illustrated London News*, the first weekly magazine to depict current events. Its launch issue of May 1, 1842 consisted of sixteen pages which featured 20 small engravings and vignettes. The magazine had a large page size, 12 inches wide by 15 1/2 inches high and was comparatively expensive. At sixpence it was well outside the reach of working-class readers. The first issue sold around 20,000 copies, but its continuation was by no means guaranteed. Success, however, was cemented when publisher Herbert Ingram sent an issue showing the installation of the archbishop of Canterbury to every clergyman in the country. Through promotional ploys, its genteel wood engravings, and its respectable content the *News*, as it was known, established itself as a family weekly for a middle-class public.[24] On the basis of this success, the

Ingram family went on to buy up competitors, launch new periodicals, and become an important press conglomerate. Major increases in circulation, in the number of pages, and the number and scale of the illustrations were associated with the Great Exhibition and with Britain's Imperial wars. Another consistently popular item was the magazine's coverage of royalty. The weekly transformed popular imagery and also transformed wood engraving.

The material that *ILN* reproduced was not, on the whole, news. There were many reports of a scientific and topographical nature, portraits of personalities, images of the exotic and strange, illustrations of natural history, reproductions of art, and sentimental pictures of children. The magazine concentrated on respectable public events and figures as well as on documenting industrial and social progress. The topical images were largely of royal weddings, balls, opening ceremonies, state visits, launchings of ships, and dedications of asylums, churches, and factories. There was also visual coverage of fires, aftermaths of train accidents and shipwrecks that might be based on photographs, on-the-spot sketches, or written reports. "Special Artists" were dispatched to the latest imperial war and sent back sketches that formed the basis for stirring images of conflict. Yet even in its depiction of warfare or disaster, the magazine was respectably middle class and fit to be displayed in the home.[25]

The civic and royal ceremonials depicted in *ILN* were important aspects of the hegemonic strategy that Eric Hobsbawm identifies as the invention of tradition. He defines this as the attempt to establish within a constantly changing present a link with a stable and imaginary national past. This move occurs at a time when the past has, in fact, become less relevant as a guide to behavior. The creation of a national narrative acts to ensure social cohesion and group identity, and public ceremonials have a central role to play in this structure. Hobsbawm notes that Victoria's Jubilees in 1887 and 1897 were directed at the populace, whereas royal ceremonials in the past had been intended for the deity and the nobility. Through the images in *ILN* these events could reach spectators far beyond the settings in which they took place.[26]

Herbert Ingram turned to Henry Vizetelly to commission and engrave many of the illustrations for his new magazine. Vizetelly recalled that, in fact, none of the images in the first issue of *ILN* was taken from firsthand sources. The major news image on the front page was based on an old engraving in the British Museum and showed the burning of Hamburg in which 39 people were killed and 20,000 were made homeless. Vizetelly's illustrator had simply copied the original topographical print of the city and added flames and onlookers. Images of the royal fancy dress ball in the inaugural issue were based entirely on written press reports. Unless they were working from life or photographs draftsmen and illustrators had a limited range of references for the images they produced. When Walter Crane was working as a draftsman in the late 1850s he drew from life, from carte de visite

photographs, and from books. When illustrating *Chambers Encyclopedia,* he worked from volumes in the British Museum Reading Room. The use of second- and third-hand sources was the norm at this stage. Sometimes Crane worked from imagination: "Among other things I remember having to put upon the wood a series of rather vague sketches of Faro and Iceland for a book of the same name."[27] Over the years the images in the illustrated magazines were collected into archives that illustrators could turn to for reference.

The *ILN* asserted its middle-class character not only through the content of the images it printed but also through the reproductive method it used. Wood engraving with its aesthetic links to fine art prints and books seemed thoroughly respectable. By way of contrast, woodcuts continued to be used in publications aimed at the working class, including the popular Sunday papers such as the republican *Reynold's News* and the liberal *Lloyd's Weekly News.*[28] These working-class papers used woodcuts not because they were crude and unsophisticated publications – on the contrary *Lloyd's* was at the forefront of technological developments in printing and paper making – but because they deliberately declared their resistance to rational middle-class culture through the reproductive codes of their melodramatic, emotional, and sensational illustrations. The woodcut's bold aesthetic was starkly different from the fine sweeping lines of the wood engraving. These images in the working-class press recalled the dubious literature of the streets, rather than reproductions in the gallery or the parlor.[29] The Sunday press promoted social meaning over realism, and the "non-naturalistic iconography" in their illustrations was at the service of their political agendas. That is not to say that the images in *ILN* were depicted in a slavishly realistic style either. They may have appeared more scientific and rational, but they were also coded as artistic and refined through their reproduction method as well as their content. They depended for their meaning on their relationships to other illustrations, as well as to theater and to painting. Gestures, body attitudes, and facial expressions were all used to a purpose. Magazines produced images that spoke to their audiences, whether these were the working-class readers of *Lloyd's* or *ILN*'s rectory public.[30]

Wood engraving became the means through which middle-class magazine readers expected to see their world depicted. Readers did not necessarily require absolute verisimilitude. In both its content and its reproduction process, the engraved image was understood to be a translation from another medium rather than a direct copy of reality. The drawn image was not simply a depiction but an explanation, its purpose to clarify and make sense of the incident it portrayed. In a similar fashion the engravers were not required to slavishly copy originals, but rather expected to adjust their work to the scale and requirements of letterpress printing while ensuring that the important themes of the original drawing came through clearly. In order to produce an intelligible image they were obliged to correct drawings considered to be

indistinct or confused, hence, an exact imitation of the surfaces and style of the original was not what was aimed for.[31]

The most common engraving method was known as "tint," or interpretive engraving. Some illustrators worked directly on the block in pencil; in other cases the drawing was made on tracing paper and then transferred onto the block. Usually only the outline would be drawn and an Indian ink wash then used to indicate shadows, after which Chinese white was used to define the highlights. The engraver then translated the areas of shadow or tint into lines. It was acknowledged that he knew best how to transform the image on the block into a printable matrix. The engraver varied the lines according to the qualities of the objects they depicted, using different techniques for organic and man made surfaces, for clouds, rocks, flesh, buildings, etc.[32]

If an exact copy was required, engravers employed the "facsimile" method. Facsimile had been used from the beginnings of the trade and was applied to technical, scientific, and some commercial subjects. It was this approach that, in the twentieth century, became the standard for all reproduction techniques. In the facsimile engraving every line of the image would be drawn on the block with the sharp point of a 4H pencil or a pen. The engraver would then faithfully cut around all of the lines, leaving out nothing and adding nothing. The facsimile method was more time consuming for both the engraver, who had to make many more incisions, and the draftsman who had to be much more detailed and precise.[33] It was also much more demanding for the artist, as a weak original would not be corrected or improved in the cutting.

Originally, engravers would be trained in both interpretive and facsimile methods and would vary their approach according to subject matter and the client's requirements. Within the illustrated magazine, wood engravers initially used both of these approaches to reproduction, applying interpretive engraving or facsimile as needed. William Linton, whose firm produced many of *ILN* images in its early years, was an outspoken proponent of interpretive engraving and harshly critical of the overuse of facsimile. Yet his office would have been able to produce facsimile images when that was required.[34]

In the 1850s and 1860s, a number of factors led to a radical change in the nature and organization of wood engraving. This transformation resulted in the eventual dominance of the facsimile approach. A key element in this move was a huge increase in the numbers of mass-produced images, as the demand for engravings from publishers and advertisers led to a sudden expansion of the trade. From the mid-1850s there was more work than engraving offices could cope with, and in order to speed up production, engravers became more specialized and switched to more fragmented methods. The trade moved from a workshop to an assembly-line system that depended on the application of photography, facsimile method, and use of segmented blocks.

Thomas Richards has identified the importance of London's Great Exhibition of 1851 in the creation of a commodity culture that depended on visual display and advertising. It was, indeed, at this point, that the wood-engraving trade began to rapidly expand in order to supply the new image economy. J. Whitfield Harland acknowledges the importance of *ILN* and the Great Exhibition to the growth of the trade. According to Harland, in order to satisfy the demand for images of the Exhibition, "Anyone who could hold a graver at all was pressed into the service, and good, quick, men could earn fabulous wages."[35] As demand continued to increase, engravers had to change their methods of training and image making; by switching to facsimile, firms could turn out images faster. Although it was slower to cut, facsimile was quicker to learn. The trade had attracted a large number of apprentices as parents were eager to place their sons in an occupation that

Figure 9 "The Russian Court from a Daguerreotype by Beard," *Illustrated London News*, 18.496, June 21, 1851, 598. (Wood engraving, detail)

seemed to offer such good prospects. Masters, in their turn, were happy to accept these parents' premiums. With the pressure to produce faster work, apprentices were increasingly expected to contribute productively to the workshop.[36] Whereas in the past apprentices would have been trained in both facsimile and interpretive engraving styles, they now concentrated on the former approach.

The training of an apprentice in interpretive engraving was lengthy as the beginner needed to work on drawings and practice blocks for a long period. The apprentice had to learn a range of meaningful, expressive marks, which were applied selectively depending on the object depicted. The apprentice also needed to develop a feeling for his subject matter; he had to study it and decide on the best approach to take. One of the most difficult aspects of interpretive engraving was learning to predict how the lines would print, since, working in relief was essentially working in negative, and the engraver was unable to see the effect of the marks he was making. Considerable experience, therefore, was required to judge the results of the ongoing engraving. Engravers could make their own proofs as the engraving progressed by inking the block and burnishing a sheet of paper placed on top of it. However, this kind of proofing slowed things down when done too often.[37]

If the engraver was working entirely in facsimile, he simply followed the lines of the drawing on the block in front of him as best as he could. There was no need to study the original or to predict the effect of the marks he was making.[38] Mastering the facsimile approach simply needed careful application. The engraver William Linton stated that almost anyone could be trained in this method: "Any lad with good eyesight and fair and continued practice can become sooner or later an expert mechanic, a close and tolerably satisfactory cleaner or carver out of the spaces between the lines drawn on a block." J. B. Groves, an engraver who produced images for *Punch,* recalled that facsimile "did not require much skill on the part of the workman, and was easily learnt, the chief thing being the careful attention to the drawing. . . . "[39] And he insisted that there was a vast difference between this and the interpretive approach: "Tint on the other hand required artistic handling, for the Artist made his drawing in wash – there was no line drawn for the engraver's guidance, and the workman had to interpret by means of his tools the colour, form, texture and style of each individual Artist."[40]

Groves stated that, by the 1860s, apprentices were no longer given a comprehensive training and that "the trade was split into two – one mechanical, the other pictorial. It was seldom that any individual engraver became proficient in both styles." As firms moved to a more segmented and specialized system, they trained workers in narrower ranges of skills, no longer producing the all-round journeymen and masters of the future. Groves stated "It was usual in a block containing figures and faces for the heads to be cut by the master hand, and what was called the less important 'facsimile' work by the apprentices."[41] Walter Crane also remembered that in this period "Wood

engraving was rapidly entering a mechanical stage, and the engravers were becoming specialised for different sorts of work.There was a 'tint' man and a 'facsimile' man, for instance."[42] In this system apprentices could be quickly trained in facsimile and would start making money for their masters within months of beginning their indentures. They became a form of cheap labor.

The larger firms, such as Groves's employer Swain and the Dalziel Brothers, were particularly associated with the change from a workshop to a facsimile-based factory system. Within these firms engravers focused on particular aspects of an image: some cut heads, some figures, others cut backgrounds.[43] The system depended on the new supervisory role of the master engravers, who no longer actually cut engravings but simply oversaw their production. Masters directed teams of workers who dealt with specific aspects of an image, and, as they became more distant from the journeymen and apprentices their role as educators and mentors declined. Journeymen, in turn, were under increasing pressure to produce work within tight deadlines and so were unwilling to spend time instructing apprentices.[44]

The workplace became spatially divided. Groves recalled that in the early days of Swain's, the master, journeymen, and apprentices all worked in the same bare room around a large green baize table. There they would have contact both socially and professionally with *Punch's* artists and authors. With increasing quantities of work and more firms competing for jobs, Swain segregated the engravers into a separate room from which visitors were banned. He took Groves, who cut the faces and hands for *Punch*, and set up his own carpeted, wallpapered and "up-to-date" room on a separate floor. In this situation, journeymen and apprentices were then unable to learn the interpretive skills that Groves possessed. William Linton decried this change and the move to a fragmented image: "Boy or man in the factory, each cut his allotted portion of unintelligible facsimile: perhaps one with more skill attended to the faces and the other important parts." The engravers had become, in Linton's terms, "two legged, cheap machines for engraving, – scarcely mechanics, mere machines, badly geared and ineffective."[45]

The growth of larger facsimile engraving factories in the 1860s brought about a revolution in image making. By using assembly-line techniques the new "illustration manufacturers" were able to produce more blocks at a faster pace. Periodical publishers could now rely on a timely and dependable supply of engravings from these large reputable sources. This meant that magazines in turn could allocate more space for imagery. In many ways the facsimile factory system of the 1860s foreshadowed the process industry of the 1890s. The large wood engraving firms depended on specialization of the labor force, managerial oversight, splitting up reproduction into many stages, and the adoption of facsimile, all of which became important factors in the process industry. Clearly, process was not an entirely new phase in reproduction. Gleeson White, who knew both industries well, equates the engraving manufacturers of the sixties with the process revolution of the nineties.[46]

In 1876, when facsimile had become well entrenched, John Ruskin published a series of lectures on engraving, in which he linked the wood engraving in the illustrated magazine to the worst aspects of Victorian capitalism.[47] Ruskin argued that wood engraving had lost its distinct qualities, its essential "differentia" that resided in its linear character and arose from the way in which the graver cut into the wood. The wood-engraved line should therefore be meaningful and definitive, not indistinct, hesitant, or tentative. It certainly should not ape other styles of image making or the continuous, graduated tones of the photograph.[48] For Ruskin, objects, whether they were engravings or churches, should be true to their materials, growing organically from the landscapes and cultures in which they developed. Ruskin was therefore critical of the engravings that looked like sketches, such as those which Swain, and Groves cut in *Punch*; these sketchy images were easy for the artist to draw in pencil or pen but tedious for the engraver to cut. They indicated, for Ruskin, the division of labor within image reproduction. In good engraving, there should, he argued, be harmony between the drawing and the engraving, as if both were done by the same hand.

Ruskin's objections to the facsimile factories of the 1870s were in keeping with his response to the effects of industrial production and the division of labor in general. Ruskin saw mechanization, with its repetition and imitation, as a rebirth of ancient slave societies. The structure of this slavery involved the close supervision of the worker who was unable, as a result, to bring his individuality to the objects they produced. The perfection of mechanical production was, therefore, a sign of nineteenth-century English slavery. His great criticism of the division of labor, "On the Nature of the Gothic" (1853), saw capitalism as dividing the worker into "segments, fragments [and] crumbs."[49] This essay greatly influenced Morris, Crane, Linton, and others, who criticized the direction in which wood engraving was heading.

For these critics, the lines that were produced through the factory system had become meaningless, since the speed at which they were cut meant that the hand was no longer under the control of the brain.[50] Ruskin doggedly counted the lines in a Hans Holbein figure, from *The Dance of Death* (1538), as a means of contrasting the methods of an earlier era with contemporary engraving. Holbein had delineated the head, using 45 deliberately engraved lines. Ruskin timed the cutting of one similar line to take three seconds and then contrasted this with a John Tenniel image of a head engraved by Swain that contained 157 lines in the hair alone which he estimated could be cut at 10 lines per second. In the same image there was a two-inch-square shadow, in which Ruskin counted 1050 cuts. It was impossible, therefore, at this pace, for the worker to have any control of the task in hand, and he was, as far as Ruskin was concerned, merely a slave.[51] His complaint with modern engraving was not simply aesthetic; for Ruskin the aesthetic was inextricably tied to wider social and moral concerns.

Ruskin proceeded to condemn the hybrid engravings in the *Cornhill*, a respected literary monthly that was produced by the publishers of *Punch* and edited by William Makepeace Thackeray. Ruskin deliberately attacked one of the better examples of contemporary image reproduction. The magazine was mainly typographical, with each issue containing only two full-page engravings. The *Cornhill* was later characterized by Gleeson White, Pennell, and others as a key site for the resurgence of illustration in the 1860s.

The kind of image Ruskin discussed was a combination of interpretive and facsimile engraving, which Ruskin thought produced a discordant, incoherent, and unharmonious image. The illustration had been drawn by George du Maurier, engraved by Swain, and entitled *Carry in her white frock, erect as a little pillar*, showing two women walking in a wood. In analyzing this illustration, he noted that different parts were treated in different ways: the face of the main character was done with care; less trouble was taken over her dress; and he described the landscape as "one mass of idiotic scrabble, without the remotest attempt to express a single leaf, flower or clod of earth." Indeed, Ruskin is correct – the foreground is simply an assortment of sketchy lines, and he brilliantly linked this blurred imagery to the railway, the major symbol of contemporary industrial society: "It is such landscape as the public sees out of its railroad window at sixty miles of it in the hour, – and good enough for such a public."[52]

The 1860s was later characterized by Pennell and Gleeson White as a "Golden Age" of illustration, in which artists such as John Everett Millais, George John Pinwell, Frederick Sandys, and Frederick Walker produced images for the *Cornhill*, *Good Words*, and *Once a Week*. In addition to many magazine images the Dalziel Brothers also produced highly illustrated books featuring these artists such as *Arabian Nights Entertainment* (1865), *Illustrated Goldsmith* (1865), and *Wayside Posies* (1867). Large engraving firms, in particular the Dalziel Brothers, exerted a significant influence over illustrated publishing in the 1860s and 1870s. Using their knowledge of the illustration trade, they were able to decide who would produce an image and instruct illustrators on how it should best be prepared.

The Daliziels also acted as art editors on behalf of book and magazine publishers. In some cases they were the producers and commissioners of books, and the publishers became merely distributors. The large illustrated books that the Dalziels produced on behalf of George Routledge in the 1860s kept their engravers and draftsmen busy.[53] Like Vizetelly, Leslie, and Landells, the Dalziels also launched their own publishing projects and later moved into magazine publishing, concentrating on comic periodicals. In 1870, they bought *Fun*, a rival to *Punch*, in 1871, *Hood's Comic Annual*, and in 1872, *Judy*. In 1884, they bought *Ally Sloper's Half Holiday*, one of the most popular comics of the time. The process firms that took over the reproduction industry in the 1890s could not follow this lead and branch out into publishing, partly because reproduction was no longer in the hands

of a relatively small number of companies. In addition, these firms did not have the same close relationship with illustrators that the wood-engraving masters had. By the 1890s, publishers kept the art direction of their products under their own control.

One of the important elements in the breaking up of the reproduction trade was the development of blocks that could be dismantled and worked on by a number of engravers simultaneously. By combining a number of small four-by-six-inch blocks magazines could produce full page or even double page images. Charles Wells, a Soho block maker, invented a technique for joining the blocks and later developed a means of constructing bolted blocks that could be joined and then disassembled. Wells claimed that *ILN* was using his blocks from its inception. From the 1860s, the bolted block was an important element in a new approach to engraving. First, an image was drawn on the assembled blocks. The draftsman needed to consider the joins between the blocks in their preparation of the image, carefully placing heads and faces so that they did not straddle two surfaces. Once the image was drawn the blocks could be split up so that a team of engravers could work on them at the same time. It would then be reassembled, the master engraver joining up the lines that ran across the various blocks.[54] This procedure allowed for much more rapid production of the large images in the weeklies. However, for the system to work, it was necessary that all of the engravers cut a drawing in exactly the same way. As one observer put it, "In the large offices the different artists [engravers] are trained to work together in the same style, so that no variety of touch or treatment is observable throughout a composite block, however large. This is a remarkable and interesting modern example of the results of the principle of division of labour."[55]

Another important factor in the mechanization of engraving was the application of photography within the trade. The two reproduction methods had, in fact, been closely connected since photography's inception. From as early as 1840, daguerreotypes were being etched to produce printed images.[56] The *ILN* made extensive use of this new imaging technology from its first years. When Herbert Ingram was planning his illustrated weekly, Henry Vizetelly had suggested that the daguerreotype would provide new opportunities for the depiction of celebrities. Jean Claudet, who in 1841 became the first in England to hold a daguerreotype license, produced images for Vizetelly's *Illustrated Times* as well as for *ILN*.[57] At this stage these photographs were traced by a draftsman, and then this image was transferred to the block and engraved in the usual way.

The increasing ubiquity of photography and its use as a means of reproducing artworks influenced expectations of other reproduction systems. Photography's apparent objectivity highlighted the subjective nature of these methods and brought a new requirement for accuracy. Although there had been a debate about facsimile in reproduction since the eighteenth century it intensified with the introduction of photography, as part of a growing

belief that reproduction processes would be objective and truthful. Ruskin wrote, in 1853, of photography modifying the art of metal engraving by setting higher standards of correctness.[58] Both Anthony Hamber and Trevor Fawcett contend that the increasing demand for facsimile in metal engraving was due to the influence of photography.[59] Walter Benjamin wrote, "And its [photography's] significance became all the greater, as, in the light of the new technical and social reality, the subjective contribution to painted and graphic information was seen to be increasingly questionable."[60] In the new "social reality" of the nineteenth century the objective visible fact became paramount, and this ideology needed a method of recording the world in an apparently neutral way. The camera was deployed to fulfill this requirement, and photographically based techniques served the same purpose in the print media. Yet, as we shall see, the yearning for truthful facsimile was impossible to fulfill.

Estelle Jussim records Ivins' comment that before photography, people had not made a distinction between "pictorial expression and pictorial communication of statements of fact." With the increasing prevalence of the photographic image and reproduction methods she identifies "a growing public consciousness of the difference between the Linton symbolic linear conceptions and the surfaces of reality, especially as the photograph was accustoming the human eye to the nuances of light and shade as converted into flat picture plane codes."[61] The engravings of Linton and other "white line" engravers were never meant to be realistic. Rather they had been paraphrases of reality, a means of translating and understanding the world. Linton was well aware of the fact that the reproduction was a representation of an original in another medium and that engraving could never be an absolute facsimile but was a translation, a representation.

Although the facsimile approach apparently became increasingly dominant, in many cases it did not produce a faithful rendition of the original. Sometimes this was due to technical limitations and because, as Linton pointed out, exact replication was impossible; in addition, magazines wanted images to be improved rather than simply transcribed. With wood engraving it was still possible to refine lines, remove objects, and adjust the visual impact of the final printed image. As the debates about photomechanical processes which continued through the 1890s and into the twentieth century indicate, it took many decades before photography established an absolute reproductive hegemony.

The move to facsimile in wood engraving was shaped not only by photographic influences on what reproduction should do but also by the application of photographic techniques within the trade. From as early as 1839, attempts were made to fix images onto woodblocks photographically.[62] With the huge increase of work during and after the Great Exhibition, engravers had experimented extensively with photography, aware that the camera would save time and might eliminate the draftsman. During the 1860s, the

major facsimile firms developed their own methods for fixing photographs onto blocks. The Dalziels stated in their memoirs that "after much time and labour" and many "spoiled blocks" they worked out a reliable method in the 1860s. "Then," they said, "followed as a matter of course, the constant practice of making drawings on paper which were photographed on wood." In fact, their archive of proofs in the British Museum contains examples from 1857 onwards that are clearly engravings of photographs.[63] Around 1866, August Hentschel developed a method that was used by John Swain, brother of Joseph Swain, *Punch*'s engraver. Being in possession of a reliable and easily worked photographic transfer technique could be a vital element in a firm's application of facsimile.[64] Some engraving offices transferred the photographs themselves, however, there were also suppliers who specialized in printing images onto blocks.[65] Although photographic transfer was common by the 1860s, it was not without its problems. Fixing a photograph onto the block was fairly straight forward and cost around a shilling, but making this image engravable was much more difficult. The coating on the surface needed to be dry and thin, but not too brittle. Engravers found these blocks were very difficult to work with, but given the cheapness and speed of the technique they had no choice. And it was the engravers who had to sort out these problems.[66] The photo on the block was usually darker than if it were fixed on paper, and it lost the subtleties of the original. Engravers, therefore, still had to clarify details and alter lines that the camera had distorted or thickened, with results said to be harder and stiffer than engravings made from drawings on the block. William Linton contended that the most serious problem was that it damaged the artisans' eyesight.[67]

This photographic system had unforeseen and disastrous consequences for the status and future of wood engraving. In the past, artists and illustrators such as John Gilbert or Luke Fildes adjusted their styles for the engraver. For instance, when John Tenniel first began working for *Punch*, Swain instructed him on how to draw on the block so that the images could be successfully and rapidly engraved.[68] But when drawings were photographed directly onto the block, there was no such control over the originals. One of the difficulties that illustrators had with the old system was working on a small scale. Photography removed this problem for them, and now they could produce large drawings and have them reduced by the camera. These originals were often made with no consideration of their reduction; the lines were not to scale and were either too detailed or too indistinct. By using photography, illustrators were also freed from the necessity of drawing their images in reverse on the block to make them print the right way.[69]

Engraver A. L. Baldry suggested that the decline of wood engraving was caused by the trade's willingness to accommodate artists who didn't work to its requirements. Illustrators no longer had to draw in a prescribed manner; rather the situation was reversed, and it was up to the engraver to try and follow the illustrators' personal styles. According to Baldry, wood engraving

"set itself, in fact, to outrage its traditional policy, to alter its methods, and become not a leader of opinion but a follower, subject to other men's fancies." With the move from translation to facsimile, wood engraving had become, he argued, simply a reproductive system rather than an interpretive art, "nothing but a mechanical device, an imitative process, copying touch by touch and blot by blot, the accidental qualities of brush and pen."[70] Baldry believed that as soon as wood engraving's aim became mimesis, photography would surpass it by duplicating an original more slavishly than handwork.

William Linton was also appalled by the new facsimile system, which he felt weakened the distinctive linear character of engraving. Rather than cutting an decisive line that was driven by content, the engraver was now forced to work on fragments of an image producing meaningless tonal dots.

When a block the size of a page of the *Illustrated London News* or the *Graphic* was cut from a photograph on the block – the photograph of a slovenly sketch with a superabundance of discordant and meaningless lines and confusion of tints, a sketch not intended for engraving, – when engravers, covering this to preserve it from destruction (for at the first these photographs faded away when exposed to the air), were obliged to work piece-meal, without the least understanding of what they engraved (the little uncovered bit might be a cloud or a door-mat, or anything else), the absence of anything like artistic work was sure.[71]

Linton acknowledged that photographs could be useful for reducing drawings onto blocks and could help with subjects such as portraits when the engraver was working to short deadlines. However, he urged that a draftsman clarify the reduced image before it was cut. But this did not generally happen as the whole point of the system was to save money by eliminating the draftsman and so the common practice was for the engraver to work directly on the photographic woodblock. The linear syntax of wood engraving was becoming finer and more vague under economic and aesthetic pressures. As Linton declared, engravers were now dexterously producing interchangeable tints and textures. They had been forced to develop a new range of marks that were comparable to the tones of the photograph. Short, broken, scattered scratches replaced the long sweeping lines of the past, "more or less stippled and chopped up with dots."

The most extreme version of this style, which became known as the "New School," first appeared in American middle-class magazines, including *Scribner's* and *Harper's*, in the late 1870s.[72] The New School was a small group of engravers that included Tim Cole, Frederick Juengling, Henry Wolf, and A. V. S. Anthony, who mainly worked on reproductions in American middle-class monthlies and books. Their approach depended on the faithful facsimile cutting of photographic images on the block using only a few gravers. Previously, engravers had used many tools to make a range of lines

Figure 10 "Delphian Sibyl, by Michelangelo," Timothy Cole, *Old Italian Masters Engraved by Timothy Cole*, New York, The Century, 1893, 219. (Wood engraving, detail)

that would be varied in type and width according to the objects they were depicting. Interpretive engraving responded to the content and meaning of the image, so, for example, a cloud would be cut with a line distinct from that used in depicting a rock. New School engravers, on the other hand, were concerned with surface rather than content and used one graver to produce a minute network of fine textured lines that treated everything in the same manner. As their style was very influenced by the photographic aesthetic, their work had an even overall effect with few dramatic differences in tone.

In their attempts at objectivity, New School engravers would copy the brush marks on the surface of a painting, something that would not have been done up to this point. Engravers like Linton were interested not in the façade itself but in its iconography, subject matter, and in the image as a carrier of social meaning. As individual brush marks became more important in painting, and as stylistic individuality rather than narrative

became increasingly important in art, wood engraving began to seem less suitable as a method of art reproduction. William Ivins argued that "Objects can be seen as works of art only in so far as they have visible surfaces. The surfaces contain the brush marks, the chisel strokes, and the worked textures, the sum totals of which are actually the works of art." He suggested that photomechanical reproduction's ability to capture the "traces of the creative dance of the artist's hand" was a key factor in its success.[73]

By combining photography with wood engraving, magazines sought to provide a balance between the demands for objectivity and cultural refinement. It is important to situate the New School in the context of the middle-class publications in which they first appeared. These genteel parlor magazines, providing uplifting literature for the middle classes, had championed and developed high-class engraving. Popular culture was seen as a threat, and the masses must therefore be educated in the elite culture contained in the magazines. Many subjects were excluded from the magazines as vulgar, such as portrayals of working-class life. The editors of these magazines saw themselves as custodians of a cultural heritage that was an antidote to the excessive materialism of American society. The style of photographically based engraving that these magazines pioneered allowed them to combine pragmatism with art, and to make objectivity palatable.[74]

In the 1870s and early 1880s, only the expensive American monthlies had the time and the precise printing equipment necessary to reproduce the incredibly fine images produced by Tim Cole and his comrades. Yet, the New School approach proved to be very influential not only in the United States but in Britain, where it was known as the American School; as a result, British engraving in the 1890s moved toward the ultra-fine American style first in the monthly the *Strand* and then in the weekly *Black and White*.[75]

However, the American School was criticized in England as being too photographic and characterless and as a bravura exercise in empty technique. This criticism needs to be seen in the context of English views of America as being shaped by commerce and industry.[76] The art critic M. H. Spielmann, who was generally in favor of new reproduction techniques, wrote that the American School had no more original feeling or quality in it than a photograph and condemned the results as an industrial aberration: "What was an art, became a science – a process: Florence, so to speak, was supplanted by Birmingham."[77] However, this merging of photography and engraving was intended to bring artistic Florence and industrial Birmingham together. William Linton, who had moved to the United States and had actually taught Cole, set the tone of much of this criticism in his article "Art in Engraving on Wood" in the June 1879 issue of the *Atlantic Monthly*. His argument was that these engravers, by paying equal attention to all parts of an image, to the foreground and background, were no longer concerned with meaning and selection but with technical virtuosity. Sky, wool, grass, water were all treated in the same monotonous way so that any part taken on its own

was unintelligible. Vizetelly, a great admirer of Linton, thought that the American School had "a microscopic minuteness of execution which has more the character of mechanism than of art."[78]

In 1890, Linton delivered a lecture to the Society of Arts in which he condemned American engravers as merely showing manual dexterity, "the sometimes useless, often unhappy minuteness [as] astonishing," that "the triumphant assertion of mechanical skill," was in effect "a tolerably good imitation of a photograph," and, finally, that the outcome was "one flat and unvarying set of monotonous and unmeaning lines so that the treatment of one part would do just as well for any other part." In the discussion following Linton's address, the photographer Henry Trueman Wood acknowledged that the American approach owed both its merits and faults to photography. He admitted that many of the engravings did look like badly exposed photographs as it seemed easier to copy photography's faults, such as its flatness and absence of vigor, than to capture the meticulous surface of a good photograph. However, Trueman Wood believed that the popularity of the new engraving was also due to the influence of photography. The public, educated by photography, were now looking for detail and renderings of tone and color in imagery.[79]

In 1893, Edwin Bale roundly condemned Tim Cole's recently published book *The Old Italian Masters*. Writing in the *Magazine of Art*, Bale complained that the market was now flooded with New School images that required only patience and physical endurance from the engraver. Cole's book represented, for Bale, the decadent state to which wood engraving had sunk in its imitation of another medium, and he noted that in the worst engravings prodigious amounts of effort had created images indistinguishable from halftones. As the photomechanical block improved, hand engraving and process had become practically interchangeable. Indeed, he suggested that it was the public's familiarity with tonal wood engraving that had made it easier for them to accept halftone images in print. Bale asked why should publishers pay for handwork when they could use process and give readers more images for their money.[80]

Linton had foreseen in 1879 that by moving from linear interpretation to tonal facsimile, wood engraving would eventually be replaced by methods that were more tonal, photographic, and mimetic:

> The most talented engravers are hampered and crippled by it [photography]; they are confined to colour, and compelled to indefiniteness; and they waste their powers in an excess of fineness. The end to this can only be imbecility in engraving, and then the substitution of some process for the mechanical weakness of the hand. For the days of the mechanic-engraver are numbered. Beware of photography![81]

Linton's concern that facsimile in wood engraving would lead to the rise of the halftone was well-founded. Indeed, the stipples and dots of the tonal

hand engraving helped inspire halftone experiments. Engravers had demonstrated how a system of marks of different sizes and at different distances could achieve the illusion of tone. Investigators theorized that the production of tone via dots could be achieved photographically, or through chemical action. The process pioneer Frederick Ives described the halftone as "a typographic relief printing plate in which the smooth shading of a photograph is translated into a pattern of definite lines and dots suitably graduated in size, as in a wood engraving."[82]

By the mid-1890s the widespread use of photorelief methods challenged wood engraving's monopoly on the production of text-compatible images. The wood engraving industry appeared to be in crisis. Poor economic conditions on both sides of the Atlantic in the early 1890s had already put pressure on reproduction costs.[83] The Dalziel Brothers' wood engraving business went bankrupt in 1893. *Punch*, the most traditional – if not to say, reactionary – of the illustrated magazines laid off its wood engravers the following year.[84] In addition, the trade became overstaffed as the large numbers of men who had been indentured as apprentices in the boom years of the fifties and sixties competed for work. Prices in the trade had been falling since the 1870s because offices and outworkers were undercutting each other. The clustering of highly specialized and skilled workers in London meant that individuals could be "sweated," that is, forced to reduce prices in competition with each other on a piecework basis.[85]

J. Whitfield Harland recalled that until the mid-1860s, wood-engraving "work was in excess of the power of production, and then commenced a slow, certain, steady, decline." Harland cited a number of factors that had contributed to this deterioration: the glut of engravers due to greedy masters taking on too many apprentices; the introduction of engraving machines; payment by the square inch for drawing and engraving; photography on wood; cheaper process work; and the division of labor in the trade. In a situation where more engravers were competing for work, semimechanized methods meant that fewer hands were needed. The pressure to turn out work more quickly had led to the development of expensive engraving machines that could produce as much work in a day as an engraver could produce in a week.[86]

However, Harland explained that the factor that caused the most damage to the trade was the spatial fragmentation and isolation of workers:

> It is beginning to be a recognised fact that whenever it is possible in any trade to take work home to do that trade begins to decline . . . the work is taken home, brought back finished, the hours of night are requisitioned to make up the deficiency in price . . . when another job is offered at a low price, the employer shows the bill and proves he can get work done at the price, and a second individual is forced to agree or starve. For many years this sweating has gone on entirely through the system of taking work home, and enabling the capitalist to deal individually with engravers instead of collectively.[87]

Figure 11 "William Ingram," *Publisher's Circular Newspaper, Magazine and Periodical Supplement*, 9, June 14, 1895, 5. (Wood engraving on photograph)

The scarcity of work had kept engravers segregated and prices low. He noted that several attempts had been made to start a union, but these failed due to fear of retaliation by employers and "the habit of acting individually." According to Harland freelance engravers were paid one-third of what the engraving firms charged their clients. Eventually freelancers started to approach publishers directly, thereby undercutting the established offices that in turn had to lower their prices. Harland stated that in 1892 fewer than four in thirty engravers are able to find regular employment, many only working a day or two a week.[88] When Charles Booth investigated the trade ten years later he described a demoralized industry. Firms that once employed 20 engravers now used only a handful of part-timers. Prices had dropped by half over the decade, and although engravers could earn £3 to £5 per week if they were fully employed, in practice very few made more than 30 to 40 shillings a week.[89]

Booth noted that many of these unemployed workers moved into process and, indeed, the wood engraving and process industries were very closely interlinked.[90] Younger engravers learned photography so that they could apply it to wood engraving. Some of these craftsmen, in fact, went on to found process firms, including Leslie E. Clift and Co., W. and J. R. Cheshire, and T. W. Lascelles.[91] Paul Martin, a journeyman who used photography in his job realized that the craft was no longer economically viable and studied the techniques of process at one of the new technical schools. He did not, however, take to it, and instead became a partner in a photographic business.[92] Some engravers did become process workers, while many others were employed in the retouching of blocks. The extensive handwork that both line and halftone processes required was labor intensive and called for the fine skills that wood engravers possessed. It is perhaps ironic that these redeployed engravers were involved in the production of photomechanical blocks that imitated the surfaces of wood engraving.[93]

Although mechanical and hand engraving were characterized as rivals, they could be seen as aspects of the same industry as both technologies were used to produce type-compatible images. From the 1890s and well into the twentieth century, mass reproduction incorporated manual interventions alongside technologies of photomechanical engraving in order to produce an acceptable mass image, one that conformed to the aesthetic standards wood engraving had set. These images struggled in a variety of ways to balance the apparent actuality of the photograph with the subjectivity of the handmade image.

4
Process Reproduction and the Image Assembly Line

> Not only is almost all of the illustrating of books and periodicals now done by "process," but there are probably a thousand illustrations used now where there was one when the wood engraving was the only method of production.
>
> – Frederick Ives, *The Autobiography of an Amateur Inventor*, 1928[1]

In his autobiography Frederick Ives looked back with satisfaction on the thousandfold increase in imagery wrought by the invention that he laid claim to. This book questions Ives' technologically determinist view of mass reproduction and looks at the development of the photorelief techniques within a wider framework. I argue that the technology was, in fact, shaped by the competitive forces of mass journalism and by the desire for a much more intense visual experience by mass audiences. Ives' account of himself as a lone inventor is also called into question. In this chapter I examine the ways in which the process industry emerged and organized itself. The shift that had already occurred in wood engraving, from workshop to factory, accelerated. One major difference was in the scale of these enterprises, as mechanical reproduction was organized around larger firms using more capital-intensive equipment. Although these undertakings employed large number of workers, they could be quickly trained in specialized tasks within image reproduction.

The inventors of the halftone situated their research very much within the existing reproduction technologies. Fox Talbot's experiments with folded gauze in 1852 were the first efforts at using a screen to break up the continuous tones of a photograph. He described the resulting print as being "covered with lines very much resembling those produced by an engraver's tool, so much so that even a practical engraver would probably be deceived by the appearance."[2] William Gamble, in his early account of the development of the halftone, explained how the increasingly fine marks used in wood engraving had shown that dots could produce the illusion of tone.

In 1884, Frederick Ives described his halftone system as a means of producing "a pure line and stipple picture, in which the shades of the original are represented by black lines or dots of varying thickness. . . . In short it is a photo-mechanical method, for producing, direct from nature, an economical and superior substitute for pen drawings."[3] In his autobiography he stated " 'Halftone' is a term first used by me to designate the character of a typographic relief printing plate in which the smooth shading of a photograph is translated into a pattern of definite lines and dots suitably graduated in size, as in a wood engraving."[4] It is clear that Ives envisioned his new process in the context of the images that already existed in the press, not as a revolutionary rupture. Ives' description used the vocabulary of other reproduction processes, for instance, as in *stipple*. Other early accounts of process often boasted that they were as good as wood engraving, "the whole aim being to successfully imitate wood engraving at a reduced cost."[5]

Process was not intended simply as a means of reproducing photographs. Indeed, Joseph Pennell claimed that halftone was invented in order to reproduce wash images. As a fierce critic of photography, his opinion may have been prejudiced.[6] But in the early days of process there is no reason to suppose that its users foresaw it would lead to a large increase in the number of photographs in the press. Magazines had used wood engravings to replicate photographs for some time, but until large numbers of halftone photographs had been reproduced alongside text on an extensive scale there was no way of assessing how popular they would be. Process reproduction led to an increase in all kinds of imagery, not only photographs.

Processes that reproduced line were developed first, followed later by halftone processes that allowed for the reproduction of tonal drawings and photographs. The French engraver Firmin Gillot established the standard method of using photography to reproduce a drawn image in the mid-1850s, although he had been refining his techniques since the late 1840s. Gillot developed a method of printing from line originals by inking them and contacting them with a zinc plate, which was then etched. His son Charles developed the system by using photographic negatives rather than contact-printing the originals and, in 1876, he set up the first photorelief business in Paris.[7]

Although it appeared to be a simple technique, photorelief line process required considerable manual labor to produce acceptable results. First, a very high contrast negative was made of the original and then contacted with a metal plate coated with a light-sensitive emulsion. Zinc plates were commonly used and the process was often called "zincography" or "zinco." The negative and plate were exposed to sunlight or electric light that passed through the transparent parts of the negative – the lines of the drawing – and hardened the emulsion. The other areas had not hardened and could therefore be washed away. The plate was then etched a number of times and after etching, plates might be engraved by hand to reduce lines that

had become thickened and to remove superfluous marks. These procedures required a good deal of care, but they could be broken down into separate stages and undertaken on an assembly-line system. They could, therefore, be easily learned, with children undertaking some of the simpler procedures, such as rocking the acid baths.

Information on line process was not spread by technical publications but by the physical movement of practitioners. In the mid-1870s, French and German immigrants brought line engraving to London, a commercial hub that had always attracted skilled artisans from Britain and abroad to its specialist trades. Charles Gillot's methods were first practiced in the capital by French engravers soon after their development in Paris. Through the early eighties many of the line-process workers in London were French.[8] From the mid-1870s, many firms began to exploit a variety of line processes and, in most cases, the information necessary to work these techniques was closely guarded by the operators. Methods were unstable and inaccurate, and often many attempts were required to achieve printable results; plates usually took some hours to produce and needed considerable hand manipulation.[9]

In *The Photographic Studios of Europe*, published in 1882, H. Baden Pritchard described a line-process firm that produced images for the press. Unlike most of the other organizations profiled in his book, this company remained

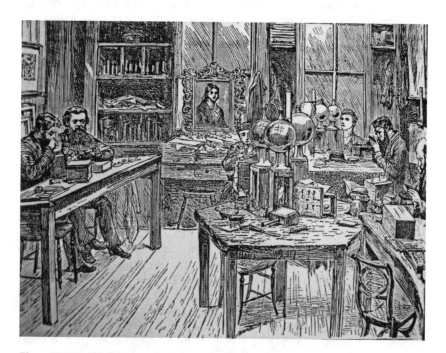

Figure 12 "The Engraving Room of the 'Graphic,'" *Journal of the Society of Arts*, January 30, 1891, 176. (Photorelief line print from pen and ink original)

anonymous and was simply called "A City Phototype Establishment." One reason for this anonymity was that many of these businesses were involved in the pirating of images, and, as Pritchard stated, cheap periodicals that could not afford wood engravings simply photographed images in foreign publications and then printed them via the line process.[10] The process used was based on gelatin. Pritchard's distaste for what he saw at the phototype firm was evident: "The 'studio' we visit – if an open glass roofed shed can be dignified with the name – is the most simple of its kind within our knowledge. The photographic arrangements, too, are of a most primitive description.... The place is littered with old frames and dirty machinery; but there is plenty of work going on never the less."[11] The production of plates involved considerable retouching and took about two days from start to finish. Clearly there were a number of firms in this business, for Pritchard also noted that aggressive competition had kept prices low, an average four-by-four-inch block, for example, costing around eight shillings to engrave.[12]

Line processes became cheaper and quicker during the 1880s and challenged wood engraving in price and speed. Wood engravers were under economic pressure both from the new photomechanical processes as well as from other engraving workshops. The numbers of engravers were growing, and competition, in particular the sweating system, had driven prices down. But hand engraving still had one advantage over process. Photorelief line reproduction was perhaps cheaper and quicker, but it could not reproduce any tonal images. Engravers, on the other hand, by using a fine network of lines and dots, could mimic the subtle graduated tones of photography, wash drawings, or paintings. It was not until the refinement of processes which were able to capture these "half tones" between black and white that wood engraving was seriously challenged as a reproductive technology.

Like the experiments in line process most of the early attempts at reproducing tonal images relied on trial and error and were complex and painfully slow. They required a great deal of hand adjustment and often produced only small runs. Many were not type-compatible. The methods developed in the 1850s and 1860s by Paul Pretch, Campbell Dallas, and Walter Woodbury were expensive, time consuming, and unsuitable for the periodical press.[13] Most of these early experiments with halftone techniques were undertaken in an ad hoc fashion by engravers, printers, and photographers. The prominent British chemist and inventor Joseph Swan, however, was an exception to this model and brought an unusually theoretical approach to his process researches. He carried out research into reproduction processes from the 1860s on in his well-equipped laboratory.[14]

The idea of using a screen of some sort to prepare a tonal image for printing was not new. Beginning with Fox Talbot's use of gauze in the 1850s through the 1860s, various techniques for breaking up continuous tones using screens and fabrics had been proposed.[15] As early as 1865, Swan had patented a line screen, and in 1879 he suggested that in order to produce an intersecting grid, a screen marked with parallel lines could be turned ninety

degrees halfway through the lengthy exposures that were required. Exposing the original through the screen's mesh of intersecting lines produced dots on the negative. These dots varied in size according to the light reflected by the different parts of the image, with the smaller ones in the dark areas and larger in the light areas.

In 1882, Georg Meisenbach refined Swan's ideas and patented his own process in Munich. Meisenbach's patent used a single glass plate with finely hatched parallel lines. The screen was placed in front of the original and an exposure made. Halfway through the exposure, as Swan had proposed, the screen was turned ninety degrees; the negative was then used to make a zinc plate as in the line process. Whereas Swan had not commercially exploited his ideas, possibly because he had many other financially rewarding projects to occupy him, Meisenbach put his ideas to work, and his was the first halftone photorelief process to be widely used in Europe. Soon after his German patent was granted, Meisenbach took out one in London. In May 1884, the Meisenbach company was established as the first halftone business in Britain, and until at least the turn of the century, Meisenbach was the generic name for halftones.[16]

The screens used by Meisenbach depended on cutting parallel lines on glass.[17] It would have been prohibitively expensive for the halftone pioneers to devise and build machines that could accurately cut lines at varying distances to such fine tolerances. Luckily, these machines already existed in the wood-engraving industry. Developed in the 1860s, costly ruling machines were used to mechanically produce areas of tint. They cut parallel lines of adjustable widths to tolerances of 1/200 of an inch.[18] Process researchers simply appropriated and adapted the ruling machines so that they engraved on glass rather than wood. Lines were cut into the surface with the engraving machine and filled with ink to create a screen. The problem was that if a second set of lines was cut at a right angle, the intersections of the lines became ragged and uneven. Swan and Meisenbach had sidestepped this problem by using a screen with a single set of parallel lines then turning it during the exposure.

The American Frederick Ives' concept, however, was to create a cross-line grid by gluing two screens together. He investigated the problem between 1885 and 1886 and in 1888 published an account of the optical principals of his technique. The first commercially successful screens, however, were produced by the Levy brothers of Philadelphia in 1887. Rather than cutting into the surface of the glass, their approach called for first coating it with wax and then using the ruling machine to cut through the wax and expose the bare glass. The glass sheet was then etched in a solution of acid, which bit into the unprotected areas. These etched lines were then filled with black pigment to bring them back to surface height. Two plates with lines running at right angles were then glued together to form the finished screen. The Levys did not disclose the materials they used to coat the glass or to fill

the etched lines or the glue they used to join the screens. Other firms were, therefore, unable to replicate these very effective and expensive products. In the United States in the 1890s prices for the cross-line screens ranged from $100 to $1000, depending on their size and fineness.[19] In London the screens could cost a considerable sum of £60, around half the yearly wages of the men who operated the process camera.[20]

As a result firms needed to have confidence in an increasing demand for halftone reproduction in order to make this considerable financial investment. The distribution of Levy screens in Britain in the early nineties turned the halftone into a reliable image-making technology that became an aesthetic and commercial rival to the wood engraving. In 1895, the *Process Photogram*, the first trade magazine for the photographic reproduction industry, launched its debut issue with the claim that "Process now stands triumphant."[21] That same year the Royal Photographic Society held its first monthly Photo-Mechanical meeting. By mid-decade process had indeed arrived. At the same time, the economic pressures that were driving wood engravers out of business were also affecting the process industry, and prices for process had halved over the previous year.

The standard halftone procedure began with the photographing of the originals through the glass screen, which could be attached to the massive process camera. Depending on the subject matter and the fineness of the screen, adjustments were then made to the camera aperture, the focal length, and the distance between the screen and the negative plate. This photography was done in batches, not one by one, to save money on materials and labor; the resulting negatives were developed, retouched, and would then be contact printed onto a sensitized copper or zinc plate. The plate was then developed before being etched, two or three times, after which a proof was taken. Very often, a fine etching was then undertaken to increase contrast and clarify detail with fine etchers, using a very thin camel's-hair brush to applying etching solution selectively to parts of the image. The depth of the etched line was around 1/32 inch, much shallower than a wood engraving, so manual engraving might be needed to clarify the image and deepen the impression.

The printing of halftones was much more problematic than for wood engravings. Powerful presses, new working methods, coated papers, and better quality inks were all needed for halftone printing. In general, greater consistency and precision were needed in order to produce successful results. Even the temperature of the printing office was a factor, and it was recommended that it should remain above 70°F. In England, however, these requirements, including the climatic conditions, were rarely met.[22] One common setback was the ink spreading on the block and causing the image to "fill in." If halftones were printed on cheap paper, the dots of ink would sink into the surface, blurring the image. Stiffer inks and smoother, more expensive papers were therefore developed. The quality American monthlies

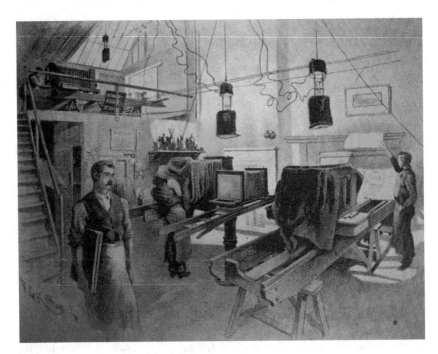

Figure 13 "Process Studio at John Swain and Son," F. G. Kitton, "The Art of Photo-Etching and Engraving," *British Printer*, 7.40, July 1894, 218–31, 218. (Photorelief halftone print from wash original.)

such as *Harper's* and *Century* devised new printing methods and were able to afford the good quality paper needed to achieve acceptable results.[23] According to the trade press, although the United Kingdom had caught up on plate making, it lagged behind the United States in printing and inks.[24] Process firms blamed the unsatisfactory appearance of halftones on the printers who, in turn, faulted the process firms for providing unworkable blocks.

The most noticeable material change in the process-illustrated magazine was the paper on which it was printed. Over the previous half century, paper prices had fallen dramatically as expensive paper made from rags was replaced by paper produced from chemically pulped wood. By the 1880s, mechanized paper mills in Britain and the US manufactured large quantities of consistant products. Rather than being made in individual sheets printing papers could now be produced on gigantic rolls for use on rotary presses. However, while these papers could cope with line process illustrations or wood engravings. they were unsuitable for halftones, the best results for which were obtained by using very smooth stock coated to prevent ink

dispersing or sinking into the surface. These "art" papers were produced by coating the paper with chalklike substances, and a cheaper alternative was calendared paper, which was passed through hot rollers in order to compress its surface. By the mid-1890s, there were over eighteen mills in Britain producing paper suitable for periodicals.[25]

When Ingram Brothers launched the *Album* as a high-class shilling monthly, the advertisements stressed that it was printed on glossy "enamelled paper." The magazine consisted almost entirely of large photographs of celebrities and this smooth, shiny surface would have yielded the best results. This kind of paper was already being used to connote the expensive qualities that the "glossy magazine" would come to embody. However, some critics thought that this highly glazed paper distracted one from the reading experience, because its intensely white, reflective surface was a sharp contrast to the mat off-white papers that readers were used to. Others objected to the mixing of different kinds of paper within a magazine such as the *Century*, which used art paper inserts for its halftones. On thinner papers, printing a heavy halftone photograph on both sides of a page resulted in "show-through" in which the image on the other side of the sheet was visible. The magazine *Pick-Me-Up* had to pulp an issue after it was accused of deliberately exploiting show-through in order to produce a sexually titillating blending of images.[26]

Despite these problems the process industry continued to grow and in 1895 there were 53 process firms operating in London.[27] By the mid-1890s, attempts were being made to establish and distribute a body of theoretical and scientific knowledge to this growing industry. The Royal Photographic Society's Photo-Mechanical Process section served as a forum in which figures in the trade, such as Henry Snowden Ward and William Gamble, and interested observers, such as Joseph Gleeson White could exchange their ideas. In 1897, when Gamble presented his paper "The History of the Half-Tone Dot" to the Society there was much disagreement among those present as to exactly how the halftone worked.[28] Some argued that the screen acted as a set of pinhole lenses, others insisted that a penumbra effect was taking place. It was clear that practice had preceded theory; process workers knew how the screen worked, even though they didn't know why.[29]

Reports on the processes and the equipment needed to work them were circulated through trade magazines that established the discourse of the emerging technology.[30] Through these texts, the industry became regulated and organized, and equipment and methods become more standardized.[31] A body of shared knowledge, essential to the wider dissemination, development, and systematization of techniques, was gradually established and published in books and magazines. The tone and content of the journals established the self-image of the trade as modern, business-like, and go-ahead. Information on photomechanical reproduction was also disseminated through reports in photographic and printing-trade magazines.

Printing publications such as *British and Colonial Printer, British Printer,* and *Printing Times and Lithographer* carried regular reports on process matters. So did publishing trade magazines such as the *Newspaper Owner and Manager* and the *Publishers' Circular*. The photographic press, including the *Photographic Journal, Photographic News,* and the *British Journal of Photography*, also frequently reported on reproduction.[32]

In 1895, the first trade monthly the *Process Photogram* was launched to address this new area of practice.[33] It was published and edited by two well-connected photographic activists, Catharine Weed Ward and Henry Snowden Ward. The magazine was a spinoff from a monthly photography magazine *The Photogram* that they had launched the previous year. The Wards were idealists, who saw photography as progressive and modern and the name of their new magazine reflected their idealism. The Wards were insistent that the objects produced by photography should be called by their correct name: they were *photograms* and not the "effete" term *photographs*. They pointed out that the word *photograph* was the verb form, and the outcome of the act of photography was a *photogram* – just as one would telegraph a telegram. They bravely fought a losing battle on this matter. Catharine Weed had been a leading figure in American Amateur photography and Henry had considerable experience in British photographic journalism. Their approach inclusive and catholic, they were intent on bringing together the commercial and artistic strands of photography, and the Wards were extremely energetic promoters of photography and its applications. Between 1894 and 1911, their publishing companies, Dawbarn and Ward in England and Tennant and Ward in the United States, published a series of innovative photographic books. In 1901 the Wards wrote and published the first English book on press photography, *Photography for the Press*, and in the same year compiled and published a huge index of photographs for reproduction in the press and launched a photographic agency. They collaborated on travel books and also contributed to other magazines including the *Sketch*.[34]

Although the Wards enthusiastically promoted the new technological opportunities that the camera made possible, they did not do so indiscriminately. Their process magazine was more commercially oriented than the *Photogram*, but it nevertheless advocated high standards in mass reproduction. The *Process Photogram* contained a great deal of technical discussion, information, and many advertisements for equipment, however, it also included critical comments on the direction that process was taking. Snowden Ward argued that an intelligent trade press could act as an effective force in educating and improving the expanding reproduction industry.[35] The first issue of the *Process Photogram* announced the importance of process, but the magazine did not aggressively assert the hegemonic status of the photorelief techniques, admitting only that they "will always have a place, in one form or another, among the popular methods of illustration."[36]

Other procedures were not dismissed out of hand, as, for instance, wood engraving, which was praised as a relief from the monotony of the halftone. The magazine was critical of the overuse of halftones and of the poor quality work that resulted from this. It decried the plethora of images in the press produced by process workers, who were forced to turn out rapid and often botched work, which, according to the magazine, had given all process imagery a bad reputation. In 1896, a year after its launch, the magazine observed that low-priced process had flooded the cheap illustrated papers with halftones that would "disgrace a greengrocer's bag" and which had produced a "revulsion of feeling" against process.[37] Another of the key figures in early photomechanical industry, Charles Gamble, was a regular contributor, and his attitude toward process was also skeptical and pragmatic. In their annual photography collection, *Photograms of the Year*, the Wards admitted the shortcomings of halftone reproduction as a means of imaging: "Reproduction by photo-mechanical process must inadequately represent many originals. Size, color, and texture cannot be reproduced; and even tone-values in many cases can only be partially recorded."[38]

There was one other contemporary English process-trade journal, *Process Work and the Printer*. First published in 1896, it emerged from a business and printing milieu, rather than a photographic one, and as the magazine's title suggested it focused on the commercial side of the business. The Wards' title, in contrast, implied that their emphasis was on the quality of the image itself. The magazine was edited by William Gamble (not to be confused with Charles Gamble), who had trained as a journalist on the *Bury Post* in Bury St. Edmunds. In 1877, he set up a line-process department at the paper. Gamble moved to London in 1886 and became involved in agencies supplying ready-made images to publications, eventually working for Nop's, the major firm in this field. He then branched out and set up a studio providing magazines with illustrated articles.[39] In 1893, realizing that there was money to be made with the increasing demand for process materials, he set up in business with chemist A. W. Penrose. Penrose's Photo Process Store became Britain's major supplier of photomechanical materials and equipment, largely because the firm was the sole agent for the Levy screens that came to dominate the market.[40]

In 1894, Gamble published his highly successful instructional manual, *The Half-tone Process*, using the pseudonym Julius Verfasser.[41] This claimed to be the first book in English to deal with halftone techniques in detail, and it went through five editions between 1894 and 1912. The reader was informed that all of the equipment in the book was available from Penrose and Co. Also in 1894, Penrose launched *Penrose's Annual: The Process Year Book*. This long-running publication collected information on new reproduction techniques and methods. Gamble's magazine started out as *Process Work*, a publicity circular for Penrose in 1893, but in March 1896 was retitled *Process Work and the Printer* and launched as a trade journal with Gamble as the joint editor

alongside William Surface. In 1899, the paper reverted to its original title and status as a trade circular. The Wards continued publishing the *Process Photogram* until Henry's death in 1911.

The sudden increase in process firms that coincided with William Gamble's publishing activities had begun slowly a decade earlier. In May 1884, the first British halftone business, the Meisenbach Company had been established in Farringdon Street, near Fleet Street. Initially, the firm had difficulties making images due to the vibrations caused by trains, and were forced to raise more capital and move to the quieter suburban surroundings of West Norwood. Within two years, John Swain (brother of wood engraver Joseph Swain, whose firm was one of the major facsimile factories) had bought out the line-process firm Leitch and Co., also set up a halftone service. In 1885 Joseph Swan, the inventor and process pioneer, founded the Swan Engraving Company; Andre and Sleigh, Carl Hentschel, and the Art Reproduction Company were among the other early leading firms.[42] The numbers of process businesses expanded considerably in the nineties with the availability of Levy's screens and with the increasing accessibility of information in previously mentioned trade books. The demand for images came from the new illustrated magazines, which were benefiting from the advertising revenues that came with the end of the "Great Depression," and in large measure these demands shaped the technologies of reproduction. Periodical publishing, in particular, had specific requirements for rapid work given the ephemeral nature of the product they were selling. The economics of London publishers had transformed wood engraving, and now they molded the new imaging industries. Although there were many provincial newspapers and publishers, in many cases these relied on in-house reproduction units and were small-scale enterprises compared to those clustered in the capital.

Process was organized as a manufacturing industry rather than a craft and was capital intensive, unlike wood engraving. A major expense for process firms was the halftone screens, as a number of these fragile and costly items was needed in order to produce different grades and sizes of image. Firms needed to buy or construct at least one large process camera, which was a huge, track-mounted machine that could produce a negative up to 30 by 30 inches. One of the advantages that process had over wood engraving was the flexibility it offered in terms of the printed image. Whereas many small woodblocks had to be bolted together to make large images for the press, metal plates could, in theory, be produced in any size. It is worth noting, however, that the standard size for halftones was six by four inches, the format of which was based on the size of the boxwood blocks used in wood engraving and related to the column size of magazines.[43]

The physical requirements of process printing were different. Much more space was needed by a process house than a wood engraving office. Following the practice of commercial photographers, process studios were often located on the top floors of buildings in order to take advantage of any sunlight they

could get. Firms also required darkrooms to develop their negatives and space for contact printing the negatives onto plates. The etching processes meant more space, equipment, and also chemicals. Accommodations were also required for retouching and mounting the finished plates onto type-high blocks. Some firms also employed in-house draftsmen and wood engravers, and proofing presses were necessary to supply prints to the client for approval. Large companies housed these and other services, such as electrotyping, but smaller firms farmed out many of these tasks to specialists.[44]

Process firms were not only much larger but were financially more complex than had been the case in the wood-engraving industry. Many process undertakings were set up as limited companies, with outside investors supplying funds. When the Meisenbach Company was established in London in 1884, Meisenbach himself was not actually involved; the firm was the property of British investors who had bought the rights to the process from the German patentee.[45] In contrast to the offices run by master wood engravers it was unnecessary for those who ran process firms to have any knowledge of or contact with the actual manufacture of the product. All that was needed was money and business connections. In the boom years of the mid-1890s, there was considerable interest in the industry as a money-making proposition, and speculators were so eager to invest in this new technology that "flat-catchers" (conmen) exploited this, offering shares in bogus patents or in dubious companies.[46]

The process firm was also a much more fluid and anonymous institution than the wood-engraving office had been. Some companies, such as Meisenbach, were named after their founders, but others such as the Art Reproduction Co. and the Strand Engraving Co. took trade names with other connotations. One of the advantages of these limited companies was continuity, for even if the founder of the firm died or retired or the company was bought by others, the institution could continue. In the wood-engraving trade a good deal depended on the reputation and guiding hand of the master engraver. The workshops were known by the name of the master, and when he stopped engraving the workshop usually closed. However, when the process pioneer John Swain died, an announcement in the trade press assured customers that his business would continue exactly as before, "under the able guidance of Mr. Dargavel the Managing Director."[47]

Process firms were organized on the bureaucratic lines of late-Victorian commerce. In wood-engraving offices, apprentices on foot not only collected and delivered blocks, but also picked up payments from customers. Now, in process firms, dispatch clerks directed messengers who could travel by tram and underground railway to collect work from clients. The clerks would also monitor the progress of work through the firm, since the workers who made the blocks no longer had any contact with those who commissioned the work or produced the illustrations. Foremen oversaw the workers and

communicated with managers and, in some cases, clients. The administration of these firms had become more complex and included managers, sales representatives, and accounting mechanisms.

Many of these firms retained premises near Fleet Street in order to offer a fast turnaround on line work. However, there were a number of difficulties in producing successful halftones in the heart of the city – a noisy, dirty, and polluted metropolis – and Fleet Street was its epicenter. Meisenbach's experience had demonstrated that central London was simply not conducive to the halftone production. The large-plate cameras used by process firms required long exposures of five to ten minutes. The cameras were therefore very sensitive to the vibrations caused by the buses, carriages, carts, trains, and cabs that jammed the city streets. Firms located near Fleet Street adopted various strategies to overcome this camera movement, including suspending their cameras from ceilings.

But there was yet another problem for process production in central London: the infamous London fog. This was, in fact, smog, caused by smoke from homes and factories, and particles of dirt in this polluted air made it hard to keep negatives and plates clean. More problematic was the fact that it was often too dark to use natural light to make exposures. London sunlight was weak and unpredictable at the best of times, and smog made this problem much worse. The firms who could afford it opted for artificial light, yet this caused yet more difficulties as there was no electricity grid in central London until the early years of the twentieth century, so firms had to generate their own electricity if they wanted to operate arc lights. The large gas-driven generators, which were used for this, also caused vibrations and were therefore generally situated in the basements of buildings, as far away from the sensitive cameras as possible. One firm embedded its dynamo in concrete and stood it on India-rubber blocks to reduce vibrations within the building.[48]

It was therefore not surprising that many reproduction businesses looked to the suburbs as a solution to the problems of noise and smog.[49] Underground and overground railways had made London's northern suburbs accessible, and many reproduction businesses relocated to this area. Farringdon Station, the nearest underground station to Fleet Street, was only forty-five minutes from High Barnet. This is where John Swain's company moved. Their works included a photographic studio, printing room, etching room, and an engraving room where a staff of wood engravers retouched plates. While the environment was free of the vibrations that hampered work in Central London, even in the suburbs the air was hazy, and arc lights, powered by a steam engine, had to be used for some parts of the day.[50]

If firms were to get a return on their investments in premises, generators, consumables, and process equipment they needed a high turnover of work and large numbers of workers to accomplish this. In an assembly-line system, workers could be relatively easily trained to fulfill segmented tasks. In the

United States, by the mid-1890s, the process industry was described as being any other system of mass production. An experienced worker stated:

Process work is now really on a manufacturing basis with labour subdivided to the uttermost. In all good houses a line block goes through something like near a dozen hands, and one would as soon expect a carpenter to make one chair as cheaply as a furniture manufacturing concern as to see one man doing all the work compete with a big concern in process work. Artistic quality is not considered for one moment; the sole question is what is the smallest margin above cost of production that will pay, and at the same time fetch business in competition with others.[51]

In this highly volatile situation, employers came to regard their workers as a drain on their profits.

Relations between employer and worker in the new, larger process firms operated on a different basis from wood engraving. In the wood-engraving office, masters had, in many cases, worked alongside their apprentices and journeymen and had daily contact with them as members of a shared craft. As we have seen, this system broke down in the larger engraving factories of the Dalziels and Joseph Swain, where the master engravers became supervisors of facsimile assembly lines. Nevertheless, these firms were still run by the masters. However, in the process industry entirely new economic and spatial relations prevailed from the start. Although many of the heads of process firms such as Carl Hentschel had backgrounds in the industry, many did not. Even those who were experienced process engravers would not have worked side by side with their staff, but adopted managerial and supervisory roles instead. Firms took the paternalistic factory owner as their role model, and image reproduction now ostensibly operated under a new system of order, discipline, and bureaucratic control. One American writer spoke of the production of an image in which "all fall into line with the precision of a parade."[52]

The effort to impose the disciplines of the factory on process workers was not entirely successful. As Richard Whipp has pointed out, the movement toward mass production was generally uneven in Britain in the nineteenth century. Management's struggles to enforce regular working habits on employees often failed, and efforts within the process firms attest to this battle.[53] Nevertheless, as in other manufacturing concerns, new practices of modern business organization were used to subdue, supervise, and control workers. Unlike the distinctly communal organization of the wood-engraving trade, process workers were now subjected to increased surveillance and discipline.

C. S. Bierce, director of an American firm, gave a very clear account of this new kind of organization in 1897. Bierce had been influenced in his attitudes toward workers and their regulation by his father, a manufacturer who

believed labor was best kept in line by the threat of immediate dismissal. Bierce described process workers as "Bohemian," "fake," "cranky," "incompetent," and "erratic" with "vicious personal habits." He advised that this difficult workforce should be treated as an interchangeable "commodity," and firms should always have workers ready to step into the shoes of any man who left or who was dismissed. The workman in this system was forced to have a more deferential attitude toward their employer; Bierce advised "Teach your men to respect you, but also teach them to obey you." This shaping and subordination of the workman encompassed all aspects of their behavior and demeanor, as Bierce insisted, for example, that no vulgarity, profanity, or even loud talking should be allowed in the workshop. This system would shape a future generation of "obliging, gentlemanly workmen," recruited from good families and working under strict rules.[54]

Not only were the language and the conduct of the worker to be constrained, but their visibility as well. Bierce stressed that it was no longer appropriate for a visitor to the firm to be greeted by an employee in shirt sleeves. In the wood-engraving office of mid-century, clients, illustrators, journeymen, masters, and apprentices all mingled, but this communal interaction between customers, artists, and staff members was no longer considered appropriate in process firms. The worker was concealed within the reproduction businesses, which now devoted considerable thought to their public face. The larger firms had elaborate reception areas that figured prominently in trade-press reports. Profiles of these businesses always started with a description and sometimes an image of the entrance, itself a clear signifier of an efficient modern business.[55]

Bierce was a regular contributor to the *Process Photogram*, which reprinted his article without editorial comment, suggesting that his attitude must have been at least comprehensible to British employers, even if it was a managerial ideal that few firms could hope to achieve. William Gamble encouraged a strict adherence to modern business practices in his capacity as editor of *Process Work*; typical of his approach is a series of editorials "Straight Talks to Practical Men," which included no-nonsense advice on "Economy," "Profits," "Keeping a System," "Giving Credit," and "Failure." In an article entitled "Keeping Time" he stated:

> Jobs which hang around always consume more of the workmen's time. Men dawdle over jobs which they get to know are not urgent. They do a little bit of the work and then put it aside for another job, so that whilst there is apparently a lot of work done, there is nothing to time, and it is almost impossible to know what such jobs cost.[56]

His frustrations hint at the difficulties that process firms encountered in moving their workers toward a Taylorist system in which all their actions could be broken down into segments and monitored by their overseers.

The new bureaucratic organization of the process industry also caused problems from the illustrator's point of view. In wood engraving, the image maker was able to deal directly with the journeyman or master and was often deeply involved in the image reproduction procedure. With the coming of process, the illustrator was unable to speak to those who were actually doing the work. Instructions on how the job should be handled were fixed on the backs of originals by clerks before the illustrations were dispatched for photographing, engraving, and retouching. Indeed, each job went through so many different stages that it was difficult to say who actually was responsible for the image. As Gleeson White put it: "The process worker is usually an intangible thing ending in 'Co.' "[57] Because of the larger numbers of semiskilled workers involved in process, the organization of the staff by experienced foremen and management was seen as vital. Yet this was not always done. Phillip Hamerton noted that the illustrator was now "at the mercy of anonymous operators," and gave an example of a firm where the foreman had left, leaving the workers without direction while the partners "in their office, were occupied with their accounts and correspondence."[58]

One of these partners' new managerial concerns was the marketing of the process firm. Rather than waiting for business to come to them, firms generated trade via networks of representatives and agents, at home and overseas. The Strand Engraving Company, founded as an offshoot of the *Strand Magazine* in 1894, dealt with customers in South Africa, France, Hungary, Holland, and Belgium through its agents, and Carl Hentschel, who was always at the forefront of the industry, employed a specialist sales staff. One of his tactics was to produce elaborately printed promotional material as a showcase that advertised his services.

Networks of personal contacts were also crucial in the development of the process business. Joseph Swan's eldest son Donald Cameron-Swan became the manager of the Swan Engraving Company in 1894 when it was renamed the Swan Electric Engraving Company, and relocated to Charing Cross Road in the West End. The firm boasted that "owing to the perfection of the electrical arrangements, work is carried on regardless of weather, the photography being done with electric light only." Cameron-Swan moved in artistic and literary circles and, possibly through these connections, undertook the reproduction of the halftones in many of the key works of Decorative illustration from Charles Shannon and Gleeson White's annual *The Pageant* to Aubrey Beardsley's *Yellow Book*.[59]

The line images in *The Yellow Book* were produced by the largest and most innovative process firm in London, Carl Hentschel and Company.[60] Hentschel had one of the longest pedigrees in the process industry. Born in Lodz, Poland, in March 1864, he arrived in England with his parents at the age of five. His father, August Hentschel, was a colorful character who claimed to have been the governor of a Russian province, a gold prospector in Australia and the US, and the inventor of the Gladstone bag and the paper

collar. Hentschel Senior also professed to have worked with Daguerre, and to have introduced photoetching into England.[61] He trained his son in a variety of techniques, which he had devised. Carl left school in 1878 at the age of fourteen to work with his father. In 1880 he joined another engraving firm, and in May 1887 set up his own business in Fleet Street with six employees and capital of £500.[62] The business initially specialized in line work and a major early client was Cassell's, the magazine and book publisher.

With the boom in magazine illustration in the mid-1890s, periodical reproduction became the firm's main activity. By 1894, Hentschel's firm was based in three "factories" in Fleet Street, and were turning out 60,000 blocks per year. A single engraver might produce up to twenty 14-by-11-inch plates a day. The firm's output is astounding when compared to that of the Dalziel Brothers, the largest wood engraving firm, who in 1875, their busiest year ever, turned out 1495 engravings.[63] In 1894 Hentschel had seventy staff, twice the size of the large wood-engraving firms and, by 1896, had grown to one hundred and thirty. The following year the firm became a limited company, which continued to grow and expand its services. In 1900 there were 250 staff, by 1904 the figure stood at 382, and by 1906 reached 400. This increase suggests the expansion of the reproduction industry in general, but it was also indicative of the firm's aggressive attitude to business – in 1899, Hentschel bought out Meisenbach with its 80 employees.[64] Hentschel was an intensely ambitious character, both in his plans for business expansion and in his ideas for the regulation of the process industry, and according to his friend Jerome K. Jerome, he also was intent on public office: "He worked the business up into a big concern; and we thought he was going to end as Lord Mayor."[65]

Carl Hentschel was an energetic, modern metropolitan at the center of a network of connections between the periodical, image making, and the modern city of leisure. With Jerome, he was one of the first to discover the Thames as a site for recreation. Jerome's fictionalized account of their adventures, *Three Men in a Boat*, started the boating craze of the late 1880s. Hentschel was also an obsessive theatergoer who co-founded the Playgoer's Club, which met at a coffee shop in unsalubrious Hollywell Street. Hentschel rarely missed a West End first night.[66] Unlike most middle-class businessmen, who aspired to a country house on an aristocratic model, Hentschel preferred to live in central London. His artistically decorated home in Chancery Lane was near his workshops, and he was connected to them by telephone. One factor in Hentschel's choice of residence may have been his regular theater attendance, with the West End playhouses only a short walk or cab ride away.[67]

Press reports portrayed Hentschel as an accomplished manager directing an organization that operated at a frantic pace. The short deadlines that the firm worked to required, as one report indicated, "special arrangements in the organization of the staff, which must entail great responsibility and

tireless activity on the part of the management."[68] Hentschel was praised for his, skill, pluck, and "faculty for management." He was the "life and soul of the whole business."[69] Profiles of the business in the trade press, constantly stressed the modernity of the undertaking, citing its use of electricity, extensive clerical organization, and sales staff. The latest communication technologies were adopted, telephone lines supplied to customers, and, by the early years of the twentieth century, the various parts of Hentschel and Company were linked by a motor-car service. Many of his firm's procedures – the routing of plates and the etching process – were partly mechanized or used electrically powered tools. By 1900, Hentschel had established a "Designing Department" in the old Meisenbach office at 188 Fleet Street, where artists produced original images or embellish photographs for advertisers.[70] Hentschel saw his business as essentially modern and in tune with the times, contrasting it with the printing industry where, he suggested, conservative attitudes had hindered progress. At the root of their problem, in Hentschel's analysis, were the strong unions and the craft identity, still in place in printing.[71] His own organizational practices were based on new bureaucratic structures rather than the craft precedent set by printing or wood engraving.

Hentschel's firm promoted paternalistic relations with its staff. An athletic club was formed in 1896, ostensibly to give the employees something to do on their Saturday afternoon half holiday and was also designed to promote good relations between employees and management by providing opportunities for interaction outside of working hours. The club offered a variety of popular sports such as cycling, rowing, swimming, track, and cricket. There was also a regular "Waygoose," an outing that included sports, food, songs, and toasts. Aside from their weekly Saturday half day off, Hentschel's employees were entitled to summer holidays and could participate in a share ownership scheme.[72] For engravers in regular employment in well-conducted firms such as Hentschel's, working hours were usually from nine in the morning to seven in the evening, with an hour for lunch and a half-hour tea break at five. The larger firms that offered an overnight service would presumably have also had a night shift. Wages by the end of the century varied from £1 to £3 per week, with the average artisan in London making £2.[73]

Publishers were not entirely reliant on firms such as Hentschel and Co. for their image reproduction. In the past large periodicals, including *ILN* and the *Graphic*, often operated in-house wood engraving workshops, and now publishers set up their own process facilities. *Black and White* was one of the first magazines to have its own line and halftone studio, which operated under the name of H. and A. Dicks and was based in Farringdon Avenue.[74] The Newnes organization created an in-house facility as early as 1896, and three years later, Penrose installed a new studio for them which included five cameras and arc lamps. This was a large and expensive undertaking, occupying three floors of Newnes' premises in Covent Garden. The

publisher stated that they would save thousands of pounds by making their own blocks, and would recoup the cost of the equipment within a year. Evening papers such as the *Star* and the *Evening News* needed fast turnarounds of images and so set up their own zinco departments for line images as did many provincial newspapers.[75] Specialist magazines, particularly those dealing with modern subjects, embraced the new technology, as evidenced by *Cycling* magazine, which had an in-house studio and its own photographers. The halftone photograph was clearly an important element within the aura of modernity that *Cycling* was intent on creating.[76]

As with many other industries, the move to more complex technologies resulted in a more dangerous work environment. The wood-engraving office was a relatively safe place. Although it was commonly thought that the fine nature of the work damaged engravers' eyesight, this was disputed by those who worked in the trade as many engravers lived and practiced until an advanced age. The process worker, on the other hand, was surrounded by a mix of chemical vapors. An American trade magazine acknowledged that many process engravers were not physically fit and claimed that four-fifths of them died of pulmonary consumption. Although other aspects of this article were later criticized by correspondents, none of the writers questioned or discussed this claim. *Process Work* suggested that the excessive drinking of some of those in the trade was associated with inhaling chemicals, with etchers claiming that they needed to drink to drown the taste of acid fumes and operators to neutralize cyanide vapors. The journal treated these assertions with a skepticism befitting its managerial bias. However, as competition forced firms to lower prices, cheaper, less effective, and more unstable chemicals were used, and in the demand for speed, deadly substances were handled with few precautions.[77]

There was considerable economic anxiety in the process industry in the second half of the decade as profits were driven down. The image-reproduction industries were volatile, and workers could not feel secure about their jobs or their futures. A fictional series of pieces on process engravers and their attitudes in the *Process Photogram* suggests the uncertainties to which workers were prey. Many of the men described in these articles had been wood engravers, others from lower-middle-class and working-class backgrounds, some were ex-clerks, and others had been in the army or in domestic service. One of these columns from 1901 suggested that with the falling wages in the industry ex-wood engravers were returning to their old trade. Process engravers were making £1.10s a week, down from £1.15s the previous year. Wood engravers, on the other hand, according to the writer, could earn the substantial sum of £4 a week due to a sudden shortage of skilled men. Another article in the series declared that unemployed process engravers were now engaged as sandwich-board men, wretched figures who were at the very bottom of the working classes. This was a humorous column, and there may be some exaggeration in this claim, but it indicates the anxious atmosphere within the process trade.[78]

Max Levy advised that because process work was so risky and profit margins were so low, the business should only be undertaken as an adjunct to other printing operations.[79] In the main, however, this was not the practice. Firms specialized in process, sometimes offering hand engraving or electrotyping as well, but process companies did not take on the publishing role that the large wood engravers such as the Dalziels had done. Power relations had changed by the nineties; not only were there many sources for reproduction but publishers were more dominant, so that the large publishing conglomerates could dictate terms to the image-reproduction industries. Ingram Brothers had a stable of magazines in addition to *ILN* and the *Sketch* and were buying more halftones than any other group in Britain. It seemed, in fact, that the publishers were the ones who had profited most from the process revolution. A letter to the *Process Photogram* in 1896 asked why the "masters of the great illustrated journals," with their enormous increases in advertising revenues and reductions in production costs due to mechanization, could not afford to pay more generously for their illustrations.[80]

J. Whitfield Harland recalled that from the line-process industry's early days competition had been intense. In 1892 he criticized the quality of line reproduction and linked this to the economic conditions in the trade:

> Nor – if we can be guided by the numerous bankruptcies and failures in the process business during the past ten or dozen years – does it seem to pay commercially. The same causes are at work to ruin it as have caused the ruin of wood engraving. Consumers will not pay proper prices, illicit competition steps in, and the work, already beginning to be miserably paid for, is scamped and spoiled – and is almost unprintable for scum and want of depth and clearness.[81]

Many firms came and went in this agitated situation. Of the fifty-three firms practicing in 1895, twenty-two had disappeared by 1900. Many of these failures were undercapitalized businesses that had started up in the hope of easy profits and "had their fingers burnt." However, in many cases these businesses were squeezed out by larger companies. Prices in the industry fell considerably during the 1890s partly because of the increasing numbers competing for work but also because large firms cut prices to force smaller competitors to the wall. In this highly aggressive environment, some companies produced plates for free in order to get their names in the press.[82] At the same time, engravers had to keep up with new developments in equipment, investing in up-to-date machinery and methods in order to remain viable. In the United States, market conditions were just as severe. As Harland noted, this price cutting meant that it was very difficult to get reliable process firms that would supply predictable and printable engravings.[83]

Prices fell as the speed of image production increased. In 1888, a basic line block cost around sixpence per square inch, dropped to fourpence by 1892, and in 1894, had dropped again to twopence. By the end of the century, an average line block took two hours to produce, a substantial improvement on the two days that it took for the "City Phototype Establishment" in 1882. Halftones were more expensive and more time consuming. In 1891, it took Meisenbach a week to make a large halftone block, although a small portrait block could be turned around in a day for a rush charge of twice the normal rate – not much of an improvement on the pace of wood engraving. The cost of a halftone at this point was one shilling, sixpence per square inch for fine quality work, with a minimum charge of five shillings.[84] Whereas prices had fallen somewhat by 1894 when the average cost of a halftone was a shilling a square inch, around a quarter of the price of a wood engraving, in 1895, however, there was a dramatic price reduction, with some firms producing halftone work at only sixpence per inch.[85] This sudden fall may well have been due to the widescale adoption of the Levy screens. In any case, it now seemed clear that process had economic advantages over wood engraving.[86]

By the end of the decade Clement Shorter noted that the boxwood that the engraver worked on cost more than a finished process block, which was only one-sixth the price of its handmade competitor. A double-page halftone block could be produced in eight hours, whereas the wood engraving would take twenty-four hours. Although this time difference was not enormous, it would have been important in periodical journalism with its short deadlines.[87] However, the economic advantages of process were not as clear-cut as its promoters suggested, because although the making of the process plate might by quicker and cheaper up to a point, a wood engraving was ready to print, whereas a process image, particularly a halftone, required considerable retouching. In the case of the images in illustrated magazines, in which very elaborate engraving was required, a block that cost ten shillings to process could cost fifty shillings to re-engrave by hand.[88]

The commercial pressures on the process industry led to the formation of the Electrotypers, Stereotypers, Process, and General Engravers Association, which attempted to control competition and fix rates. As prices plummeted at the end of 1894, the association was founded by the larger companies – Meisenbach, Hentschel, and the former champions of wood engraving, the Dalziels, who had now moved into mechanical reproduction. At their first general meeting seventy firms attended to discuss methods of trade protection.[89] Hentschel urged that businesses should not descend into a competitive price war and his plea was greeted by cheers; but exactly how this aggressive and damaging rivalry could be avoided was not clear. Firms were divided on what the agreed minimum charges should be, and when these were eventually established at three shillings for a line block and eight shillings for a halftone, they were often ignored.

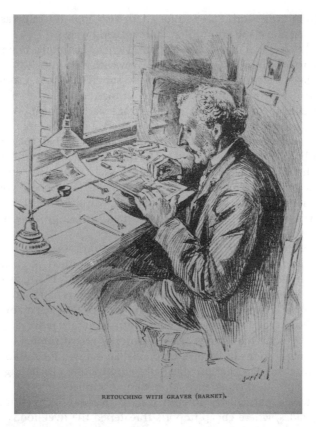

RETOUCHING WITH GRAVER (BARNET).

Figure 14 "Retouching with Graver," F. G. Kitton, "The Art of Photo-Etching and Engraving," *British Printer*, 7.40, July 1894, 218–31, 228. (Photorelief halftone print from pencil original.)

It was difficult for firms to regulate and stabilize the trade by limiting entry through, for instance, apprenticeship. In wood engraving, up until the 1880s, apprenticeship had been an efficient means of controlling the numbers of those who could practice the craft, thereby reining in competition. However, there were no similar restrictions on entry into the process industry. By the 1890s, technical information on photorelief methods was readily available in magazines and books, so, those who had the capital and experience or who could employ a knowledgeable foreman, the setting up a process house was relatively straight forward. Once the equipment was in place there was a ready supply of cheap hired hands, including many unemployed wood engravers. In the United States the Photo Engravers' Union was formed in 1894 in response to the large numbers of undertrained boys and men being

employed in firms, and it pressed for a four-year apprenticeship as a means of restricting entry and controlling standards and wages.[90]

The reality was that, in a volatile situation where techniques might change, bosses were unwilling to provide employees with a thorough training. The various stages in process production were subdivided into many discrete tasks, and it was impossible for workers to master the range of skills that would enable them to produce a plate from start to finish. Workers had no time to explain techniques to newcomers and were, in many cases, unwilling to instruct them. They feared, correctly, that they might be undercut by this cheaper labor force. The industries that relied on a combination of hand and mechanical production, such as printing and process, used boys and young men as a cheap, expendable labor pool, who, if they demanded higher wages after a year or two, were dismissed, with new recruits taking their places – a practice that only intensified in printing during the 1890s.

Efforts were made by some sectors of the process trade to establish formal training structures and took place in the context of an increasing demand for technical education by industry. From the 1830s, as free trade opened up international markets, British manufacturers had been concerned about overseas competition. The Paris Exhibition of 1867 fed manufacturers' growing fears that foreign goods were both more attractive and cheaper than those produced at home. Their superiority was attributed to the technical training systems in Europe, especially Germany's, for instance, which had technical schools that provided all-round training, including drawing, theory, and practical experience on modern machinery.

There was a particularly intense fear of overseas competition in the printing trades, where cheap imports threatened the livelihoods of British printers and process workers. American and German process workers had been at the forefront of the commercial exploitation of photomechanical reproduction, and now the trade press acknowledged that British reproduction and printing firms were not able to match foreign rivals in either quality or price. Posters were imported from the United States, Christmas cards and books from Germany, and much reproduction work in general was carried out abroad. German and Austrian process firms advertised in the press offering zinco blocks at the "lowest terms." Ironically, the patriotic color supplement issued by the *Times* celebrating Queen Victoria's Jubilee in 1897 was printed in Germany.[91]

As a means of bolstering British industry, for over fifty years the government had financed a series of ineffectual educational initiatives in technical instruction. In 1837 the Board of Trade set up the Normal School of Design at Somerset House to teach crafts, architecture, and design. Twenty-one provincial schools of design were established between 1837 and 1851, but their curricula neglected trade in favor of a rigid, Academic, fine art approach. Henry Cole reorganized the schools in the 1850s, and his new system offered

courses in chromolithography and wood engraving. However, these national schools remained very ineffective in teaching practical skills to artisans. The 1884 report of the Royal Commission on Technical Instruction concluded that design for manufacture "has not received sufficient attention in our schools and classes. In fact, there has been a great departure from the intention with which the Schools of Design were originally founded, viz. the practical application of a knowledge of ornamental Art to the improvement of manufactures." It was not until the 1890s with changes in the financing of technical education and the infusion of new thinking from Arts and Crafts activists, such as Walter Crane and W. R. Lethaby, that the situation began to change.[92]

Apprenticeship was not considered to be an appropriate means of training for the new reproduction industry as the *Photogram* noted in 1894, when it argued that the rapid development of trade required new systems of instruction:

> Owing to the increasing keenness of competition, revolutions have taken place during the past decade in almost every branch of industry and commerce, and the necessity for further developments in the system of training for the various branches of technical trades is constantly before our minds. The old system of apprenticeship is dying fast, and in its place, we see on the Continent, and already to a small extent in England, the birth and growth of Technical Institutes, Schools and Universities devoted to the practical training of youth for specific trades.[93]

The provision of practical training that the *Photogram* referred to had been accelerated in 1888 by the institution of a nationwide system of local government, the county councils. The Technical Instruction Act of 1889 was amended in 1891 to allow these bodies to fund technical education from local taxes. Education in London was now managed by the London County Council; since its creation in 1889, the council had been controlled by the Progressive Party, which implemented an ambitious plan for the modernization of the metropolis, including environmental improvements, transportation initiatives, expanded provision of housing, and education reform. After another election victory in 1892, radicals and Fabians, including Sidney Webb, became council members. Webb then became chairman of the powerful Technical Education Board, and in March 1894, the board issued a report which confirmed that reproduction work was going abroad, claiming that this was due to the lack of trained men in Britain. It also condemned the continued employment of large numbers of foreigners in British reproduction firms. Webb saw process reproduction as an industry of the future that should be nurtured for sound economic reasons. To that end the Council joined with a print trade union, the National Society for Lithographic Artists, Designers, Writers, Draughtsmen, and Engravers, and

founded a photoprocess school. The Bolt Court Technical School was opened on November 4, 1895, just off Fleet Street with the *Process Photogram's* Charles Gamble in charge of the engraving department.[94]

Those who attended the classes at Bolt Court were not young apprentices, but were older workers, like the engraver Paul Martin, who were retraining or adding to their skills. Indeed, those enrolled had to be already employed in printing as there was a suspicion that technical schools might flood the industry with new workers. Bolt Court stressed that it only trained employed people and did not wish to add to the numbers in the trade. In addition to training in reproduction processes, courses were offered in drawing, design, lettering, lithography, elementary photography, and photographic copying. Soon after its opening the school inaugurated an impressive series of Saturday evening lectures, scheduled so that they did not interfere with working hours. Within a few months the major figures in modern printing and image making had all given talks: T. R. Way spoke on lithography, Joseph Gleeson White on posters, Cobden Sanderson on bookbinding, Emery Walker on typography, William Morris on early illustration, and Joseph Pennell on contemporary illustration. The *Art Journal* reported that the attendance by "working craftsmen" at the lectures had been "most satisfactory."[95] Clearly the aim of the school was to provide a practical training to workers, unlike the long established state system. In 1898 the school was renamed the London County Council School of Photoengraving and Lithography, and by the turn of the century, it had around 400 students.[96]

There were obstacles, however, to the acceptance of this form of training. Workers were, in many cases, unwilling to attend technical classes. Many of the schools were poorly equipped, and although British schools tried to compete with their European rivals, they had neither the necessary resources nor facilities. Without up-to-date equipment there was little of practical use to learn, and theoretical studies were often seen by workers as pointless. Classes were in the evenings after work, and often attendance was poor. Management supported the system in the abstract, but did little to make it easier for workers to pursue their studies.[97] There were also complaints that these schools were training workers in too broad a range of skills. In 1896, *Process Work* criticized the new system for being out of step with the specialized requirements of the reproduction industries stating, "From Technical Schools 'beardless youths' are turned out as 'all-round-men' with the same regularity and the same monotony of pattern as the block of chocolate from the penny-in-the-slot machines." The article suggested that the trade needed specialists and that a return to some modified form of apprenticeship might, paradoxically, be the best way forward.[98]

In a very short period of time the workers in image reproduction had undergone a radical change in their status, and their conditions of work. In the 1880s, images for the press were still being created by hand in a system

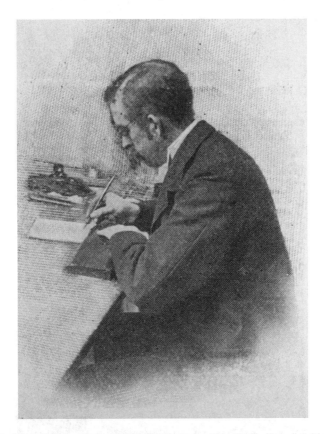

Figure 15 "Fine Etching Plate," "Pictorial Reproduction Up-To-Date," *British Printer*, 13.77, September 1900, 223–31, 230. (Photorelief halftone print from retouched photograph with extensive hand engraving on the block)

that had been in place for almost half a century. Workers owned the tools of their craft and worked in small groups, or as individuals, in workplaces that required little in the way of equipment other than chairs, tables, and oil lamps. Within a decade the reproduction trade had been transformed into an industry that required considerable capital investment, extensive premises, and new work relations. Process engravers were now operated within industrial conditions where their actions were supervised by tiers of foremen, administrators, and managers. This disciplinary structure allowed for the production of many more images than in the past. The next chapter examines the magazines that used these photomechanical images and supported the expansion of the process industry. Of course, process workers, clerks, foremen, and managers were also the audience for the modern magazines of the 1890s.

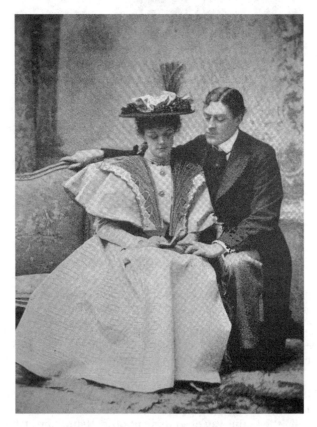

Figure 16 "Hon. Gwendolyn Fairfax (Miss Irene Vanbrugh) and Worthing," Worthing: "Will You Marry Me?," *Sketch*, 9.112, March 20, 1895, 412. (Photorelief halftone print from retouched photograph, detail.)

5
The Pictorial Magazine and the City of Leisure

Woe betide the man who does not know his way about.
– "Small Talk," *The Sketch*, February 6, 1895[1]

The first illustrated magazines to adopt and develop new methods of imaging and reproduction were not devoted to news but to the depiction of the ephemeral spectacles of the London metropolis. This chapter looks in detail at the *Sketch*, the first English weekly magazine to be illustrated entirely by process, and one which imaged the diverse activities of modern life. Just as the *Illustrated London News* helped the middle classes gain a sense of what it meant to be middle class in the 1840s, so its sister magazine the *Sketch* enabled them to imagine a collective identity around leisure and consumption in the 1890s. In its columns of comment, its photographs and illustrations, the *Sketch* delineated a variety of ways in which city dwellers could find meaning in mass-produced goods and entertainments. Many of these were new leisure activities such as shopping, spectator sports, cycling, and tourism; others were older pleasures that had been recently updated and commodified such as theatergoing, fashion, art, and literature. Indeed, the *Sketch* demonstrated the new importance of leisure in modernism. As work become a place of increasing conformity and regulation for the middle and lower middle classes, time spent away from work, at home, shopping, or at the theater, became the location of the true self, and of the expression of this self.[2] The *Sketch* and its imitators, rivals, and stablemates, through their ability to combine text and photorelief images, were able to rapidly circulate information on how one might live. This chapter explores the intimate connections between the periodical, theater, fashion, and consumption as they became entwined in novel and potent ways.

By the 1890s London was the center of a boom in mass-produced entertainment serving an audience that had free time and some surplus money to spend. Many city dwellers were no longer simply subsisting but were enjoying themselves. Charles Booth stated that in the 1890s there was a fresh demand from all classes that they should be entertained. He observed,

"To 'What shall we eat, what drink and wherewithal shall we be clothed?' must now be added the question, 'How shall we be amused?' "[3] Pleasure was legitimized within the middle classes, and there was a new sense that rather than simply improving and bettering themselves, people were entitled to personal enjoyment. Peter Bailey has traced the gradual change in middle-class attitudes over the second half of the nineteenth century as they adjusted uneasily to the "problem of leisure" that modern systems of production had created. He argues that by the end of the century, although there was less of a sense that leisure or recreation must be self-improving, anxieties persisted. "Central to the discomfiture of the Victorian bourgeoisie had been the realization that modern leisure threatened the ties that bound men and women to society." The illustrated magazines of the 1890s validated consumption and self-gratification and helped their readers to become expert pleasure seekers. I also argue that these periodicals addressed the anxieties that Bailey identifies by helping this audience to see themselves as taking part in the collective consumption of leisure.[4]

In 1895 the *Sketch* quoted a bookseller in London's Westbourne Grove: "Nine tenths of my trade . . . is in fiction. I think people read more for fashion's sake than for self improvement nowadays. You must read *Trilby* to keep respect."[5] This comment highlights the social role of reading. Whereas reading for self-improvement suggests an introspective reflection on one's own character, the reading of George du Maurier's hugely popular *Trilby* clearly took place in an imagined community in which one engaged with other readers. Conversations about the book, brief allusions to its characters, and reading about the book in magazines were some of the many interconnected elements in of the social consumption of *Trilby*. Magazines such as the *Sketch* helped readers to quickly know which books and entertainments their fellows were consuming, and whether or not they too should acquire these experiences.

Trilby became so popular that a stage play based on the book opened in London in 1895 and continued to attract audiences for years. Its appeal was to the diverse groups of city dwellers who attended popular theater. *Trilby* was produced by the actor-manager Beerbohm Tree, but audiences were also entertained by the many innovative shows that were promoted by large theater conglomerates. Moss, Stoll, McNaughton, and Thornton controlled chains of venues that depended on the creation and maintenance of a large mixed audience.[6] By the mid-1890s the music-hall, which had been a working-class amusement, had been tamed and transformed into a middlebrow entertainment format with wide appeal.[7] In a city where social classes increasingly lived in separate areas, mass entertainment was one arena in which they could come together. Although segregated in some parts of the theaters, there were common spaces where the classes would circulate and mix. Audiences were wide ranging in age and social strata – clerks and shop workers of both sexes, middle-class families, and upper-class couples could all mingle. This shared culture was intended for as

large an audience as possible, the *Sketch* characterized it in a particularly inclusive way. For instance, a matinee performance of Ibsen's "Little Eyolf" was reviewed in the *Sketch* by both a drama critic and a lower class theatergoer, "one of the Gods." Although this had been her first experience of Ibsen, and she had not fully understood the play, she was fascinated by it and had pondered over it ever since. Whether or not this report was genuine, the *Sketch* intended that Ibsen would be appreciated by a mixed audience, and, moreover that this miscellaneous audience should be aware of itself.[8]

The "star system" was central to the appeal of many of these entertainments. Indeed, one of the attractions of "Little Eyolf" for the *Sketch's* proletarian critic was that its three well-known actresses were involved with the production. Variety performers, such as Marie Lloyd and Little Titch, projected distinctive personalities through their dress, mannerisms, and catchphrases as they made the rounds of the chains. At the same time in the legitimate theater, success depended not so much on the quality of the play as on the popularity of its leading actors. Just as commodified mass journalism emphasized personality, so did mass theater by highlighting the distinguishing individual characteristics of their stars. Some venues were fronted by actor-managers such as Beerbohm Tree, Henry Irving, and Charles Wyndham, the visible, bankable players who took a prominent role in every drama. In order to recoup the costs of the elaborately staged productions that had become common the star had to perform in the same play over a period of many months. This "long production run" system was a new theatrical format that could only be sustained by a large, mobile audience. George Bernard Shaw estimated that in order to make a profit, a typical West End play had to attract 50,000 to 75,000 customers within five months of its first night.[9] The city's public transport networks enabled these audiences to reach the West End theaters from across the sprawling metropolis. This theatergoing population was also swelled by many tourists and out-of-town visitors. There was intense competition between theaters to draw in these audiences, and large sums were spent on advertising through posters and the press.[10]

Shaw pointed out that the theater had to lure its audience away from their domestic pleasures, which included the illustrated press, the consumption of which was indeed an important leisure activity in the home. But these media forms were not necessarily in competition as the theater relied on the press for publicity, and the press depended on the theater for content and advertising. The success of the star system was built on the public visibility of actors and actresses in the press, and so they were not only fixtures on the stage, but appeared in the editorial pages and advertising sections of magazines. The theater, as well as being one of the major leaders in visual advertising, also lent its stars to the selling of mass-produced goods; the promotion of products by professional beauties and actresses became

an important tool for advertisers from the 1880s onwards.[11] By the early nineties, Walter Crane was suggesting that a visitor from another planet would assume from looking at advertising posters that actors were society's "greatest public benefactors."[12]

The publishing, theater, fashion, and advertising industries created media networks that generated content and ensured economic survival. Theaters placed advertisements in magazines, which in turn publicized their stars, while these same stars appeared in the advertisements in the magazines. On a deeper level, the relationships between fashion, theater, magazines, books, and posters were central to the creation and maintenance of meaning. The magazine readers were also the audience for many other visual spectacles including spectator sports, posters, and film. These entertainments informed the way in which readers looked at images in the magazine and understood the personalities depicted. Because the information provided in the magazine helped city dwellers make the visual world around them legible, they would not make the same error as Walter Crane's alien.

By 1891, William Ingram, the head of Ingram Brothers publishing group, was looking for a new direction for his flagship weekly, the venerable *ILN*. The magazine had been the most respected middle-class weekly for almost fifty years. However, many of its staff had been with the magazine for decades, and it had become staid. John Latey, the editor, had died in January 1891 at the age of 83, and Ingram wanted to replace him with a much younger man.[13] He was also worried by the success of a new rival *Black and White*, which had been launched in 1890 by Charles Williamson of the *Graphic* with the prominent art critic M. H. Spielmann as its art editor.[14] Although *Black and White* was aimed at a middle-class audience it took a more creative approach than its competitors. In a gibe at the established illustrated weeklies, Williamson promised that "Piteous accidents and the tamer of ceremonials will not be featured in its pages."[15] It was well printed and highly illustrated, with almost twice as many images as *ILN*, many of which were photographs, rather than hand-drawn illustrations. Not only was it innovative in the amount and type of imagery it contained, but it was the first magazine to print a self-contained short story each issue. The *ILN* contained a good deal of fiction, but these were long serials that ran for months. *Black and White's* short fiction marked a new direction in weekly journalism, featuring writing of a very high quality from Robert Louis Stevenson, Thomas Hardy, Rudyard Kipling, and H. G. Wells among others. The short story format was to become the epitome of nineties fiction.

Ingram was looking for a young journalist with a modern approach to both image and text, and had initially offered the job to Charles Morley, editor of the *Pall Mall Budget,* an up-to-date weekly that made a feature of its many halftone photographs. But Morley turned him down. Ingram was then approached by Clement Shorter, a columnist who had been working for him on a freelance basis.[16] Shorter was in his early thirties, well connected,

energetic, and ambitious. As well as having a full time government job in the Audit Office, he was also the literary critic of the *Star*, an evening paper that was one of the leaders in new journalism. Shorter took the offered job at the very low salary of twelve guineas a week, the same as his combined earnings from his clerk's salary and his freelance writing.[17] With no previous full-time journalistic experience, he became the editor of the most prestigious illustrated weekly of the nineteenth century. The appointment was, as he said himself, a little eccentric. He resigned from the Audit Office, left the *Star*, and got to work.

Shorter's charge was to modernize *ILN* along the lines of *Black and White*, to improve its illustrations and introduce better writing. On his appointment he found much of the editorial content to be "scissors and paste" material that had been recycled from other papers,[18] its tone and content to be, on the whole, dry, formal, and old fashioned, with its lists of wills, obituaries, and a great deal of topographical material. Shorter brought in new writers: L. F. Austin contributed a theater column; Andrew Lang became a regular as did Grant Allen; and soon leading literary figures such as Edmund Gosse, Walter Besant, J. M. Barrie, and Jerome K. Jerome were also writing for the magazine. Shorter's columnists brought an emphasis on literature and theater and introduced a lighter, more gossipy content, which led to accusations that *ILN*'s coverage of the news had declined.[19] And he also instituted another distinctive new journalistic trope, the photographically illustrated interview.[20]

Although he put a good deal of effort into transforming the literary side of the paper, Shorter believed that illustration was its chief attraction.[21] Shorter said, "I was the first man in the chair of a picture paper to become a fanatical champion of the photograph and the process block," and he changed the appearance of *ILN* using these technologies.[22] His background was in literature, not in the world of art and engraving, so he had, therefore, no attachment to traditional ideas of appropriateness or artistic status as far as reproduction processes were concerned. At the end of the decade Shorter argued that for a magazine to use anything other than photomechanical process would be economic suicide.[23] Yet he valued the handmade illustration, if it was reproduced by photorelief, and was convinced that photography alone could not provide a satisfactory depiction of contemporary society.

Back in the 1840s, the *Illustrated London News* had been the first weekly to portray contemporary events, and its reproductive demands had molded the technologies of wood engraving. When he took over as editor, Shorter found *ILN*'s illustrations to be "reproductions by wood engravings in its decadent period," by which he meant that they were highly finished tonal images, often with photographic origins. The magazine had already experimented with photomechanical processes during the previous decade; it had used line process since the early 1880s and had first used halftones in the

late eighties.[24] Halftones were used for small photographic portraits, but they were rarely used for large-scale images. Although the numbers of these process photographs had been slowly increasing before Shorter's arrival, the magazine was still visually dominated by large wood engravings. Shorter introduced full-page halftones from the beginning of his tenure, and also used many small process illustrations of theatrical performances. In addition, he started to promote process technologies in the editorial sections of the magazine.[25]

Shorter's innovations were successful, and within a year of his appointment *ILN*'s circulation had improved.[26] But not everyone thought that the changes were for the better. Henry Harland believed that many of the photorelief images in *ILN* could have been better reproduced by wood engraving.[27] This might well have been the case, as wood engraving was still far superior to process in the clarity of the printed image. However, for Shorter, wood engraving was an outmoded and expensive technology. Nevertheless, although he greatly increased the number of halftones in the magazine, he was also forced to continue to print hand engravings.[28] The wood engraver Mason Jackson had been the art editor of *ILN* since the 1860s, had also dominated the editorial side of the magazine, and was now a director of the Ingram group. It is probable that Jackson, although no longer the art editor, was able to maintain a place for wood engraving in the magazine, thereby protecting the jobs of the in-house engraving staff. In addition, William Ingram was also a supporter of the continued presence of engraving within his magazines as a means of providing relief from photomechanical images.[29] Shorter was, therefore, unable to oust wood engraving completely; it took eight years before the magazine's engravers were found other employment.[30] The overall result of Shorter's innovations was not a triumph for process, but an expansion in the amount and variety of visual material in the magazine. But, as far as content was concerned, the weekly continued to reproduce the same kinds of conventional imagery that it had previously featured, and when Shorter did try and introduce new subject matter he would come into conflict with Ingram.

In 1892, the painter Walter Sickert submitted a picture to Shorter for publication, a portrait of Albert Chevalier, the music-hall entertainer who had reinvented the cockney stereotype.[31] Sickert had made many paintings of music-hall subjects, and was trying to establish himself as a portrait painter and illustrator.[32] When Shorter showed Sickert's image to Ingram, his employer was appalled, fearing that any association with the morally dubious world of music-hall would damage the magazine's reputation. Such illustrations, he suggested, might encourage young readers to frequent these indecent and plebeian venues. The *ILN* had always wanted to be accepted by as much of the middle classes as possible, and Ingram obviously felt he could not afford to offend any of his readers.[33]

In response, Shorter persuaded Ingram to come out for an evening at the Empire Music Hall in London's West End. There the two journalists

mingled with the audience of middle-class couples and the fashionable young men in evening dress who crowded the theater. Shorter pointed out to Ingram that this respectable and well-to-do group didn't have any periodical covering their interests. Ingram was persuaded to launch a new magazine that would appeal to this readership. It is telling that this potential audience was constructed on the basis of their communal consumption of leisure and by their appearance. However, Shorter, a keen theatergoer, would have been aware that all was not as respectable as it seemed at the Empire as the theater's Promenade was frequented by young artists and bohemians including Sickert, Aubrey Beardsley, and Max Beerbohm. There were also many members of the lower classes in this large and diverse grouping. Perhaps Ingram would not have been too disturbed by this, but the Empire was also a place where male and female prostitutes could solicit customers.[34]

It didn't take Shorter long to get the new magazine together, and production of the *Sketch* started in December 1892. There was some interference from his penny-pinching employer who suggested that the new publication could cheaply recycle the sketches that were the originals for the finished engravings in *ILN*, and Ingram christened the new weekly the *Sketch* with this in mind. But Shorter thought these images were useless journalistically, so they were dropped after a few issues. Shorter's intention was not to show drawing of news items but photographs of celebrities, stage productions, actors and actresses, and sketches of modern manners.[35] However, the magazine's name proved ideal, capturing the lively ephemeral character of Shorter's new venture. The launch issue appeared on the first day of February 1893 as a sixpenny weekly, slightly smaller in format than *ILN*, but larger than *Punch*, and Shorter was paid £5 a week to edit it.[36]

In his first editorial, Shorter stated that his intention was to follow a very different agenda from *ILN*: "While our venerable parent pursues her stately flight down the broad avenues of public life, we shall hunt and illustrate that sudden and slippery worm, the popular whim in all its haunts."[37] Shorter's metaphor evoked the difficulties of tracing society's rapidly changing fashions and tastes, in contrast to the easily visualized civic events taking place on the "broad avenues" of the city. The rhetoric of self-improvement, Imperial destiny, and progress that *ILN* had embodied since 1843 was missing from the *Sketch*. In its stead the magazine offered readers an intense visual encounter with up-to-date urban life. Its subject matter was not to be dictated by what politicians or officialdom thought was important, but rather by what its audience was interested in. Shorter's promise was that he would delineate "the popular whim" and did so through the many large photographs and pen-and-ink drawings that the magazine contained. By using *ILN*'s printing resources and expertise, the *Sketch* was able to illustrate the pleasures of the contemporary metropolis using only photorelief images. To Shorter and the *Sketch*'s readers, the mechanically reproduced pen-and-ink illustration and the halftone photograph signified modernity.

ILN's wood engravings, and the events and people they pictured, in contrast, now seemed staid, stiff, genteel, and old-fashioned. For the cost-conscious Ingram, the attraction of process finally may have been that it appeared to cost a quarter of the price of wood engraving.[38]

Within months the new magazine had established itself alongside its sister magazine and the *Graphic* as one of the most successful weeklies. Critics were aware that this was a new departure in illustrated journalism. A year after its launch Henry Blackburn, in his review of the illustrated press, praised the *Sketch*'s innovative use of photography, although he was rather surprised that there was an audience for these images; "Some of the pages reproduced from photographs are undeniably good, and interesting to the public, as is evidenced by the popularity of this paper alone."[39] The *Sketch* was, for Blackburn, the epitome of the modern illustrated magazine.[40] Shorter went on to launch and edit a number of other very successful magazines in a long career, but about the founding of the *Sketch* as his most important contribution to the press, he said, "Now the *Sketch*, being the forerunner of a revolution in journalism, transforming it entirely, separating the old from the new by a great gulf, was and is, I repeat, my one positive achievement in journalism." Shorter claimed that his magazine ushered in a new and modern form of journalism with its use of process, its light tone, and its content.[41] The *Sketch*'s subtitle was "A Journal of Art and Actuality," which relates, in one sense, to the illustrative content of the paper, the fact that it contained art in its handmade illustrations and reality in its photographs. The word *actuality* also indicated that the paper reported the topical, the everyday, and the up-to-date. In the French press the word *actualité* had a double sense of journalism that was "real" and also "topical," journalism that portrayed contemporary events in an entertaining way.[42]

It is important to further examine Shorter's background and journalistic experience in order to grasp the influences on this new direction in publishing. Shorter stated that "the *Sketch*, in its inception, was a reflection of my then mentality – the escape to unconventionality of one brought up in a Puritan environment."[43] This Puritanism meant that at the age of thirty Shorter had neither smoked a cigar nor drunk alcohol. It was only after he became editor of *ILN* that this changed. A nonconformist religious background was a factor that also shaped many other journalists, from W. T. Stead to Jerome K. Jerome, as it was a culture that respected literacy and learning while questioning authority. Born in 1857, Shorter came from what he called "the poor middle-classes." His family had indeed come down in the world. Despite this he grew up reading the illustrated periodicals of the 1860s and was particularly affected by John Gilbert's illustrations in *Good Words for the Young*, one of the many publications art directed and reproduced by the Dalziel Brothers. This was a new formative experience, and Shorter was part of the first generation to have a regular supply of varied images at hand. The young Shorter was educated in Norfolk from the age of six to fourteen, after which

he moved to London and worked in the book trade. At nineteen he became a government clerk at Somerset House at a salary of £80 a year. He had no sustained formal education past fourteen but read avidly, especially his favorites, Carlyle, Ruskin, and Rousseau. He also took classes in his spare time at the Birkbeck Institute where his left-wing political ideas were further developed.

Shorter's experience was typical of the young, lapsed chapelgoers from outside of London, who were a significant and distinctive presence in the metropolis. Their upbringing had ensured that they were literate but also that they were outsiders.[44] Most were well educated but, like most of their peers could not pursue a university education and thereby enter the professions.[45] They were freethinking and intellectually curious, and they often supported radical and socialist causes. For many of them, journalism, one of the fastest growing semiprofessional jobs, was an attractive option, since unlike other trades and professions it did not require a university degree, specialist knowledge, or an apprenticeship – just the energy and ability to write to order. Between 1881 and 1911, the periodical-reading public increased fourfold; so did the number of journalists, authors, and editors, at a faster rate of growth than any other major professional category. Although most journalists were men, an increasing number of women were also attracted to the profession. Some journalists became media celebrities, but many hovered on the lower reaches of economic and social respectability.[46]

Jerome K. Jerome gave a graphic account of the status of newsmen in the 1880s, and also suggested the many links between theater and the press in this period. After working as a railway clerk he took up acting, barely eking out a living in traveling companies that often had to sleep outdoors. Back in London, after giving up the theater he lived in cheap transient accommodation. One of the other inhabitants of the "doss house" was an old friend who also "had fallen upon evil days, and had taken to journalism. He was now a penny-a-liner – or to be more exact, a three-half-penny-a-liner. He took me round with him to police courts and coroners' inquests. I soon picked it up. Often I earned as much as ten shillings a week, and life came back to me." The work was unpredictable as some weeks Jerome would earn two or three pounds, other times only shillings. As far as his sister was concerned, "The stage had been a long way towards perdition, and journalism a step further." Journalists and entertainers were both on the periphery of the lower middle class.[47]

Alongside his duties as an Audit Office clerk Shorter gradually made a career as a freelance literary critic. In 1888 one of Shorter's radical connections, Henry Massingham, became the assistant editor of a new evening paper the *Star* and asked him to contribute a regular book column. As a result Shorter became involved in a major new direction in the press, thereby shaping his own editorial style. The *Star* – launched by a group that included Alfred Harmsworth, W. T. Stead, and the Irish politician T. P. O'Connor

to promote Irish Home Rule – was one of the first daily papers to adopt new journalism.[48] O'Connor's aim was to produce a popular radical paper which mixed political coverage with culture, sport, gossip, and society news. O'Connor had worked as a journalist in America and made use of this experience in his new venture. In the first issue in 1888 he stated that the *Star*'s style would be brief and to the point; there would be no place for the "verbose and prolix articles to which most of our contemporaries still adhere," and he promised that apart from one longer article, "the other items of the day will be dealt with in notes terse, pointed and plain-spoken."[49] The opinionated personality of the paper was typified by O'Connor's "What We Think" editorials that were platforms for his political views.

The paper also looked different from other newspapers, using lively layouts and maps and cartoons. Its content was also new with entertaining and light human-interest material and extensive use of interviews. Although it was a cheap paper aimed at a lower-class audience, it contained a good deal of what would now be considered "high culture." Besides its politics, women's columns, and sports, it also regularly covered art, theater, music, and books. Aesthetes and decadents, such as Arthur Symons and Richard Le Gallienne, were among its literary contributors, and its critics included Fabians such as George Bernard Shaw and Sidney Webb. Shorter's biweekly columns of gossipy, brief, literary comment, or "causerie" made his name.[50] For a daily paper, the *Star* was also innovative in its advertising policy, since it followed the lead of the illustrated magazines by allowing display ads. The fact that one of its backers was Coleman of Coleman's Mustard, a leader in poster advertising, may have been a factor in this move.[51]

The tone and content of Shorter's *Sketch*, with its mixture of high and popular culture, was very much influenced by the *Star*. The *Sketch* covered the arts, literature, sports, and fashion in short conversational columns written, in some cases, by *Star* contributors. One difference between the two was that the *Sketch*, like most illustrated magazines, did not support a political agenda, with contentious and possibly divisive material excluded so as to attract as wide an audience as possible. The other great difference was Shorter's ability to successfully incorporate imagery into his magazine. In 1895, his assistant J. M. Bullock declared that his chief had instigated "The New Illustrated Journalism" with the *Sketch*, and in an address presented to Shorter on his marriage to the Irish nationalist poet Dora Sigurson, Bullock defined exactly what he meant by this phrase:

> I take it, sir, to be the art of treating pictorially every aspect of the passing pageant of life that can be illustrated at all. The older illustrated weeklies discovered only a small part of this secret. They acted on the belief that the public were interested only, or at least mainly, in the events of national importance – in the ceremonials performed by royalty, in the news of the battle, in the accidents of flood and field

that make the world pause at times. But the little side-shows of the great pageant were contemptuously ignored. The leaded leader obscured the pithy paragraph. Even had they been willing to accept the larger theory of their mission, the older editors were handicapped in practice. The black-and-white draughtsman, on the one hand, was either inadequate or exorbitant. On the other hand, the art of wood engraving, the medium through which he reached the public, was far too costly to be utilised except for outstanding events. . . . You, sir, foresaw a new sixpenny public, a hungry crowd, which all the draughtsmen in the world could not appease, who had their eyes on the side-shows, and were content to let the older generation look at the princes and revel in the solemn events of life.[52]

So, for Bullock, the new illustrated journalism's role was to depict those everyday parts of city life not being visualized and to show the apparently less consequential aspects of the metropolitan scene. The *Sketch's* readership, "a new sixpenny public" was characterized by Bullock as a young, middle-class throng absorbed in what surrounded them. For this "hungry crowd," the state events that had traditionally been depicted in the illustrated press were of less interest than the everyday world of the city. This public, according to Bullock, wanted to read about and see images of art, theater, sports, and books.[53] Significantly, they required this material to be depicted and reproduced in a new way. They could no longer be satisfied by the draftsman or the engraver, whose expensive and laborious techniques were more suited to the reproduction of "outstanding events" in *ILN* and the *Graphic*. The ephemeral episodes of city life demanded the quantity, speed, and modernity offered by the mass-reproduced photograph. The contemporary scene, captured by the camera, had a powerful attraction for the audience that Bullock delineated.[54]

The *Sketch*, then, was a metropolitan commodity, produced in the city, and intent on evoking the metropolis in a new way. In one sense, the arena depicted in the *Sketch* was more confined than that shown in *ILN*. The subject matter of *ILN* was, as Bullock observed, wide ranging: "events of national importance, ceremonies, battles, accidents." The *ILN* brought the entire Empire into the living rooms of the Victorian middle-classes, whereas the territory that the *Sketch* traced mainly encompassed the shopping, sporting, and entertainment sites of London and Paris. The *Sketch* didn't need to send "Special Artists" and reporters to China or Africa to cover events, a fact much appreciated by its frugal publisher, but, in another sense, it portrayed a more extensive, fragmented, and complex world.[55] Whereas *ILN* reported the Empire from afar, the *Sketch's* subject matter was the social experience of a rapidly expanding, and sprawling metropolis. When the spectacle of Empire and nation passed before the reader of *ILN*, they were unlikely to have personal knowledge of most of the scenes depicted, for example, the

details and subtleties of life in the Sudan or even in Scotland. In contrast, the *Sketch* envisaged people, events, and places that the reader might well encounter in their daily lives.[56]

The city was brought to life in the *Sketch* through short items of text. Columns and features rarely extended beyond one page, and most sections of the paper were divided into paragraphs, each dealing with a separate topic, a style of journalism particularly associated with the reporting of the metropolis.[57] Most of the magazine's written contents were regular columns of causerie, similar to Shorter's work in the *Star*. These columns emphasized the personalities, the opinions, and characters of their writers. Like the name of the magazine itself, these pieces suggested the ephemeral, a slight touch, something rapidly dashed off, not overworked or plodding. The *Sketch's* flippant, light, conversational tone was typical of journalism of the period and was, perhaps, a more appropriate means of describing contemporary life than the detailed, factual journalism of the previous decades.[58]

The *Sketch's* format of miscellany allowed for a number of diverse viewpoints to be expressed within the same issue. Some of the comment in the magazine was contentious, with writers defending Aubrey Beardsley's *Yellow Book* and championing Ibsen against widespread criticism.[59] But these statements were made in the relaxed urbane tone the magazine was intent on creating, and expressed in this manner, these opinions were less likely to alienate readers, rather they added to the sense that the reader was one of a sophisticated reading community, above the reactionary and the suburban. At the same time these points were expressed in short and varied paragraphs as opposed to sustained and detailed arguments. Within this structure, therefore, they become throwaway lines, so that if the reader did not agree with an opinion they could pass on to the next one.

Shorter believed that it was essential that an editor should know and respond to his readers' taste. In a discussion in the *Idler*, entitled "Is the Public Taste in Literature Correct?" he insisted that this was not a question that an editor should ask. Rather, they should respond to their readership. Providing he knew his audience it was possible to publish a wide variety of material.[60] He did this with the varied material the *Sketch* contained. Its writers were mainly liberal journalists and critics, who supported new developments in theater, art, and literature. There was a core of regular columns but also space for occasional outside writers; Max Beerbohm, for instance, contributed occasional humorous pieces. The magazine's recurrent sections included a good deal of literary coverage: books were discussed in "Literary Lounger" with gossip and reviews;[61] other literary sections were "The Book and Its Story" and "A Novel in a Nutshell." The *Sketch* never printed serials, so, like *Black and White*, all its fiction was short and contained within a single issue. George Gissing was Shorter's favorite contemporary author and one of the regular fiction writers. These literary sections were accompanied by photographs of authors, but unlike the *Strand*, for instance, the fiction in

the *Sketch* was not illustrated. Indeed, by not printing fictional images, the *Sketch* confined itself to showing the here and now, whether in its photographs or its caricatures, and it could be said that the only fantasy images printed in the paper were its pinups of glamorous females.

Developments in the visual arts were illustrated and discussed in regular columns such as "The Art of the Day," "Art Notes," and "Art News." In general, the *Sketch* was supportive of venues such as the New Gallery, enthusiastic about French artists of the Barbizon School, pro-Whistler, and critical of Academic narrative painting. A scathing review of the Royal Academy Summer Exhibition of 1895 dismissed the majority of the works as "shallow, unpoetical, foolishly sentimental, affected, or dull."[62] Material on art also included positive articles and interviews with avant-garde figures such as Beardsley and the Vale artists. A series of detailed articles by Alice Stronach profiled London art schools and contained much information on women students.[63] There was also coverage of modern image making including a series of articles on posters, interviews, and profiles of illustrators, poster designers, and engravers. There were reviews of books on illustrators, on photography, and on reproduction, including pieces on *The Penrose Annual* and the *Photogram*. Clearly this reflected Shorter's interests in process, but is also indicative of the conspicuous nature of the discourse around image reproduction in the 1890s. The inclusion of this material on reproduction processes connected them to the *Sketch*'s coverage of new developments in technology and its progressive attitudes to events in the arts.

The *Sketch*'s art criticism and news were accompanied by halftone photographs of sculptures and paintings, the reproduction of which was not universally popular. A group of artists led by Stacey Marks complained that the printing of photographic images of paintings in the press devalued the original works and diluted their impact and was particularly concerned about the publication of these halftones before the original works were exhibited. Up to this point, line images had been used to show works of art in guides and catalogues. The most well-known examples were published by Henry Blackburn, whose guides to the Royal Academy Exhibition were illustrated by small line drawings that were sometimes provided by the artists themselves, and because these images were linear rather than tonal, they acted as aide-mémoires and not as rivals to the originals.[64] It was only after the Royal Academy Exhibition opened that the illustrated magazines would publish lavish, large-scale wood engravings of the major paintings. With the coming of halftone techniques, photographs of paintings could now be produced much more rapidly and cheaply. Marks and his associates demanded that halftone images should only be published in the press after exhibitions had closed. The *Sketch* strongly disagreed with this idea and argued that many artists actively sought publicity by sending the magazine photographs of their pictures and offering free reproduction before exhibitions. Publicity in the press, the *Sketch* maintained, merely stirred up the

public's interest in the painting, and rather than diminishing the original added to its aura.[65] Many artists continued to embrace the illustrated press as an arena for self-promotion and provided images of their work for free; art was an economical way for magazines to fill space while simultaneously elevating their editorial tone.[66] In his book, *Photography for Artists*, Hector Maclean observed "Perhaps with the majority of painters the most important personal service performed by the camera is the copying of their finished pictures in order that the publishers of newspapers, magazines and illustrated catalogues, etc. may be furnished with prints of good *quality* in good *time*." He provided detailed instructions on how paintings should be photographed and on how they should be sent to magazines.[67]

Another form of mass entertainment covered by the *Sketch* was spectator sport. Horse racing had long been a popular spectacle with both the upper and lower classes, and Captain Coe of the *Star* contributed a column of betting tips. Other sports, including rugby, tennis, boxing, and cricket, were extensively covered in "The World of Sport," and from 1896, the *Sketch* contained frequent articles on cycling in "Society on Wheels."[68] These and other cycling columns stressed that bicycles were part of a contemporary lifestyle and also emphasized their suitability for women. Cycling appealed to a young middle-class audience that was open to novelty, the reporting of it essential to the creation of a market for this radically new form of recreation. Editorial coverage was linked to the illustrated advertising for cycles that became an important feature of the press. It was the marketing of the safety bicycle, via press reports and advertising, that demonstrated to business that a demand for expensive nonessential goods could be created.[69]

Shorter contributed to the longest section of the paper, "Small Talk," whose very title suggested the magazine's light conversational format. The tone of the text was of a knowing complicity, of information and gossip shared "between ourselves" making the reader part of a community coalescing around the magazine. Indeed, Shorter's texts were spoken not written as he dictated them directly to typists. Bullock wrote of his boss that "he made little or no distinction between the spoken word and the written word, setting forth on the spur of the moment, largely through his typists, the ideas and emotions that came chasing through his brain."[70] The "Small Talk" column, which extended over six to eight pages, was a mixture of poems, commercial plugs, and short pieces of comment. Theater was a recurring topic, but apart from this most of the section's ingredients were extremely varied. A typical column from 1896 consisting of forty-two paragraphs spread over six pages included:

Messrs. Bewlay and Co. have just been awarded a further gold medal for their Flor de Dindigul Cigars at the Empire of India Exhibition . . . A friend in Cyprus has just sent me a set of the new postage stamps . . . A French

gentleman of my acquaintance... Cheior is back in town for a few months and when I called upon him a week ago in his Bond Street flat... women are taking to walking sticks... insure against twins.[71]

It was not only because a larger number of illustrated advertisements were included that the magazines of the nineties became commodified, as clearly demonstrated by the fact that much of "Small Talk" consisted of commercial plugs. This system of concealed advertising was well established in the press; plugs were often paid for and were also expected by manufacturers in return for placing their advertisements elsewhere in the paper. The borders between editorial and advertising were very fluid.

Shorter's rambles in "Small Talk," both textual and physical, took him all over the capital, traveling by foot, train, bus, and the underground. In the column quoted above he also commented on a picturesque cockney used-clothing market in the East End, a wine sale in the City, and a "mock auction" in the West End, at which less savvy onlookers were duped. On another occasion, he recommended that readers eat in the Continental restaurants of Soho rather than endure the stuffy English fare offered on the Strand. He visited a friend after midnight in the West End, and they drank Savory and Moore's "peptonised" milk and coffee, which he found "first rate." The writer was a man of the world, moving at ease between the diverse geographical and social worlds of late-Victorian society. The repetition of the strolls in "Small Talk," week after week attempted to reassure the reader that this huge and potentially overwhelming city was navigable.[72] Judith Walkowitz has suggested that late-Victorian male novelists saw London as impossible to grasp or map in a coherent fashion, expressing this anxiety about the city in accounts that were "marked by fragmentation, complexity, and intro-spection, all of which imperiled the *flâneur's* ability to experience the city as a totalizing whole."[73] Popular journalism seems better adjusted to this fragmentary mapping of the metropolis, although the accounts in "Small Talk" conjure up an ambivalent city that mixed excitement and pleasure with danger. The image of the city provided by the *Sketch* augments that provided by the printed maps and guides that inhabitants and visitors now needed. Patrick Joyce speaks of the London maps of the nineteenth century as creating a modern sense of the city, as they played a part in consti-tuting an alert, autonomous, private self "one realized in purposeful and easeful movement through a city itself conceived of as a place of traffic and unfettered communication." In the *Sketch* the reader who is consuming the city is cautioned that they must indeed remain alert while freely exploring the overwhelming variety of metropolitan amusements. The *Sketch's* message was "woe betide the man who does not know his way about."[74]

Compared to its sections on the media and entertainment, the *Sketch's* coverage of news and current affairs was limited. It was intended to be a magazine about leisure, and, indeed, the *Sketch* plays a part in demarcating

the division between work and leisure that is a central aspect of modern life. Consumption was allied to cultural values and activities that were opposed to the industrial and the world of production.[75] The only regular reports of the world of work was a page of investment advice and tips entitled "City Notes," a column that seemed to have more in common with Captain Coe's racing tips than with worthwhile employment. The industries featured in the *Sketch* were those associated with leisure and entertainment, for example the theater, publishing, and bicycle manufacturing. A long series of articles on magazine publishing called "Journals and Journalists of To-Day" interviewed the major figures in the press. However, innovative technical developments such as autocars, phonographs, X-rays, and cinema were discussed as soon as they were made public. For instance, the March 18, 1896 issue published an enthusiastic account of an early cinema presentation at the Empire, only a week or so after the Empire had first shown the new phenomenon, where the audience applauded until the ten brief films were shown again. The article's author predicted that "soon nothing that is beautiful will be mortal."[76]

The readers of the *Sketch* were clearly interested in keeping abreast of the latest cultural and technical developments, and were willing to consider the unconventional, to question the establishment, and to enjoy themselves. It is for these reasons, I suggest, that Aubrey Beardsley chose the *Sketch* to launch his publicity campaign for the *Yellow Book* in April 1894. Beardsley was already a well-known and controversial figure in the art world, having been catapulted to fame the previous year. His new publication was to be a radical illustrated quarterly, in which text and image were entirely independent from each other. Beardsley provided portraits of himself and his fellow editor Henry Harland to accompany an interview entitled "What The *Yellow Book* Is To Be: Some Meditations with Its Editors."[77] Beardsley and Harland evidently hoped to attract the *Sketch*'s readership to their new venture, but how to characterize this audience? The *Yellow Book* was aimed, it seems, at a readership that included both the avant-garde as well as sections of the middle class, however, contemporary reviewers noted that the *Yellow Book* had, in fact, a large lower-middle-class readership.

Beardsley's publication contested the boundaries between high and low culture in a number of ways. In terms of its production, it had the appearance of an expensive volume with uncut pages, textured paper, and old-fashioned type. However, like the *Sketch*, its images were photomechanical, containing a variety of images from bold line to ersatz wood engravings, all photographically reproduced. At five shillings, it was a relatively cheap publication compared to the average novel, which cost six shillings.[78] Like the *Sketch*, its editorial content mixed high and low culture, including images of well-known actresses alongside its literary contributions, thereby replicating the hybrid nature of the city.

The readership of both publications included individuals who wanted to engage with modern life, even if they weren't wealthy. Some of the *Sketch*'s readers may not have been able to afford the books and entertainments it

featured, but they could at least be aware of them. Mass production had brought a greater variety of cultural experiences to a wider range of classes. Process methods brought the *Yellow Book* and the *Sketch* within the reach of the lower middle class, just as the mass theater could accommodate a gamut of patrons from the toffs in the boxes to the clerks in the "gods" (the theater gallery).

There were, of course, vast differences between Beardsley and Harland's literary and artistic quarterly and Shorter's topical weekly. For one, the actresses in the *Yellow Book* were drawn by Beardsley, those in the *Sketch* were photographs. These large-scale reproductions were an important element in the *Sketch's* success. It is important to note that the images in the *Sketch* were mainly images of people, unlike, for instance, in *ILN* which also featured many illustrations of architecture, natural history, topography, and general science. The image of the individual visually dominated the *Sketch* from the hand-drawn social caricatures and glamour images to its many photographs of personalities. Although this interest predated the photograph, it was heightened by the mass distribution of images. Photographic cartes de visite, cabinet cards, and mosaic cards of well-known figures were all popular.[79] With the coming of the halftone, the star's image and opinions could be cheaply and rapidly diffused on an even larger scale. In fact the modern form of celebrity depended on the inexpensive mass reproduction of the photograph.[80]

The *Sketch's* discourse of personality reached its most intense in the photographically illustrated interview, a new format that brought the subjectivity of the interviewee to the forefront. The interview had originated in American journalism during the 1860s, where it had replaced the written reply to a reporter's questions.[81] In the late 1880s, Stead's *Pall Mall Gazette* began to use the interview on a regular basis, and it rapidly became a staple of English magazines and one of the defining elements of new journalism. The interview was a compelling journalistic device that recounted an apparently intimate spoken encounter between two individuals, with its apparent spontaneity and familiarity emphasizing the personal qualities of both participants to a much greater extent than a nonoral presentation. The interview's oral mode suggested that it was revealing in a very direct way the characters of those involved, claims that were augmented by the use of photographs of the people interviewed.[82] The wood-engraved portrait seemed to add grandeur and distance to its subject, but the halftone created a less formal and more direct connection between the reader and the subject of the photograph. The photographic image offered readers a closeness that was perfect for the conversational tone of "the spoken magazine."

In the interviews of the 1890s, the circumstances of the encounter, time, surroundings, even the journalist's mood were described in detail. Moreover, in many cases these interviews occurred in the home of the subject. As Charles Ponce de Leon argues there were a number of factors behind this emphasis on the meticulous depiction of the domestic. On a journalistic

Figure 17 "Dr Joseph Parker in his Study, Photo by Russell, Baker Street, W.," "An Hour with Dr. Parker," *Sketch*, 2.17, May 24, 1893, 185–86. (Photorelief halftone print from retouched photograph)

level these descriptions were intended to make the piece more dramatic and compelling for the audience. Moreover, these interviews, with their focus on the individual and their home, originated in a modern conception of the self. As individual autonomy was becoming severely restricted in the workplace, private life became the arena where the true self was expressed. This was tied to a changing focus on "personality" and on the inner individual, rather than "character," which was the disciplining of the emotions through reason, in the manner celebrated by Samuel Smiles. Charles Ponce de Leon suggests that it was in the cultivation of personality that the subject became "real."

> The freedom to fashion one's own identity and pursue the new economic and social opportunities made possible by modernization aroused a profound suspicion of appearances – including a suspicion of the personas that public figures projected in the public sphere. With the public sphere viewed as a realm where everyone was acting, people concluded that a person's real self could only be viewed in private, and only if that person wished to be seen.[83]

The halftone photograph had an important role in this new emphasis on personality. These accompanying photographs, allied to the written accounts with their concentration on the minutiae of a specific encounter and on the appearance of the interviewee, worked to reassure the reader of the reality of the subject, and of the interview. Like the interview, they showed the real person in an intimate fashion. Most of the *Sketch*'s interviews featured at least one halftone photograph, often capturing the interviewee in his or her domestic surroundings where the encounter took place. Artists and authors were shown in their workplaces, in studios or at their desks, or in public spaces within their homes. The venue for the photograph was important, since the artist's studio and writer's study were heavily symbolic spaces signifying status and professional attitude, as well as their personal lives.[84] Actresses were also shown in their homes, even sometimes in their bedrooms or dressing rooms.[85] With the boudoir as the site where the actress put on and removed her public persona, these photographs therefore suggested both an exceptional and privileged intimacy while offering a glimpse into the performer's real personality.[86] The camera could now take the ordinary reader to places to which only the rich, influential, or talented previously had access. Faster shutter speeds, lighter, more portable cameras, magnesium flash lighting, and above all dry plates had made it much easier for the photographer to leave the studio and take photographs on location. By the 1890s the photographer had moved into offices, theaters, homes, and public spaces, providing more intimate and apparently more casual images.[87]

Personalities of many kinds were interviewed in the *Sketch*, including entertainers predominately, but also sportsmen, writers, and artists. The *Sketch*'s launch issue had promised that representatives of all classes, including shoeblacks and organ grinders would be featured. "To beguile the humblest units of the social system into the portrayal of their lives, will be a joy to our chroniclers and artists." The *Sketch* promised that its pages would be inclusive, based on a conception of society as being interconnected. This democratic pledge was followed up, to a certain extent.[88] However, most of the individuals featured in the magazine were from the middle and upper levels of the "social system." A typical issue from July 1893 included, "A Chat with Madame Bartet," "A Chat with the Sisters Ravogli," "Ten Minutes with the Bank-Smasher," "A Chat with Mr. Walter Crane," and "A Cup of Tea with Mr. Cecil Raleigh." Both the temporal specificity and the intimacy of the encounter between the journalist and their subject were conveyed in the titles of these pieces. The emphasis on personality in the interview format connected their subjects to everyday life and to "the humblest units of the social system." In 1895 the *Sketch* parodied the journalistic obsession with interviews, with "A Chat with Niagra," where the reporter pretended to interview the famous falls "as so few celebrities are left to be interviewed."[89]

The majority of the images in the *Sketch* were of women, including sportswomen, cyclists, journalists, and authors, however photographs of actresses,

drawings of glamorous coquettes, and fashion illustrations dominated. By the 1890s women were highly visible in London and, depending on their class, the location, and the time of day, they could move with some freedom through its streets. Yet, this freedom involved a careful public presentation of femininity constantly adjusted to the spaces and people they encountered. In a city where people could circulate freely, as Patrick Joyce suggests, they had to become responsible and self-monitoring.[90] These thoroughfares were spaces where women could be looked at, but where they, too, had the opportunity to gaze and observe. Lower-middle-class shop workers and typists took public transport to and from their places of work in the mornings and evenings. During the day, married middle-class women – unaccompanied by husbands or chaperones – shopped and attended matinee theater performances.[91] Respectable single young women might still be chaperoned, but they enjoyed the attractive displays of goods in department stores and joined the spectators outside publishers' and booksellers' windows. In the evenings, these same streets were the sites of lower-middle-class flirtations. Jerome K. Jerome recalled his days as a young clerk:

> For the more sentimentally inclined, there was Oxford Street after the shops were closed. You caught her eye; and if she smiled you raised your hat and felt sure you had met her the summer before at Eastbourne – Eastbourne then was the haunt of the *haut ton*. All going well, you walked by her side to the Marble Arch; and maybe on a seat in the park you held her hand. Sometimes trouble came of it: and sometimes wedding bells and – let us hope – happiness ever after. Most often, nothing further; just a passing of shiplets in the night.[92]

The city was a place that enabled women as well as men to exchange sexually charged glances, its streets the site of what Lynda Nead terms "scopic promiscuity."[93]

In the 1890s, female dress was particularly alluring: colorful, elaborate, rich, and tactile, it was bound to attract the gaze of both sexes. As male garb had grown increasingly restrained, sober, and dark, the ornately dressed female became a visible indication of her husband's social status.[94] Individuality and personality, as well as status, were projected visually through the carefully manipulated ornamentation of the body. Dress was an arena in which a woman could, within limits imposed by money, public opinion, and the fashion business, exercise judgment and obtain pleasure. It offered women a sense of adeptness in achieving the desired appearance through their skills as readers, shoppers, and, in some cases, dressmakers.[95]

In the *Sketch*, "Fashions Up To Date" were discussed and illustrated as part of a two-page section entitled "Our Ladies' Pages." The fashion coverage in the *Sketch* was intended to be a tool that women could use in their creation of a middle-class femininity. Because of this there were very specific

imaging requirements within this section that did not apply to the rest of the magazine. Although the *Sketch* used photographs for portraits of actresses and society beauties, wash paintings were used in the fashion pages in order to show clothes in detail since the halftone photograph was not always able to capture the subtleties of the outfits with the necessary clarity. Fashion images needed to be particularly precise in order to show the meticulous details of cut, fabric, and decoration, the vital signifiers of status. They were used as guides by professional dressmakers and therefore needed to be very accurate, with all parts of the costume in sharp relief. In addition, because the images were paintings rather than photographs, they were more open and the reader could then project her own likeness onto them. The leading fashion magazine, *Lady's Pictorial* used photorelief line images. However, by 1900 line process and wood engraving were rarely used for the imaging of fashion, and the halftone was used almost exclusively.[96]

Figure 18 "Fashions in the New St. James's Piece," *Sketch*, 9.108, February 20, 1895, 210. (Photorelief halftone print from wash painting)

In many ways the aristocracy still influenced fashions, even as their financial and political influence was being undermined by powerful new business and industrial groupings. In order to assert its cultural hegemony, the aristocracy indulged in evermore sumptuous public displays of wealth. The spectacular balls, receptions, and openings of the London social "season," during which the upper crust exhibited its finery, could be observed by magazine readers far outside of the city. The theater was also an important space for aristocratic fashionable display, as many were electrically lit and, as auditoriums were not dimmed during performances, patrons were able to see the clothes worn by wealthy theatergoers, whose fashions, in turn, influenced and were also influenced by the costumes worn on stage.[97]

The garments described and illustrated in the *Sketch* could, therefore, be at the same time fashion items, society news, entertainment news, and consumer guides. Many of the outfits were inspired directly by costumes in the plays the *Sketch* reviewed. In the 1890s, a close reciprocal relationship developed between the press, stage, and fashion industry. A new breed of fashionable dressmakers, including Lucile and Henry Arthur Jones, promoted themselves by providing costumes to actresses in prominent theaters, and by ensuring that these outfits were discussed in the press. The *Sketch, Black and White, Lady's Pictorial,* and the *Illustrated Sporting and Dramatic News* all gave detailed accounts of theatrical costumes and identified their creators, which was crucial as the names of the dressmakers were not provided in the plays' programs.[98] These magazines were the most highly illustrated middle-class weeklies of the time; all of them used process technologies, and all included urban leisure and fashion as important elements in their editorial content.

A typical theatrical fashion article in "Our Ladies, Page" for February 6, 1895 was entitled "The Gowns for 'An Artist's Model.' " The report reviewed the costumes in the play, crediting the dressmakers, and urged that "women should accord a vote of thanks to the management for providing them with such a feast of gowns to admire, to talk about, and, above all to copy."[99] In most of the plays discussed in the *Sketch* there were various grades of costume and of dressmaker, ranging from the expensive creations worn by the leading lady to the supporting players' more affordable gowns. This corresponded to the range of economic classes within the *Sketch*'s readership – or at least to how the magazine imagined its readers. These lavish, detailed and sensuous reports of every detail of the clothes suggested the intense visual pleasure to be had by the female public. A review of the costumes for "The Importance of Being Earnest" describes "A bonnet with a crown of gold sequins, studded with gold eabochons and surrounded by tiny, gracefully curving black ostrich tips and clusters of pink roses, completes the costume worn in the first act." The stage was by no means the only focus of this intense visual focus, and the report also described the outfits worn by women in the audience. "The dress which attracted the most attention off the stage

on the first night was undoubtedly that worn by a beautiful dark-haired and dark-eyed woman . . . " after a sumptuous description the writer states "I can assure you that the box in which sat the wearer of this gown was the cynosure of a good many feminine as well as masculine eyes."[100]

Actress's elaborate costumes elicited comment from critics as well as fashion writers. In his panning of another Wilde play "An Ideal Husband," the critic "Monocle" complained that the costumes were so extreme that they were out of step with the play itself: "The mounting was very handsome, and the gorgeous gowns will interest the ladies, though, from my point of view, clever as was the workmanship, most of the hats and *confections* seemed unsuccessful experiments tried on the English by Parisian *modistes*."[101] Even a serious drama critic like William Archer felt compelled to comment on the leading actress's costumes. Speaking of one of the major English actresses of the period, he observed: "From the moment of Mrs. Campbell's first entrance it was clear that Sarah Bernhardt had found a rival in the art of wearing clothes." Although Archer admitted that he was ill-equipped to describe her costume in detail, he offered his "unqualified homage to Mrs. Campbell's dressmakers."[102]

The full range of theatrical entertainments was covered by the *Sketch*, from the performances of the stars of French cabaret such as Loïe Fuller and Yvette Gilbert to English music-hall artistes like Marie Lloyd, and from Roman epics and musical comedies to the plays of Ibsen. This extensive stage coverage was contained in various sections such as "The Play and its Story," "Dramatic Notes," and reviews and features on particular plays. A regular series, "Behind the Scenes," provided readers with elite backstage access at theaters, described as "a sphere beyond the ken of the un-initiated."[103] Vivid full-page photographs of actresses, actors, music-hall entertainers and scenes from plays formed the main pictorial content of the *Sketch* and illustrated coverage of an important play might continue for weeks. In one issue the poster of the play might be shown, a week later the leading actress profiled, followed by photographs of the performance, and then interviews with the author and the leading man. The publicity for a play had to be stretched out over the long run that was now a necessity for financial success.

The theatrical photographs in the *Sketch* were mainly supplied by London-based studios that specialized in theatrical and celebrity portraits. The Alfred Ellis studio was one of the most often used firms. Ellis' photographs were frequently of groups of actors in tableaux from plays, as well as portraits of leading players. W. and D. Downey, Russell and Sons, the London Stereoscopic Company, and Bassano were other companies that also regularly supplied images to the magazine.[104] When Shorter initiated the *Sketch* in 1893, he was able to take advantage of the "countless photographs" for publication from these firms and from other sources, making the job of art direction much easier. The first photographic press agencies then began to appear in the midnineties adding to the supply of pictures.[105]

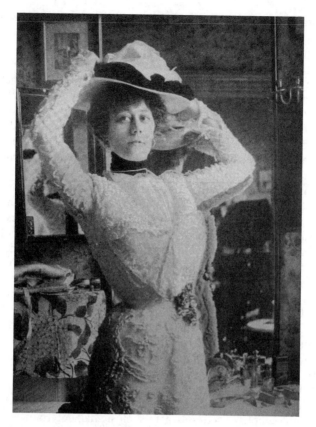

Figure 19 "Miss Violet Vanbrugh in the Dressing-Room of her Residence in Earl's Court Road Specially Photographed for 'The Sketch' by R. W. Thomas, Cheapside," *Sketch*, 27.346, September 13, 1899, 23. (Photorelief halftone print from retouched photograph, detail)

The *Sketch*, like the Empire Music Hall that had inspired it, offered middle-class males a voyeuristic glimpse of flirtatious sexuality.[106] Shorter boasted that "The *Sketch* had developed under my charge along the lines of abundant unconventionality. Photographs of fair ladies from the theaters and music halls abounded."[107] It is clear that these pictures of women, in some cases in revealing costumes, were one of the *Sketch*'s major selling points. Actresses, society beauties, and music-hall entertainers were all photographed for the male viewer to examine and enjoy. The magazine's initial issues, in fact, created something of a sensation: "At that time the costume of Opera Bouffe was more ethereal than it is to-day, and the earlier reproductions of many photographs in the *Sketch* did not altogether recommend themselves to the

more serious-minded of the community. The *Sketch*, indeed, in its earlier days enjoyed something of a *succes de scandale.*"[108]

The actress of the nineties was represented on stage and in the magazine as "naughty but nice," visually available, and glossily sexual but untouchable.[109] The *Sketch* was able to offer its readers images that captured the scopic intensity of a highly charged visual realm, where a glimpse of ankle, a fleeting glance, an ungloved hand, could be arousing.[110] Shorter promised in his introductory editorial that "the man who buys the *Sketch* every week may form a perfect seraglio of sirens, without molting a feather of his propriety."[111] In the privacy of his home, the reader could stare to his heart's content.

Shorter's pictures of women included not only photographs but also glamorous images by pen-and-ink artists such as Dudley Hardy. Shorter referred to these as "ballet girls scantily clothed and Dudley Hardy damsels of the leggy variety."[112] In keeping with the *Sketch's* racy theatrical content, Hardy, Frank Richards, and others supplied drawings in which curvaceous, smiling girls made eye contact with the reader. David Williamson, Shorter's first editorial assistant, had not entirely shaken off his Nonconformist upbringing and was uncomfortable pasting up layouts of these titillating images. He transferred back to the staid *ILN* and Shorter replaced him with the theatrically obsessed and more open minded J. M. Bullock.[113]

The *Sketch* included illustrations by the major figures in nineties pen-and-ink drawing among whom were Phil May, Rene Bull, Leonard Raven-Hill, and Louis Wain.[114] What is noteworthy about these images was not only their content but also their size and placement. Shorter treated these social caricatures as worthy of large-scale reproduction, each on its own page. In the *Sketch* there was a strict demarcation both spatially and in subject matter between photography and illustration. Other periodicals such as the *Strand* and *Black and White* used drawings for portraiture, fiction, political caricature, and news images and, as such, were often small and placed within editorial matter, amid photographs that illustrated similar material. The layout of text and image, on the other hand, was different in the *Sketch*. Photographic material, including portraits, images of theatrical shows, and current events were scattered among the editorial columns, however, almost all of the drawings were placed within a nine-page section called "The Lighter Side." The *Sketch's* drawings were social caricatures or glamour images, not news images or portraits, and were mainly either half- or full-page, because Shorter thought that pen-and-ink drawings looked cramped when reduced, and he was determined to print them at a reasonable size. Fortunately for him process reproduction had simplified the printing of these large images.[115]

Punch epitomized the English tradition of caricature. Each weekly issue of *Punch* contained two large full-page political cartoons and many smaller "socials," or sketches of manners. Their size was tangible proof of the importance attached to the political images and, conversely, it is noticeable that

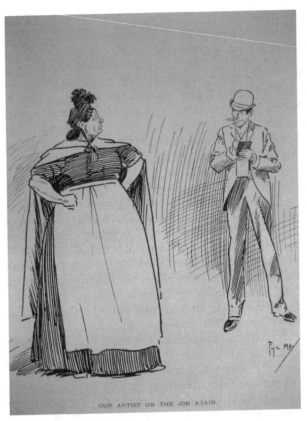

OUR ARTIST ON THE JOB AGAIN.

Figure 20 "Our Artist on the Job Again," Phil May, *Sketch*, 11.134, August 21, 1895, 187. (Photorelief line print from pen and ink original)

there were never any full-page social cartoons, which ranged from the depiction of upper-class foibles in the work of du Maurier to the drawings of the lower orders by Charles Keene.[116] Rather than mixing social and political caricature as *Punch* had done, the *Sketch* avoided political cartoons entirely. In addition, Shorter's decision to reproduce social cartoons at an even larger size than the political cartoons in *Punch* indicated the importance that he placed on them. The erasure of the political from caricature was a new development for illustrated magazines that was not limited only to the *Sketch*. In 1892, Charles Harper reviewed *Pick-Me-Up*, a modern process-illustrated comic weekly, and praised it for turning away from politics. He noted that "the degrading spectacle of party recrimination is always set before the press. A comic journal which refrains from political allusions and caricature is very much a novelty, and one which should command support."[117]

The *Sketch*'s avoidance of political cartoons was matched by its strict control of political comment throughout its pages. Shorter believed that the illustrated magazine editor should keep "opinions of a controversial character out of his journal."[118] Although he had strong left-wing beliefs, Shorter thought that the daily press and the serious reviews were the appropriate arenas for political opinion, and that the exclusion of controversy, analysis, and comment was an intrinsic element of the illustrated magazine.[119] On a purely economic basis, publishers did not want to alienate any potential purchasers and, in new journalism the political became a spectacle or a game to be viewed from a distance rather than something in which the reader was actively involved. Jean Chalaby has traced the depoliticization of new journalism, not only in the reduction of the amount of political coverage in the press, but also in the way in which politics was reported. Rather than giving a detailed account of a complex political process in which the reader and the publication had a stake, the press focused on personalities and on the spectacularization of political events. The reader simply watched a series of events as an observer of a game, not as a participant. The growing importance of visual reporting led to an emphasis on politics as image, with the highlighting of ceremonies and personalities, rather than showing politics as a process.[120] This was certainly the case in the *Sketch* where any political coverage was positioned as a kind a sport. Its opening editorial set the tone for what was to follow. Speaking of Parliament the piece distanced the paper from politics as ideas and policies became simply an entertaining contest. "We have nothing in common with Ministerialists or Opposition, except the unassuming confidence and exuberant spirits with which they address themselves to the political fray."[121]

In place of political conflict and tension, the *Sketch* visualized a commodified city of pleasure for its readers. Manufacturers had stepped in to fill the place previously occupied by political patronage of the press and were subsidizing the growth of the popular magazine through advertising, and most of the *Sketch*'s subject matter was for sale, from books, plays, and spectator sports, to stock market tips, with the review of a book or a play an invitation to buy. All in all, the magazine implicitly encouraged personal consumption. The *Sketch*'s editorial content therefore both supported the purchase of goods in a general way and helped its readers to become expert consumers.[122] The knowledgeable literary and theatrical comment and criticism in the magazine enabled its audience to keep abreast of the ephemeral nature of capitalist production, and through it this information became shared knowledge with a social function. The reader could see what books were generally popular, which play was a hit, who the latest actors and actresses were, which fashions were on the wane and situate themselves in relation to these trends.

In the *Sketch* the reader encountered a fantastic profusion of new products and ideas. The magazine acted to instigate and direct change through Shorter

and his contributors' advice. Change, an essential element of modernity, leads to the necessity of choice and the inevitability of contradiction; the magazine was a site in which these three elements could be played out. In some sense, the magazine was able to naturalize this situation for the reader by promoting change, offering choice, and safely containing contradiction within the multiplicity of its fragmented structure. In the *Sketch* change was usually achieved through consumption with the purchase of a book, a visit to the theater, or, if one needed change on a larger scale, by taking up cycling. All of the options that the magazine offered were seen as aspects of the personal, as individual decisions, but, at the same time were elements in the imagining of the consuming social subject.

The editorial and advertising content of the illustrated periodical now formed an interlocking whole.[123] In the *Sketch*, it was impossible to draw a line between editorial matter and ads. The weekly included paid advertisements as well as the commercial plugs within "Small Talk" and the other editorial sections. Moreover, an editorial halftone of an actress in a current play or a halftone photograph of a painting in an exhibition operated as both editorial and advertising. Culture and commerce mingled intimately in the structure of the magazine. After taking in a photograph of an actress smoking, the reader could see a cigarette advertisement on a subsequent page. A Geraudel's Pastilles advertisement illustrated by Phil May or Dudley Hardy would appear in close proximity to full-page editorial illustrations by the same artists.[124] The sports coverage was regularly bracketed by advertisements for Elliman's Embrocation, an ointment for sports injuries.

The embrace of editorial and advertisement could also be more subtle. The *Sketch*'s April 1895 interview with Aubrey Beardsley, entitled "An Apostle of the Grotesque," kept returning to the theme of his French influences. The interior of his home in a conventional and unremarkable part of London was described as more suited to "Paris than Pimlico." Surrounded by French literature, the young illustrator praised the Parisian poster artists Toulouse Lautrec, Jules Cheret, and Adolphe Willette and was full of admiration for French style and fashion. His disdain for the picturesque and classical and his praise for the beauty of modern dress, the poster, and the modern city all spoke of French influences.[125] This fascinating article was surrounded by advertisements for Easter trips to Paris by train. Inspired by Beardsley, the reader could purchase a first-class return ticket for thirty-nine shillings and experience Parisian culture firsthand. From reading an earlier issue of the *Sketch* they would already know to avoid the Chat Noir, which was now thoroughly bourgeois, and instead head for the Cabaret des Quat-z-Arts.[126]

Consumption in the *Sketch* was not restricted by gender. Although "Our Ladies' Pages" specifically addressed a female audience, Shorter expected women to read the entire magazine. He also anticipated that his male readers would be active consumers and offered them a whole world of possible purchases, in addition to particularly male forms of consumption, such

as collecting stamps. In this period, women were conventionally associated with the purchase of items for the home and for themselves, as the bulging advertising pages of late-Victorian women's magazines suggest.[127] Margaret Beetham has demonstrated that the distinctive editorial elements of new journalism, that is, the use of a personalized, informal tone, brevity, increased illustration, and the emphasis on human-interest stories had all been associated with women's journals. With the wide-scale adoption of these approaches, the press opened up to a general audience a range of qualities previously characterized as feminine, such as an interest in appearance. In the *Sketch*, men and women were both imagined as finding pleasure and fulfillment in the assessment, selection, and purchase of goods and experiences.[128]

A. L. Austin contributed a regular *Sketch* column called "At Random," mainly relating to arts matters although he held forth on everything from divorce to the fashion for mauve. Occasionally his columns dealt with a single subject, but more often they did not, with each individual paragraph, as the column's title suggests, treating a different, often radically disparate, topic. In his column for August 4, 1897, Austin attacked Augustine Birrell for his complaints about the commercial character of the press, noting that Birrell's discussions of literature appeared in papers where they were surrounded by advertisements for biscuits and sauce. There was nothing to be done about this situation, Austin insisted, and Birrell should just accept the inevitability of the mixing of literature and commerce, of editorial and commercial matter. The press was inevitably a commercial enterprise. He noted with tongue in cheek, "Mr. Birrell seems to think it would be a boon if news could be administered to the public without any contaminating sense of the newsman's commercial personality. Alas! the world is full of illicit mixtures."[129]

The editorial hybridity of the magazine was, in fact, an important part of its commercial structure. Shorter spoke of his "varied wares" – his women's pages, books reviews, articles on cycling, reviews of musical comedy, essays on new drama, sports coverage, and stock market tips.[130] Shorter's term "wares" evokes the origin of the word *magazine*, from the Arabic *makhazin*, meaning warehouse or storehouse, and the French *magasin*, meaning shop or department store. Indeed, the commodified illustrated magazine mirrored in many ways the department stores of the 1890s with their aesthetic of spectacular variety and abundance. Enticed by window displays, individuals could enter department stores freely and wander where they wished, browsing through goods with no obligation to purchase. The attractive layout of products in windows and within the stores themselves encouraged and legitimized the purchase of unessential items. As Rachel Bowlby notes in her discussion of the department store this mixture of goods encouraged browsing, a mode of attention in which the viewer was not looking for anything in particular but became open to the consumption

of everything.[131] This mode of attention is very much that of magazine consumption, one looks rather than reads. The magazine offered an apparently endless variety of material presented for the reader to peruse and possibly buy. Like the department store, the illustrated magazine immersed its readers in an aesthetic of spectacular abundance through its diverse photos and illustrations. The halftone photograph in particular suggested an infinite and effortless circulation of images. Just as the myriad goods in the department store window appeared as if by magic, so, too, the profusion of halftones seemed to have been produced without human exertion or intervention.[132]

The *Sketch's* layout had not initially reflected the variety of material it contained. At first the new magazine was similar to the regular booklike format established in *ILN*. Its text was arranged in two equal columns with little variation in size. Justification, which produced margins flush on both sides of a block of type, was the standard method of arranging text. Images were usually fitted within the even columns of text, and woodblocks were manufactured at sizes that matched these column widths. The technologies of mechanized typesetting and the increased numbers and size of process images were changing the appearance of periodicals. Images could now be photographically enlarged or reduced to any width, and the copper or zinc plates on which they were etched could be cut to any size. With more illustrations to accommodate, magazines looked at new systems for integrating type and image.

Pictures could now be more fluidly combined with text through the use of mechanized typesetting. Up to this point, individual letters had been picked by hand from type cases and arranged letter by letter in lines to make up pages of text. After they were printed letters were redistributed back to their original positions in the type case for reuse. The first fully automatic typesetting machine was the Linotype, which was introduced in the *New York Tribune* in 1886. A keyboard operator caused type to be cast from molten lead and at the same time automatically justified into lines, whereas previously justification had required laborious hand adjustment of the spaces between words. The Linotype also solved the problem of the redistribution of the type: the metal blocks of text were simply melted and reused. The first Linotype machine in London was installed at the *Globe* in 1893, after which there was a rapid adoption of the technology, so that by the following year half a dozen papers including the *Financial Times* and the *Daily Telegraph* were using it. The new machines cut down the number of compositors employed to set type and, at the same time, speeded up periodical production. A skilled hand compositor could set up to 1000 characters per hour; by the turn of the century mechanical typesetters could turn out six to ten thousand letters in the same period.[133]

These machines enabled type to be arranged in more unusual layouts than the standard justified columns. In the past *ILN* had occasionally produced

very elaborate "run arounds" which integrated wood engraving and hand setting, but this was a very time consuming and expensive procedure. Automated typesetting, on the other hand, made the interweaving of text and image quicker and more economical. But while the adoption of mechanical setting systems aided in the increased "aesthetic productivity" of the press, to use Georg Simmel's phrase, the results were often chaotic and the legibility of the text suffered in these experimental layouts.[134] Many monthly magazines used elaborate run-around techniques in which the regular columns of type were split apart by vignettes and photographic images set at extreme angles. Crane referred to illustrations "daringly driven through the text, scattering it to the right and left, like a coach and four upon a flock of sheep."[135] A visual and typographical chaos reigned as images broke out of columns, and abrupt illegible lines of justified text ran along their edges in what were known as "let-in blocks." It was not the custom, as it later became, for photographs to be the same width as text columns.[136]

This visual chaos was particularly common in the monthlies such as the *Strand* or *Pearson's*, where pages became very fragmented, at the expense of readability. The shorter production cycles of weeklies initially limited their ability to experiment with layout. From 1897 onwards, the *Sketch's* appearance became more elaborate with articles running around the illustrations, unequal columns of text, and asymmetrical layouts, which may have meant that the magazine had switched to using the newly introduced Monotype machines. In October 1897, the *Sketch* featured an article on the Monotype, noting that input could even be made directly by the journalist, but the article doesn't say if the magazine had adopted mechanized typesetting itself.[137] It would not have been out of character, however, for the magazine to print this kind of clandestine advertising in return for a price reduction from Monotype. If journalists were indeed directly keying in type at the *Sketch*, this might have contributed to the breakdown of the regularity of the column grid. Around the same time the photographic content of the *Sketch* took on a more snapshotlike appearance. The magazine started to crop images rather than using the entire negative as had been the standard practice in the press up to this point. Prints were often simply cut with scissors to exclude unwanted portions of the image.[138]

According to Bullock, other publications rapidly imitated the *Sketch*, including the *Pall Mall Budget*, *St. Paul's Magazine*, and the *St. James' Budget*, as well as a downmarket penny weekly called *Sketchy Bits*. Whatever its direct influence may have been, by the middle of the decade periodicals had been transformed – the illustrated new journalism was intent on visualizing the world in a fresh way. Using photographs and drawings, the *Sketch* and its companions mixed art and reality, although it was not always that photographs showed reality and drawings the ideal; the pen-and-ink sketch often depicted the everyday, while photographs showed fantastic worlds of entertainment and consumption. These magazines formed a popular illustrated

press that envisaged the social as commercial. Through these countless and varied texts and images, magazines offered readers imagined trajectories of consumption, trajectories that intersected with fellow city dwellers in rich and complex ways. In the next two chapters we will trace the manner in which illustration and photography responded to the task of imaging commodified modernity.

6
The Illustration of the Everyday

Is it not strange how some events are fixed in the memory – silhou-etted, sharp, distinct, like one of Mr. Aubrey Beardsley's "latest latitudes"?

– Emily Soldene, "How the Alhambra Was Shut,"
The *Sketch*, January 30, 1895[1]

Photomechanically reproduced pen-and-ink line drawings were hugely popular in the magazines of the 1890s. Illustrators such as Phil May, Maurice Greiffenhagen, Leonard Raven-Hill, Bernard Partridge, and Fred Pegram produced social caricatures that, above all, explored the everyday in late-Victorian society. These sketches depicted aspects of the social scene that the photograph could not. The modern illustrator was a knowing observer of the contemporary scene differentiating in minimal drawings the meaningful details of the bodies and dress of city dwellers. Furthermore, their sketches could depict subject matter that would have been unacceptable if shown in photographic halftones. The photograph was considered too direct and too detailed to show poverty, carnage, or sex. Critics saw the sketch as a radical new art form able to portray contemporary life directly to a modern audience unfettered by academic conventions. The sketch was characterized as an immediate, subjective impression, its speed and authenticity attested to by the supposed autographic qualities of process reproduction. These sketches gave magazine readers a reassuring sense that the city and its denizens were knowable, legible. Rapid minimal sketches were deployed in the press as the antithesis to the overdetailed, static photograph, yet, as we will see, these illustrations were influenced both directly and indirectly by photography.

Photorelief reproduction enabled many kinds of illustration to be printed in the books and magazines of the 1890s. Although the daily papers could only print simple line images on their presses, the longer production cycles of weekly and monthly magazines produced a rich pictorial mixture. The amount of detail, the style, and the presence or absence of tone varied according to the text that the illustration accompanied. A certain style of illustration was associated with the imaging of news and different ones with fiction or fashion. It was usual for detailed tonal images to be used with

fiction and bold line images to be used in social caricature. These handmade drawings and paintings appeared alongside the halftone photographs that were now becoming more prominent in periodicals.[2]

Photography and the distribution of photographic images through the halftone, influenced the way in which the handmade imagery was perceived and created. Wash images, used in the press, for example, became more factual, detailed, and tonal, a shift Walter Crane referred to as the "photographic effect."[3] The pen-and-ink sketch, also in response to the photograph, became more minimal and gestural, whereas decorative pen-and-ink images by Beardsley and the followers of Crane and Morris depicted fantastical worlds entirely removed from the factuality of the camera. Yet all of these different genres of image, including Beardsley's ersatz wood engravings, were reproduced using photorelief processes.

As far back as the 1870s, photorelief line processes had enabled line drawings to be reproduced. Yet it wasn't until the 1890s, with the increasing use of photographic halftones by the press, that there was an explosion of line illustrations. It is clear, then, that the variety and number of images in the press were not just technologically determined and that all of these methods were interrelated. Moreover, because they were all embedded in specific media and directed at specific audiences, they were not simply free-floating technologies. The publisher and illustration pioneer Henry Blackburn noted that mechanical processes had been "neglected and despised" by illustrators before the "sudden freak of fashion" for them in the 1890s.[4] Indeed, part of the reason for this craze in publishing was that the dynamic black and white of the sketch provided a relief from the repetitive monochrome rectangles of the halftone. While photographs in the press were static, the sketch was, in contrast, lively, even frenetic at times. The photograph was highly detailed, the sketch minimal and incomplete. The halftone was mechanical, and the sketch emphatically asserted its handmade qualities. However, there were other cultural factors that link the photograph and the sketch. I suggest that the sketch and the photograph were both particularly suited to the fragmented editorial structures of the illustrated magazines of the 1890s, that both genres provided viewers with a swift reading of the surfaces of modernity, and that both could be inexpensively and rapidly reproduced.

The process imagery of the 1890s can be divided into two major camps in terms of their placement and style – realist and decorative. Decorative illustration included the work of Beardsley and Charles Ricketts, the Birmingham School, and other illustrators associated with the Aesthetic and Arts and Crafts Movements. It was often highly detailed and ornate and appeared to be slow, heavy, deliberate, and time consuming in its making. Its subject matter was historical, mythological, or symbolic, and it used distorted figures, organic forms, and fantastic events. Its various styles looked back to the archaic or the exotic, as distinct from quotidian modernity. Gleeson White wrote of the illustrator and wood engraver Ricketts: "Emotion, passion

and the decorative pattern of his design sway him the most; and to this end he evolves types of humanity which are not common, and proportions which do not agree with the Kodak."[5] In Ricketts' work, as in most Decorative images, the renunciation of modern life was reinforced by the referencing of reproduction processes from the past. While Ricketts actually made his own woodcuts, usually these pictures were really pen-and-ink drawings in the style of wood engraving reproduced by photorelief line process, something that Gleeson White referred to as "the idea of the woodcut." Writing in the *Studio*, he noted,

> as many examples from Birmingham and elsewhere have clearly shown, the idea of the woodcut is peculiarly suited for photoreproduction; the drawing in bold thick lines loses nothing worth mentioning, even in an ordinary "zinco" of commerce. Indeed when printed on rough paper, it needs a strong lens and some amount of technical skill to decide whether it be an impression from a woodblock or a metal *cliché*.[6]

In the midnineties there was an explosion of books, including Beardsley's *Morte D'Arthur*, that took their lead from William Morris' Kelmscott Press publications. However, unlike Morris' expensive hand-engraved and hand-printed productions, these process-reproduced books were within the reach of the middle classes. Decorative illustration was the book-publishing equivalent of the process phenomenon in the periodical press. Gleeson White noted that these books were surprisingly popular in an age of music halls, trains, impressionism, and capitalism. Decorative imagery was used not only in illustrated books, but also in advertising posters and in smaller run periodicals, which are largely outside the scope of this study.[7]

The majority of the hand-drawn images that appeared in the monthlies and weeklies, on the other hand, were realist illustrations, and included the pictures accompanying factual and human-interest reports. Descriptive images ranged from simple line drawings traced from photographic originals to realist topographical images in pen and ink, notably those produced by Herbert Railton and Joseph Pennell. Special Artists, as they were called, such as Melton Prior of *ILN*, Frederick Villiers of the *Graphic*, and Seppings Wright of *Black and White*, produced sketches of major news events from wars to royal weddings and funerals on location, which were then translated back in London into elaborate wash paintings.

The Special Artists worked up rapid sketches of events, clarifying and refining them shortly after the incident they portrayed. The sketch could be based on direct observation or might be produced from verbal reports of an incident. The Special was able to create a narrative report by combining elements that occurred at different times or locations into one image that captured the important actions in an incident. Rather than these images being finished by the artist, they were then dispatched to London for

completion. The Special's sketches included much written information, expanding on the incidents portrayed and on details of the appearance of the participants. These rough outlines and textual annotations were then used as the basis for highly finished tonal wash paintings that were reproduced by halftone process. The London-based studio artists who reinterpreted the information in the sketches gathered extra reference as necessary. As one magazine put it,

> it matters not how rough these are, inasmuch as they are suggestive and give something like a clear notion of what they are intended to represent.... The metamorphosis of these news pictures is truly wonderful. The original model may be, in the main, adhered to, but the detail, the local colouring, and needful accessories are supplied *ad libitum*.

Some of these studio artists were well-respected figures, such as Luke Fildes, Hubert Herkomer, and Caton Woodville. The multiple authorship of these elaborate narrative images was acknowledged in the printed illustrations, and credit was given to both the Special and the artists who had completed them.

Since the wood engravings of the 1840s, the illustration of news had not been expected to be slavishly realistic. Rather, it was the combination of text and image within the magazine that produced meaningful accounts of newsworthy events. Early in the 1880s, H. Barret, writing in the *Magazine of Art*, judged imagination to be an essential tool for the Special.[8] He suggested that if facts were all that were required then a camera would suffice. Indeed, he thought that some sketches were as bad as photographs and said, "Sketches which are destitute of spirit and innocent of imagination, however full and accurate in detail, are not properly realistic; they are dull and unsuggestive – they are the raw material the common place of illustrated journalism." The Special was required to make sense of the facts, the crude data of the incident, and invest them with drama. Joshua Brown notes that this system produced images that conveyed a temporal narrative rather than a static instant and states that in "viewing an engraving, readers registered a sequence constituting an event as well as that event's defining or decisive moment; framed within one image, time extended, and cause and effect became apparent."[9]

In the 1890s, news coverage mixed heavily retouched photographs with drawings that were also often retouched. These combinations of illustration and photography and text allowed readers to gain a sense of the individuals involved in an event, as well as the setting. The photograph provided static topographic information and portraits, while the drawn images presented a narration. In the press coverage of the Boer War of 1899 to 1902, both illustrators and photographers were dispatched to the front; although there was some discussion in the press regarding the superiority of one method over another, most magazines combined the two approaches. In

Clement Shorter's new publication the *Sphere*, Special Artists covered battles while photographers provided details of camp life and photographs of the participants. This combination of photography and illustration continued in news coverage until well into the following century. *ILN*'s coverage of the First World War merged dramatic scenes of action produced by its Special Artists with heavily retouched photographs of the battlefield.[10]

Although Special Artists were highly respected and well-paid figures, illustrators such as Phil May, Charles Dana Gibson, Maurice Greiffenhagen, Leonard Raven-Hill, and many others created the most popular drawings of the time, the social caricature. These sketch artists drew recognizable people in believable poses and everyday settings. These images made everyday people visible on a new scale, plucking ordinary individuals from the masses,

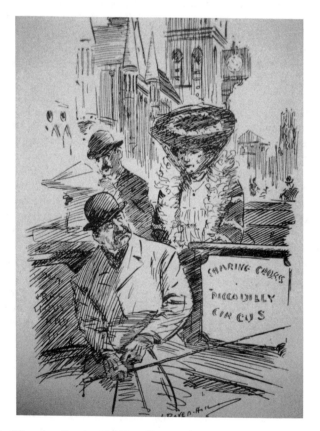

Figure 21 "Country Cousin: 'Do You Stop at the Cecil?' Bus Driver: 'Do I Stop at the Cecil!' – On Twenty-Eight Bob a Week!," Leonard Raven-Hill, *Mr. Punch's Life in London*, London, Educational Book Company, 1908?, 37. (Photorelief line print from pen-and-ink drawing, detail)

even when those individuals were representative of social types. Unlike the exaggerated drawings of Hogarth, Cruickshank, and Phiz, the caricaturists of the 1890s eschewed obvious political comment or biting social satire. Nevertheless, as we will see, the sketch of manners did comment in both overt and covert ways on the social tensions of the 1890s.

The pen-and-ink sketch was the most distinctive of the photomechanical images. It was, unlike the photograph, painting, or wash drawing, intimately associated with the method by which it was reproduced. In his *English Pen Artists of Today*, published in 1892, Charles Harper maintained that not only had photomechanical reproduction brought black-and-white illustration to prominence but the technical limitations of process had shaped its aesthetic:

> Pen Drawing in its practical application is a very young art, and owes its present very important position solely to the invention and gradual perfecting of reproductive processes. And not only does it owe its vogue to mechanical reproduction, but its evolution has been dictated by the requirements of photozincography and allied methods of autographic engraving.[11]

While Harper's claims were partly true, pen-and-ink was linked to a fresh approach to drawing that had emerged over the last few decades. Realist and Impressionist drawing diverged from finished Academic approaches and became increasingly linear. In Academic drawing the artist carefully built up detail in the various sections of an image to gradually create an entire scene. In contrast, the sketch artist, like the plein-air Impressionist, worked on the whole image at once. The artist's eye was not fixed on one point but moved rapidly around his subject. These new approaches emphasized seeing the whole, and students were encouraged to train their visual memory and powers of observation so as to capture the essence of a subject. The rapid sketch, or croquis, executed on the spot, was an encounter with the everyday rather than with the academic ideal, and the sketch, rather than the finished drawing, became more central to artistic practice. These French methods were applied to English art education by teachers such as Fred Brown at Westminster School of Art, who taught many of the illustrators of the nineties.[12] Some prominent illustrators, such as Leonard Raven-Hill, also studied in Paris and absorbed these approaches firsthand.

In England, the minimalism of the sketch was also linked to new developments in painting and in printmaking. Alongside Ruskin, Philip Gilbert Hamerton was the most prominent art critic of the day.[13] Hamerton edited the *Portfolio*, a notable art magazine, and was also the art critic of the *Saturday Review*. In his books, his criticism, and his monthly magazine, Hamerton challenged Ruskin's ideas on finish and detail in image making. Whereas Ruskin saw attention to detail as a sign of morality, artistic honesty, and conscientiousness, Hamerton argued that only the absolutely essential

facts were to be shown in a work. For Hamerton, the more unfinished a sketch was, the more it would appeal to artistic tastes and he rejected Ruskin's ideas on aesthetics as primitive and advised that "Progressive drawing" should abandon the unsophisticated and childish outline. Writing in 1892, Hamerton linked this approach to drawing to the wider artistic field, saying that "Suggestion is preferred to hard fact. Hence sketching, for its power of hinting and suggesting much more than what it states explicitly is not only valued for itself, but is carried into engraving (in the form of etching), into watercolor painting, and even into oil pictures, many of which, in an advanced condition of the fine arts, are sketches on a large scale."[14]

The pen-and-ink drawing was linked to these developments but was also radical in its own right. It applied this linear art to the depiction of contemporary subject matter. J. M. Bullock noted the youth of the majority of illustrators whose school was "absolutely modern."[15] The illustrator A. S. Hartrick stated, "I am a Modern . . . and believe in trying to deal in the material, in thought and action, about me today."[16] Hartrick saw himself as an Impressionist, in his desire to directly transmit his immediate sensations of the world around him to his audience. Sketch artists were not dependent on the Academic system for either training or financial support, and, indeed, some were self-taught. The aesthetic freedom that illustrators enjoyed relied on the fact that process made their images cheaply and widely accessible in the press. There were no set models for how this work should look, a fact that Charles Harper recognized when he asserted, "there are numerous styles at the moment as the pen artist is able to work out his individual 'artistic salvation' free from the constraints of the academy." Process, he argued, had enabled artists to put aside tradition and trust instead their own "artistic perceptions."[17] Frank Holme also urged that the illustrator look directly at the "visible facts of everyday life," as they were, and record his impressions of the moment "not handicapped by sets of rules, but looking at the world with their own eyes and acting on their own responsibility." Holme asserted that time-consuming academic methods, aimed at creating an idealized and timeless beauty, had nothing to teach the illustrator whose work must be factual, immediate, and of his own time.[18]

There were, in fact a number of stylistic influences on this supposedly direct, factual, and individual vision. One was the link to contemporary French drawing and, through this, to Japanese art. Leonard Raven-Hill's French training led him to assert his belief in "the principle of the Japanese artist, that impressions – otherwise memory – is of greater value in giving vitality to a drawing than any amount of deliberate searching after accuracy of proportion and truth of outline."[19] Therefore, the veracity of a sketch artist's work related to his internal subjective consciousness rather than external and objective facts. Gleeson White linked the sketch to contemporary models of subjective vision in his discussion of photomechanical reproduction. Drawing on the theories that had influenced Pictorialist

photography, he argued that perception consisted of a narrow vignette of detail. Walking through the city, the viewer took in impressions in rapid but tightly focused glimpses that were then reassembled internally. "The details he has caught in this sweeping glance he pieces together, so that his impression is as much mental as visual."[20] This vision was personal and fleeting, rather than being a detailed trace of a fixed external reality. Like Baudelaire's painter of modern life, the sketch artist's vision captured the essence of the contemporary scene.

The sketch's slight and unfinished appearance evoked the transitory and individual nature of the urban experience. For Gleeson White, the process illustration's apparent slightness and ephemerality were therefore not drawbacks, but indicative of its modernity and in harmony with the contemporary taste for the ephemeral, the terse, and the epigrammatic. Gleeson White observed that nowadays, "In place of the theme overlaid with details and demanding sheer genius to carry it through on a huge scale we prefer the idea epigrammatically put." There was no longer any need for "superfluous elaboration"; indeed, the distinctive cultural form of the 1890s was the fragment.[21] From the short story, the aphorism, and journalistic causerie, to the essay, the snapshot, or the pen-and-ink sketch, the brevity of these forms seemed appropriate for a period of rapid social upheaval and constant change.[22]

David Kunzle in *The History of the Comic Strip* (1990) notes the growing minimalism and fragmentation of drawing styles in the press of the 1890s and links this to new patterns of work and communication, particularly travel by train.

Indeed, many a paper then, as now, would be bought, read, and discarded en route, like a candy wrapper. The magazine thus consumed represented the fragment of an experience that included yet smaller fragments: short texts, cartoons, and comic strips, themselves composed of individual scenes. The very style of drawing was fragmentary, increasingly so as the century progressed and new shorthand codes, new abbreviations were devised. The tendency affected not merely caricature and popular culture but all the arts at every level, especially those in the vanguard (most noticeably, impressionism). Learning to live with appearances and a fragmented reality, the social commuter assembled the shards of experience into a new aesthetic.[23]

However, given their relatively expensive cover price it is unlikely that middle-class magazines would have been thrown away in this manner; rather they would have been brought into the home where they would be shared with family members or friends.

Manuals for illustrators stressed that they should develop a concise, simple approach. The professional draftsman was advised to learn to leave out the

inessential and concentrate his efforts of the key details; he must go for the "striking fact."[24] English manuals by the illustrators Joseph Pennell and Charles Harper were shaped by Hamerton's theories of image making. Influenced by Hamerton's writings on drawing, illustration, and printmaking since his days as an art student in the United States, Pennell's theories on minimalism in pen and ink were expounded in his book *Pen Drawing and Pen Draughtsmen* (1889), which was the first to identify and discuss modern developments in illustration. A few years later in 1892, Charles Harper took much the same approach in *English Pen Artists of Today*, in which he advised the artist "must cultivate the power of expressing in as few and as meaning lines as possible – each stroke having its use and value – all he wishes to convey: he must, in short, be concise and epigrammatic. For the pen artist, in his highest expression, is your true impressionist." Pennell's illustrations were praised for their exclusion of detail, for what was dubbed "leaving out." A review of his drawings for Washington Irving's *The Alhambra* noted the importance of his style: "Mr. Pennell is particularly happy in his power of 'leaving out' what it is to the advantage of his drawing should be admitted. It is a rare talent in a draughtsman, and one much to be commended."[25] For Pennell and Harper, the subjective selection of detail in the sketch separated it from the overliteral and vulgar photograph. As Harper put it: "The student will find for himself that it is not possible to legitimately express in pen-and-ink the whole scheme of an indescribably complex nature, but that he can present an epitome that will appeal to the intellect far more strongly than a photograph, however good."[26]

Process reproduction apparently allowed the distinctive autographic qualities of an illustrator's individual style to come to the fore as he was no longer working in partnership with the wood engraver. The deputy editor of the *Sketch*, J. M. Bullock, noted the importance of process reproduction in the assertion of stylistic individuality. He asked his readers to look at the drawings of Charles Dana Gibson, saying "Think how a graver would ruin that line, coarsen it, take the life out of it. But for process, in short, Mr. Gibson would not be Mr. Gibson."[27] As a token of this artistic independence the signature of a wood-engraving firm no longer dominated that of the illustrator at the foot of a block; the dual signatures, common in the past, acknowledged the joint authorship of the printed image, but now the illustrator's name often stood alone. If a process firm did mark its work it was generally with a subdued logo.

Whether they were caricaturists such as Phil May or decorative illustrators like Aubrey Beardsley, the most prominent of them became celebrities. Speaking of American illustrators, Neil Harris points out:

> These commanding figures brought to the field of illustration their insistence on autonomy. And, even more important, they transmitted a special individuality. Illustration would no longer have to rely on standardized if

arbitrary conventions. These artists took orders from no one and insisted on establishing their own style of design. This was still novel in the eighties and nineties.[28]

This individuality was, in some cases, very lucrative. In the United States, Maxfield Parrish and Charles Dana Gibson could charge $1000 for a periodical cover illustration; Gibson's yearly earnings were supposedly $25,000.[29] The prospect of these enormous incomes attracted many young men to the field, but few became wealthy. Nevertheless, it was possible to make a reasonable living in illustration. In the United States a young illustrator could expect to make $5 to $8 a week, and an established newspaper illustrator could make $25 a week.[30] In 1893 at the beginning of his career, Beardsley was earning £10 per week as one of the regular illustrators at the *Pall Mall Budget*. In the midnineties this was a good wage and a well-paid alternative to other white-collar jobs. Pen-and-ink artists who could draw for reproduction were increasingly in demand as the amount of press imagery increased. If they were working for magazines such as the *Pall Mall Budget*, *Black and White*, or the *Sketch*, they had the time and the technical resources to produce crisp sketches and elaborate tonal images. Newspaper illustrations on the other hand were poorly printed on cheap paper and many newspaper artists were anonymous draftsmen who converted news and portrait photographs into line illustrations for the press, yet even they could earn reasonable wages.[31]

When Beardsley was starting to make his way as a caricaturist at the *Pall Mall Budget*, Phil May was rapidly establishing himself as the most popular and artistically respected pen-and-ink illustrator of his day. From the early 1890s through the rest of the decade, May was renowned for the extremely minimal style through which he was able to suggest the clothing, expression, and postures of his subjects. Whistler proposed, in fact, that black and white art could be summed up in two words – Phil May. In weeklies including the *Sketch* and later *Punch* May delineated brief snatches of public dialogue in the city, the sort of encounters May's middle-class readers might well face. The anxieties of these bourgeois viewers were assuaged by May's depictions of the cockney and the urban poor in a positive and humorous light.[32] May seemed to epitomize the illustrator as an artist in the city. He depicted the public spaces in which the classes mixed, and, unable to be solitary he obsessively haunted these places in his own life. May's engagement with the visual surfaces of the city was intense. A fellow illustrator remembered his first encounter with May at the offices of the *Graphic*: "I can recall that first vision of his slim figure, his smile and his eye that seemed to take in all at once as he passed. It was a compelling eye; when it looked up from his drawing at his model, it was like a flash and gave one an uncanny feeling of insight."[33]

Born near Leeds in 1864, May was an unsettled figure who moved between classes both from necessity and by choice. His father was an unsuccessful

entrepreneur and engineer whose brass foundry failed. May claimed that he came from a poor background, and described himself as a guttersnipe and street urchin. Yet, although his middle-class family had come down in the world, it was not as destitute as May had suggested. On his mother's side May had rather distinguished theatrical connections. At fourteen, he joined a traveling stage company and drew caricatures of the performers that were displayed outside the theaters. In the early 1880s he came to London looking for work and on occasion slept in the open. But about 1883, his luck improved and May started his career as a caricaturist, initially working in a style inspired by Linley Sambourne of *Punch*. For about two years he contributed drawings to the *St. Stephen's Review* and in 1885 moved to Australia, partly for health reasons. During the three years he spent there he earned £20 a week drawing for the *Sydney Bulletin*, a well-respected paper known as the "Australian Bible." While in Australia May experimented with a range of styles and was particularly influenced by Jan van Beers and Caran d'Ache.[34]

Phil May's bold technique was supposed to have developed in response to the requirements of rapid reproduction, and Holbrooke Jackson recalled: "It was often said that the extraordinary economy of line which was a characteristic feature of his drawings had been forced upon him by the deficiencies of the printing machines of the *Sydney Bulletin*,"[35] which May vehemently denied. However, it seems clear that producing illustrations for rapid printing on cheap paper would have necessitated an easily reproduced, dependable style. Marion Spielmann stated that May grew to like the effect imposed by process and experimented extensively to produce the most economical line possible.[36]

May's artistic direction was further shaped by his exposure to contemporary French art in Paris. In 1888, with a generous backing of £1000 from an Australian patron, May returned to Europe with the intention of becoming a painter. A year later, after stops in Rome and London, he arrived in Paris, the hub of the contemporary art world. May had no formal training – he boasted that he had never taken an art lesson in his life, but he was genuinely eager to extend his practice. In Paris he encountered at firsthand the work of the French print and poster illustrators, such as Adolphe Willette, Théophile Steinlen, and Toulouse Lautrec, who had been inspired by the simplicity of Japanese art. May took a studio that he furnished with Liberty prints and Louis XVI chairs, but he didn't make much progress in painting. Like Beardsley, he was a master of the monochrome line but was unable to manipulate paint or color with the same ease. Instead, he plunged into Parisian bohemia.[37] With the painters William Rothenstein and Charles Condor, May became a constant presence at venues such as the Moulin Rouge where he would work on sketches and socialize with Lautrec. May's heavy drinking might have well been a factor in his artistic routine but Spielmann asserted that May wanted to study life and art, not in painter's studios but in the streets and public places.[38]

While in Paris, May illustrated a series of articles entitled "The Parson and the Painter" for his old London employer the *St. Stephen's Review*. These pieces delineated bohemian life in England and France as Charlie Summers, a young artist, introduced his unworldly uncle, the Reverend Joseph Slapkins, to the modern pleasures of both cultures. In London they visited Petticoat Lane, theaters, music-halls, clubs, sports events, and seaside resorts. In Paris their outings included the Chat Noir and the Moulin Rouge where Summers chatted with his friends Verlain and Rodolphe Salis. In his drawings, May mixed styles by combining fairly straight representational heads, probably based on photographs, with more freely drawn bodies and backgrounds. His work was fresher and more daring than before, influenced by the bold gestural marks of lithographic posters and by the techniques of French magazine illustrators. May was still finding his way, however, and experimented with a range of styles from very bold dramatic pen-and-ink to much finer crosshatched work. He used mechanical tints on a number of sketches, a technique widely employed in avant-garde publications, such as *Le Courrier Française* and *Le Chat Noir* to produce tonal variations in a line image. The artist would mark his original sketches with a nonreproducing blue pencil or blue wash to indicate the areas where tints were to go and these would be laid by the engraver. These dots could be specified in a number of different intensities and would give the effect of flat areas of shading, the advantage of which was that the image was still in line and would not need to be reproduced as a halftone. The flatness and artificiality of these tints evoked the aesthetic of the Japanese print.[39]

May's illustrated articles were published in book form with the same title in 1891, creating something of a sensation and laying the foundations for May's career.[40] After his return to London the following year, critics detected a strong French influence in May's increasingly epigrammatic pen-and-ink drawings. Walter Crane thought that May represented "the modern impressionist feeling in line drawing influenced by the Japanese; his outlines are often extraordinarily graphic, and convey a great amount of character with very slight variation, and very little detail."[41] This *Japonaise* boldness and simplicity led to May being described by the *Studio* as "the English Hokusai." The reviewer noted that, like the Japanese master, he captured the life and movement of street scenes with the "minimum of detail." He wrote that May had realized that the fewer lines there were, the more meaningful each one became, and concluded that "Mr. Phil May's simple line work is a keener and more brilliant expression of nature than would be the finest snapshot photograph that could ever be taken."[42] Crane, although he admired May's style, objected to the contents of his images; he identified in May's work "a noticeable tendency toward awkward composition and ugly or repulsive types" and considered this emphasis on the unexpected and the unprepossessing artistically flawed, straying too far from the harmonious, the ideal,

and the beautiful. As Morris' closest disciple, Crane believed that art should heal the fractured dissonance of contemporary life. But for May, the discords and ugliness of the everyday were at the center of his work.

May's first major new client on his return to London was the *Daily Graphic*, which, in 1893, sent him off on an abortive around-the-world trip.[43] May only got as far as Chicago and the Columbian Exposition before returning home. Nevertheless, Frederick Villiers, who was illustrating the exposition for *Black and White*, said he was amazed at the quantity of work May completed, given the amount of socializing he did. Over the next two years May contributed to all of the major illustrated journals of the nineties, including the *Pall Mall Budget*, *Black and White*, the *English Illustrated Magazine*, *Eureka*, and *ILN*. May also produced work for the *Sketch* and *Pick-Me-Up*, two of the most innovative illustrated magazines of the time. In 1895 May joined *Punch*, much more conservative in its approach but the most renowned illustrated humorous periodical of the period, becoming one of a group of staff illustrators who produced weekly "social" caricatures. Until his death from cirrhosis of the liver in 1903 at the age of 39, he was hugely popular and the most visible artistic personality of the 1890s.

Although May was renowned for the extreme brevity of his style it was often based on painstaking preparation. His pen-and-ink sketches appeared to be *chic*, that is, drawn from memory, but May used Londoners near his studio as the basis of his caricatures. After making a quick sketch in pencil, May posed his models to get the details of his figures. He also borrowed props and photographs from his colleague at *Punch*, Linley Sambourne, who had assembled a notable visual reference system based on an archive of photographs. Like most pen artists May first developed his drawings in pencil and would erase and refine these lines before filling in the final image in ink. He stated, "I knock away the scaffolding, so to speak, and in my final sketch I put in nothing but what I regard as the essential lines of the picture" and said that he took away "all that is superfluous and accessory."[44] The effect was to erase everything but the fundamental details of a scene. Holbrooke Jackson noted "May's work was always that of the brilliant sketcher who records only those essentials which express the soul of the object before him . . . with unerring instinct, he knew how to discard the merely superfluous."[45]

As he developed his style, May needed less and less preparatory work. He produced "lightning cartoons" in his public lectures and in social situations, impressing his viewers with their fluidity and skill.[46] His technique seems most pared down at mid-decade, when he was working for the *Sketch* and produced images that were collected in his *Sketch Book* of 1895. His album *Guttersnipes*, published the following year, contained some of his most vivid drawings. Perhaps there was an economic aspect to May's increasing simplicity. Because his daily round often consisted of pub-crawls with friends and hangers-on who sponged from their generous host, when May was short of

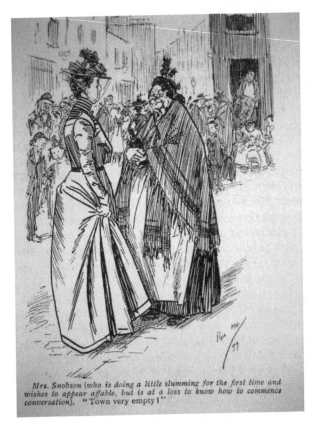

Figure 22 "Mrs. Snobson (who is doing a little slumming for the first time and wishes to appear affable, but is at a loss to know how to commence conversation). 'Town Very Empty!,' " Phil May, *Mr. Punch's Life in London*, London, Educational Book Company, 1908?, 121. (Photorelief line print from pen-and-ink drawing, detail)

cash, which was often the case, he would borrow an illustration board from the *Graphic*, do a quick drawing, and take it around to the *Sketch*. Money was left in the *Sketch's* reception area for any image he brought in.[47]

May was not only a success, but he had become a well-known figure on both sides of the Atlantic. The American critic H. C. Bunner, however, sneered at "the hopelessly vulgar 'middle class' who read Mr. Phil May's publications." Yet, May's series of eighteen *Phil May* annuals, published between 1892 and 1905, contained articles by distinguished literary and journalistic contributors including H. G. Wells, Kenneth Grahame, Walter Besant, Grant Allen, Richard Le Gallienne, Arthur Conan Doyle, and Raymond Blathwayt.[48] May provided drawings to accompany some of these texts as well as including many of his own sketches; some of the annuals

boasted more than sixty of May's images. May himself was a conspicuous presence in the annuals. His self-portrait appeared on the cover, a photograph of him was used as the frontispiece alongside a self-portrait drawing, and he drew himself in a jester's costume for the tailpieces to each article.[49]

May had numerous theatrical connections and interests and, like the music-hall and cabaret performers of the nineties, he consciously projected a distinctive personality through his appearance. Although he was a shy, taciturn man, he was a sharp dresser with his hair brushed flat to his forehead, an idiosyncratic style he claimed he had retained from boyhood.[50] May was attracted to the world of the turf, often drawing the shady characters associated with the sport.[51] In the midnineties, dressing across class, May adopted a loud horsy style of clothing, wearing the brash checks of the hucksters and conmen in the racing scene, and intentionally challenging bourgeois propriety by wearing clothes that suggested the shifty lower-class denizens of the track. His idiosyncratic appearance, circulated through his own drawings, meant that he rapidly became a highly visible figure. An Australian journalist friend recalled that on their evening rambles in London's West End, even American tourists recognized May and would insist on drinking with him.[52]

May can be seen as a combination of Beaudelaire's "Painter of Modern Life" and Poe's "The Man of the Crowd," incessantly moving through the city, observing its inhabitants with, to use Baudelaire's phrase, "an eagle eye." Driven by his addiction and his personality, May was unable to stop. Like the "Man of the Crowd," May had a desperate need to be in busy places and an aversion to being alone and so he was a constant presence in the theaters, clubs, restaurants, and pubs of the Strand and the West End. As an illustrator friend recalled, " 'My Strand' was the land of Phil's heart's desire. . . . For Phil it was the perpetual change and bustle of night and day, and the turning of one into the other in the wearying search for fun that wore him out."[53]

From these constant wanderings, May brought back scenes of classes mixing and colliding in the city. According to the *Studio*, May drew "the little comedies of modern existence," everyday situations, things that on the surface were not very dramatic.[54] His figures usually encountered each other in the streets, unlike, for instance, George du Maurier's upper-class *Punch* characters who were typically shown in private interiors. His social cartoons depicted the city streets as ambivalent public spaces, inhabited by indeterminate characters: entertainers, costers, sandwich-board men, and beggars. His working-class characters were often shown in conversation with their economic superiors, the purchasers of *Punch*, the *Sketch*, and May's annuals. There was not a great deal of physical action in the drawings; the two classes were shown encountering and often misunderstanding each other. The interest was in the subtleties of expression and pose in their interactions.

May's caricatures were usually hybrid texts, mixtures of spoken and visual communication, that often depicted brief, cross-class dialogues between individuals. The illustrator E. J. Sullivan described his sketches as drawings in which the text and the image were in absolute harmony, both being taken from everyday happenings. He recalled that May would seize on snatches of overheard conversation and use them directly in his drawings.[55] Yet, although the texts for these social sketches were from everyday conversations and the images showed typical interactions, the relationship of meaning between texts and images was far from straightforward. Instead, there was usually a tension between the dialogue – or "cackle" as it was known – and the sketch. May's work therefore articulates a state of tension, misreading, misunderstanding, confusion, and dissonance between the texts and the drawings, as well as within the images themselves. In social situations May, the man of few words, was as brief as most of his captions.[56] But, although his images and text apparently show a brief moment, the reading and misreading produced in the works involves the reader in a "double take" as they unravel the puzzling encounters of modern city life.

The figures in May's images are not persons but types based on his drawings from models who epitomized them. May used his readers' existing knowledge of these types, gained from other depictions in the press and theater, as the basis for his humor. The public spaces of the city are usually very sparingly indicated using just a few outlines or widely spaced parallel lines, leaving the viewer to complete the picture. Likewise, his figures are insubstantial, mobile, and fleeting and often consist of just a fluid outline. When they are shaded, the lines or mechanical tints seem to lie on top of the figure, sometimes spilling over the edges of the character, defining shape but not volume. His line is abrupt, scratchy, fragmented, and he rarely uses a solid black. Using this linear shorthand, May provided clues that enabled his audience to successfully categorize the types depicted.

Echoing Baudelaire's comments on modern illustration, J. M. Bullock stated that May "sees the satire of the streets with an eagle eye." He dubbed May the "Hogarth of costerdom," who used an appropriately unadorned line to portray his "primitive" characters with their common clothes, down-to-earth emotions, and "primeval physiognomy." The simplicity of these characters' worldviews and drives, according to Bullock, was reflected in the simplicity of May's style.[57] Certainly May's minimalist depiction of the "lower orders" permitted magazines to show individuals and situations that could not be pictured by the photographer. One of his obituaries declared that although May's images were realistic his work was never coarse; by excluding or only suggesting details the drawings became subtle and "aesthetically correct." If May had insisted on the "obvious surface facts" his subject matter would have become vulgar; this kind of selection and censoring was something a camera was unable to do.[58]

May, as we have seen, was particularly associated with the poor urban underclass, specifically the cockney or costerdom. The metropolitan masses

had been perceived as a threat to social order in London during the 1880s, when the capital was shaken by labor unrest, and the huge numbers of the nameless working class in the East End seemed an impending menace to order and propriety. Through the 1880s, E. J. Milliken's *Punch* sketches had established "Arry" as the epitome of the cockney, a lower-class cad masquerading as a swell. During the 1890s, the cockney, now recast as a costermonger, was established as a rough diamond with a heart of gold, and the performances of Albert Chevalier were central to this transformation. Chevalier was an actor rather than a music-hall entertainer, and he sang his first cockney songs in February 1891 at the London Pavilion. He invented a generic cockney, who spoke in a form of slang that could be understood by all audiences, even the aristocracy. His sentimentalized and depoliticized characters were taken up in other forms of representation. All of these characters were based on imagination rather than firsthand knowledge. As the dangers of class insurrection faded in the 1890s, the message that emerged through these representations was that the cockney was no longer a threat. As Gareth Steadman Jones argues:

> As a form of representation, whether brutal, comic, or sentimental, the cockney archetype was intrinsically connected with the attempt to discover and embody a form of national spirit in the city dweller, to break down the anonymous and shabby crowds into a catalogue of particular types and incorporate them into a national community.[59]

May's cockneys were very much in this genre and were praised by critics for their positive, cheerful character; the *Sketch* described his work as "the best sort of realism" with its optimistic view of the lower classes. Margaret Armour noted that in the popular weeklies "Phil May, Raven Hill and Greiffenhagen depict the sunny side of working class life." It was this positive attitude, she suggested, that kept these drawings of vulgar people within the bounds of acceptability. The *Sketch* contrasted May's positive view of the lower classes with George Gissing's fiction: where Gissing found sordidness and oppression, May found humor.[60] The cheerfulness of May's characters enabled them to survive in conditions of dire poverty; some of May's cockneys also relied on their quick wits, and were depicted as cheeky and rather shady; and, in general, these characters epitomized the resilient individuals who made their living on the streets. May's large numbers of middle-class readers would, in everyday life, have attempted to avoid the destitute, drunks, and street sellers that he described, yet, as the popularity of his work demonstrates, they were at the same time fascinated by these so-called coarse individuals, who, in fact, seemed to be enviably well adjusted to the conditions of city life. For the bourgeois reader the cockney seemed to represent freedom from social convention and sexual restraint.[61]

However, in some respects there was not in much of a gap between these groups. In economic terms artisans and clerks earned the same, and there

was a good deal of anxiety about the lower classes dressing like their superiors. May's drawings showed the city that the lower-middle-classes might easily descend into. The middle classes were, as we have seen, particularly vulnerable to changes in status and many were only barely "respectable." As Baudelaire suggested in "On the Essence of Laughter," humor rests on contradictory feelings. On one hand the viewer feels superior to, for instance, the person who is falling – "Look at me, I am not falling" – but laughter is also an uncomfortable sensation, "the expression of a double, or contradictory, feeling." He relates comedy to the "permanent dualism in the human being – that is, the power of being oneself and someone else at one and the same time." In May's images, I suggest, the middle-class viewer could see two aspects of themselves.[62]

Phil May's experience of actual cockney life was most probably limited, a northerner, his London home and studio were in a respectable and artistic section of West London. Although he was seen as the delineator of cockney life his models were not in fact East Enders, but came from Hammersmith. His leisure time was spent in the West End and the Strand. "Slumming it" with the working classes was popular with the upper crust and with artists such as Walter Sickert, but May does not seem to have been attracted to this form of entertainment. His own life was marginal and bohemian, poised between spheres of respectability and poverty and he probably felt no need to slum it.[63] Nevertheless, May's upbringing and his own economic hardships presumably gave him sympathy for the poor in general. His depictions of his characters made them sympathetic figures, but did nothing more than this: there is no suggestion that the extreme poverty of the East End could or should be alleviated. Gareth Steadman Jones noted that in the media "the prevailing tone of this new depiction of the cockney was conservative rather than reformist, and populist and celebratory rather than elitist and moralistic."[64]

May claimed that he wanted to emulate Hogarth in recording his times, and others also saw him as Hogarthian. However, he entirely lacked Hogarth's satirical and political perspective, and was not intent on changing society or improving the lot of the poor. As Spielmann wrote, "His aim is to show men and things as they are, seen through a curtain of fun and raillery – not as they might or ought to be."[65] James Thorpe also believed that: "He was concerned only with presenting clearly and simply the momentary humour of the story or situation, not with its possible sequel, nor with the deduction from it of any moral."[66] May was concerned with the fragmentary moment – a ludicrous instant – a personal encounter snatched from the chaos of the city, and his approach seems to have been related to his own pessimistic and fatalistic worldview. One of his fellow illustrators recalled his "hopeless eyes" showing a man trapped in the present with no dreams for the future, a man who was only interested in the city as a spectacle. Moreover, even if May had produced satirical images, it is unlikely that they would have been so widely

published, for the middle-class magazines in which his work appeared, would not have found space for a Hogarth or Cruickshank. Brian Maidment links together the wane of caricature and, by inference, the rise of these magazines when he notes "The decline of the caricature tradition . . . and the rise of the wood engraving to dominance as a graphic medium coincide closely with the emergence of the middle classes as a coherent social force."[67]

May's caricatures were, in some cases, the result of collaboration. This "multiple authorship," as Richard Terdiman puts it, was an extremely common practice at the time, and although illustrators signed their work the subject matter and texts were often provided by others. May had a locker at the *Punch* offices and would go there weekly to collect the suggestions sent to him by the public. He claimed that many of the ideas were unusable and that he usually wrote his own jokes, but he certainly used material from others, including Clement Shorter. *Punch* had a particularly well-organized system of multiple authorship, in which illustrators and journalists met for a weekly meal and thrashed out the subjects for the next issue's cartoons. Although it was openly practiced at the time, subsequent scholarship has often glossed over the fact that the image makers were often not the sole originators of their works.[68]

May's stylistic influences were his contemporaries from Linley Sambourne's *Punch* images, to French caricaturists such as Caran d'Ache. Unlike the decorative images of Beardsley or Ricketts the realist pen-and-ink sketches of the 1890s were entirely contemporary, displaying few historical influences. Illustration styles circulated rapidly and internationally in the press, thereby inspiring other image makers in Europe and North America. Henry Blackburn, urging illustrators to keep abreast of modern styles as the image was becoming increasingly transitory, stated, "It is an age of vivacity, daring originality, and reckless achievement in illustration. 'Take it up, look at it, and throw it down' is the order of the day . . . the life of a single number of an illustrated newspaper is a week, of an illustrated book a year." Fashions in illustration changed with increasing rapidity as illustrators strived to remain up-to-date and to introduce novelty into their work.[69]

The new source of artistic influence in the print media was a challenge to the existing artistic order. Illustrators had no need to attend academies to study the models for their craft, for cheaply reproduced drawings by the most popular and esteemed pen-and-ink artists were available from every bookstall and news-vendor.[70] These prints were final artworks, reasonably accurate versions of drawings that had been made for reproduction. Unlike press reproductions of paintings, in which color and scale were drastically altered, these images gave the fans of pen and ink a clear sense of the illustrator's style and intention.

Although would-be sketch artists could pick up a great deal from studying the images in the press, the increasing demand for illustrations led to calls for more formal training structures. In 1893, the *Studio* encouraged art schools

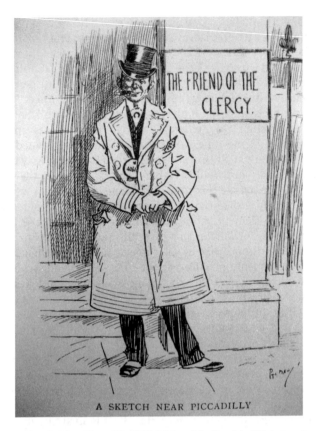

Figure 23 "A Sketch Near Piccadilly," Phil May, *Mr. Punch's Life in London*, London, Educational Book Company, 1908?, 164. (Photorelief line print from pen-and-ink drawing, detail)

to provide instruction in this new financially rewarding and economically important field.[71] In 1895, the *Publishers' Circular* emphasized that the press needed well-trained illustrators to provide an alternative to the overused halftone photograph: "Now that we are looking for something fresh when too much process illustration – without the intermediary of artists – is beginning to pall, let us hope that the means for developing talent will not be neglected."[72] Drawing for process demanded a different approach from the standard academic curriculum; an art education that prepared students for careers as painters did not enable them to think in linear terms. In addition, process images had to be prepared in specific ways if they were to reproduce successfully. The schools that did take on the training of illustrators were commercially oriented art schools able to break away from the rigid, centrally dictated curriculum and included municipally run schools, such

as Birmingham School of Art, as well as independent art schools, such as Westminster School of Art, and the new technical schools, including Bolt Court.

In London, Westminster School of Art was a training ground for some of the major illustrators of the nineties. Dudley Hardy, Maurice Greiffenhagen, Fred Pegram, A. S. Hartrick, Robert Anning Bell, Alice Woodward, and Leonard Raven-Hill all studied there. When he was a junior clerk in the early 1890s, Aubrey Beardsley attended Westminister's evening classes. These after work sessions were much more socially mixed than the school's day classes; in 1895 one group of evening students included a clerk, a salesman, a lithographer, a wood engraver, a street artist, and a countess. Bearsdley was taught by the charismatic young artist Fred Brown, whose Parisian-inspired approach encouraged students to experiment and to develop their own individual styles. In France charcoal had became the standard medium for life drawing, and Brown required students to use this medium to produce rapid studies that emphasized line and contour. These methods were a radical departure from the concentration on detail and tone dominating both the Academy and the state system.[73]

The technical schools, such as Bolt Court or Camberwell, were founded by local governments to provide a commercially oriented training. The lower-middle-class students who attended them were dismissed by some critics as jumped-up office workers. The author of *The Art of Illustration* remarked condescendingly on the backgrounds of the new illustrators that "the system is degrading all round, and, to meet the ever increasing demand for illustrations, good and bad, City clerks are being taught in droves at technical schools, under the auspices of the London County Council." The *Pall Mall Gazette*'s art critic also scoffed at the municipally trained illustrators emerging from art schools and technical schools saying, "Because a number of young men who do not like office work have taken to pencils rather than pens, we are asked to call them artists and be generous."[74]

Some press illustrations were produced by young clerks who only had a very limited art education, such as Beardsley, and others were created by artists, such as Dudley Hardy, who had been thoroughly trained at art schools in England and in the studios of Paris. Other images were made by individuals such as Phil May, who were entirely self-taught. In press interviews the illustrators who had attended art colleges were at pains to downplay their schooling. The denial of Academic influence by illustrators had a number of reasons: a traditional training would simply not have been appropriate for this radical new form of image making; in addition, illustrators could position themselves as being involved in everyday life, as opposed to the rarified world of art, and if they appeared to be untrained, their successes could be attributed to their innate personal talent, rather than education.[75]

The divisions between fine art and illustration were not as clearly defined as they would become in the twentieth century. Although May practiced

almost entirely as a humorous commercial illustrator, his work was admired by the leading artists and critics of the day, and he moved in artistic circles socializing with Whistler, Crane, and Lord Leighton, the president of the Royal Academy; he participated in shows alongside Whistler, Monet, Rodin, and Toulouse Lautrec.[76] Like a number of other illustrators during the midnineties he exhibited at the Fine Art Society in Bond Street.[77] The illustrations of May, Beardsley, and William Nicholson were published in portfolios and limited editions that aimed at collectors, an example of which was May's *Songs and Their Singers*, issued in 1898 in a portfolio of "Japanese proofs."[78]

Process-illustrated magazines not only provided a new venue for image making outside of the established structures of the art world, at the same time they also encouraged a new kind of illustration because the format and practices of the mass periodical opened up fresh opportunities in terms of composition and subject matter. In the 1870s, the artists of the *Graphic* had engaged with a wide range of contemporary subject matter; these images were commercially successful and influential. Hubert Herkomer's discussion of his painting "The Last Muster," originally drawn for the *Graphic* in 1871, is worth considering in terms of this departure from existing models of image making. It shows retired soldiers at the Royal Chelsea Hospital attending a chapel service and one of them has died quietly in his seat. In 1877, when Herkomer enlarged his image to a huge scale, the picture created a sensation at the Royal Academy Summer. Herkomer maintained that this image differed compositionally from an Academic painting as it was a fragment, rather than a conventional pictorial composition, and that "It represented a 'section' of the chapel, with all the figures, sitting in their benches, that that section contained. It had no beginning and no end in the grouping of the figures; and it only suggested by the attitude and demeanor of the pensioners, that a service was going on in the building, which was unmistakably a chapel."[79] Rather than showing a complete scene, the section implied a larger picture. The characters, cropped in an apparently arbitrary fashion, became the focus of the painting. This kind of fragmentation, Herkomer thought, gave the image greater visual interest. Ruskin, in his review of the Royal Academy show of 1875 acknowledged that "The Last Muster" made a good illustration, but disapproved of its use as a painting and deplored this move in fine art away from the ideal toward the accidental and the ephemeral. He saw illustration and paintings as both tainted by their rapid production and consumption and suggested that the exhibition had became merely a three-dimensional version of the *Graphic* itself.[80]

In contrast to process illustration, the fiction illustrations of the 1890s were a continuation of the tonal wood engravings the *Graphic* had developed. The illustration of the novels and short stories that had became an important aspect of periodicals, often required a higher degree of finish than the sketch, one that was closer to the tonality of the photograph. Although

these images were more detailed that the pen-and-ink sketch, they were, as Herkomer's example demonstrated, fragmentary in both their composition and their content. Anne Hollander argues that the apparently arbitrary composition of the fiction illustration of the 1890s engaged the viewer in a particularly compelling way by arousing their curiosity and she cites Sydney Padget's Sherlock Holmes images from the *Strand*, as an example, for, like Herkomer's work Padget's images were framed so that the composition itself was unresolved.[81] Illustrators asserted their new right to choose which incidents to depict, often showing less dramatic moments from a narrative, moments that depended for their interest on the illustrator's abilities rather than the story itself, moments that were fluid narrative fragments.[82]

Undoubtedly, the production and reception of these fragmented illustrations were influenced by the photograph, just as the cropped forms and apparently chance framing that Herkomer described were intrinsic to photography. Many illustrators, including Herkomer himself, used photographs in their practice. In his book of photographic information and advice for artists Hector Maclean maintained that the vast majority of contemporary painters made "free and full use of all the help they can get out of the camera." Although painters were reluctant to acknowledge their use of photography for fear it would damage their reputation, illustrators, he claimed, "unblushingly own up." Maclean stated that illustrators, working to tight deadlines, could coalesce raw data from photographs into meaningful and effective narratives, and he argued, "I may say that those who live by the newspapers cannot hope to succeed unless they are habituated to working from photographs, and have acquired the facility of rapidly combining photographic information supplied them into a telling and forcible statement of pictorial story."[83] One of the advantages that illustration possessed over photography was that it was able to combine elements from different moments in an event within the same image in order to tell a story.

As the contents of Mclean's handbook suggests, illustrators incorporated photography into their practices in numerous ways, using the camera as a research tool so that it became an adjunct to or a replacement for sketching; photographs were also used as references for people, places, and objects that image makers had neither time nor opportunity to study firsthand. Its role expanded when the huge demand for illustration in the 1890s required a faster pace of image production.[84] The veteran illustrator Frederick Villiers, dispatched to the Chicago Columbian Exposition of 1893 by *Black and White*, admitted that of the one hundred and fifty illustrations he produced, only around six were developed from observational drawings; the rest were based on snapshots that he had worked up into illustrations. Blackburn commented that "The photographer is, as I said, marching on and on, and the demarcation between handwork and photographic illustration becomes less marked every day."[85] Blackburn, something of a traditionalist, worried that illustrators were becoming dependent on the camera to do their

seeing, and relying less on their direct personal experience of a person, place, or object.

On a wider scale photography had changed the entire visual terrain, and its influence on illustration was inescapable. Gleeson White, writing in 1895, maintained that photography had shaped the public's expectation of all imagery. He suggested that in the past illustrations had been symmetrical, composed, stiff, and static, comparing them to the artificiality of opera. Indeed, the popular illustrative tropes of midcentury consciously evoked the dramatic poses of the theater where actors adopted conventional poses and gestures familiar to the audience. These narrative images in the press were also, in a sense, performances, staged and assembled by the illustrator in order to tell a story.[86] Nowadays, Gleeson White argued, contemporary illustrators' informal asymmetrical compositions were a response to the photographic aesthetic and stated:

Turn to modern illustration, and you will find always an effort to be naturalistic – in the photographic sense – that is, an imitation of the accidental grouping of common life, in place of the arbitrary pose of grand opera. Today we find the figure, half cut off by the frame, or playing almost secondary parts amid their surroundings. A chair-back or a tree may be usurping the important place, and human beings be no more always to the front than they are in the common order of things.

Gleeson White argued that although illustrators themselves might also have been influenced by the Japanese print in their cropped compositions, public taste certainly had not, and only accepted the new style of illustration because the photograph has already made the fragmentary image familiar. "In this respect it seems hardly possible to over-estimate the importance of the silent teaching of the photograph," Gleeson White said, and also suggested that the photograph had prepared the viewer for a new kind of subject matter, the everyday episodes central to the new illustration. Photography had, he argued, given the public a new appreciation of the "effects of ordinary life, heretofore deemed too common to be represented in high art."[87] The photographer Major John Nott claimed that photography's popularity was due to its unequalled ability to capture the rapidly changing contemporary scene, like Gleeson White he complained that Academic artists had ignored this everyday subject matter but now everyone could be caught by the camera.[88]

This emphasis on the disjointed and the everyday and the move from the beautiful and ideal were not universally welcomed. From Walter Crane's point of view this was a unhealthy step. He believed, like Gleeson White, that photography had heightened the artist's awareness of appearance, of the accidental and transitory, but Crane, a graduate of William Linton's "office" and follower of Ruskin and Morris, saw this as a troubling new

direction. Instead of finding regularity and pattern in nature or using the visible world as an inspiration for ideas, illustrators were now imprisoned by the visible fact. Not only had their content become less motivated by concepts, but the way in which modern illustrators delineated their images had become more mechanical. Crane feared that as more illustrators worked from photographs and mimicked their tonal qualities, the decisive, observed, and imaginative individual mark would disappear from the popular media. However, although he thought photography had influenced audience's expectations of imagery, Crane did not see the photograph as the only factor driving these changes in the visual realm but, rather, photography was enmeshed in a wider cultural shift toward "superficial facts, and instantaneous impressions."[89]

Hybrid combinations of the photographic and the hand drawn took a number of forms, with a number of motivations. Many of the news images in the press, for example, were based directly on photographic sources. When William Thomas, the publisher of the *Graphic*, was planning the first illustrated daily newspaper, he set up an in-house school to train illustrators to work for process. The *Daily Graphic* relied on line-relief reproduction for most

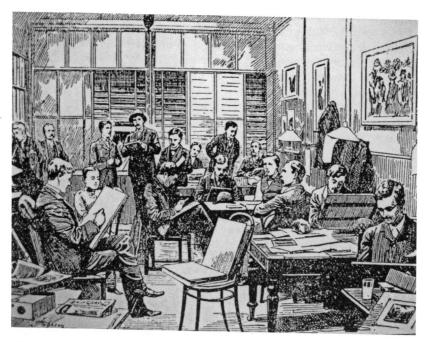

Figure 24 "The 'Daily Graphic' Studio," *Journal of the Society of Arts*, January 30, 1891, 179. (Photorelief line print from pen-and-ink original.)

of its images, tonal images being too time consuming to print at this stage. Its illustrators were trained to draw in a rapid, interchangeable style so that they could work in teams on large drawings.[90] They were also taught how to clarify and simplify photographs, perhaps tracing the image or working directly on a photograph before bleaching it out. The conversion from tone to line was a means of quickly and cheaply producing clear images that would be easy to print. In the *Daily Graphic* the photographic origins of the drawing were not concealed; in fact, in order to bolster the trustworthiness of the image, its caption often announced that it was based on a photograph.[91]

Gleeson White provided students with detailed instructions for bleaching out the photographic image after it had been drawn on. He averred that this method should not be a substitute for drawing but a time-saving device especially useful in portraiture and architectural work. He noted that the bleaching process was much used in the daily and weekly press because of the difficulty of reproducing halftones, yet he also saw the technique as a means of providing a more direct and effective image than the photograph by "effacing the needlessly minute detail recorded by the camera." To achieve this it was necessary to ruthlessly remove most of the image; "Of one hundred facts to the square inch ninety must be discarded," he said, and warned that this kind of editing wasn't easy to do, but by working selectively it was possible, with practice, to produce a "charming" image. He advised that the illustrator work in a free manner on an enlarged photograph before photographically reducing the final image. This method would produce an artistic drawing whose appeal lay in the imperfections of the loosely sketched lines.[92]

Gleeson White advocated this minimal and irregular approach for aesthetic and conceptual reasons, yet in many cases illustrations based on photographs used their "sketchiness" to efface their photographic origins. As Gleeson White noted, hybrid drawings gave the illustrator a means of rapidly generating easily reproduced images, but they were also used by illustrators who were simply unable to draw. T. C. Hepworth insisted that no great skill was needed to produce what were known as "line drawings" – merely practice and application. He provided explicit directions on drawing from a photograph so as not to give the source away and explained that the illustrator must aim for a "sketchy" rapid effect which was as far from the photographic aesthetic as possible. One trick was to copy every detail of the photograph in pencil and then go over it with ink lifting the pen every quarter of an inch, a method that automatically produced wavy, gestural lines of varying thickness. He suggested that Joseph Pennell's work should be studied to get an idea of the most widely used method.[93]

Linley Sambourne, the illustrator who was one of Phil May's early influences, used photography in the most sustained, open, and well-organized manner of any illustrator of the 1890s. He was a keen amateur photographer who assembled an archive of thousands of carefully filed images. At *Punch*

Sambourne had to produce accurate, topical cartoons to very tight deadlines. He was given the subject of the weekly's full-page political cartoon on Wednesday evenings and had to deliver the finished drawing two days later. Spielmann stated that Sambourne used photography as *"documents d'authenticité,"* that is, as a means of ensuring that his images were up-to-date and correct. Since he was dealing with current events and well-known personalities, the accuracy of his images would indeed have been important. But his dependence on photographic reference was actually more extreme than Spielmann suggested: Sambourne, who had no artistic training, depended on photographs that showed the exact pose of his characters, the precise angle of a head, for instance, before he could produce a reiteration of it through drawing. To that end, he photographed models and his servants in very specific poses, with the resulting illustrations photographically precise but somewhat cold and machinelike.[94]

Sambourne was one of the illustrators who found the transition of photographic reproduction difficult, for even though he relied on photographic reference extensively, up to the 1890s Sambourne's rigid aesthetic had been softened by the variations and slight imperfections of wood engraving. He worked in pencil for the woodblock, but when *Punch* switched to photorelief-line reproduction Sambourne had to abandon pencil and only use pen and ink. He was forced to simplify his style, which only served to further heighten the stiffness and harshness of the finished images.[95] The faults of a drawing were often exposed by process reproduction, and according to critics, the results were often unsuccessful.[96]

Line process initially required that illustrators use very black ink on very white board as the camera could not pick up fine or indistinct lines. But even when originals were prepared according to these limitations, the outcome was unpredictable. Although Joseph Pennell urged that illustrators should know the technical requirements of process drawing, he admitted that it was difficult to say how illustrations would turn out, because the results could vary so widely. Areas might appear light for no reason, and subtleties could be lost in printing; dark lines might darken, and scratchy lines become more so. Particularly in newspaper work, with its fast presses and poor paper, it was difficult to forecast the appearance of the finished printed piece, and illustrators therefore adopted bold, sketchy styles that could cope with this unpredictability. Herkomer criticized the results, saying that "The vicious necessity to 'draw for the process' which has arisen in late years has led the illustrators in the coarse and summary treatment of black and white which is now almost universal."[97]

As line process was refined during the 1890s, it was able to capture fine lines and crosshatching, and there were no longer any technical reasons for using stark black lines on smooth white paper. Yet, the bold stylistic conventions associated with process's early technical limitations remained. Henry Blackburn criticized the fashion for busy, bold, scratchy, and meaningless lines and insisted "There is no reason why in drawing for process, a

man's coat should be made to look like straw, or the background (if there is a background) have the appearance of fireworks."[98] Blackburn was clearly irritated by what he saw as the development of conventions in an arena that was supposed to be free of restrictions.

Yet there were a number of reasons for the continuation of these bold sketchy styles, some of which were economic. The illustrator Leonard Raven-Hill complained that process firms were unwilling to spend time capturing the linear complexity of his originals. They wanted clean, easy-to-reproduce work and expected the illustrator to sacrifice the variations of line in his original in order to achieve this. His own drawings had been wonderfully reproduced by the French engraver Gillot, although this attention to the autographic gesture had, paradoxically, entailed hand retouching.[99] Art editors therefore played it safe and were unlikely to devote time and money to potentially hard-to-reproduce originals. Particularly in the weeklies, editors did not want to risk slowing down the printing presses, so work that appeared bold and easy to print was therefore preferred.[100] In addition, as we have seen with May's images, the stylistic conventions of boldness and minimalism seemed appropriate to their subject matter and journalistic context, their brevity and liveliness fitting perfectly within the fragmented, paragraphic new journalism of the 1890s. Speaking of the apparent rapidity of pen-and-ink sketches, Margaret Armour stated, "Such draughtsmen dance to the tune of the letterpress, which is seldom a stately measure."[101]

In 1895 there appeared to be a shortage of illustrators as the numbers of drawings increased in an increasingly visual print media. Only a year later, however, the field became much more competitive. The *Magazine of Art* commented on the many new books on drawing for reproduction tempting people to become illustrators; the review advised caution and stated that there were many unemployed illustrators who knew more than these books could teach. By 1897 the field was apparently flooded. The *Studio* referred to one reason for the dramatic growth in the numbers of illustrators, saying that "The army of black-and-white draughtsmen is constantly reinforced by recruits fresh from Art-Schools, in London and the provinces."[102] In 1896 Pennell gave a series of lectures to a group of these students at the Slade School of Art. In the first of these he announced that the profession of illustration was now full of a "crowd of squirming, struggling, advertising hacks." Commerce was the only concern of most illustrators, and many of them were in desperate straits. In the course of a few short years, he asserted, an intense competition had emerged in an overcrowded profession that had led to sweating and a decline in quality. Pennell's tirade must have left his young audience in a thoroughly depressed state.[103] In his survey of contemporary illustration two years later H. W. Bromhead also noted the intense competition in the trade but, in contrast to Pennell, he suggested the struggle for work had raised standards.[104] Despite Pennell's gloomy picture,

illustration continued to provide employment for young men and women as the press demanded increasing quantities of rapidly produced images. The position of these illustrators was not challenged by photography, as it took many years before photographs began to oust illustrations from the press. Rather, a mixture of the two continued in both newspapers and magazines well into the twentieth century.

7
The Photograph on the Page

> The trail of the camera is too much in evidence in the work of the
> artist, while too often the artist has been entirely superseded by the
> photographer, and instead of the vigorous, masculine handling of
> the engraver, we see only for the most part the thin, emasculated
> tones of the machine-made picture.
>
> – H. Lamont Brown, "Facts Versus Art," *Penrose Annual*, 1898[1]

From the 1840s, wood engraving had translated the continuous tones of
the photographic surface into raised lines that could be printed alongside
type. By the 1880s, it had become common practice for photographers to
supply press agencies and magazines with photographs that would be traced
by pen-and-ink artists for reproduction by line process; in 1884, Stephen
Horgan claimed that the majority of the portraits in the American press
were derived from photographs.[2] The following year, *Amateur Photographer*
reported that in New York "innumerable" prints were made each day for
use as the basis for drawings and stated, "etchings and relief prints managed
in this manner, are frequently of equal beauty to any well-executed wood
engraving."[3] By the late 1880s, halftone technologies were making the repro-
duction of photographs in the press more economically viable, and with the
increased efficiency of halftone techniques during the 1890s, the demand
for photographs increased still further.

A British trade journal noted in 1887 that "there is a larger resort than
ever on the part of newspaper proprietors to cheap illustrations, and about
a dozen firms in London alone are now engaged in furnishing surface
blocks from photographs produced entirely without the intervention of the
engraver."[4] By the early 1890s, periodicals on both sides of the Atlantic had
began to incorporate the photograph into their journalism on a regular basis,
as editors realized that the halftone was an attractive way of filling edit-
orial space and capturing new readers. Their first problem was how to place
these plentiful images with their different tonal appearance on their pages.
The active and complex layouts of type and image in the process-illustrated
magazines mark the beginning of modern graphic design.

Lecturing to the Society of Arts in 1891, Carmichael Thomas of the *Graphic* commented on the novelty of the use of photography as a means of illustration:

> In America there is another startling change in illustrated journalism, for some of the papers over there are not only giving up the wood-engravers, but they are giving up the illustrators as well. The illustrations are composed of photographs taken from nature or life, and reproduced direct by process without a touch from artist or engraver. The manager of the paper, instead of asking an artist to illustrate a story puts it in the hands of a photographer, and makes him do the work with his camera. Here, on the screen, is an illustration to a novel prepared in that way. In another case the manager wishes to illustrate the work being done by the Salvation Army in New York, and sends the photographer around with the reporter, instead of the artist. The result is terribly monotonous and devoid of artistic treatment, but I think it is interesting here, as showing the latest developments of illustrated journalism.[5]

It is telling that imagery which was intended, in this case, to communicate specific information about the work of the Salvation Army, was expected at the same time to be more than factual and that it should ideally also be "artistic."

The coming of photomechanical reproduction challenged the editorial structures that had matured in the illustrated press over the past fifty years. Up to this point it was usual for one editor to oversee the literary content of the magazine while an art editor looked after illustration. Some of these art editors, such as Mason Jackson of the *Illustrated London News*, dominated their magazines.[6] Often the visual content of the press was controlled by men trained as wood engravers, like Jackson or William Thomas, the publisher and art editor of the *Graphic*, and the father of Carmichael Thomas.[7] However, the art editors of the eighties and nineties were much less likely to have any knowledge of, or attachment to, wood engraving, and, in any case, process reproduction demanded new methods of visual management. Clement Shorter, who became editor of *ILN* after Jackson's departure, advised that weeklies which were mainly photographic should have only one editor. He believed that this arrangement was an "absolute condition of success, so essential is it that the photograph and its accompanying letterpress should be interwoven under the direction of a single mind." Shorter had grasped from his editorial experience that the drawn illustration and the photograph operated in different ways and that the semiotically indeterminate photograph needed to be carefully anchored by the text. He thought that this could only be done by someone who had a clear grasp of both the texts and the images in each issue.[8]

It was acknowledged by editors that the pictures were the weekly magazine's main attraction, and so their positioning was a key consideration.

In most illustrated weeklies a dummy was made up by the assistant editor a week before publication, with spaces for photographs and drawings decided on first and the texts then arranged around them. The art editor then chose and briefed the illustrators. After the illustrations were completed and the text proofed, the editor would cut up the columns of text and the images to adjust the balance and harmony of the pages.[9] The perceived monotony of purely photographic spreads was relieved by the introduction of decorative borders or line images. Achieving typographical unity was a particular problem with the variety of kinds of image that were now incorporated in the press.

With the increase in the number, complexity, and variety of imagery in the press, the layout, reproduction and printing of magazines became much more complex. With wood engraving the design of the magazine was comparatively straightforward as there was one type of reproduction process and a limited range of pictures. Wood engraving harmonized with type and unified diverse material, including photographs, through its web of lines; process, on the other hand, tended to emphasize the differences between originals. An art editor might need to place line process, tonal wash, halftone photographs, and ersatz wood engravings all on the same page.[10] Halftone reproduction brought other restrictions, such as the need to place dense images so that they were backed by text and not by another image. With the heavier ink coverage produced by halftone, the image could show through onto the other side of the page. Process was notoriously unpredictable in terms of the printed results. In the past, the master engraver would guide publishers and editors on the details of reproduction and, as we know, many editors and art editors had backgrounds in wood engraving. With the multiple pitfalls and possibilities opened up by process, more editorial expertise was required, but seldom existed.[11] Some magazines were able to call on their in-house process departments to supply images and technical advice; even so, blocks would come from a variety of process houses, each possibly bringing a specific technical problems. Not all editors were up to the task, unsure how images needed to be produced, retouched, and printed.

In order to fill the spaces allocated for images, editors needed a steady and dependable supply of suitable material, and they could not rely on news images. Newsworthy occurrences were unpredictable and the availability of photographs of these incidents even less dependable. It is significant that the early photographically illustrated magazines contained little news. Magazines such as *Lady's Pictorial*, the *Illustrated Sporting and Dramatic News*, and the *Sketch* specialized in the imaging of leisure and fashion rather than news events. In addition to images of this subject matter, magazines also drew on non-news genres of imagery that had been staples of the illustrated weeklies since the 1840s: there were numerous portraits of personalities as well as images of staged, predictable ceremonies, such as royal weddings, state visits, and municipal openings – the kind of prearranged events that

became known as the "photo opportunity," which, up to this point, had been visualized by illustrators and wood engravers who sometimes used photographs as the basis of their imagery. The halftone photograph added to the imaging methods available, but did not introduce new kinds of images.[12] Photographers conformed closely to the established norms for composition and content, for as Maren Stange asserts, photographers continued the "narrative and rhetorical strategies" that were already established in the pictorial press.[13] Initially they kept well back from their subject matter, and it was only toward the end of the decade that photographers started moving closer and framing their images in a new way.

By the early 1890s, art editors could rely on a number of sources for their photographs. Indeed, there was already a well-established industry in place for the recycling of images, which had developed from the practice of printing firms and publishers lending their woodblocks to others. These collections were often extensive; the printer William Clowes, for example, had a stock of over 80,000 blocks.[14] Eventually specialist "cut agencies" developed to supply magazines not only with woodblocks that had already been printed elsewhere but also with original images. By the 1880s, large agencies, such as the American Press Association and Nops' Electrotype Agency distributed everything from hybrid line illustrations and ornamental designs to handmade fashion images and halftone photographs of celebrities. Nops claimed to be the largest cut supplier in the world and issued a classified catalogue of its holdings. It provided material in a number of formats, including wood engravings, line-process blocks, as well as halftone blocks in different screen rulings. Their stock of clichés included much material that had already appeared in periodicals, both in Britain and abroad, in addition to cuts they generated themselves. Much of this material was generalized and standardized in its approach, and it is during this time that the terms *cliché* and *stereotype* took on their current meaning.[15]

The extensive availability of images was a relatively new phenomenon. In the early days of pictorial journalism, draftsmen and illustrators had to base their images on written texts or direct observation. London-based illustrators such as the young Walter Crane often used books and prints in the British Museum's collections. By the 1890s, though, there was a much richer range of imagery available to the sketch artists who worked for the press, and much of this reference material was culled from other periodicals as magazines systematically assembled archives of material by stripping prints from rival magazines and foreign journals.[16] These were stored along with a publication's own images and blocks for later use. For example, the illustrations of a German royal wedding in 1903 were based almost entirely on 1881 images of the Kaiser's nuptials.[17] Throughout the nineteenth century there had been proposals for ordered collections of photographs for educational purposes, which eventually came to fruition, in a way, with the image archives assembled by magazines, and, later, by photographic agencies.

In the twentieth century the collections of media organizations and photographic agencies became image libraries, such as the Hulton Press's Picture Library, which is now part of the vast online digital archive owned by Getty Images. The first specialist photographic agencies were established in the mid-1890s, including the Illustrated Journals Photographic Supply Company, founded in London in 1894, and the Bain News Picture Agency, launched a year later as the earliest dedicated photographic agency in America.[18] And by 1897, a variety of new firms also ensured that magazines had a regular supply of illustrative material. In London there was Hare and Company, Walter Hill and Company, the National Press Agency, and T. B. Browne. Printers, process houses, advertising agencies, and magazines all offered images.[19] Underwood and Underwood, which started as a producer of stereoscope cards, would later dominate press photography, and by the turn of the century had offices in Toronto, New York, and London.[20] The major British photographic agencies at the time were Bolak's Electrotype Agency, the Illustrated Press Bureau, Nops, Augustin Rischgitz, Van Noorden, and W. P. D. Press Agency, agencies that could supply images of distant events magazines were unable to cover.[21]

From the middle of the decade, a small number of publications started to employ in-house staff photographers in order to report on specific events; many magazines also drew on the services of well-known portrait photographers for their images of celebrities. The *Sketch*, for example, used such leading firms as Alfred Ellis, Bassano, W. and D. Downey, and Russell and Sons in its coverage of the theater. These photographers, with prestigious central London addresses, had an established and profitable trade in selling celebrity prints to the public, a market that would be soon destroyed by the illustrated press. Editors could also call on professional photographers in the regions to cover news events and local celebrities. Some of these photographers worked fairly regularly for publications, but only a handful of firms specialized in press imagery. Many of the photographs in the periodicals were supplied for free by those with something to sell, such as artists, theaters, and manufacturers. Even the public could submit images, and some magazines found that photographic competitions were a cheap way of filling their pages with pictures.

For would-be illustrators there were training schools, and instructional books, but there was no similar support for budding press photographers, only a smattering of articles on press photography in the journals aimed at amateur and professional photographers. Major John Nott, an active amateur, who contributed images to the *Graphic* and the *Daily Graphic* that were used as the basis for manually traced line process images, offered advice to his peers in 1891. The guidance that Nott gave demonstrates that press photographs were made within a framework of expectations and beliefs about the role of representation. Photographers who worked for the press constructed images with expectations of what their employers required in

Figure 25 "Some Snapshots of Barnet Fair by Mr. T. G. Callcott, Teddington," *Sketch*, 3.33, September 13, 1893, 369. (Photorelief halftone print from retouched photograph, detail)

terms of content and style. These photographs were created within the existing reporting practices of the illustrated magazine, and, as such, they aimed to produce a meaningful representation of an event rather than "capture" a fragment of reality. As Miles Orvell notes of early photographic practices: "What one finds, in short, is that even while the image was presented as a 'document,' the photographer was constructing a general representation, a simulacrum of the real thing. Once again, verisimilitude was the goal, though verity was the claim."[22]

One factor shaping these photographic constructions was the requirement that they should be aesthetically attractive, for as Nott cautioned, although historical truth must come first, the photographer must also try to produce a pleasing composition. As he was forced to work rapidly and decisively, formal artistic rules should become second nature, almost mechanical. Nott's paradigm for press photography was the recording of the unveiling of a monument "by some person of eminence, with an imposing ceremonial," a category of image long a favorite of the illustrated press. Nott recommended that the photographer always keep the meaning of the ceremony in mind,

with its narrative of rank and dignity; the purpose of the final images was to tell this story. The photographer must therefore find out what is going to happen beforehand, and position himself to capture the key moments that would "give him his pictures." Unlike a sketch artist, the photographer could not select elements from a scene and so must wait for "the proper moment." If this instant was captured correctly by the camera, the image would "tell its own tale," only requiring a slight leap of imagination on behalf of the reader to hear the cheers of the crowd and the band playing the national anthem.[23] Nott's recommendations demonstrate that rather than capturing a slice of "reality," the photographer was involved in the careful construction of a preconceived narrative, with the photographer, participants, and magazine working together to create a comprehensible and acceptable representation of the world.[24] Photographers, in fact, were working within the formats of press imagery that had been developing over the past fifty years.

The forward-looking publishers of the *Photogram* and the *Process Photogram*, Catharine Weed Ward and Henry Snowden Ward, wrote the first English manual on press photography in 1901. Only 48 pages, *Photography for the Press* was published because of "the increasing importance of press work to all classes of photographers" and was aimed at the "outside" photographer who would occasionally contribute a photograph to periodicals "on spec." According to the authors, magazines' reluctance to employ more staff photographers or to go to the expense of sending them all over the country had opened up new opportunities for local photographers. The Wards advised that photographers should specialize so that editors would think of them when they needed a particular genre of image. They listed half a dozen large London firms dedicated to celebrity portraits, and other more arcane specialists included Gambier Bolton and his zoo photographs, Charles Reid's domestic animals, and Thomas Fall's pedigree dogs.[25] The book contained technical advice, suggestions on taking and placing photographs with periodicals, a list of photographic agencies, a directory of periodicals to approach, and advertisements for professional press photographic equipment. It also includes some detailed information on copyright for photographers.

The contents of *Photography for the Press* indicate that photographic journalism was beginning to establish institutional and technical structures as well as stylistic conventions. The Wards lamented that photographers were slow in taking up this new area of practice, but at this stage the status of press photography was low. Another reason for photographers' reluctance to deal with the press may have been the pirating of images, practiced by both dubious and respectable publications. Indeed, since 1893 the problematic nature of mechanical replication had been a regular topic in the photographic press. The widespread illegal copying in the press forced photographers to try and prevent piracy and assert control over the use of their originals.[26] The Wards gave sample prices for press reproduction, which varied according to the size of the photographs and their position within the

magazine and ranged from ten shillings sixpence for a four-by-three-inch image printed inside the periodical, to sixteen guineas for an exclusive news photograph on the front page.[27]

The book's list of periodicals that photographers could contact suggests the scope of English press photography at the beginning of the twentieth century, with most of the opportunities existing in the weekly market. The list of general weekly magazines included *Black and White, ILN, Illustrated Bits*, the *Illustrated Mail*, the *Penny Magazine*, the *Sketch*, the *Sphere*, and *Pick-Me-Up*. There are also a number of women's weeklies, such as the *Gentlewoman, Girl's Own Paper, Lady's Pictorial, Ladies Field*, the *Queen, Woman at Home*, and *Home Notes*. Specialist weeklies such as gardening, sports, and country magazines brought the total of photographic weeklies to 80. In contrast, only two daily papers were listed, the *Daily Graphic* and the *Daily Mirror*.[28]

The extent of the photographic material available to these periodicals can be gauged by another Ward publication of 1901, the *Index of Standard Photograms*. The book was a massive classified listing of available images and of photographers who could supply prints to the press. This directory, aimed mainly at "Authors, Editors and Publishers of Illustrated Books and Periodicals,"[29] included many thousands of photographs arranged by subject. The index enabled editors not only to find existing photographs but also to contact photographers with specific expertise. The vast majority of these photographers supplied press images as an adjunct to their commercial practice, but there were a few who specialized in press work. American women photographers appear to have been particularly active in this new area of practice.[30]

In total the *Index* lists 219 photographers as "professional illustrators," including a number of firms specializing in press work. The entry for Symmons and Company states they "are press photographers only, and do not sell prints except for reproduction"; the Brighton firm R. C. Ryan also specialized in press photographs; Reinhold Thiele and Co. claimed to have one of the largest collections of pictures made specifically for the press; and R. W. Thomas concentrated in sports including cricketers, footballers, and particularly cyclists, many of the images of which were featured in the *Sketch*. The *Index*, in fact, recorded around 4500 portraits of sporting celebrities.[31] The Wards suggested that many commercial photographers were neglecting this potentially lucrative source of business and claimed that photographers who specialized in press work could earn hundreds of pounds a year.[32] There were indeed, some major firms who were making considerable profits from press photos.

The Wards' index covered professional photographers but magazines also solicited images from readers, who could now make their own pictures. The introduction of the Kodak in 1888 made the practice of photography much more accessible so that now individuals no longer needed to learn to develop

and print their own film, but simply shoot the photographs and send them to Eastman Kodak who returned the finished prints. By 1896 Kodak had sold over 100,000 cameras in the US and Britain. Carmichael Thomas admitted that the illustrated press owed a great debt to these nonprofessional photographers and claimed there was no longer any need to send artists to cover distant or unanticipated events, because so many people now carried cameras there was almost bound to be a photograph.[33] But Major Nott, who worked for Thomas at the *Graphic*, argued that many of these snapshots were "haphazard" and useless, lacking the careful planning and selection that he thought was essential for press photography.[34] Thomas, on the other hand, saw these photos as simply the raw material for extensive retouching – they would inevitably be manipulated or redrawn to overcome their deficiencies. In 1905 Thomas stated that the "truthful testimony" of the photograph could be clarified by the artist correcting the indistinct, confused, or insufficient "impressions of the camera" and could "convert an uninteresting photograph into a true and lively picture of what actually occurred."[35]

With the increasing ubiquity of the Kodak camera the middle classes became accustomed to the new aesthetic of the snapshot. Hand cameras allowed the photographer to move into the streets and deal with the same material as the sketch artists. Two of the most innovative evening papers, the *Pall Mall Gazette* and the *Westminster Gazette*, made a feature of snapshot images, thereby associating themselves with the modernity, informality, and fluidity of the snapshot. Its lack of apparent artifice invested the image with a sheen of authenticity. Indeed, the snapshot aesthetic influenced professional portrait photographers toward a less posed, more natural approach.[36] When the *Sketch* used snapshot-style photographs, they were, in fact, taken by professional photographers.[37]

Technological changes had a profound impact on press photography in the 1880s and 1890s. Previously photographers had used fragile glass plates and large cumbersome cameras that had to be placed on tripods. But beginning in the 1880s, fast gelatin plates and lighter hand-held cameras enabled photographers to cover a wider range of subject matter, to go into the streets and houses, and to do so in a less formal way. Roll film, which was introduced by Eastman in 1889, essentially allowed the camera operator to adopt the methods of the sketch artist. The photographer could concentrate on the scene rather than on his equipment; he could move rapidly to different positions and take a succession of views. Would-be press photographers were advised to use hand cameras with a long focal length, a large aperture, and a good size viewfinder. Kodaks were used by some, but it was difficult to accurately frame images through their viewfinders. Consequently, in-house press photographers tended to use larger format cameras developed specifically for illustrated journalism.[38]

The photographer W. D. Welford believed that the hand camera was very much of its time, a tool fit for the frenetic nineties, and the best means of

Figure 26 "Fashion Figure," *Penrose Annual*, London, A. W. Penrose and Co., 1903–1904, 104, 105. (Photorelief halftone print from photograph)

capturing modern life. He went so far as to suggest that it actually speeded up the perceptions and movements of the camera operator:

> Speaking personally the hand camera has quickened my thoughts and actions to a not unimportant degree. Speed in work and thought in these go-ahead times is not to be sneered at. . . . I therefore claim that the hand camera so improves our vision, our thoughts, our actions in the direction of speed as to materially alter even a man's character. He decides and performs the results of the decision more quickly. He becomes sharp, prompt and decisive and past hesitations vanish. The hand camera therefore has considerable influence in altering the mold of man.[39]

Welford's speculations were representative of a common contemporary belief that modernity was changing perception. The bicycle, another emblem

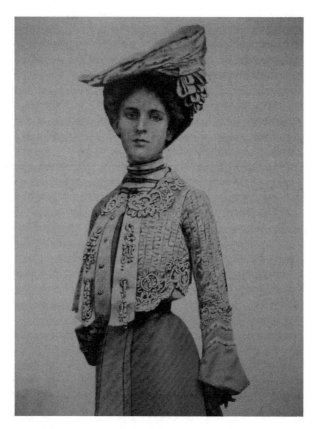

Figure 27 "Fashion Study," *Penrose Annual*, London, A. W. Penrose and Co., 1903–1904. (Photorelief halftone print from extensively retouched photograph based on Figure 26)

of mobility and modernity, was also seen as a means of "quickening the perceptive facilities of young people and making them more alert."[40] There were also less positive interpretations of the effects of technology on the psyche. Max Nordau in Europe and C. L. Dana and George Beard in the United States blamed the pace of modern life, the press, the telegraph, and mass transportation for mental degeneration and nervousness.[41]

Near the end of the decade these various technologies of communication and observation were deployed in the first large-scale modern war, which was, fittingly, the first media war. Although a number of photographers covered the Spanish American War of 1898 far greater numbers were sent to South Africa in 1899. The leading illustrated magazines in Britain all sent photographers as well as illustrators to capture the events of the Boer War. Pearson's, by now one of the largest British media conglomerates,

claimed it had 50 photographers and artists at the front.[42] The illustrated weekly *Black and White* had a "little army of correspondents" with fifteen artists and photographers, including René Bull, an illustrator who also took photographs.[43] Many of the artists and reporters sent to South Africa were issued cameras; in addition, many of the troops on both sides had Kodaks and submitted images to publications. The Wards' agency, the Illustrated Press Bureau, requested military officers to send them negatives from the front that the bureau would develop and sell to suitable publications. The demand for pictures of the war resulted in more sophisticated systems for image production and circulation in particular the establishment of many photographic agencies.[44]

The Boer War also marked the first time a British magazine relied entirely on photography for its documentary images. The *King* was launched on January 6, 1900 by the Newnes conglomerate on the premise that photography was the only trustworthy method of recording the war. The magazine, while it published many cartoons and sketches, didn't use drawings for news items and promised in its first issue that "The *King* will make a specialty of its news photographs. Its photographers are now at the front, and no money is being spared to give the reader the earliest obtainable photographs of the actual fighting." Newnes already had considerable experience producing popular photographically illustrated magazines and had made extensive use of photographs in the *Strand*, on which he employed a staff photographer. The *King*, like the *Strand*, featured many photographs not related to the news, fillers that could be dropped into any issue, including photographs of curiosities as well as adorable animals and charming children. The magazine described itself as "The paper of today for the people of today. It will be live, interesting matter, full of anecdote, crisp and newsy, specially prepared by gossipy and able writers." The *King* took the editorial tone and photographic content of new journalism to war.

The paper's chief war photographer was Henry Shelley, and his images were clearly its main selling point. The *King*'s editorials dealt exclusively with Shelley and with the magazine's photographic coverage. Shelley was characterized, accurately, as a "rare combination of the practical journalist with the practical photographer." Unlike most of the image makers who went to South Africa, he had a good grasp of the political and military aspects of conflict. In addition, he was a technically proficient and resourceful photographer. Unable to get the lighting equipment he needed to record a banquet, he made his own at two hours' notice. He had an extremely active war covering the battles of the Modder River and Magersfontein, the relief of Kimberley, the surrender of General Cronje, the occupation of Blomfontein, and the capture of Brandfort and Kroonstad. These photographs, while not showing actual combat as the *King* had promised, were especially thorough in their coverage of army life.

Shelley used a Kodak that he fitted with a telephoto lens, and the portability of this equipment must have been one of the reasons he was able

to cover so much ground. While other photographers took cumbersome darkroom apparatus with them to South Africa that they had to transport in carts, Shelley traveled lightly. He simply dispatched his negatives by ship to London for developing and printing. The film took about a month to reach the magazine, and on at least one occasion the negatives were lost at sea.[45] Once they were safely in the magazine's hands, Shelley's images were enlarged and printed; all being well, they appeared in the paper a week or two later, depending on their content and quantity and whether or not they had to be retouched. Despite the *King's* claims that its photographs were directly taken from the original negatives, they were usually quite the opposite. In fact, it was rare for photographs to be considered fit for publication without considerable retouching and in some cases extensive redrawing.

One of the most experienced press photographers in South Africa was Reinhold Thiele, sent by the *Graphic* to cover the conflict in December 1899. He had set up business in 1896 as a press photographer with a specialty in military and sporting subjects. Although German by birth, Thiele was a member of the British Naval Reserve and was closely associated with the military. His firm had taken photographs of "every phase of life in the British Navy and Army; the work; the recreation; the social life of sailors and soldiers."[46] In a profile entitled "Reinhold Thiele: A Man of Genius and Enterprise," he was described as "capable and cosmopolitan," "self reliant," and a robust sporting type who was able to leave for the front at a moment's notice. In the article, his identification with the military was absolute; he wore a khaki uniform and his 10 × 8 camera with a telephoto lens was described as "his great gun."[47]

The Special Photographers shared in the glamor and status of the illustrators and journalists who also covered the war, but this was not the case with press photographers in general. The firms that supplied the press with portraits of celebrities were usually highly regarded professionals, however, the photographers who were employed in-house enjoyed an uncertain status and class. The press photographer Eustace Gray spoke of the way in which photographers were treated when going on interview assignments. "We are treated very much the same as a plumber. The people whose houses we visit do not know whether to shake our hand or send us down to the kitchen for a glass of beer."[48] At best the staff photographer was seen as a technician who lacked the artistic skills of the illustrator; at worst they were characterized as intrusive, untrustworthy, and liable to fake events for the camera.[49]

Nevertheless, subjects were more cooperative with photographers than they had been in the recent past. In the mid-1880s magazines had found it difficult to persuade individuals, even celebrities, to pose for press photographs, something that was seen as undignified. A "resolute young man" approached an actor, author, or politician, who might or might not send a photo to the paper. It was said that a woman was even less likely to agree with a request for a photograph as she worried about the image being

distorted. Indeed, professional photographers themselves often refused to supply images for publication. There were initially loud protests in the American print media when images of society ladies were first reproduced in Pulitzer's *World*. But by the 1890s the situation had changed. Photographic firms were now happy to supply images and to make money in the process. In addition not only performers but prominent people of all walks of life were willing to have their images made and distributed to a mass audience.[50]

As the Wards' publications demonstrated by the turn of the century, there was a large market for press photographs. Established periodicals increased their photographic content in order to compete with the new photographically illustrated periodicals. At the same time the quality of photographs was now improving as editors were demanding better images. The flood of halftones of the Boer War was associated with a noticeable improvement in reproduction standards. The Wards stated that beginning in 1900, "it is no longer possible to run a competition with two or three guineas in prizes and to publish page after page of the competition photograms – good, indifferent, and bad – during the next few months. And editors no longer consider that 'any' portrait of a celebrity, and 'any' view of a notable spot will answer the purpose."[51]

However, photography was not the only means of generating images and was not without its limitations and drawbacks. When Clement Shorter launched his new illustrated weekly the *Sphere* in 1900, he acted on his belief that photography alone could not provide a complete coverage of events. Although he had increased the photographic content of all the magazines he edited, Shorter was convinced that photography by itself could not encompass the multifaceted complexity of the visual world. Shorter praised the photograph as a popular and effective means of conveying contemporary reality, but he was critical of its indiscriminate use by the press. Although photographs were appropriate for portraiture and for some images of current events, he argued that the handmade illustration was an essential element in the periodical. Sketches were able to depict events that the photograph was unable to capture and could do so in a meaningful way. In many cases, photographers simply could not gain access to certain people or places. Special Artists, on the other hand, were able to attend Royal events and there were links between some of these artists and members of the Royal family.[52] Shorter recounted how William Sampson, a Special Artist for *ILN*, was able to draw the dead Duke of Clarence through his connections with the Prince of Wales; most press photographers would not have had the opportunity to rub shoulders with the prince.[53] In Shorter's opinion, the ideal weekly should combine the veracity and topicality of the photograph with the individuality of the drawing, and with both types of image at his disposal, the editor's job was to establish how best they could be applied. Although Shorter's *Sphere* did print large photographic portraits of politicians and generals, most of

its full-page images were hand-drawn illustrations, a dramatic and effective means of conveying information and providing an essential visual relief to the subdued tones of the halftone photograph.

Shorter raised questions that concerned many journalists and editors of the late 1890s – would the photograph prove to be a passing fad? Would the public simply get tired of it?

> I think not – while they are able to convey with such intense reality many of the incidents of the hour. At the same time, however, the future of the black and white artist who illustrates current topics is absolutely assured. . . . One friend of mine – an accomplished journalist – does, indeed, insist that he prefers a photograph of a house to the most finished drawing by Mr. Pennell or Mr. Railton. I do not, however, accept this as a normal state of mind. I believe that there will always be a large public to whom good art will always appeal. The photograph, however, must have an ever larger place in the journalism of the future than of the past, and the editor will prove himself most skilful who most perfectly realizes the limits of the artist and the limits of the photographer.[54]

The halftone photograph was able to provide the viewer, as Shorter notes, with an enhanced sense of the actuality of an event, while hand-drawn illustrations continued to provide the narrative that the photograph lacked.

The placing of the large numbers of gray halftone rectangles on the page was a new ordering of the visual that was to radically alter the appearance of magazines. Wood-engraved drawings had, in many cases, floated within a vignette, a graphic idiom originating in the eighteenth century and associated with the picturesque landscape. In the vignette the image faded towards the edges, rather than extending to the limits of the woodblock. With no hard boundaries to the image, both text and illustration seemed to sit on the white surface of the paper further integrating the printed image with letterpress type.[55]

In the previous decades when wood engravers were working with photographic originals, the vignette was often used to keep these images within the layout conventions established by the wood engraving. But increasingly the halftone image began to fill a rectangle block, which, in many cases, was reinforced by a black line, originally a technical necessity, as the ink would smudge at the sides of the image if it were not ruled. Eventually the lines became a convention and machines were developed specifically to produce them.[56] The stark rectangle of the photographic halftone clearly marked the limits of what was seen, an area of empirical knowledge. The photographer Horsley Hinton commented on the repetitive nature of the photographic block and noted that "a succession of pictures all of about the same tone, and in every case filling the whole space within boundary lines, strikes one with a great sense of monotony."[57] The cropping or "trimming" of photographic images to exclude unwanted detail or to fit them within the formats

required by the press, was also a new visual experience for viewers. Drawings could be amended with ease, but photographs had to be physically cut. Hinton suggested that this cropping "offends [even] the least cultivated artistic sense, as when, in order to exclude things, the particular object or building to be represented fills the entire plate."[58] The harmony of wood engraving and type was replaced by the severe rectangle of the photographic halftone.

Magazines tried a number of tactics in order to lessen the mechanical appearance of the halftone. Admitting in 1895 that journalists were irked by the repetitive process image, the *Process Photogram* stated that "Anyone who closely observes must know that there is a growing feeling of dissatisfaction with the monotonous, hard outlines and the monotonous dead tone of much of our process work." The writer argued that the poor quality of the photographic originals was to some extent to blame, but believed that the dreariness was intrinsic to the technique itself and continued:

> But the monotony is there and every sub-editor who has to attempt to make up attractive pages with type and rectangular half-tone blocks is feeling sick of the effort. He has realized the hopelessness of it, even if the public has not yet done so, and he is seeking everywhere for something to give brightness and variety. He is turning to wood-engraving, to line work, to anything that is a relief.[59]

Introducing other kinds of line imagery, such as the *Process Photogram* suggested, was one possibility. Another tactic was to break apart the rectangles of the halftone. Editors used complex arrangements known as "mosaics" to relieve the regular photographic slabs, grouping together a number of blocks within drawn decorations and borders.[60] Sometimes tonal images were cut into geometric shapes, or lozenges. Machines were developed to produce vignette effects, softening the edges of the halftone in an attempt to inject an artistic element into the page design.[61] The use of elaborate framing devices became so common by 1900, that the *Process Photogram* advised that a halftone without a frame of some kind looked incomplete, like an unframed painting or an unmounted photograph.[62] Freelance photographers were advised to add a decorative border in pen and ink around their prints before submitting them to editors.[63]

As a result of these framing devices, the American writer Will Jenkins observed that photography had, perhaps surprisingly, created a new space for decorative art in magazines:

> A spot of black here, a swing of line or an arabesque there, will do wonders to enliven a commonplace group of half-tone blocks. . . . The pages made up of half-tone blocks by themselves and containing none of the artist's

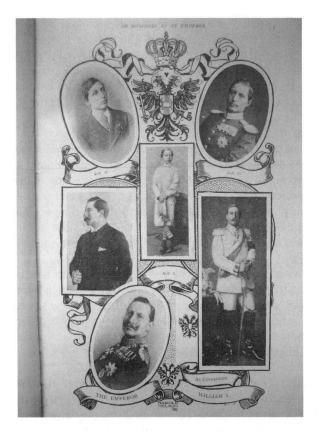

Figure 28 "The Emperor William I," "In Business as an Emperor," *Harmsworth Monthly Pictorial Magazine*, 2, February 7, 1899, 3–12, 7. (Photorelief halftone prints from photographs, photorelief line prints from line drawings and mechanical tints.)

work are anything but pleasing, merely so many rectangular smudges of ink, oft times grouped or scattered over the space with no relation either to each other or to the page.... Through careful arrangement and the deployment of decorative elements these pages could be made much more pleasing and help to improve not only public taste but the daily beauty of the world.

However, these borders and mosaics, while distracting the reader from the gray monotony of the rectangular halftone, further fragmented the page, but the decorative approach to page layout continued for a number of years before the rectangles of the halftone became the norm, the accepted and natural structure for an illustrated magazine.[64]

Retouching and the hybrid image

From the beginning the combination of the photograph and photorelief reproduction was problematic. Neither the photograph nor photomechanical reproduction was as easy to manipulate as the handmade image or the wood engraving. In the mid-1880s the American photographer Stephen Horgan was already printing halftones of photographs in the press, but he admitted that these photographs inevitably required alteration.

> I have many examples of such a process as is now used in the illustrated press of today, and the difficulty in its more general adoption will be found in the fact that very rarely will a subject be photographed with the composition, arrangement, light and shade, of a quality possessing sufficient "spirit" for publication in *facsimile*. All photographs are altered to a greater or less degree before presentation in the newspaper.[65]

The improvement of the original had been an intrinsic part of the wood engraver's task, and this enhancement and clarification continued to be an important element in mechanical reproduction processes.

Although the photorelief techniques were promoted as a means of producing a direct facsimile, in practice they were not deployed to this end, but rather, they were combined with hand technologies of retouching and re-engraving to produce culturally acceptable and commercially successful images. The wood-engraved image, which had been the norm in the press for over fifty years, consisted of clearly differentiated black marks contrasting with distinct areas of white paper. The halftone's entire surface, on the other hand, appeared to be gray with no strong blacks or crisp whites. Commercial process engravers attempted to imitate the tonal qualities of the wood engraving by retouching and manipulating the process image to achieve greater contrast. Throughout the production process, from the making of the negative to the finished block, the aim was not, in fact, photographic facsimile but the production of an image matching the wood engraving's strong visual impact.

The fusion of handwork with chemical and photographic technologies was so pervasive throughout this period that it is more accurate to speak of "semi-mechanical" rather than mechanical reproduction.[66] From the 1880s until well into the twentieth century there was a great deal of manual manipulation involved in the reproduction of photographs, just as digital retouching and manipulation became the norm in the 1990s. The photographic image in the press was far from a direct transcription of the original; on the contrary photographs were subject to modification at every single phase of their replication.

There were four distinct stages at which retouching took place. First, the original negative was often retouched before a print was made. Next, the

resulting print was painted on, or "worked up." The content of the print was modified; objects and people would be added, removed, or transformed. The print was also retouched to heighten its tonal contrast so that it could withstand the dulling effect of the screen. Next, during the etching of the halftone block selected areas of the image were subject to selective "fine etching" to improve clarity and detail. Finally, once the block was etched, its entire surface might be "engraved up" by hand.

The alteration of the mass-reproduced image relates to the retouching of negatives and prints that was widely practiced in commercial photography. Retouching was described as "the Cinderella of the photographic arts" whose very existence was unsuspected by those who admired the results it achieved.[67] A certain amount of retouching was frequently necessary in order to remove marks and scratches from negatives, but in portraiture it was also used to idealize the sitter, erasing "imperfections" such as wrinkles and altering lips, chins, and noses in order to produce a physiognomically acceptable image. Retouchers developed specific conventions for portraiture, in which light was added in the eye, hair was highlighted, and drapery softened. This was done not only to make the sitter more attractive, but had a psychological aspect, as one expert advised: "any furrow between the eyebrows should be almost entirely removed, as it indicates uneasiness of mind."[68] The aim was not only to erase these physiognomic imperfections but to soften the harshness said to be inherent in photographs.[69] The front of the negative was covered with a medium providing a surface that would take pencil and watercolor and placed in a special holder and illuminated from behind. The retoucher's tools included pencils, brushes, varnish, watercolor paint, and a sharp knife. Minute patterns of lines, whirls, and circles were then used to clean and model the image. Charles Booth recorded that retouchers earned from 20 shillings up to over 40 shillings per week, but he also observed that much of the work was now being done by women in their homes on a piecework basis, presumably for less.[70]

Women also undertook the majority of the retouching of negatives and prints in the reproduction industries and also were heavily involved in the fine etching of plates. Just as in wood engraving this painstaking and precise work was recommended as a respectable calling for working women. Yet, as was the case in wood engraving, female workers were excluded from the higher levels of the process trades. Women process retouchers were skilled, trained workers who were seen as more compliant than their male counterparts and were willing to work for lower rates. The head of the Acme Tone Engraving Company stated, "There is a quality of acquiescence about women . . . which is soothing for employers." According to the *Process Photogram* they brought a feminine presence to the workplace, dressing in pretty blouses, decorating their studios with plants, and occupying themselves knitting clothes for charity between plates.[71]

Once a print had been made from a negative, it was subject to further alteration. A direct halftone copy of a photograph produced results that were deemed "flat, insipid and in many ways disappointing, unless the original is exceptionally full of detail." In order to rectify this deficiency retouchers added contrast to the print before it was screened. Highlights and shadows were exaggerated using brushes to produce an "artificial contrast" that would withstand screening and would give the process workers more latitude and detail in the final image. Retouchers wore blue-tinted spectacles in order to judge the effect of their work, and when the photograph appeared balanced through these glasses they knew it would produce a successful halftone.[72]

So common was this retouching of prints that photographers who were intending to submit images for publication were advised not to worry about the technical qualities of their originals. The Wards' *Photography for the Press* stressed that clarity and simplicity were the keys to success. The ideal print for publication ought to be "a little hard" to survive the "slight degrading action of the half-tone ground."[73] It should be, in essence, a "large snap-shot" in its harsh contrast, unlike the subtlety and softness that would be achieved in an exhibition print. Magazines specified that prints should be on mat paper so that they could be easily retouched. Even in 1901 the Wards' book assumed that a photograph for the daily press would be used merely as the basis for a line drawing. Only the weeklies and monthlies could print tonal images: "The weekly, inasmuch as it makes a halftone block, wants a fairly good print, but the worker-up of originals and the fine etcher have made editors very independent of brilliance and 'snap' in submitted prints."[74] *Photography for the Press* was illustrated using shots of Queen Victoria's funeral, the most notable press event of the recent past, and the degrees of retouching required for different kinds of magazine were demonstrated using a snapshot of the Prince of Wales. In the most elaborate example, regarded as suitable for a high-class magazine, the original photograph was all but erased by redrawing. In general, the original image was reshaped at each stage to meet the expectations of specific groups of viewers; the higher the class, the more obviously idealized and artistic the image appeared to become.[75] The adjustment of originals became so prevalent that tools were created specifically for this task, for instance, the airbrush or aerograph, which was developed in the 1890s and used to produce a smoothly graduated tint like the continuous tone of a photograph.

Once the photograph had been retouched and screened, the resulting block was etched. The hand, guided by subjective judgment and experience, was in reality at the center of photorelief reproduction. Pennell, despite his insistence on the line zinco as the direct trace of the artist's gesture, acknowledged that the success of line engraving depended more on the skill and "artistic intelligence" of the engraver than on mechanical or chemical action.[76] This was even more the case with halftone reproduction. The

Figure 29 "Funeral of Queen Victoria: King and Kaiser Entering Hyde Park, From the Original Snap-Shot by T. W. Dorrington," *Photography for the Press*, London, Dawbarn and Ward, 1901, 6. (Photorelief halftone print from photograph)

copper plate was initially subjected to a series of submersions in an acid solution to bite out shadows, midtones, and highlights. After each stage parts of the image were protected by "stopping out," that is, by painting a resist onto the plate. These first stages were known as "dark etching" or "rough etching," and, if necessary, manual "fine etching" was then undertaken using a very thin camel's-hair brush to selectively apply solution to improve the detail and contrast of the plate. The major firms employed large staffs of fine etchers.[77] This procedure became so elaborate that it was said to resemble wood engraving in the amount of skill and judgment it demanded. The *Penrose Annual* stated that with fine etching "most of the details will have to be drawn in, being lost in the inevitable 'screen tint,' so that a good fine etcher must be a draughtsman etcher. In truth a first-class fine etcher is on the same footing as a wood engraver."[78]

Figure 30 "Funeral of Queen Victoria: King and Kaiser Entering Hyde Park, From a Worked-Up Print," *Photography for the Press*, London, Dawbarn and Ward, 1901, 9. (Photorelief halftone print from extensively retouched photograph)

The photographer Hector Maclean saw the manual manipulation of the halftone as an integral part of the process, not an optional extra, stating, "The result of the etching depends entirely upon the skill and judgment of the craftsman. The procedure is by no means an automatic one, and is therefore subject to distinct failure – this without any regard for what is called 'fine etching.'" He noted the ubiquity of fine etching itself, stating, "I am told by workers in large firms that very few blocks are prepared without some such handiwork as aforesaid being imperatively needful." With all of this hand intervention Maclean advised that the artist should carefully check the proof before "accepting it as a passably faithful rendering . . . if the work has been done by an imperfectly trained staff (for such blocks are usually produced by the co-operation of men who each keep to one section of the process) be sure it will fall far short of what it should attain."[79]

Given the laborious nature of the technique, it may seem surprising that process firms saw fine etching as a means of saving money. But time spent on camera work was even more expensive – electric lighting, materials, huge process cameras, screens, and operators' labor were all costly. Originals were therefore shot in batches using an average exposure length, but even when only one image was shot at a time, it was difficult to get an accurate negative on the first attempt, since there were so many variables in exposure and the positioning of the screen that it was very hard to predict what the result would be. So, rather than undertaking a number of trial runs, camera operators produced negatives that were tonally flat but could capture detail. The lack of contrast in these negatives was then remedied at the block-making stage by fine etching. But as I've mentioned, because many of these etchers were women, their time and labor were comparatively cheap.[80]

After the halftone plate had been etched it needed re-engraving by hand so that it would print more successfully. The furrows produced by the chemical etching of the block were only 1/32-inch deep, much shallower than in a woodblock, and ink was liable to "fill in" the recesses in printing. Moreover, these problems were exacerbated by the fact that printers did not use the delicate original blocks but printed from electrotype or stereotype copies, not only to protect the original from damage on the press, but also to allow an image to be printed on more than one machine at a time.[81] Re-engraving or "tool work" was also used to remove the "monotonous uniform mesh" of the halftone, by adding highlights and disrupting the regular rows of halftone dots. Burnishers and roulettes with toothed wheels were used, with areas hatched and stippled to break up the repetitive grain. In some cases a hand engraver could spend over thirty hours on one image.[82]

The major illustrated magazines such as the *Graphic* and *ILN*, had employed large staffs of in-house wood engravers. When these publications switched to process reproduction around the midnineties, the engravers were redeployed in the retouching of halftone and line plates.[83] However, the wood engravers who had worked in the many small workshops or as freelancers were not so lucky and, as their trade declined, they scrambled for work re-engraving blocks in process houses. But these jobs were often badly paid as there were so many engravers competing for the work.

In many cases these redeployed craftsmen were engaged in producing images that looked, in part, like wood engravings. The semimechanical imitation of wood engraving was not new; as early as 1882 counterfeit wood engravings were being prepared by line process, and later, ersatz wood engravings known as "scratch tints" were produced by wood engravers working on top of photographs.[84] But toward the end of the 1890s engravers were extensively employed to work on top of the halftone block in a manner that visibly combined the machine and the hand in a technique known as the "wood-cut finish." As a reaction to what was perceived as

the overuse of halftones and the visual monotony of the reproduced photograph, the hand-engraving trade experienced something of a revival. Unlike the many retouched blocks where the engraver's work was hidden, these images highlighted the trace of the hand. Sometimes hand engraving was used to produce a syncretic image in which areas that looked like wood engravings were juxtaposed with those that looked like halftones, as in, for example, photographic portraits where the background and clothing were almost completely re-engraved.[85] *Harper's* led the way in this vogue in October 1894, and the fashion spread from there. The redeployment of in-house wood engravers at *ILN*, *Harper's*, and the *Graphic* at this time may have been one reason for the revival, but the style was not only used by the long-established periodicals but also by new, cheaper illustrated publications such as *Munsey's*, a popular American monthly.[86] William Gamble stated that, by 1897, wood engraving was rarely used as a reproduction method in the press, for even the *Graphic*, the last bastion of the old methods, had gone over to process. However, he observed that wood engraving was still extensively used within the process industry.[87] Wood engraving, while no longer seen as a viable method of reproduction, had come to connote an artistic and superior image. The established American monthlies like *Harper's* had resisted halftone reproduction as inartistic, and tainted by mass culture. But the "wood-cut finish" allowed them to incorporate halftones as an artistic and refined means of representation.

In the early 1890s, the extensive retouching that was needed meant that the halftone could not compete with the wood engraving in quality or price. The savings on the photomechanical production of the block were eaten up by the various stages of retouching and re-engraving, and, by the middle of the 1890s, the modification of a block by hand could cost five times as much as the reproduction of the block itself.[88] Although halftone reproduction techniques improved in their ability to capture and communicate detail, the retouching of originals did not decrease. Even at the turn of the century a very large proportion of negatives and original images was subjected to extensive retouching to produce what was known as the "American Style" block.[89] As one contemporary writer put it, "At present most of the ability of the wood engravers who survive is devoted to handworking half-tone blocks, which often are engraved over almost their whole printing surface, and begin to rival wood-cuts in their elaborate retouching and finish."[90]

It might seem surprising that prominent figures in photomechanical reproduction approved of these methods of refashioning the image; it might appear that they were acknowledging the limitations of their technology. But for Frederick Ives, Max Levy, and Carl Hentschel, hand engraving allowed the halftone to look its best and linked the new technology with the positive qualities of it predecessor.[91] All that was visible on the surface of the photographic halftone was a machine-made photograph replicated via a repetitive

pattern. For many viewers the regularity and mechanization inherent in the mass-reproduced image were indicative of the worst aspects of capitalist industrialization. Followers of Ruskin in the Arts and Crafts Movement prized the handmade variation and imperfections of the wood engraving, and hand engraving on the block reinserted these creative irregularities. Those in the industry could therefore claim that these hybrid blocks merged the factuality of photography with the aesthetic Vigor and artistic refinement associated with wood engraving.

In Victorian art and design, the amount of work that went into an object had moral and economic implications. Art involved work, discernible work, and the art object was the evidence of the diligent effort to solve technical difficulties and produce a highly finished surface. One of the most notable manifestations of this thinking was the legal dispute between Ruskin and Whistler, which revolved around the fact that little effort or time seemed to have gone into the American's paintings. The problem with the photographic halftone was that neither the photographer nor the process worker's skills and judgment were visible; indeed, it appeared to have been created by machines. The mechanical repetition of the grid seemed to have been produced instantly and without effort, although in actual fact there was, of course, a great deal of human labor involved in the reproduction process, but it was concealed behind the screen.[92] Visible re-engraving became a means of reinserting discernible artistic labor into the halftone, a move that can be seen as extending the duration of the printed image by countering the camera's capture of a momentary temporal fragment.

Hand retouching was not cheap, and it made sound commercial sense for Carl Hentschel to praise it because his firm offered this costly service.[93] One reason for the expense was the slow pace involved. Unlike a wood-engraving block, which could be split up for a number of hands to work on it simultaneously, the process plate consisted of a single sheet of copper, and, therefore, only one man could work on it at a time. In addition, the metal was not as easy to cut as the woodblock, as an engraver advised his peers: "Do not try to take out too much at a time, you cannot cut out the metal as you can make the chips fly from a woodblock." These factors therefore limited the elaborate, visible re-engraving on halftones to monthly periodicals and to less urgent material in the weeklies.[94]

These extensive retouching procedures demonstrate that, as in so many other aspects of reproduction, the appearance of the image was shaped by commercial and cultural concerns rather than a drive for an accurate replication of an original. Indeed, instead of producing facsimile, firms aimed to create high-contrast blocks. An art editor writing in the trade press, complained that businesses relied on fine etching to correct any deficiencies in their prints, just as commercial photographers relied on retouching, and protested that "violent contrast," known as "pluck" or "punch" – rather than

a faithful reproduction of the original – was always the aim of the process man. The industry, in other words, was simply working to the demands of magazine editors who, although they asked for "fac-sim," in practice wanted bright pages with plenty of contrast. Robert Vincent, a process worker, asserted that although artists or critics might want an exact reproduction, publishers wanted pages that would "catch the eye of the general public" and regarded the original as only a means to this end.[95]

All of these interventions in image reproduction procedures diluted photorelief's promise that it could, unlike wood engraving, provide an accurate and neutral copy of an original photograph, painting, or drawing. In 1901 the Victoria and Albert Museum mounted an exhibition, in which original images and their printed reproductions from the 1860s to 1900 were displayed side by side, with contributions from the key illustrated periodicals of the last half century: the *Graphic*, the *Daily Graphic*, *ILN*, *Once a Week*, the *Cornhill*, *Lady's Pictorial*, *Black and White*, the *Sketch*, *Pick-Me-Up*, the *Pall Mall Gazette*, the *Westminster Gazette*, and the *Sphere*. The show reinforced concerns regarding process's ability to produce a facsimile. The catalogue for the exhibition openly admitted the necessity for re-engraving and retouching, particularly in work done for the illustrated press: "Without this touching, the process plates, especially with rapid printing, are apt to appear flat, for lines necessarily cover the whole plate unless taken out by hand."[96]

As the debate around "facsimilitude" demonstrated, the mass image was produced within economic, industrial, and social constraints. The photographs printed in magazines conformed to editors' views of what would appeal to their readers. Editors realized that the most effective images would continue to do what the wood engraving had done for so long – provide audience with sharp and acceptable pictures. But, by using photomechanical techniques rather than wood engravings, magazines could operate in a new fashion: the repetitive surface of the halftone literally screened the labor of duplication so that the reproduction seemed natural and direct, as if the original had made the dots. Even when they were retouched, therefore, the photograph and the halftone both retained a sense of an immediate and direct contact with their subjects. Editors could have it both ways.

Giving audiences what they wanted, or what publishers' believed they wanted certainly sold magazines. Photographers and illustrators produced thousands of originals that process engraving firms rapidly turned into photorelief blocks. Popular illustrated periodicals filled with these photomechanically reproduced snapshots, drawings, and paintings packed newsagents, windows. Audiences clearly found these images entertaining and informative, indeed essential, but critics were mainly negative about this new phenomenon. The condemnation of the mass image was, as I discuss in the final chapter, part of a criticism of the popular press that was seen by elite critics as posing a serious threat to existing cultural values, and established forms, such as the book.

8
Learning to Read the Halftone

> A feature of the year was the excess of illustration, if, indeed, you can call that illustration which illustrates nothing. It is unfortunately, our own art which has brought upon us this plague of unnecessary pictures from which we suffer. In some papers illustrations are so numerous – and so bad – that editors can find nothing to say about them, and dot them over their pages without any apparent object.
>
> – Henry Peach Robinson, *Photographic News*, December 28, 1894[1]

By the middle of the 1890s there was an unmistakable shift in the appearance and ubiquity of the mass-reproduced image. Distinguished photographer Henry Peach Robinson and other observers noticed that images, particularly halftone photographs, had achieved a greater prominence in the press, even constituting a deluge, and many blamed photomechanical reproduction for degrading the visual world. The Levy screens that made halftone reproduction a commercially viable undertaking were obtainable in Britain in 1893, and from this point on the debates around the mass image became more intense. However, it is important to stress that the availability of the technology itself was not the determining factor here. Rather, a number of interwoven cultural and economic forces helped shape the new illustrated magazine so that it could embrace the halftone photograph. As far as Henry Peach Robinson was concerned, these photographs were "unnecessary pictures" randomly scattered about the magazine page, not telling the viewer anything. But their popularity suggests otherwise. I suggest that the multiplicity of the halftone photograph was in itself meaningful and this abundance of fragments necessary in the creation and active maintenance of the social. The fact is that the rapid consumption of the photograph, as well as the minimal pen-and-ink sketch, for that matter, made them both particularly useful in an era that envisaged itself as moving at increasing speed.

Many observers from the 1890s onwards have argued that wood engraving was simply unable to keep pace with the increasing demand for images, that

it was too slow and expensive. While it is true that the halftone appeared to be cheaper and quicker to produce than the wood engraving, once the costs and the time taken in retouching and re-engraving were included, the savings may not have been great.[2] What was important was that the process image looked quicker than the wood engraving and appeared to be a facsimile rather than a translation, both factors important to its acceptance with magazines. The criteria for the success and application of these imaging and reproduction technologies were, however, complex. At times critics and process workers believed that the halftone was a fad that might fade away or that it would be, at best, one of a range of methods used; hand engraving was dismissed as old-fashioned, only to be reinstated as an artistic alternative to the machine-made image; and the photograph was thought to be a hackneyed and vulgar form that might well disappear from the press.[3]

Process reproduction had to meet not only the expectations and demands of the mass audience, but also operate within the economic structures of capitalist industrial production. Photomechanical processes fitted fairly neatly within an assembly-line system, in which tasks were divided into easily mastered segments.[4] Crucially, this segmentation included the separation of the author of the image from the workers who reproduced it. Wood engraving had attempted to move to a factory system by becoming increasingly fragmented and specialized and by adopting a facsimile approach. It was able to rival the mechanical processes in terms of speed and cheapness and to outdo halftone reproduction in its ease of printing. But the obvious presence of the engraver's hand, manifested in the lines of the engraving, had now become an insurmountable difficulty. Not only did the engraved line suggest more time taken to produce the image, it branded the reproduction as a translation. Process, on the other hand, managed to conceal its production and appeared to be a facsimile rather than an interpretation. One of process's major advantages was that it allowed, therefore, for the separation of creativity from reproduction. Authorship became located entirely within the artist's hands, and the illustration became the product of one individual, rather than an interpretive team.

Cultural expectations had changed since the 1840s, and faithfulness to the original, rather than translation and interpretation, had become the new standard for reproduction. Photography was used as a method of duplication, for instance, providing photographic prints of paintings to Art Union subscribers, thereby influencing the expectations of other reproductive processes. The photograph became the criterion for effective reproduction. Just as the photograph was seen as an authorless and unmediated trace of external reality, photographic processes of reproduction were promoted as direct channels of communication in which the hand had been excised. Of course, the photograph was not purely mechanical; human agency operated at all stages, from the design and manufacture of equipment and film to decisions about what to shoot and how to shoot it. In the

same way photorelief processes were shaped and controlled by human ideologies, decisions, and actions. Considerable human agency and discretion were still essential in the reproduction processes, but the evidence for these interventions was not necessarily visible. Behind the rhetoric of facsimile, the reality was that hybrid technologies combined the photograph and the hand to produce interpretive rather than mimetic images. Magazine editors and publishers employed photomechanical methods as a means of indicating the modernity of their magazines, while using hand retouching to produce an image that was acceptable to their audiences.

The increasing use of photomechanical processes by magazines in the 1890s led to an intense debate about the fidelity and suitability of the various imaging and reproduction methods. The introduction of line process in the 1880s had been more gradual and covert, and critical discussion had not been as animated. The difference between line images and the existing wood engravings had, in many cases, not been obvious as both used a linear syntax. In addition, line process was often used to duplicate or pirate wood-engraved images or to produce ersatz wood engravings. However, the introduction of the halftone in the 1890s was much more visually obvious and contentious. Even though wood engravers had used photographs as the basis of their images since the 1840s and had produced increasingly finely textured prints, these images were totally unlike the gray, subdued halftone. Far more photographs were now appearing, both in the established magazines and in a new wave of photomechanically reproduced periodicals. There were two linked phenomena that provoked critical concern: the increased use of photography as a means of illustration and the general increase in printed images. Critics took a number of positions regarding the new reproductive technologies ranging from those who embraced them as a means of uplifting the masses to those who condemned them as undermining society as a whole.

Some critics praised photomechanical reproduction for its ability to improve the middle and lower classes, as evidenced when W. C. Eddington, addressing the Royal Photographic Society in 1896, stated, "We may claim, without presumption, that the advent of the half-tone reproductions have proved a material factor in the educating factors of the past few years, more particularly amongst the middle and humbler classes."[5] Process, it was claimed, could serve noble ends transmitting high culture, beauty, and art among the masses.[6] Critics who took this position assumed the natural superiority and universal appeal of their own tastes. Academic art was at the zenith of its popularity and visibility in Britain at the time, partly as a result of the role that illustrated magazines such as the *Graphic* and *ILN* had played through their lavish and regular reproductions of paintings.[7] Even with the expense involved in reproducing paintings, they still provided magazines with a relatively inexpensive means of filling space, for although illustrators were paid for their work, artists often allowed magazines to reproduce their

works for free to generate publicity and sales.[8] Usually these reproductions were accompanied by very bland texts that gave little critical context to the work. Some argued that the public's taste could only be improved by an increase of artistic images in mass periodicals, as process allowed viewers to have a direct contact with the artist's touch. However, a few knowledgeable critics questioned whether process was actually able to produce a facsimile, while others expressed doubts that facsimile was really required of a reproduction method. The view of the photomechanical image as potentially uplifting can be linked to the twentieth century responses to mass culture that D. L. LeMahieu, examines in *A Culture for Democracy*. For example, John Reith's "middle-class cultural paternalism" at the BBC employed new broadcasting technologies to expose a wide public to uplifting models of high culture.[9]

On the other side of the debate, many more critics argued that process had resulted in a flood of vulgar, debasing, and banal images. According to these detractors this vast, uncontrollable, and threatening flood of images bombarded viewers with incessant visual stimulation. They also condemned process for the kinds of images it reproduced, from the trivial, vulgar, and commonplace to the sensational and immoral. As far as drawings were concerned process allowed slapdash pen-and-ink sketches to replace the artistic images of the draftsman and wood engraver. Mass reproduction and the use of the photograph had cheapened and diluted the artistic standing of the image. Much of the reaction to process was negative, with the mass-produced image, both hand drawn and photographic, roundly condemned by critics on both the left and the right, a negativity that continued to be the critical norm for much of the subsequent discussion of mass imagery from film, to television, to video games.

In the nineteenth century some commentators saw all forms of imagery as undermining the rational and intellectual foundations of a word-based, literate social order and so saw the illustrated periodical, therefore, as an instance of an emerging mass culture that threatened existing hierarchies. It seemed, to some critics that the sheer quantity of these images would overwhelm and degrade existing standards. This was an element of what Neil Harris identifies as a "pictorial turn" in the nineteenth century that challenged existing sources of authority.[10] Mass-reproduction technologies did indeed destabilize established values by depicting commonplace subject matter in more intimate ways, both through photography and pen-and-ink sketches.

At the beginning of the nineties, George du Maurier, *Punch*'s high-society caricaturist, declared that the intelligent individual didn't need any illustration to accompany fiction or reporting. He asserted that this minority of readers liked to make their own mental image of a text, and he contrasted this with the general public who wanted their books and newspapers filled with pictures. This was, he suggested, because the majority could not, or

would not, use their minds. Ideally they would prefer to sit passively while the story was presented on the stage, as it was in the contemporary productions of Sir Henry Irving and others featuring very elaborate and realistic stagings that left little to the imagination.[11]

Throughout most of the nineties Clement Shorter was firmly in favor of photomechanical reproduction as an efficient and modern means of reproduction; in a lecture in 1899, he insisted that the illustrated press was here to stay – it would not be "crushed out." However, by this point, he had reservations about the direction that publishing was taking and wondered whether photographically illustrated journalism could be justified at all. He worried about the increase in press photography and, like du Maurier, he compared modern illustrated periodicals to overrealistic stage productions. Shorter suggested that if the magazine were to give a rounded, effective, and artistic account of the world it must continue with the judicious mixture of hand-drawn illustration and photography that appeared in the *Graphic* and the *Illustrated London News*. His closing comment was, "If the photograph is really the 'last word' in illustrated journalism, perhaps even an enthusiast for topical pictures might admit that we had reached 'a lower stage.'"[12]

The phrase "a lower stage" was Shorter's quotation from a Wordsworth sonnet entitled "Illustrated Books and Newspapers" that Wordsworth had published in 1845 in response to the recently launched *Illustrated London News*:

> Discourse was deemed Man's noblest attribute,
> And written words the glory of his hand;
> Then followed Printing with enlarged command
> For thought – dominion vast and absolute
> For spreading truth, and making love expand.
> Now prose and verse sunk into disrepute
> Must lacquey a dumb Art that best can suit
> The taste of this once-intellectual Land.
> A backward movement surely have we here,
> from manhood, – back to childhood; for the age.
> Back towards caverned life's first rude career.
> Avaunt this vile abuse of pictorial page!
> Must eyes be all-in-all, and tongue and ear
> Nothing? Heaven keep us from a lower stage![13]

Wordsworth's piece evoked the Platonic distrust of the image in his evocation of cave-dwelling primitive man and echoed the classical belief in the supremacy of the invisible realm of ideas and thought over the visible image. For Wordsworth printing existed to widen "discourse," the written and verbal communication of ideas. It was not possible to hold a conversation

with an image because it was an irrefutable artifact. The introduction of "dumb" imagery into books and magazines was, therefore, a retrograde step that threatened the basic values of society, both intellectual and moral. The images provoking Wordsworth were wood engravings of handmade images, which to many Victorians were the epitome of middle-class refinement. But to Wordsworth – perhaps more sensitive to the image's inherent subversive power – he saw even these respectable engravings as threatening the word's dominion. For the Victorian intellectual elite, the word was supreme, sanctioned and controlled by educational, legal, and governmental institutions, and from their viewpoint, the visceral and unfettered mass image was inherently challenging.[14]

Wordsworth and most of the critics who followed in his path, however, ignored a number of vital points about the image in the press. The image had, in fact, preceded the text as a printed artifact, and had, from the illuminated manuscript onwards, shared space alongside the written text. In his condemnation of the "pictorial page," Wordsworth failed to acknowledge the presence of text in illustrated publications. He was not alone in this, for few contemporary critics commented on the periodical's central structural feature, its mixture of text and image. This could, of course, still be disturbing for defenders of the status quo: the magazine opened up a more hybrid and less hierarchical space in which word and image could be juxtaposed in various ways, so that meaning was no longer fixed.

From the early part of the century illustration had been seen as an aid to reading or a substitute to text for the illiterate. As the historian Roy Porter notes, this characterization was erroneous, asserting,

> despite our clichéd stereotypes, word and picture were never antitheses or alternatives, still less rivals. It was never words for the literate and pictures for the unlettered. There is little evidence within English culture from the seventeenth century onwards of the production of visual images independent of writing, targeted at those who could not read. What was normal, at all levels from the patrician to the plebeian, was the marriage of word and image.[15]

This union took various forms, it was not always an easy relationship, with text and illustration not always in agreement, but it was, nevertheless, a fruitful and interesting "marriage."

Indeed in his analysis of the first ten years of *ILN*, Peter Sinnema notes the frequent conflicts between word and image in the depiction of the poor and of railway accidents and suggests that illustrators and journalists operated within different conventions of suitability.[16] Nevertheless, from its launch *ILN* had promoted its illustrations as partners to text. In its first issue the front-page editorial described illustration as "the bride of literature" and the "handmaiden of genius." In the preface to the first bound edition,

the magazine boasted that it was "clasping Literature and Art together in the firm embrace of the Mind," with the idea that neither one nor the other would dominate but rather add to each other's usefulness, "the eternal register of the pencil giving life and vigor and palpability to the confirming details of the pen." The preface promised that through this combination of text and image, the illustrated magazine would provide a fuller, more vivid, and more permanent record of the Victorian era and that the text would be transformed and enriched by its juxtaposition with the image. The "illustrated text," a hybrid of written word and illustration in the magazine, was to be a new entity that was entirely different from text and image taken individually.[17]

Yet, anxieties regarding the new commercial duplication of imagery blinded many critics to the hybridity of the popular periodicals. Illustrated magazines often devoted a great deal of attention and money on their written content, and from the 1860s had commissioned articles and stories from the leading writers of the day. During the 1890s H. G. Wells, Arthur Conan Doyle, and many others, were regular contributors to the weeklies and monthlies. Much of the literary canon from that era made its first appearance in illustrated periodicals. The advertisements that promoted magazines highlighted both the literary and the visual contents of the periodicals, and the names of both well-known authors and illustrators were listed as a means of attracting customers.

Some commentators argued that the journalistic text needed the image in order to keep pace with modern life. Hence William Gamble's portrayal of the printed word as being slow and out of step with contemporary readers when he forecast in 1898 that the newspaper of the future would be largely visual. Even though the texts in new journalism had become more succinct Gamble foresaw an almost wordless illustrated paper that would be a mixture of photographic and drawn images, with articles reduced to the status of captions. Whereas Gamble's role as a supplier of process equipment may have influenced his conclusion, his claims were part of an emerging modernist media discourse:

> We venture to predict that the time is not far distant when the dull platitudes of long-drawn-out "leaders" which perhaps not more than one per cent of the readers ever go through, will be superseded by smartly drawn cartoons, hitting off the salient social and political features of the day. At the same time the "news" will be pictorial with just sufficient description to carry the story which all pictures immediately convey to the mind. The world is too busy to read, but never too busy to look at pictures.[18]

When the thoroughly jingoistic weekly *Under the Union Jack* was relaunched by Newnes in July 1900, its commendation of process was part

of a New Journalistic structure in which the magazine offered its readership a rapid and concise coverage of events. Its editorial stated:

> In these busy times, when men are so engrossed, there is a greater need of presenting the facts briefly, brightly and pictorially. Comparatively few are those who can find time or opportunity to read and discuss the weighty articles in the great reviews.... If there ever was a time when it was true that he who runs may read, it is a thousand times more true now, when the pen has more powerful auxiliaries, the pencil and the camera. The latest developments of process for reproducing pictures mark a vast stride of progress, and will be fully utilised in this paper....[19]

In both of these examples the photograph and the sketch are characterized as more effective than written text in conveying information. The word, by way of contrast, is portrayed as slow, tedious and old-fashioned, behind the times, and in need of assistance from its more dynamic visual partners. The *Under the Union Jack* editorial demonstrates the approach to word and image that the magazine thought would be meaningful to its readers.

The deployment and criticism of the image need to be seen in the context of the criticism of popular journalism and its audience. There was a widespread condemnation of the new journalism for its supposed superficiality, and this disapproval also encompassed the readers of the new magazines and papers. This linking of readers and the press was exemplified by Matthew Arnold's disparagement of W. T. Stead's innovations as lacking coherence and analytical rigor, and in 1887 Arnold wrote:

> We have to consider the new voters, the democracy, as people are fond of calling them. They have many merits, but among them is not that of being, in general, reasonable persons who think fairly and seriously. We have had opportunities of observing a new journalism which a clever and energetic man has lately invented. It has much to recommend it; it is full of ability, novelty, variety, sensation, sympathy, generous instincts; its one great fault is that it is feather brained.[20]

Arnold also set the tone for later criticism. In 1891 in George Gissing's novel *New Grub Street* the publisher Whelpdale saw his readers as poorly educated workers who "want something to occupy them in trains and on buses and trams ... what they want is the lightest and frothiest of chit-chatty information – bits of scandal, bits of description, bits of jokes, bits of statistics, bits of foolery."[21] The veteran journalist Edward Dicey agreed: "The newspaper reading public of today wants to be amused not instructed. They do not wish to use their minds more than they can help. They like to have their mental food given to them in snippets, not in chops or joints."[22] By the end of the century this was a general critical position, and there

were concerns that this public was now reading magazines and newspapers rather than books, that their attention spans were shortening. Moreover the material in these periodicals was presented in brief paragraphs rather than extended columns.[23]

The long-standing view, still held by the cultural elite of the late-nineteenth century, was of a human nature divided into base sensual instincts that were controlled by emotion, and higher faculties ruled by intellect and reason. Popular culture was believed to play to these base instincts while elite culture appealed to only a select few.[24] The less sophisticated, less well-educated sections of society – children, the illiterate, and the unsettled lower classes – were supposedly dominated by their feelings and were, therefore, particularly susceptible to the image's immediate emotional appeal. Women of all classes were also seen as impulsive and irrational and therefore more easily swayed by the visual, from an enticing display of goods in a department store to a detailed fashion plate in a periodical. Whether the cause was age, poor breeding, lack of education, or gender, these groups were controlled by sentiment rather than rationality, and therefore the potential effects of the illustrated magazine on these readers were particularly worrying for pundits. The critics of the 1890s had a determinist view of the relationship between images and audiences, who were characterized as passive recipients of the images' effects. The pundits themselves, however, were immune from these wiles.[25] John Carey has noted how the widespread intellectual hostility to the commercial press with its light tone, feminized subject matter, and pictorial content, characterized the public as dupes of the mass media. These attitudes continued through Nietzsche, and George Gissing, to T. S. Elliot, F. R. Leavis, D. H. Lawrence, and the Frankfurt School.[26]

LeMahieu has observed the growing sense of this mass audience among British intellectuals, initiated by the growth of mass consumption and popular entertainments. As with Ruskin's "bestial English mob" of the 1870s, this audience was pictured as less than fully human, as animal, or childlike. They were certainly not individuals, but a herd, and were therefore unable to make individual judgments. Rather, they were controlled by the businessmen who produced publications for the masses. Although they were not all women, they were all feminized by their emotionalism and by their easy manipulation by appeals to their senses, in particular the sense of vision.[27]

It is not surprising, therefore, that highly illustrated periodicals were associated with moral laxity and sensationalism. In 1896 in an article entitled "Up-to-date Journalism," the author stated, "up-to-date now signifies flippant, superficial, immoral, empty and cultureless." He argued that periodicals that described themselves as "up-to-date" were usually printed on shoddy paper with inferior ink and employed third-rate artists and photographers. Their attraction, he suggested, was simply to the pocket and the eye, with their low prices and the large numbers of illustrations they contained.[28] A piece entitled "The Use and Abuse of Illustration" published the same year, claimed

that the "popular pennyworths and third-rate gaudy weeklies which border on the indecent" were now dominated by the image and not by the text: "This upsetting of the true value of things has been brought about by photography, and the inexpensive methods of reproduction, and it is only natural when a new invention is so rapidly brought into use." The author hoped that this was a passing fad and that things would rectify themselves so that fewer images would be offered in magazines.[29]

Three years later a journalist who was profiling the *Daily Graphic* was at pains to stress its propriety, in spite of its extensive use of imagery: "One matter deserves favourable comment – the absence of sensational pictures, the paper is and always has been entirely free from anything approaching vulgarity or sensation, which is something to be thankful for in these days when the debasing influence of objectionable posters and journals is so great and far reaching."[30] Indeed, the *Daily Graphic* promised its readers that it would be suitable for the whole family, without being prudish.

It was not only the lower orders that came in for critical condemnation; the visual tastes of the middle classes were also suspect, though their problem was not that they were too emotional but rather too rational. The stereotypical characterization of the middle class was that they were imperfectly educated, literally minded, materialistic philistines, and both the aristocracy and the avant-garde were scornful of bourgeois mores of hard work and self-control. The epitome of middle-class taste was the factual and scientific photograph prompting Charles Harper to write disparagingly of the readers of popular illustrated magazines:

Let this matter-of-fact nature take to itself the most sharply defined photographs and live with them; yes and look at them always with magnifying glasses, so that nothing in their minuteness shall be lost; let it revel always in the crudities of the unselective actual; then the true era of art dawned with the discovery of photography, and behold, the sun is the only artist and the photographers his prophets.[31]

Photography and mass reproduction were focal points in an anti-industrial critique that was a distinctive element in English society. Criticism of industrial society, the society developed and maintained by the middle classes, came from writers as diverse as Dickens, Ruskin, Arnold, and John Stuart Mill.[32] William Morris, Walter Crane, and Whistler were all influenced by Ruskin's scathing critiques of contemporary society but their responses led them in opposing directions. Ruskin had eventually despaired at the fate of England under capitalism, but Morris and Crane promoted a socialist route forward. Whistler, on the other hand, intensified Ruskin's disdain for his fellow men into an anti-democratic, antibourgeois elitism. For both the Arts and Crafts Movement and Whistlerian Aestheticism, the scientific pragmatism of middle-class culture was epitomized by the mechanical,

unselective, and inartistic photograph.[33] Photography was the ideal means of depicting a mass-produced, materialistic, ersatz culture.[34]

Since the 1840s, photography itself had been criticized as mechanical and soulless and, not surprisingly, these terms were also used to condemn process technologies. The negative critical reaction to the photomechanical image emphasized its characteristics as a mechanically generated artifact, a monotonous, mass-produced replica. Those who looked at images in periodicals were accustomed to the varied lines of wood-engraved images, lines that connoted the worlds of art and of feeling. The repetitive grid of dots that made up the halftone image on the other hand, merely confirmed its machine-made character. Joseph Pennell's principal objection to the halftone was that "the squares of lozenges produce a mechanical look."[35] The terms used to describe the appearance of the halftone evoked the industrial city and mechanized production. The *Telegraph* newspaper criticized line blocks, but added that halftones were even worse: "More lamentable still are the blurred and sooty reproductions likewise due to processes of which lugubrious presentments surfeit the columns of the monthly and weekly periodicals."[36] The word *sooty* evoked the fetid smoke of the metropolis and the factory. The journalist George Sala noted that William Ingram had passed away before the advent of process, that "he died before the introduction into pictorial journalism of those sooty, smoky and blurred 'processes' with which the illustrated press high and low is now afflicted."[37]

The reproductive codes of tonal process were jarring, and audiences had to learn to ignore the new visual formation of regular dots. Commentators found that the dot grid of the halftone was so intrusive that it detracted from the communication of the image itself. The visibility of this grid was known by process workers as the "screeny effect," and it was said that it was noticeable with screens of 120 lines to the inch or less, the ruling used for most general printing; newspaper work, however, was produced on much coarser screens of 85–100 lines to the inch. The use of finer screens entailed printing on smoother, more expensive paper, which meant that newspapers and many magazines could not afford to do this.[38] W. Cheshire maintained that looking at halftones could be mentally exhausting for the viewer, and that photomechanical reproduction had a tendency "by constant repetition to tire and weary the mind of anyone looking through a volume entirely illustrated by its means."[39]

In order to overcome the problem of screen visibility, experiments were conducted using various alignments of screen dots. Horizontal and vertical lines were thought to be too noticeable, and eventually most screens were placed in the diagonal arrangement developed by Levy, considered to be "less objectionable" than other alignments; later experiments that attempted to soften the mechanical appearance of the screen grid included the use of wavy screens. Even in 1921, the illustrator E. J. Sullivan referred to "the mechanical dots and squares of the half-tone block that are so irritating

to all but those who cannot see them."[40] William Ivins' claims for the halftone as a reproductive system without a code or syntax rested on his assertion that the grid of dots was below the threshold of normal vision, but he was mainly concerned with the reproduction of art in which very fine screens would be used. In day-to-day use, however, the codes of halftone reproduction certainly were visible and viewers had to learn not to notice them.[41]

The smooth, shiny "art" paper, on which many halftones were printed was also a new experience for viewers that took getting used to. In 1898 Wallace L. Crowdy, the editor of the *Artist*, commented on the overdramatic contrasts in black and white in some halftones: "Not a little of this falseness of effect – in which the faces of the people are made to glitter like common pottery, and everything else to glisten like new patent leather – is secured at much cost by the use of what is called art paper." Crowdy's similes suggest the mass produced, the middle class, and the shoddy.[42] The use of this shiny paper also evoked the commercial photograph as opposed to the artistic photographic print. Fine photography used unglazed photographic paper in its attempts to simulate printmaking. German opticians concluded that the experience of reading this glossy paper could damage the eyesight, and they recommended that unglazed "sanitary paper for the eyes" should be used for schoolbooks in order to protect children's vision.[43]

The visibility of the screen and the use of glossy paper weren't the only difficulties process had to overcome before the new reproductive aesthetic could be established as normal. In 1882, the art critic and editor J. Comyns Carr stated emphatically that "the appearance of a photograph has absolutely nothing in common with that of printed text, and it is impossible to combine the two so as to produce a satisfactory or harmonious result."[44] This was a commonly held belief, and it was strongly espoused by those associated with the Arts and Crafts Movement. Walter Crane was particularly critical of process reproduction, which he saw as destroying the visual unity of text and image. Since the sixteenth century, wood engraving had developed in harmony with the printed text, but process, on the other hand, took no account of the presence of text on a page. Crane, like Comyns Carr, thought that there was something intrinsically visually awkward in juxtaposing photography with text and apologized when he had to use it in his books.

Wood engraving was also able to bring together different kinds of images. Although originals might come from a variety of sources – photographs, sketches, diagrams, or wash paintings – they were all filtered through the linear codes of the engraver and draftsman. Engraving brought disparate images into a compatible relationship with each other and the typographic elements on the page. In contrast, process made the aesthetic differences between images more apparent. No longer did reproduction stylistically unite diverse originals, but each element retained its own distinct and potentially jarring qualities.

The halftone treated all originals in the same way, whether they were of potatoes or politicians, which in a sense was democratic but could also be demeaning. Wood engraving, however, had conferred a sense of distinction on the individuals it depicted. To be the subject of a time consuming and expensive handmade image suggested a person was of some importance or at least of public interest; an incident or individual had to be considered significant to warrant the expense of creating a drawing and transforming it into a woodblock. This procedure therefore acted as a form of quality control in the press. Almost any image that used the fine linear codes of wood engraving, with their stylistic affinity to metal engraving and fine-art reproduction, attained a certain dignity and artistic status.

Reproduction by halftone dot was, at best, neutral. As Tom Gretton has suggested, the viewer was left to decide the status of the objects depicted in the halftone, as it was no longer inscribed within the reproduction process.[45] A poem reproduced in a trade paper and entitled "That Vile Process" dwelled on the undignified nature of mechanical reproduction and showed an enlargement of a halftone photograph of Lord Kelvin, the venerable aristocrat reduced to "A pattern nebulous / and made of dots and squares." The sitter was degraded by being turned into meaningless particles for the sake of profit, "Where dignity is sacrificed / To tawdry art that pays."[46]

Photography allied with process was able to depict everything and to do so fairly inexpensively and rapidly, but to its critics process had cheapened and vulgarized reproduction. Unlike the wood engraving, the halftone photograph often depicted the prosaic, mundane, and everyday. The lowering of costs had allowed not only an increase in the numbers of images printed but had encouraged the publication of pictures that would not have been considered worth printing previously. Rather than portraying personalities deemed important or events considered noteworthy, process was visually promiscuous.[47] The re-engraving of halftone portraits in middle-class magazines was an attempt to reinsert a notion of status into photomechanical portraiture.

Despite the efforts to improve the aesthetic impact of the halftone, it continued to be regularly criticized by many of those involved in the press. Writing in 1894, publisher and imaging pioneer Henry Blackburn lamented that the halftone had cast a gloom over illustration saying, "the uniform, monotonous dulness [sic] with which we are all familiar pervades the page" and that it flattened tones and removed contrast. Blackburn condemned the disastrous consequences of process prominently displayed on every railway station bookstall in the country and concluded that "it would be difficult, I think, to point to a period when so much bad work was produced as the present." Blackburn, was not entirely antiprocess although he expected that it was so unpredictable in the way that it dealt with drawings and so murky in its general appearance that it would need considerable improvement before it could supplant wood engraving. It needed to be carefully handled if it were to produce successful results, and this was generally lacking.[48]

From Ruskin onward critics characterized the audience for mass-reproduced images as gawpers, demanding to see as much as possible, accepting crude and unartistic work in an unselective and unthinking fashion.[49] As previously discussed, with the introduction of the halftone photorelief into the press the number of printed images increased enormously. It seemed that the public wanted a constantly updated novelty in its images rather than an engagement in depth with any single one, and the sheer quantity of pictures prevented anything else. Illustration, critics claimed, was for those who had neither the education, the time, nor the powers of concentration to deal with extensive reading. An American journal stated in 1893 that

> the youth does not want to read about Bering Sea, and is satisfied with a picture of Mr. Carter. He would like to know something about the disturbances in Brussels, and is satisfied with a picture of the King's palace. He does not care to look into the merits of the Webster Bill, and is content with a picture of some of the nuisances on the Croton River.[50]

Writing in 1894, the art critic Philip Hamerton also linked the acceptance of process by the public to the new fragmentary reading practices in the popular magazines. Due to its cheapness and rapidity of production process was becoming widely used in the press, but these technical and economic factors alone did not account for its acceptance as "there must have been a great change in the public taste for these reproductions to be so generally admitted."[51] An indiscriminating mass audience was now willing to accept any image, Hamerton suggested, as they consumed them rapidly and thoughtlessly, just as they consumed the accompanying written texts.

> We know already the descent in the power of reading: how those who cannot fix their attention on a book read newspaper articles; how, for others, the article is too much, and they read paragraphs; lastly, how even the paragraph requires too much mental application, and the enfeebled intellect has to be fed "tid-bits." So it is in the graphic arts when . . . the public is satisfied with an unending succession of ephemeral sketches, badly reproduced; and it matters nothing whether the reproductions are good or bad, as people only give a glance to each, and, so far from examining or studying anything, never look at the same illustration twice.

Hamerton suggested that in the face of an overwhelming onslaught of images, the public became blasé, and that the plethora of process work and the speed at which it was consumed had deadened popular discrimination. This was, he complained, part of the general vulgarization of modern culture.[52]

The commercially produced magazines consumed by the new popular audience were condemned by Hamerton and many others for their roles in

encouraging transitory reading habits. Yet, the rapid scanning of imagery that Hamerton censures was exactly what was needed by the visually sophisticated, knowing audience for the popular press. They did not have to dwell at length on a particular image, and did not require that these were works of art. Process allowed a democratizing of the image, so that many everyday images could circulate in the press, images that were less precious, more "vulgar." The reader of a popular illustrated periodical engaged in a pleasurable mode of reading that allowed them to shift their attention as they pleased from one item to another, rather than having to dutifully proceed through dense columns of text in a linear fashion.

To mark its first successful year of publication the *Sketch* published "Our Own Trumpet" on the first page of its issue for January 31, 1894. Rather than being a self-congratulatory piece, the article consisted largely of a series of imaginary letters from unlikely readers: a pair of working-class music-hall performers, a young lower-middle-class woman, an "emancipated curate," and a "University man." This very broad and diverse audience all read the *Sketch* for very different reasons – the music-hall artistes to see themselves in print, the young woman to compare herself to the women depicted, the curate to ogle those same women, and the University man to feel disgusted. All of these imagined readers may have used the *Sketch* for their own particular reasons, but all were implicated in the magazine.

> As a University man, I beg to inform you that your paper represents the most decadent tendency of the age. We live in days in which serious study is becoming more and more irksome, and an uneducated public resorts for a passing sensation to pages that can be skimmed without thought. Many a reader who might brace his intellectual energies with a leading article in the *Times* is seduced into mere frivolity by a paragraph in *The Sketch*. I always turn with disgust from your demoralizing journal to bury myself in reflection inspired by an obituary notice. Several members of my club, I rejoice to say, are of my way of thinking. We discussed the matter last night, and came to the unanimous conclusion that the dearth of solid matter in so many of our papers is bound to exercise the most injurious effect on posterity.

In this piece the *Sketch* lampooned criticisms that the shortening of attention span would have physical, mental, and social consequences. These ideas were indicative of widespread concerns about the effects of modernity on the body of the individual. In the United States physicians such as C. L. Dana and George Beard grouped the periodical press with steam power, the telegraph, and city life as contributing factors in a decline of health and an increase in crime. The symptoms of this ill-defined condition included loss of energy, and loss of "nerve force," depression, and anxiety, which they named "neurasthenia."[53] Theories of degeneration were also rife in Europe in

the 1890s, the most widely disseminated and hotly discussed of which were those of Max Nordau, a prominent German journalist. His book *Degeneration* was published in Germany in 1892, and in 1895 the English translation of the book became the most successful and talked about book of the year.[54]

Nordau claimed that the pace of life, public transport, and the media literally abraded the brain, causing weakening that produced a self-obsessed egotist who flitted from subject to subject. The shortening of the attention span was a key sign of degeneration. "The degenerate," Nordau stated, "is not in a condition to fix his attention long, or indeed at all, on any subject, incapable of correctly grasping, ordering jumbled impressions, nebulous blurred ideas."[55] Nordau's concern was not simply about the pace of contemporary life, but about the variety of ideas, styles, people, and objects in the modern metropolis. The contemporary mixing of styles, genres, objects, and classes was, for Nordau, a sign of this degeneracy. Irrational mixtures that challenged accepted standards of aesthetics and beauty were to be seen in fashions, hairstyles, accessories and furnishings as well as in the arts. Nordau described the crowds at an opening of a Royal Academy exhibition or the varnishing day of the Paris Salon as full of strange juxtapositions:

> One seems to be moving amongst dummies patched together at haphazard, in a mythical mortuary, from fragments of bodies, heads, trunks, limbs just as they came to hand and which the designer, in heedless pell-mell, clothed at random in the garments of all epochs and countries. . . . Let us follow there folk in masquerade and with heads in character to their dwellings. Here are at once stage properties and lumber rooms, rag shops and museums. . . . everything in these homes aims at exciting the nerves and dazzling the senses.

In music as in painting and daily life the modern aim was, according to Nordau, to produce a jarring polyphony. His greatest spleen was reserved for the unnatural mixing of media, for new kinds of spectacle where paintings were exhibited to musical accompaniment, or puppet shows were played before an adult audience. "And to enjoy such exhibitions as these society crowds not a suburban circus, but the loft of a back tenement, a second-hand costumier's shop, or a fantastic artist's restaurant, where the performances, in some room consecrated to beery potations, bring together the greasy habitué and the dainty aristocratic fledgling." Nordau lived in Paris, and so would have been well aware of the venues, such as the Chat Noir where these disturbing mixtures of classes and genres occurred. His diagnosis was that both the artists and their audiences were suffering from a composite of degeneration and hysteria, the symptoms of which were insanity, emotionalism, depression, inaction, and mysticism. But, he also stated that it wasn't only those who sought out these hybrid entertainments who were in danger – every city dweller was susceptible. Any newspaper

reader was bombarded with what Nordau believed was an overwhelming amount of information, aware simultaneously of revolution in China, war in Africa, famine in Russia, and an international exhibition in the United States.

Although his numerous readers may not have agreed with, or indeed, understood, his medical theories, the international success of Nordau's book suggests that he addressed middle-class anxieties regarding modern cultural developments and the pace of life. Looking back over this period, journalist J. D. Symon recalled an incredible cultural restlessness and an insatiable demand from the public for entertainment and distraction. He suggested that the press was very much part of this shift and that the extreme energy and liveliness within it had started with *Tit-Bits*, and that, to a greater or lesser extent, this frenetic approach had spread to all publications, including even the *Times*. Symon suggested that the fragmentation of the press had become almost pathological so that looking through a publication placed a mental strain on readers.[56]

Since process allowed a plethora of styles and individual approaches to image making, the concerns about cultural destabilization also focused on the heightened visual hybridity of the illustrated press. The increasingly rapid circulation and mixing of styles were epitomized in Aubrey Beardsley's eclecticism; Beardsley, as Joseph Pennell stated, founded his style on "every age and all schools."[57] His many influences included Whistler, Pre-Raphaelite art (particularly Burne-Jones), Andrea Mantegna, the medievalism of William Morris, French symbolism, Japanese prints, and the French poster artists, who were influenced by medieval art, such as Eugène Grasset. These sources were also explored by many other artists at this time. However, Beardsley was unusual in his combining of styles and in his rapid movement through them. By quoting in such variety, Beardsley highlighted the artificiality of style itself, making the manner in which an image was made a conscious personal choice rather than something imposed by the academy, or by "reality."

Critics were either fascinated or appalled by these amalgamations. Beardsley's illustrations for Oscar Wilde's *Salome* were dismissed by the *Times*: "They would seem to represent the manners of Judea as conceived by Mr. Oscar Wilde, portrayed in the style of the Japanese grotesque as conceived by a French *décadent*. The whole thing must be a joke, and it seems to us a very poor joke."[58] M. H. Spielmann's positive assessment, on the other hand, praised the way in which Beardsley added a personal touch to the styles he appropriated and claimed that there was originality in "his distorted echoes of Chinese or Annamite execution and Rossettian feeling, seen with a squinting eye and imagined with a Mephistophelian brain, and executed with a vampire hand."[59] Margaret Armor thought Beardsley's superimposition of Japanese on medieval and medieval on Celtic was not necessarily wrong, providing that the styles were unified. But, she found the subject matter that Beardsley depicted through these methods to be, at its heart,

vulgar, the problem being that he had mixed refined artistic styles with indecent subject matter. The characters he depicted were coarse cockneys dressed up in Japanese finery as Armor described: "in fact, *The Yellow Book* was just a glorified *Pick Me Up,* and both are the utterances of the Cockney soul."[60]

With the coming of photorelief line process, any style, no matter how grotesque or poorly drawn, could be reproduced and printed in facsimile, warts and all. Even an untrained amateur could now draw an image in pen-and-ink for duplication in the press. The process expert Charles Gamble observed that the cheapness of photorelief allowed the reproduction of "worthless" originals that would never have been considered acceptable in the past. In comparison to wood engraving, process was easily learned and the technology accessible to anyone who could buy the equipment and employ a staff but, as Gamble regretted, most process workers lacked the artistic vision of the experienced wood engraver. The output of most process firms was, therefore, he suggested "aesthetically negligible."[61]

Even supporters of process were critical of its overuse in the press as publishers, editors, and critics all commented negatively on the growth in the use of photographs and process reproduction. Jerome K. Jerome was very much involved in the promotion of new forms of photomechanical imagery in the magazines that he edited. However, on taking over the *Idler* in 1895 he complained: "Poor photographs and cheap drawings badly reproduced, lumped down upon the pages of a magazine without discrimination or selection, must have begun to pall upon the subscriber to modern periodical literature."[62] Like Peach Robinson he objected to these pictures that appeared to be placed randomly on the page, and "lumped down," and he broadened Peach Robinson's criticism to include both the photograph and the sketch in his condemnation, vowing that in the *Idler* and the other magazines he edited, he would use the image in a more discriminating fashion.

The publishing magnate William Ingram was interviewed in June 1895 soon after Clement Shorter had increased the amount of process images in Ingram's periodicals. Ingram was convinced that the halftone photograph was merely a novelty and that its days were numbered, stating, "I think that the public will in time become tired of mere reproductions of photographs." His proposed solution was to use artists to transform photographs into photomechanical illustrations, while continuing to use wood engravings in order to add variety to the layouts.[63] Commenting on the interview, the *British Journal of Photography* agreed with Ingram regarding the overuse of photographs and wondered whether the mass of indifferent halftones in the press was due to poor editing or to the lack of good photographic originals. In the same issue the journal praised American wood engravings based on photographs as being just as accurate as halftones but considerably more artistic and interesting.[64]

A major figure in the debates surrounding photography and process, Joseph Gleeson White's most influential roles were as an author, founding

editor of the *Studio*, and editor for the publisher George Bell, where he wrote, commissioned, and designed many important books on illustration and reproduction.[65] His activities are indicative of the visibility of the discourse around reproduction and process illustration in the press at this time. Readers of specialist art magazines such as the *Studio* and the *Magazine of Art*, as well as mass-market publications such as the *Idler*, the *Sketch*, and *ILN*, were made aware of the upheavals in reproduction and image making through contributions by Gleeson White and others.

Gleeson White's editorship of the *Studio* demonstrated the dramatic and democratic transformation that modern methods could achieve in art publishing. The magazine championed pen-and-ink illustration and used process to depict new developments in art in a fresh and accessible way. Launched in April 1893, the *Studio* was informal, photographically illustrated, inexpensive, and brought the tactics of new journalism to its depiction of art. Its readership was assured of the suitability of process as a means of reproducing art by regular comments on the subject with articles, book reviews, and editorials that all dealt with reproduction and modern imaging. The *Studio* featured pen-and-ink process illustration as one of a range of modern image-making and image-reproduction practices that included photography, etching, and lithography, in which the common thread was the individuality each of the illustrator, photographer, or lithographer brought to his task. Indeed, in the *Studio's* discourse on artistic value, the defining quality assigned to the artist and his products was that of individuality; Gleeson White asserted that "in art, especially in design, personality and individual feeling are the chief things."[66] Process, therefore, was generally praised for its ability to communicate this individuality, while wood engraving was criticized for the insertion of the engraver's personality into the image.[67]

Gleeson White's interest in reproduction techniques led him to attend the meetings of the Royal Photographic Society's process section and to send his son to study process at Bolt Court.[68] His attitudes toward the mass-produced image were complex, however. He was in favor of process as a reproduction method and claimed that those who pined for the old standards were simply out of touch with the times, but he was also concerned about the overuse of photographs as a means of illustration. There were, he admitted, many positive aspects to photography: it had been hugely influential on image making, freeing illustration from outmoded conventions, and it had created a widespread appreciation of "the effects of ordinary life" by depicting subject matter considered too commonplace to be shown by artists. However, this was a two-edged sword for Gleeson White: photography had broadened but at the same time debased mass-reproduced imagery, and he said, "one evil may be laid at the camera, namely a craving for the journalism of pictures, the presentation of ephemeral scenes, and portraits of nobodies."[69] The public was indifferent to the quality of these pictures

and simply wanted quantity, Gleeson White maintained, and he believed that this demand had resulted in a "flood" of commonplace images. Yet, unlike other critics, Gleeson White regarded the success of the halftone as inevitable. The public responded to these images with great enthusiasm and even though it was "abhorred by artists and ridiculed by critics," these elites should adjust themselves to the inevitability of the popular choice.[70] Not everyone agreed with him regarding the superiority of photomechanical reproduction methods. Process, particularly halftone, as we have seen, was criticized as being limited in its abilities. Compared to the wood engraver who could clarify and dramatize an image, process produced a picture that was too literal, an image that missed both the subtleties and the overall impression of the original. All it could hope to do was produce a facsimile, and it couldn't even do that very well. Indeed, Charles Harper argued that the screen itself undermined any claim that halftone might have to be a direct transcript of an original photograph and said, "The necessary reticulation of their surface subtracts from them something of the documentary value of the photograph, and deriving directly from photographs, they have no personal or artistic interest." For Harper the halftone was, at best, a failed and lifeless facsimile.[71]

Phillip Hamerton had used high quality photomechanical reproduction in his monthly art magazine the *Portfolio*. Despite this he believed that process was only accurate within very specific limits; boundaries and details might be in their correct places in a halftone image, but tonal values and modeling were often very poor. The halftone was a weak version of the original, unable to accurately translate the tonal values because it could not produce pure black or white, only gray. Therefore, although the halftone could convey some information about an original, particularly if the original was a line drawing or a three-dimensional object, it missed the atmosphere and the overall unity of the image. And, ultimately, the halftone could not capture the spirit of the original.[72]

In *Industrial Madness*, Elizabeth McCauley discusses the changing ideas of the role of reproduction in nineteenth-century France and notes the commonly held belief, expressed by the art critic Henri Delaborde in 1870, that the engraver needed to interpret an artwork so that a monochrome reproduction at a smaller scale would successfully capture the essential qualities and meaning of the original. She says, "for Delaborde, the function of the copy of a painting is to reconstruct the experience of looking at the original, unlike our twentieth century expectation (perhaps even more naive) that the copy is identical to or congruent with the original."[73] The late-nineteenth century discourse of photomechanical reproduction as facsimile was a step toward our current failure to see the act of representation within reproduction. The industry needed to establish its superiority over the interpretive wood engraving in a situation in which a new, photographically inspired expectation of reproductive mimesis replaced the ideal

of translation or interpretation. But the impossible ideal of facsimile was continually thwarted. Those involved with the industry struggled with the uneasy status of photomechanical reproduction, for on one hand its claims to be a facsimile fell short of the mark and on the other, its aesthetic impact was often flat and uninspiring. These shortcomings could only be rectified by extensive retouching which, in turn, undermined the halftone's claims to truthfulness and accuracy. As the American print curator Frank Weitenkampf put it in 1907, "it is well to remember the limitations of process, limitations which are many and are in many instances glossed over by meretricious tricks and miserable subterfuges."[74]

It seemed that the halftone was so problematic and needed so much handwork that it would prove to be unviable. H. W. Bromhead, writing in the *Art Journal* in 1898, also discussed its many problems. Acceptable results could only be achieved through the use of coated paper and glossy ink but the paper was disagreeable for the reader to handle and the ink produced an "unpleasant, varnished, shiny effect in the shadows which the printer considers so beautiful." Overall, he derided the effect of "the ghastly, ubiquitous half-tone blocks, the greasy ink and the horrid glazed paper that are at present necessary for the production of the high-class illustrated periodical." The process was "capricious" and unpredictable since, for no apparent reason, the tones of an original might come out flat and lifeless. Engravers blamed the drawings, some of which were impossible to reproduce, but, for Bromhead, the problem lay in "the marring grain of the half-tone block" that erased the textures of the original. At the same time he criticized the re-engraving used to remedy this tonal uniformity saying, "the result is often a piece of hideous patch-work, a kind of bastard engraving, neither a satisfactory reproduction of the original, nor an artistic interpretation of it in another medium such as the old wood-engraving often was." The American blocks that were given an elaborate all over "woodcut finish" looked impressive but were a dead end. Bromhead suggested that the problems with the halftone were structural, that there was no way around the dots of the grid, and he predicted that the technique would eventually die out.[75] Sixteen years later, though, the *Penrose Annual*, which provided a yearly overview of developments in reproduction, was still forecasting the halftone's demise. Halftone had never satisfactorily captured the original, so that retouching was required but, even so, electrotyping was unpredictable, and printing was difficult and required extensive time-consuming make ready. All in all, the outlook was not good, and the annual predicted that many halftones would soon be replaced by rotogravure.

However, these assessments turned out to be wrong. Photorelief halftone proved to be a remarkably long-lived imaging technology, partly because of the continued use of retouching. The fashion for wood engraving on top of photographs faded, but less obvious forms of manipulation did not, and so the reproduced photograph continued to be a hybrid of hand and machine.

The 1912 edition of William Gamble's *The Halftone Process* noted that the preparation of originals for halftone reproduction had become an important branch of the photoengraving industry: "It is found desirable, in the case of commercial subjects particularly, to retouch the photographs, so as to increase contrast and bring out detail, as well as to soften harsh or intense shadows, and to eliminate undesirable objects in the background."[76] In the 1930s, the highly experienced process worker and educator Charles Gamble declared in his textbook for student printers that all blocks, even line blocks, needed retouching, and praised the widespread use of the airbrush that had greatly extended the use of the halftone by rectifying its inherent tonal deficiencies, and, more important, could selectively emphasize or remove parts of the image, something the photographer was unable to do within the camera. He also argued that there was now so much manipulation of the photograph that the airbrush and not the photographer created the image. Gamble saw the airbrush as enabling, at long last, the photographic processes to rival the wood engraver's ability to improve on the original. For those who claimed that the halftone was a faithful copy, this amendment was a problem. However, Gamble was unusually clearsighted when he insisted that "a reproduction can never be an exact facsimile, only a transcript" and acknowledged that printing an image in a magazine always involved a shift in scale, color, or medium. He argued that "facsimile of effect," that is, an appearance of mimesis rather than complete fidelity to an original was the best that could be hoped for. In this situation Gamble saw the process worker's task as one of subjective translation, rather than mechanical copying. "The worker in process methods is often placed in the position of an interpreter, and his rendering can be made to show good taste, or the reverse."[77]

As Gamble's textbook makes clear these hybrid combinations of hand and machine remained in printing well into the twentieth century. As J. M. Bullock forecast in 1901, "What we shall see a great deal more of is the manipulated photograph; that is to say, either the photograph painted on by an artist, or at any rate used as the basis of his drawing. . . . One of the best artist on *L'Illustration*, whose originals I frequently examine, is not too proud to paste one piece of photograph here and another there, and work the medley up in such a manner that it is impossible on seeing the reproduction to detect where one begins and the other ends."[78] In addition to these amalgamations, hand-drawn illustration continued to have an important role in popular magazines. For example, in periodicals' coverage of the First World War photography was used to record objects, portraits, and places while illustrations captured the action of battle. Magazines and newspapers only moved to photographic coverage in the 1930s when journalists began to construct narratives through the careful editing and placement of text and photographs.[79]

It was only with the coming of digital reproduction systems in the 1990s that the halftone screen was eventually replaced. The physical screen,

interposed between an image and a plate or negative, has now been supplanted in the printing industry by digital flatbed and drum scanners. The regular lines of the grid have been replaced by stochastic screening in which the image is created from minute, randomly placed dots.[80] However, just as the former technologies offered a previously unrealizable level of faithfulness to the original image, digital software now allows photographic manipulation through programs such as Adobe PhotoShop that enable the modification of images to reach a new intensity and ubiquity. The retouching of photographs for print by designers and specialists has become even more elaborate and ambitious so that the photograph is now simply the raw material for intricate composite images, far in excess of Bullock's predictions. At the same time a whole new area of amateur practice has opened up, and anyone with access to a personal computer can rapidly correct "red eye" with the click of a mouse or, with a little more effort, remove a family member from an image. The old unresolved tensions between facsimile and attractiveness inherent in the growth of photomechanical reproduction are now played out on a new scale. The combination of the hand and camera, though both now digitally mediated, continues as a means of attempting to merge the real and the ideal.[81]

This study has examined the halftone not as a freestanding technology but as a form that was enmeshed in the new illustrated periodicals of the 1890s. These magazines helped to sustain a distinctively modern subjectivity that was always in flux, and that responded to the ephemeral nature of experience in a rapidly changing present. The photomechanically illustrated magazine with its diverse attractions encouraged modes of reading that were particularly appropriate to the modern commercial metropolis. As Patrick Joyce notes of the *flâneur*, "The basis for the nineteenth-century *flâneur*, especially as discerned by Baudelaire, is apparent in the construction of a form of subjectivity which was restless, and constantly in search of distraction. Urban commercial life itself provided this distraction, in that the life of urban consumption was all-absorbing."[82] Similarly, the reader was able to flip or browse through the magazine until something caught her attention.

The popular illustrated press was a complex cultural phenomenon with both positive and negative implications. Certainly the periodical press was controlled by a new commercial alignment of mass production, advertising, and the press conglomerates. The mercantile character of the press, and its positioning of the reader as consumer not only produced content that was light and entertaining but also resulted in the exclusion of many possibilities from its pages. Jean Chalaby argues that in selecting material to print the press defines the "realm of the knowable" for their readers. Their decisions are commercially driven, based on what they think readers already know, and will be entertained by. The problem arises, for Chalaby, when the small sector of information within the realm of the knowable appears to the reader to be the "realm of knowledge."[83]

However, it is not enough to dismiss the illustrated press on the basis of its commercialism, triviality, or vulgarity, as critics of the time did. As Chalaby also points out triviality is in the eye of the beholder. Pictorial magazines visualized the everyday for their readers, and in doing so demonstrated that they were important, that the commonplace was important. The press, beginning with the magazines, showed a broader spectrum of life in a less hierarchical manner. Periodicals allowed a wide range of readers who were broadly defined in terms of their social groupings and gender new opportunities to understand themselves and their world. In a print culture that was shaped by the market there was a democratizing effect; there was no difference in a copy of the *Sketch* read by a university man, a vicar, a respectable middle-class woman, or a clerk. The "new sixpenny public" that Bullock saw as the readership for the *Sketch*, suggests not only the commercial thrust at the heart of the press but also the social nature of the magazine and its important role in the imagined collectivity through which groups made meaning in the city.[84]

Yet there is a negative aspect of the popular press that seems to connect directly to my investigation of photomechanical reproduction itself. Although in some cases manual work was visible on the surface of the halftone, carved into the surface of the block by redeployed wood engravers, the effect of photomechanical processes was to erase its production. The myriad images in the press seemed to have appeared there without effort as the screen hid the extensive labor that their manufacture entailed. This profusion of imagery, like the goods on display in the department store, seemed to have appeared by magic, as the link between product and worker was severed. Similarly, in the popular periodical the spheres of politics, economics, and work were either erased or were treated as spectacle. In addition, these magazines were read by workers who increasingly located their social identities in leisure time. In their production, content, and use photomechanically illustrated periodicals seemed to embody an unsettling form of magical modernity in which meaning became firmly situated in the realm of consumption.

Notes

1 Introduction: Mass reproduction and the mass audience

1. *The Illustrated London News*, January 6, 1843, iii.
2. In terms of the social I draw in particular on Patrick Joyce, *The Rule of Freedom: Liberalism and the Modern City* (London: Verso, 2003), and also Patrick Joyce, *Democratic Subjects: The Self and the Social in Nineteenth-Century England* (Cambridge: Cambridge University Press, 1994).
3. Richard Salmon suggests that the emphasis on the personal was intrinsically linked to the new structures of the press. "It is surely not coincidental that at the very moment when the material basis of the press made it harder to locate an individual source of authorial value, the discourse of journalism should so insistently declare its personalized character." He notes "As a prototypical form of modern mass culture, the New Journalism extols the virtue of 'personality' whilst simultaneously extending the division of labour against which it protests. For this reason, the antagonism between intimacy and abstraction remains unreconciled." Richard Salmon, "'A Simulacrum of Power': Intimacy and Abstraction in the Rhetoric of the New Journalism," *Nineteenth-Century Media and the Construction of Identities*, ed. Laurel Brake (Basingstoke: Palgrave, 2000), 29, 37.
4. Jennifer Green-Lewis, *Framing the Victorians* (Ithaca: Cornell University Press, 1996), 113.
5. Benedict Anderson, *Imagined Communities: Reflections on the Origin and Spread of Nationalism* (London: Verso, 1983), 39–40.
6. Valerian Gribayédoff, "Pictorial Journalism," *The Cosmopolitan*, 11.4 (August 1891), 471–481.
7. Joshua Brown notes that the leading American middle-class magazine, *Frank Leslie's Illustrated Newspaper* segregated the crowds in its engravings of New York, rarely showing the classes mixing within the same image. Joshua Brown, *Beyond the Lines: Pictorial Reporting, Everyday Life, and the Crisis of Gilded Age America* (Berkeley: University of California Press, 2002), 80–81.
8. Charles Knight, *Passages of a Working Life During Half a Century*, vol. 3 (London: Bradbury & Evans, 1865), 246.
9. Plunkett argues that the images are not, in the final analysis, about Victoria, who is "effaced." "This engraving dramatizes the dialectic between the power and powerlessness of Victoria, a tension which is at the heart of the monarchy's media-making." John Plunkett, "Queen Victoria's Royal Role," *Encounters in the Victorian Press: Editors, Authors, Readers*, eds Laurel Brake and Julie F. Codell (Basingstoke: Palgrave, 2005), 24.
10. John Ruskin, "Ariadne Florentina: Six Lectures on Wood and Metal Engraving Given before the University of Oxford at Michaelmas Term 1872," *Proserpina* (Boston: Dana Estes and Co., 1872), 324.
11. Walter Benjamin, "The Work of Art in the Age of Mechanical Reproduction," in *Illuminations* (London: Fontana, 1973), 211–44, 225, 235.
12. On the everyday in the press see Margaret Cohen, "Panoramic Literature and the Invention of Everyday Genres," *Cinema and the Invention of Modern Life*, eds Leo Charney and Vanessa R. Schwartz (Berkeley: University of California Press, 1995).

13. Vanessa R. Schwartz, *Spectacular Realities: Early Mass Culture in* Fin De Siècle *Paris* (Berkeley: University of California Press, 1998), 44.

14. See Salmon, " 'A Simulacrum of Power': Intimacy and Abstraction in the Rhetoric of the New Journalism."

15. Clement King Shorter, *C.K.S. An Autobiography: A Fragment by Himself,* ed. J. M. Bullock (London: Privately Printed, 1927), xviii.

16. Recalling his career in the press in 1897, Sir Wemyss Reid stated that new journalism had brought a number of changes, mostly concerned with an increasing emphasis on personality, not only in the content of the papers but also in their style. Leading articles have become less like discursive essays and more like emphatic speeches by the leader-writer. Newspapers no longer employ the unobtrusive descriptive journalist to cover events. Instead, "The new journalist when writing the account of a ceremony talks as much about himself as the event he is describing." In general, he concludes that the personalities of the journalist, of the paper and of the press itself are much more prominent. He christened this type of journalism "wegotism" as the identity and opinions of the papers, "We think" had become so pervasive. Wemyss Reid, Sir, "Some Reminiscences of English Journalism," *Nineteenth Century*, XLII.CCXLV (1897), T. P. O'Connor's leader in the *Star*, an influential evening paper that I discuss in Chapter 5, was entitled "What we Think."

17. Raymond Williams, *The Long Revolution* (London: Chatto and Windus, 1961), 176.

18. On the complexities of middle-class groupings in Manchester see Joyce, *Democratic Subjects: The Self and the Social in Nineteenth-Century England*, 164–66.

19. As Richard Terdiman suggests these items were much like an array of consumer goods displayed on shelves in a store. This sense of abundance was heightened in the new illustrated magazines with the variety and quantity of their illustrations. Richard Terdiman, *Discourse/Counter Discourse: The Theory and Practice of Symbolic Resistance in Nineteenth Century France* (Ithaca: Cornell University Press, 1985), 187.

20. Margaret Beetham offers a compelling analysis of the relationship between the woman reader and the magazine in *A Magazine of Her Own?* (London: Routledge, 1996). She shows how the miscellaneous format of the magazine and its temporal structure gave the reader a degree of freedom. Yet she also observes that readers often wished to remain safely within the prevailing point of view expounded by the magazine. "For many – perhaps most – readers the desire to be confirmed in the generally accepted or dominant discourse may be a more powerful need than the dream of a different future or the desire to construct alternatives. ... The periodical both offers and witholds the possibility of what we may call 'polymorphously diverse' readings." Beetham, *A Magazine of Her Own?*, 30. Not only were there a variety of voices within each magazine, the range of magazines differed in their overall tone. In his analysis of American illustrated magazines of the late nineteenth century Schneirov notes that periodicals contained a wide variety of ideas; *McLure's Cosmopolitan, Munsey's* the *Century* all had large circulations and all had divergent views. Matthew Schneirov, *The Dream of a New Social Order: Popular Magazines in America, 1893–1914* (New York: Columbia University Press, 1994).

21. Most of the large London publishers used American Hoe presses, and many of the key developments in imaging technologies were first developed in the US. Illustrated magazines were also influenced by publications from other countries. This was especially true of English and American magazines, which, in some

cases, published overseas editions. Publishers in both countries were inspired by formats developed by their transatlantic peers.

22. John Southward, *Progress in Printing and the Graphic Arts During the Victorian Era* (London: Simpkins, Marshall, Hamilton, Kent and Co., 1897), 21. The various photographic relief techniques were known collectively as "process."

23. Carl Hentschel, "Process Engraving," *Journal of the Society of Arts*, 49.2474 (1900), 463–474.

24. Lena Johannesson argues that the idea that the picture printing industry was dominated by the photograph and photo processes is untrue. She admits that the photo had an influence on the visual idiom and finds before 1900 fluid "graphic intersections" between photo and other prints. Lena Johannesson, "Pictures as News, News as Pictures: A Survey of Mass-Reproduced Images in 19th Century Sweden," *Uppsala: Acta Universitatis Upsaliensis*, 1984. Also see Helena E. Wright, "The Osbourne Collection of Photomechanical Incunabula," *History of Photography*, 24.1 (2000).

25. Brian Maidment, *Reading Popular Prints, 1790–1870* (Manchester: Manchester University Press, 1996), in particular, "The Victorian Wood Engraving and Its Uses," 145–48.

26. For Harris the construction of categories of "appropriateness" in the types of technology used to reproduce particular images marked a new cultural moment. Neil Harris, "Iconography and Intellectual History: The Halftone Effect," *Cultural Excursions* (Chicago: University of Chicago Press, 1990).

27. This study deals with magazine illustration and apart from Peter Sinnema, *Dynamics of the Pictured Page: Representing the Nation in the* Illustrated London News (Aldershot: Ashgate, 1998), there has been little attention paid to imagery in popular magazines in the nineteenth century. However, illustration, particularly the relationships between text and image, has received increasing amounts of critical attention. Recent scholarship on specific aspects of illustration includes Rosemary Mitchell, *Picturing the Past: English History in Text and Image, 1830–1870* (Oxford: Clarendon Press, 2000); Julia Thomas, *Pictorial Victorians: The Inscription of Values in Word and Image* (Athens Ohio: Ohio University Press, 2004); and Lorraine Janzen Kooistra, *Christina Rossetti and Illustration* (Athens: Ohio University Press, 2002); and For the use of photographic illustration in other media see Anthony J. Hamber, *A Higher Branch of the Art: Photographing the Fine Arts in England 1839–1880* (Amsterdam: Gordon and Breach, 1996), and Helene E. Roberts, *Art History through the Camera's Lens* (Amsterdam: Gordon and Breach, 1995). On the use of photography in science see Jennifer Tucker, *Nature Exposed: Photography as Eyewitness in Victorian Science* (Baltimore: Johns Hopkins University Press, 2005).

28. See Richard Altick, *The English Common Reader: A Social History of the Mass Reading Public, 1800–1900* (Chicago: University of Chicago Press, 1957), 356–57, on publishing as a modern industry. Charles Booth, *Life and Labour of the People in London*, vol. 4 (London: Macmillan, 1903), 2nd Series IV Industry "No other occupation has suffered more than engraving from the competition of new inventions and the change from ancient to modern methods. Every branch of the business has been effected in this way," 112.

29. Ruskin, "Notes on the Present State of Engraving in England," *Proserpina* (Boston: Dana Estes and Co., 1876), 390–91.

30. My reading of the concept of hybridity is informed by Homi Bhabha's *The Location of Culture* (London: Routledge, 1994) and the notion that the unsettling of fixed identities, or in this case fixed cultures of representation, can bring

together contradictory elements in a productive way. Associated with this notion of hybridity is the questioning of the purity of those existing categories.

31. William Ivins, *How Prints Look* (New York: Metropolitan Museum of Art, 1943), 144.

32. For instance, an investigation in the *Process Photogram* found that the expensive retouching that would be used in a respectable middle-class magazine produced the least accurate halftone photograph. An Art Editor, "Fac-Sim by an Art Editor," *Process Photogram*, 8.88 (April 1901), 52–54. For a rebuttal of Ivins' linear account see Susan Lambert, *The Image Multiplied: Five Centuries of Printed Reproductions of Paintings and Drawings* (London: Trefoil, 1987). "A drawback of this essentially chronological account, beginning with the comparatively crude woodcut and ending with photographic veracity, is that it imposes on the creators of the works singled out a false role as protagonists in a purposeful drive towards a method of reproduction which represented its original ever more faithfully. In fact, consideration of which technique to use at any particular moment was governed by quite other factors. Markets tend to impose a certain uniformity of presentation on objects and the choice of medium was therefore considerably influenced by market expectations. There were conventions for the reproduction of certain sorts of subject matter by certain kinds of technique, and even within broad categories there were technical subdivisions, or methods of manipulating the technology, in order to appeal to the desired public," 118.

33. There were a number of interrelated factors in the slow adoption of photography, and, in some cases, photomechanical reproduction, by advertisers. Henry Blackburn argued that the main reason was that wood engravings were easier to print than halftones. In 1894 he analyzed the *Sketch*, and noted that whereas the editorial illustrations are all processes, 85 of the 88 advertising illustrations were wood engravings. Henry Blackburn, *The Art of Illustration* (London: W. H. Allen, 1894), 163. Michele Bogart in her fascinating study of advertising imagery demonstrates that in the US photography was not widely used in advertising until well after World War I and was not dominant until the 1930s. Among the reasons, she argues, was that the halftone lacked the dramatic tonal qualities of the wood engraving. Michele H. Bogart, *Advertising, Artists and the Borders of Art* (Chicago: University of Chicago Press, 1995), 175–77. For the struggles to establish photography see in particular, "The Rise of Photography," 171–204. Richard Ohmann suggests the major reason was that photography was not used in the 1890s was that it was unable to appeal to fantasy and emotion in the same way as hand-drawn images. Richard Ohmann, *Selling Culture: Magazines, Markets, and Class at the Turn of the Century* (London: Verso, 1996), 185. For an earlier view of this problem see S. H. Horgan, "Photography and the Newspapers," *Photographic News*, 38.1348 (1884), 427–428. Horgan noted that images often require retouching or engraving on the block to make them more acceptable. "Advertised objects must be made prominent. The camera, as we all understand does not show the partiality that the advertiser wishes; for instance his two story building must become a five story one, with throngs of customers passing in and out, and loaded trucks at the curbstone."

34. For a discussion of the difficulties with Ivins' theories see Gordon J. Fyfe, "Art and Its Objects: William Ivins and the Reproduction of Art," *Picturing Power: Visual Depiction and Social Relations*, eds Gordon Fyfe and John Law (London: Routledge, 1988). He notes that Ivins' arguments rest on a fairly recent conception of the artist as a sovereign individual, and indeed that the changes in reproduction were essential to the making of the modern artist. "From the eighteenth century

214 *Notes*

an *impersonalization* of reproduction went hand-in-hand with a *personalization* of the artist," 84. Estelle Jussim has produced a refinement and revision of Ivins' theories. She finds some of Ivins' arguements untenable and acknowledges that photography is subjective, the result of human choices, and that the halftone has a visible syntax. Estelle Jussim, *Visual Communication and the Graphic Arts: Photographic Technologies in the Nineteenth Century* (New York: Bowker, 1974). However, her argument that the development of the graphic arts was centered on the imaging of works of art does not seem tenable. In the nineteenth century the numbers of printed images of art, in any medium, would have been dwarfed by many other genres of image.

35. Harris, "Iconography and Intellectual History: The Halftone Effect." Harris also observes that it was many decades before the photograph could rival the hand-drawn image as a means of creating effective imagery in advertising.

36. Joan M. Schwartz notes how the halftone severed the photograph from its status as a physical object, "Un Beau Souvenir Du Canada," *Photographs Objects Histories: On the Materiality of Images*, eds Elizabeth Edwards and Janice Hart (London: Routledge, 2004), 29. This collection contains a number of interesting invest-igations that demonstrate the importance of the physical qualities of photo-graphic objects to their meanings; for an overview of these issues see Edwards and Hart, "Introduction: Photographs as Objects," *Photographs Objects Histories: On the Materiality of Images*, (London: Routledge, 2004).

37. See "Multiples" in Mary Warner Marien, *Photography and Its Critics: A Cultural History, 1839–1900* (Cambridge: Cambridge University Press, 1997).

38. Régis Durand discusses the ways in which different types of photographic images can be consumed depending on their materiality. "(P)hotography seems to call for so many different ways of viewing. It is not even clear that it exists (and how) as a medium. Is the medium the paper print, the ordinary print we use for our snapshots? Or is it the artist's print, which can be put up on the wall, matted and framed, or kept loose in a portfolio? Or is it the photograph as printed on the page of a magazine, or in a book (by far the most widespread use today)? The object itself lacks all 'certainty' (to use Barthes's word), making the phenomenological reading of it problematic and plural." Régis Durand, "How to See (Photographically)," *Fugitive Images*, ed. Patrice Petro (Bloomington: Indiana University Press, 1995), 146.

39. The transformation of the photograph through digitization is outside the scope of this study. It is clear that once digital photographs are placed on the web they can be multiplied, distributed and shared in new ways. Anyone with the right software can now be a retoucher. As W. J. Mitchell observes in the digital realm, "the original distinction between producers and consumers of images evapor-ates." W. J. Mitchell, *The Reconfigured Eye: Visual Truth in the Post-Photographic Era* (Cambridge, MA: MIT Press, 1992), 51. For a discussion of the digital image within the home see Don Slater, "Domestic Photography and Digital Culture," *The Photographic Image in Digital Culture*, ed. Martin Lister (London: Routledge, 1995).

40. See Victor Burgin, "Looking at Photographs," *Thinking Photography*, ed. Victor Burgin (London: Macmillan, 1982), 152. Durand suggests that the photograph demands that it be read quickly. Durand, "How to See (Photographically)," 146.

41. Of course the halftone can be removed from the magazine, decontexualized and placed in a scrapbook, pinned on a wall, or framed. But this is not the same as the photograph that is often treasured from the moment of its production. The

reproduced photograph is something public that can become private, rescued from its ephemerality to become part of the collector's personal narrative.
42. Maidment, *Reading Popular Prints, 1790–1870*, 15.
43. For a rich exploration of relationships between text and image in Victorian culture see Thomas, *Pictorial Victorians: The Inscription of Values in Word and Image.*
44. Roland Barthes, "The Photographic Message," *Image – Music – Text,* ed. Stephen Heath (London: Fontana/Collins, 1977), 17.
45. See Green-Lewis, *Framing the Victorians,* 109.
46. Walter Crane, "Modern Aspects of Life and the Sense of Beauty," *William Morris to Whistler,* ed. Walter Crane (London: G. Bell and Sons, 1911), 210.
47. It was not until after 1900 that the editorial pages of the daily press were opened up to display advertising. For a firsthand account of this struggle see Wareham Smith, *Spilt Ink* (London: E. Benn, 1932).
48. Anon, "The Encroachment of the Advertisement," *Process Work and the Printer,* 6 (1897), 106.
49. Raymond Williams states: "The Great Depression which in general dominated the period from 1873 to the middle 1890s (though broken by occasional recoveries and local strengths) marks the turning point between two moods, two kinds of industrial organisation, and two basically different approaches to distribution. After the Depression, and its big falls in prices, there was a more general and growing fear of productive capacity, and a marked tendency to reorganise industrial ownership into larger units and combines, and a growing desire to organise and where possible control the market. Advertising then took on a new importance, and was applied to an increasing range of products, as part of the system of market control which, at full development, included tariffs and preference areas, cartels quotas, trade campaigns, price fixing by manufacturers and economic imperialism." *The Long Revolution,* 200. Richard Ohmann and Daniel Pope both identify a similar pattern emerging at roughly the same time in the United States. Ohmann, *Selling Culture: Magazines, Markets, and Class at the Turn of the Century.* Pope, *The Making of Modern Advertising* (New York: Basic Books, 1983). On the Great Depression and trade see Donald Read, *England 1868–1914: The Age of Urban Democracy* (London: Longman, 1979), 214–42, and also Eric Hobsbawm, *Industry and Empire: The Making of Modern English Society from 1750 to the Present Day* (New York: Pantheon, 1968), 103–08.
50. For a contemporary account of advertising in this period see John Morgan Richards, *With John Bull and Jonathan: Reminiscences of Sixty Years of an American's Life in England and the United States* (New York: Appleton and Company, 1906).
51. His comments originally appeared in *Die Zeit* in July 1896.
52. Alexandre asserted that this was a phenomenon of the last ten years and although there was in France a move away from the illustrated cover this was simply a change in fashion. The book cover was now irrevocably marked as the site of visual appeal, so that a plain cover became "coquetry." Arsene Alexandre, M. H. Spielmann, H. C. Bunner and August Jaccaci, *The Modern Poster* (New York: Scribner, 1895), 15.
53. On the encouragement of consumption in women's magazines of the period see Cynthia L. White, *Women's Magazines 1693–1968* (London: Michael Joseph, 1970), 52, 68.
54. See Deborah Wynne, *The Sensation Novel and the Victorian Family Magazine* (Basingstoke: Palgrave, 2001), 43–50, on the Victorian obsession with nervous debilities and concerns over the pace of modern life and health. It was these fears that advertisers invoked.

55. Holbrooke Jackson, *The Eighteen Nineties* (London: Grant Richards, 1913), 279.

56. Walter Crane argued that pen drawing was suitable for small-scale work and went particularly well with written text, linking the illustrator's pen line to that of the writer. "Its true province is in comparatively small scale work, and its natural association with its sister-pen of literature in the domain of book-design and decoration, and black and white drawing for the press." Walter Crane, *Line and Form*, 8th ed. (London: George Bell and Sons, 1900), 71.

57. Judith Wechsler, *A Human Comedy: Physiognomy and Caricature in 19th Century Paris* (Chicago: University of Chicago Press, 1982), 14.

58. See J. Hillis Miller, *Victorian Subjects* (Durham, NC: Duke University Press, 1991), 157–58, and Wechsler, *A Human Comedy*, in particular "Caricature: Newspapers and Politics," 66–111, which looks at the explicit connections between the use of physiognomical codes in theater, mime specifically, and in newspaper caricature. See Wynne, *The Sensation Novel and the Victorian Family Magazine*, 127–28, on George du Maurier's exploration of theatrical poses in his illustrations of the 1860s.

59. Anon, " 'Bon Voyage' to Phil May: A Chat with the Popular Artist," *Sketch*, March 29, 1893.

60. Charles Ashbee, *Caricature* (London: Chapman and Hall, 1928), 111.

61. Ibid., 61.

62. Julian Franklyn, *The Cockney* (London: Andre Deutsch, 1953), 207.

63. Terdiman, *Discourse/Counter Discourse: The Theory and Practice of Symbolic Resistance in Nineteenth Century France*, 164.

64. "He is interested in the *outward show of life*, such as it is to be seen in the capitals of the civilized world." Charles Baudelaire, "The Painter of Modern Life," *The Painter of Modern Life and Other Essays*, ed. Jonathan Mayne (London: Phaidon, 1965), 24.

65. Baudelaire, "The Painter of Modern Life," 4.

66. Most artists in fact produced a pencil drawing and worked on top of that in pen and ink, so the execution of the drawings was not as rapid as it appeared.

67. Newnes claimed that *Tit-Bits* was inspired by his own experience as an apprentice when he had been unable to find entertaining reading matter that he could enjoy during his brief breaks from work. Hulda Friederichs, *The Life of Sir George Newnes Bart* (London: Hodder and Stoughton, 1911).

68. Charles G. Harper, *English Pen Artists of To-Day: Examples of Their Work with Some Criticisms and Appreciations* (London: Percival and Co., 1892), 257.

69. Speaking of Harmsworth's *Daily Mail* Escott noted that: "The leisurely descriptive writing has gone out. The condensed three line paragraph has come in. The *Daily Mail* has shown a busy generation which reads its papers as it takes its lunch standing up at a buffet, that the essence of the day's news of the world can be read in a few odd minutes" T. H. S. Escott, *Social Transformations of the Victorian Age: A Survey of Court and Country* (London: Seeley and Co., 1897), 386.

70. Peter Bailey, " 'Naughty but Nice': Musical Comedy and the Rhetoric of the Girl, 1892–1914," *The Edwardian Theatre*, eds Michael R. Booth and Joel H. Kaplan (Cambridge: Cambridge University Press, 1996), 48.

71. Peter Bailey, *Popular Culture and Performance in the Victorian City* (Cambridge: Cambridge University Press, 1998), Chapter 6, "Music Hall and the Knowingness of Popular Culture," 128–50.

72. Patrick Joyce examines the performance of knowingness in the context of the working class "free and easy" entertainments in the pubs of Manchester and sees

them as a means of discerning and negotiating a rapidly changing city. Joyce, *The Rule of Freedom: Liberalism and the Modern City*, 205–10.

73. "For it is by appearances that civilization turns the basic contradiction of its construction into a miracle of existence: a cohesive society of perfect strangers. But in the event, its cohesion depends on a *coherence* of specific kind: on the possibility of apprehending others, their social condition, and thereby their relation to oneself 'on first glance.' " Marshall Sahlins, "La Pensée Bourgeoise: Western Society as Culture," *Culture and Practical Reason* (Chicago: University of Chicago Press, 1976), 203–04.

74. On the photographic image in the magazine see Siegfried Kracauer, "Photography," *The Mass Ornament*, ed. Thomas Y. Levin (Cambridge, MA: Harvard University Press, 1995).

75. Margaret Beetham points out the serial form of the periodical means that "It always points beyond itself – to other numbers of the same periodical, to other words and texts to give it meaning, to other periodicals, books or entertainments." Beetham, *A Magazine of Her Own?*, 26.

76. Wilke argues that a single advertisement cannot signify; it needs repetition and reinforcement over time. The associations between a whole series of messages have to be seen as interconnected in order for the message to convey a meaning. Jennifer Wilke, *Advertising Fictions* (New York: Columbia University Press, 1988), 163.

77. Patricia Anderson, *The Printed Image and the Transformation of Popular Culture, 1790–1860* (Oxford: Oxford University Press, 1991), 193.

78. Gabriel Tarde, *Gabriel Tarde: On Communication and Social Influence*, ed. Terry N. Clark (Chicago: University of Chicago Press, 1969), 297, 318.

79. Joseph Gleeson White, "Some Aspects of Modern Illustration," *Photographic Journal*, NS 19.11 (1895), 350.

80. Wilke, *Advertising Fictions*, 78.

81. "The configuration of advertisements told a collective story – a narrative – to society at a given moment." Wilke, *Advertising Fictions*, 120.

82. William Archer, *The Theatrical "World"* (London: W. Scott, 1896), 303. Archer refers to sexual knowingnesss in his review. "What evidently took best indeed, was a sort of deliberate vagueness, the 'you know what I mean' effect implied by an adroit reticence (an 'aposiopeses' the rhetoricians call it) helped out with a nod, a wink, or a grimace", 303.

83. On topicality and its role in fiction and the press see Richard Altick, *The Presence of the Present: Topics of the Day in the Victorian Novel* (Columbus: Ohio University Press, 1991). Altick sees these references as satisfying the reader's "insatiable interest in the contemporary scene," For authors, "the usefulness of topical references in strengthening a sense of community between themselves and the readers of their own day." He notes a particularly strong sense of presentness in the nineteenth century, a phenomenon that he regards as a symptom of a greater self-awareness within English society as it attempted to define itself in a time of rapid and bewildering change, 4, 9.

84. On simultaneity see Wynne, *The Sensation Novel and the Victorian Family Magazine*.

85. On Mikhail Bakhtin and the principal of heteroglossia and Julia Kristeva's "intertextuality" in relation to periodicals see Mark Turner, "Towards a Cultural Critique of Victorian Periodicals." Turner sees this as related to the readers' ability to make their own path through the magazine. "In this sense, reading periodicals can be liberating, presenting as they do the freedom for the reader to roam, to wander textually – a pleasure of the periodical text." Turner, Mark, "Towards a Cultural

Critique of Victorian Periodicals." *Studies in Newspaper and periodical History 1995 Annual*, eds Michael Harris and Torn O' Halley (Westport, CT: Greenwood press,), 111–26.

86. Michele Hannoosh, *Baudelaire and Caricature* (University Park: Penn State University Press, 1992), 299–307. There is, Hannoosh suggests, an inevitable dualism in the comic depiction of the modern metropolis.

87. "Yet I have done more than float new and successful journals. I have started a new era in journalism which is in evidence to-day in the picture page of every newspaper." Clement King Shorter, *Publishers Circular* (August 28, 1926).

2 Imaging the city: London and the media in the 1890s

1. Joseph Gleeson White, "The Lay Figure Speaks," *Studio* (October 1893). The "Griffen" is the heraldic griffin statue that marks the boundaries of the City of London.

2. For a fascinating account of the way in which London's urban life, its popular culture, economy, and architecture were shaped by its role as the hub of the Empire, see Jonathan Schneer, *London 1900: The Imperial Metropolis* (New Haven: Yale University Press, 1999), in particular, Chapter 5, "Popular Culture in the Imperial Metropolis," 93–118.

3. See Gareth Steadman Jones, *Outcast London* (Oxford: Clarendon Press, 1971), Chapter 8, "The Transformation of Central London," 159–78.

4. For instance, Charles Booth recorded that those in the trades connected with printing seldom lived near their Central London places of work. Many workers walked every day from Islington or Walworth, or took trains from the suburbs. Booth, *Life and Labour of the People in London*.

5. On the pleasures and dangers of London's thoroughfares see James Winter, *London's Teeming Streets, 1830–1914* (London: Routledge, 1993), Jones, *Outcast London*.

6. Anon, *Illustrated London News Her Majesty's Glorious Jubilee 1897: The Record Number of a Record Reign* (St. Albans: Oxford Smith and Co., 1897), 50.

7. The classic British outline of time standardization is E. P. Thompson, "Time, Work Discipline and Industrial Capitalism," *Essays in Social History*, eds M. W. Flinn and T. C. Snout (Oxford: Clarendon Press, 1974). Richard Whipp has pointed to the uneven success of attempts to standardize working times in Britain. Richard Whipp, "A Time to Every Purpose: An Essay on Time and Work," *Historical Meanings of Work*, ed. Patrick Joyce (Cambridge: Cambridge University Press, 1987).

8. On the size of the theatrical industry in London, see Michael Booth, *Theatre in the Victorian Age* (Cambridge: Cambridge University Press, 1991), 11. The staff at The Empire was even larger than the Lyceum numbering 670 employees. Michael Chanan, *The Dream That Kicks: The Prehistory and Early Years of Cinema in Britain*, 2nd ed. (London: Routledge, 1996), 147. There were many more isolated individuals employed on an irregular sweated basis in the producing of clothing which was in effect the largest industry in the capital, Schneer, *London 1900: The Imperial Metropolis*, 6.

9. Joyce, *The Rule of Freedom: Liberalism and the Modern City*, 154.

10. On imperialism and commerce, see Bernard Porter, "The Edwardians and Their Empire," *Edwardian England*, ed. Donald Read (London: Croom Helm, 1982). Also see Hobsbawm, *Industry and Empire: The Making of Modern English Society from 1750 to the Present Day*, 107–08, 110–27, 201–02.

11. On anxieties, see R. K. R. Thornton, *The Decadent Dilemma* (London: E. Arnold, 1983), 9. On general cultural paranoia, see Judith Walkowitz, *Prostitution and Victorian Society* (Cambridge: Cambridge University Press, 1980), 247. Also see Lori Anne Loeb, *Consuming Angels: Advertising and Victorian Women* (Oxford and New York: Oxford University Press, 1994), 100–27.
12. Susan D. Pennybacker, *A Vision for London, 1889–1914: Labour, Everyday Life and the LCC Experiment* (London: Routledge, 1995), 24.
13. On class divisions in London, see Jones, *Outcast London*, 159–239. On lower-class consumption, see Terry Nevett, "Advertising and Editorial Integrity in the Nineteenth Century," *The Press in English Society from the Seventeenth to Nineteenth Centuries*, eds Michael Harris and Alan Lee (London: Associated University Presses, 1986), 150. On the lower middle classes as the market for new cultural and economic forms, see Geoffrey Crossick, "The Emergence of the Lower Middle Classes in Britain," *The Lower Middle Class in Britain, 1870–1914*, ed. Geoffrey Crossick (London: Croom Helm, 1977), 34.
14. T. H. S. Escott, "The Past, Present and Future of the Middle Classes," *Fortnightly Review*, NS 88 (1907), 117–18. Escott was the editor of the *Daily Telegraph*.
15. On the employment of servants as an indication of respectability, see Hugh McLeod, "White Collar Values and the Role of Religion," *The Lower Middle Class in Britain, 1870–1914*. Although 36 percent of Booth's printers fell into the "central classes" only 4.6 percent of them employed servants. Booth, *Life and Labour of the People in London*, 228.
16. Read notes the increasing numbers and prosperity of the middle classes. Read, *England 1868–1914: The Age of Urban Democracy*.
17. Joyce, *The Rule of Freedom: Liberalism and the Modern City*, 148.
18. On physiognomy and on types depicted in elaborate iconographic series see Wechsler, *A Human Comedy: Physiognomy and Caricature in 19th Century Paris*, 22–26.
19. On clothes and the middle class see James A. Schmiechen, *Sweated Industries and Sweated Labour: The London Clothing Trades 1860–1914* (London: Croom Helm, 1984). Richard Sennett, *The Fall of Public Man* (Cambridge and New York: Cambridge University Press, 1976), 161–74. Charles Ashbee believed that the intense sense of decorum in the Victorian era was the reason that "the Victorians are so concerned about clothes and how they should be worn." Ashbee, *Caricature*, 114.
20. Speaking of developments in France, Judith Wechsler states: "The illustrated newspapers were a vehicle for identifying, deciphering and communicating the signals and norms of urban existence." Wechsler, *A Human Comedy: Physiognomy and Caricature in 19th Century Paris*, 14.
21. On the importance of middle-class organizations as means of creating a shared sense of what it was to be middle class see Martin Hewitt, *The Emergence of Stability in the Industrial City: Manchester, 1932–67* (Aldershot: Scolar Press, 1996), in particular, Chapter 3, "The Genesis of Middle-class Moral Imperialism," 66–91.
22. Artisans' earnings were much more subject to fluctuation with the trade cycle and with overtime. Many artisans were not paid at all if there was no work to be done. See Crossick, "The Emergence of the Lower Middle Classes in Britain," 34.
23. The advertising director of Shredded Wheat noted that since the mid-1880s advertising had enabled "specialities" to become "staples." His list included cameras, the safety razor, the phonograph, the fountain pen, ready-made clothes, soups, life insurance, sanitary supplies, and breakfast cereals. Trueman A. De Weese,

"The Magazine in National Advertising," *The Library of Advertising*, vol. 1, ed. A. P. Johnson, (Chicago: Cree, 1911), 179–82.

24. Mason Jackson, *The Pictorial Press: Its Origins and Progress* (London: Hurst and Blackett, 1885), 2.

25. By the turn of the century it is claimed that many families read three or four sixpenny illustrated weeklies. See Richards, *With John Bull and Jonathan: Reminiscences of Sixty Years of an American's Life in England and the United States*, 64.

26. On the sharing of literature see Terry Nevett, *Advertising in Britain: A History* (London: Heinemann, 1982), 49–52. He estimates that thirty to fifty people might read a weekly magazine. See Jenni Calder, *The Victorian Home* (London: Batsford, 1977), 134, on reading as one of the most appropriate middle-class activities. J. D. Symon observed in the early years of the twentieth century that the weekly passed "through hands innumerable" before it was kept and bound. J. D. Symon, *The Press and Its Story* (London: Seeley, Service and Co., 1914), 134.

27. Mark Hampton, *Visions of the Press in Britain, 1850–1950* (Urbana: University of Illinois Press, 2004), 83.

28. The Foster Education Act of 1870 and the Mundella Education Act were aimed at regulating education rather than enforcing literacy. On the literacy debate see Vincent, David, *Literacy and Popular Culture* (Cambridge: Cambridge University Press, 1989). Vincent puts the figure for illiteracy in the population at the time of the Mundella Act in 1880 as 5 percent. Since midcentury Sunday papers had been popular with a working-class readership, as they could be consumed on what was most workers' only day of leisure. *Lloyd's Weekly London Newspaper*, *The News of the World*, and the republican *Reynolds's Weekly Newspaper* all had huge sales. By 1896 *Lloyd's* was selling more than one million copies every week. Their content was light, entertaining, and miscellaneous.

29. Sala is quoted in Swan, *Progress of British Newspapers in the Nineteenth Century* (London: Simpkins, Marshall, Hamilton and Kent, 1901), 206–07. Speaking of Newnes, Symon stated "He had seen that the plain man got probably his greatest entertainment from the non-essential part of his daily newspaper." Symon, *The Press and Its Story*, 253. This, of course, brings into question what is important to the mass reader.

30. The "taxes on knowledge" were gradually removed in the middle of the century. Stamp duty was levied on each sheet of a newspaper, and was a penny a sheet until 1855 when it was abolished. Advertising duty was charged at a flat rate of one shilling and sixpence per advertisement. This was abolished in 1853. Paper duty of one and a half pence per pound was abolished in 1861. On stamp duty restricting illustration see Nevett, *Advertising in Britain: A History*, 44–45.

31. On Ingram's aggressive business practices see H. R. Fox Bourne, *English Newspapers: Chapters in the History of Journalism*, vol. 2 (London: Russell and Russell, 1887). They were able to "crush or control" any rivals, 295–96.

32. Dicey uses the phrase "men of straw" to describe the new newspaper proprietors who were driven by profit. See Edward Dicey, "Journalism Old and New," *Fortnightly Review*, 83 (1905), 906. On changes in the press see Williams, *The Long Revolution*, 205–06; also see Alan J. Lee, *The Origins of the Popular Press* (London: Croom Helm, 1976), 76–79, 117. The tax applied to periodicals containing news, so papers like *Lloyd's* avoided it by not printing news. By the time the stamp tax was lifted the newsless magazine format was well established as a publishing genre. On this see Beetham, *A Magazine of Her Own?*, 24–26.

33. James Moran, *Printing in the Twentieth Century* (London: The Times Printing Company Limited, 1930), 24.

34. In the US periodicals were primarily sold through subscription. In Britain, however, there was a mixed distribution through newsagents, railway stations, and street sales in addition to subscription. Also, in contrast to the US, periodicals faced competition from national daily newspapers. Newnes and his imitators therefore employed aggressive marketing techniques in order to build their circulations. These included many promotions and prizes including the offer of jobs, of houses, treasure hunts, competitions and free insurance schemes. Through these incentives and the qualities of the magazines themselves the major publishers were able to build and sustain very large circulations. Unfortunately, we have no idea exactly how big these circulations were. Figures supplied to the publishers were marketing tools, used to attract advertisers and readers, and were usually exaggerated. It was only in the following century that audited circulation figures were finally provided by publishers.

35. For an absorbing account of Newnes' publishing activities, and his key role in the British press see Kate Jackson, *George Newnes and the New Journalism in Britain, 1880–1910: Culture and Profit* (Aldershot: Ashgate, 2001). *Tit-Bits* was launched on October 22, 1881. Newnes was a thirty-year-old fancy-goods representative from a Free Church background when he and his wife hit on the idea of turning his hobby of snipping items from periodicals into a magazine. He could not initially raise backing for the project and opened a vegetarian restaurant in Manchester as a way of raising funds. As the paper developed it incorporated more original material, but still kept the material short. See also Friederichs, *The Life of Sir George Newnes Bart.* Quotation *The History of the Times: Volume Three, the Twentieth Century Test 1884–1913* (London: The Times, 1947), 94–95.

36. Chalaby calls the expansion of Newnes and his rivals from the periodical to the daily press a "two-step investment strategy" and notes that Newnes and Northcliffe each had built up a stable of twenty magazines before venturing into the daily press. Jean K. Chalaby, *The Invention of Journalism* (Basingstoke: Macmillan Press, 1998), 49–50. On the continued "magazinization" in the press today, as newspapers attempt to cater for the individual within a broad customer base by providing many diverse sections, see John Tulloch, "The Eternal Recurrence of New Journalism," *Tabloid Tales: Global Debates over Media Standards*, eds John Tulloch and Colin Sparks (Laneham, Maryland: Rowman and Littlefield, 2000), 139–45.

37. Chalaby, *The Invention of Journalism*, 50.

38. Gleeson White noted that periodicals' steady readership allowed them to commission illustrations, unlike books, for instance. The illustrator, he argued, was the product of the structures of publishing. Joseph Gleeson White, *English Illustration "The Sixties" 1855–70* (London: Archibald Constable and Co., 1897), 9–10.

39. McClure in his autobiography noted how photomechanical process opened up publishing. "The development of photo-engraving made such a publication then more possible. The impregnability of the older magazines, such as the *Century* and *Harper's*, was largely due to the costliness of wood-engraving. Only an established publication with a large working capital could afford illustrations made by that process. The *Century Magazine* used, when I was working for it, to spend something like five thousand dollars a month on its engraving alone. Not only was the new process vastly cheaper in itself, but it enabled a publisher to make pictures directly from photographs, which were cheap, instead of from drawings, which were expensive." S. S. McClure, *My Autobiography* (New York: Frederick A. Stokes Company, 1914), 207–08.

40. On the role of competition in the adoption of technology see Chalaby, *The Invention of Journalism*, 42–43.

41. Ellic Howe, *Newspaper Printing in the Nineteenth Century* (London: Printed Privately, 1943), 25.

42. As Raymond Williams points out: "The true 'Northcliffe Revolution' is less an innovation in actual journalism than a radical change in the economic basis of newspapers, tied to a new kind of advertising." Williams, *The Long Revolution*, 202.

43. For instance, Henry Blackburn writes of "weekly newspapers" in his analysis of press illustrations in 1894. Blackburn, *The Art of Illustration*, 157.

44. On the cultural connotations of traditional newspaper layout see D. L. LeMahieu, *A Culture for Democracy: Mass Communication and the Cultivated Mind in Britain between the Wars* (Oxford: Clarendon Press, 1988), 67–68.

45. Stead's *Pall Mall Gazette* was the first daily to use line illustrations, though it did so intermittently.

46. The staid *Times* was the epitome of the respectable daily; the *Daily Telegraph* offered a more lively approach; other morning papers included the *Daily News* and the *Morning Star*. Harmsworth launched the *Daily Mail* in 1896 as a halfpenny morning paper, with a lighter tone than its competitors. On newspaper delivery systems and newsagents see Booth, *Life and Labour of the People in London*, 299–301.

47. The London evening papers included the *Star*, the *Evening News*, *St. James Gazette*, *Pall Mall Gazette*, and *Westminster Gazette*.

48. On the use of hand camera snap shots see W. D. Welford, "The Influence of the Hand Camera," British Journal of Photography, XL (1893). On the *Westminster Gazette* and the *Pall Mall Gazette*, see Jonathan Rose, *The Edwardian Temperament* (Columbus: Ohio State University Press, 1986), 166–70.

49. The sixpenny weekly *Pall Mall Budget* collected together much of the material from the daily *Pall Mall Gazette*. The *Westminster Gazette* also issued a budget edition.

50. Horace Townsend, "Modern Developments in Illustrated Journalism," *Journal of the Society of Arts*, 42.2152 (1894).

51. "The environment of events is inevitably haphazard. Inevitably, in a profit driven system, this dictates the manufacture of reliable nonevents." Tulloch, "The Eternal Recurrence of New Journalism," 137.

52. Usually a copy of the woodblock and the type was made by an electrotype or stereotype process and these, rather than the originals, were used on the presses. This not only preserved the original from any damage on the press but it enabled the same pages to be printed on multiple machines. This considerably speeded up the production run. It was only in the 1850s with the development of paper moulds or "flongs" that the technology was widely applied in periodicals. Ellic Howe, *The London Compositor* (London: The Bibliographical Society, 1947), 259–61.

53. The comic is largely outside the scope of this study. Starting with *Funny Folks* in 1874 this was a vibrant form of the illustrated press. Characteristically, the press conglomerates were not slow to enter this market. Harmsworth launched *Comic Cuts* in 1890 aimed at office boys, and within two years it was making more than his flagship magazine *Answers*.

54. There was a growth in women's magazines in this period, as women were seen as the main consumers of household goods. Some of these were leaders in the incorporation of illustration and advertising. In particular, the weekly *Lady's Pictorial*

emphasized printed illustrations and attracted a large number of advertisements. See Shorter, *C.K.S. An Autobiography: A Fragment by Himself*, 7, also see Clement King Shorter, "Illustrated Journalism: Its Past and Future," *The Newspaper Owner and Manager*, April 5, April 12, 1899. Other women's magazines included: *Woman at Home* (1893), *Forget Me Not* (1893), *Home Sweet Home* (1894), *Home Notes* (1895), and *Home Chat* (1895).

55. *Black and White: A Weekly Illustrated Record and Review* was launched in 1889 by C. N. Williamson as editor and M. H. Spielmann, the art critic of the *Magazine of Art* and the *Graphic* as its art editor.

56. In 1891 Newnes transformed the monthly market, just as he had transformed the weeklies. Capitalizing on the success of *Tit-Bits*, he launched the *Strand*, a sixpenny monthly aimed at a more respectable middle-class audience. Its title, and the image of the *Strand* on the cover were intended to evoke the excitement of city life. On the naming and launch of the *Strand* see Friederichs, *The Life of Sir George Newnes Bart*, 120–21. On the significance of using fashionable London place names for titles of magazines see Mark Turner, "Saint Paul's Magazine and the Project of Masculinity," *Nineteenth-Century Media and the Construction of Identities*, 233. The *Strand* adopted *Tit-Bits'* disparate approach, but allied it to imagery. By 1897 the *Strand* claimed that it had published 15,000 pictures. In 1899 the *Strand* boasted that its circulation stood at 300,000 copies per month in the UK and 200,000 in the US. According to Gleeson White Newnes' magazine was the first monthly magazine to exploit the possibilities for cheap imagery offered by snapshot photography and the process block. White, *English Illustration*, 127. Symon was rather critical of this highly successful monthly and believed that the *Strand* "betrays its kinship with *Tit Bits* in a multitude of ways, some subtle, some not so subtle." Symon, *The Press and Its Story*, 254.

57. There were also many other types of magazines. These included serious reviews that featured political comment, criticism, essays, and analysis. The *Spectator*, and *Saturday Review*, and *Fortnightly Review* were less stodgy than the long established *Edinburgh Review*, *Quarterly Review*, and *Westminster Review*. There was also a very lively provincial press: The *Manchester Examiner*, the *Manchester Weekly Tribune*, its weekly edition, and the *Northern Echo* were among the many important newspapers that served a regional audience. These papers were often innovative in their adoption of new production and imaging technologies.

58. Booth, *Life and Labour of the People in London*, 190.

59. Joyce, *The Rule of Freedom: Liberalism and the Modern City*, 199–203.

3 Wood engraving: Facsimile and fragmentation

1. Ruskin, "Ariadne Florentina," 299.

2. Paul Dobraszczyk has identified topes of the sublime in the magazine's delineation of engineering works in the capital, Dobraszczyk, "Sewers, Wood Engraving and the Sublime: Picturing London's Main Drainage System in the Illustrated London News, 1859–1862," *Victorian Periodical Review*, 38.4 (2005). Peter Sinnema has analyzed the use of the sublime in *ILN* as a means of making reports of railway accidents less disturbing. Sinnema, *Dynamics of the Pictured Page: Representing the Nation in the* Illustrated London News, see Chapter 4, "Representing the Railway," 116–41.

3. Brian Maidment, *Reading Popular Prints, 1790–1870*, 145.

4. See Hamber, *A Higher Branch of the Art: Photographing the Fine Arts in England 1839–1880*, quotation page 3. Hamber's discussion is concerned principally with the reproduction of fine art. In *Parallel Lines* Stephen Bann looks at the complex situation in the nineteenth century when both reproductive engraving and photography were used in order to reproduce art. Bann demonstrates the struggles and failures of photographers to match the standards set by reproductive engraving in producing copies of artworks, and he examines shifting conceptions of the original and the copy. Stephen Bann, *Parallel Lines: Printmakers, Painters and Photographers in Nineteenth-Century France* (New Haven: Yale University Press, 2001).
5. On Niépce and printmaking see Bann, *Parallel Lines: Printmakers, Painters and Photographers in Nineteenth-Century France*, 92–103. On the influence of engraving on photographers in Britain see Anne Kelsey Hammond, "Aesthetic Aspects of the Photomechanical Print," *British Photography in the Nineteenth Century: The Fine Art Tradition*, ed. Mike Weaver (Cambridge: Cambridge University Press, 1989). On wood engraving's influence on Marville's photography see Constance Cain Hungerford, "Charles Marville, Popular Illustrator: The Origins of a Photographic Sensibility," *History of Photography*, 9.3 (1985).
6. On relationships between processes see Allen Staley, *The Post-Pre-Raphaelite Print: Etching, Illustration, Reproductive Engraving, and Photography in England in and around the 1860s* (New York: Columbia University Press, 1995), and Jens Jäger, "Discourses on Photography in Mid-Victorian Britain," *History of Photography*, 19.4 (1995), 316–321.
7. On metal engraving see Staley, *The Post-Pre-Raphaelite Print*, and Rodney Engen, *Pre-Raphaelite Prints* (London: Lund Humphries, 1995). The critic P. G. Hamerton ranked reproductive techniques in order of their artistic importance as follows: metal, etching, mezzotint, and wood engraving. P. G. Hamerton, *Drawing and Engraving: A Brief Exposition of Technical Principles and Practice* (London: Adam and Charles Black, 1892), 75–77. Gleeson White insisted that although the term "wood-cut" was commonly used to indicate wood engraving the two methods were very different and needed to be differentiated, Gleeson. White, *English Illustration*, 132.
8. Maidment suggests that wood engraving "presupposed an intense relationship between text and image." Due to size limitations it seemed particularly appropriate for use alongside text on the printed page rather than as an autonomous image. Maidment, *Reading Popular Prints*, 15.
9. Linton stated that engravers such as Orrin Smith and Harvey, who worked soon after Bewick, aimed to imitate the fineness and look of copperplate engraving. William J. Linton, "Art in Engraving in Wood," *Atlantic Monthly*: (June 1879), 705–715. George Woodberry asserted that copper engraver Robert Branston introduced the codes of copper engraving into the trade and these were diffused via Orrin Smith. George E. Woodberry, *A History of Wood-Engraving* (New York: Harper & Brothers, 1883), 164–67.
10. The split between work and home operated differently according to class. In the middle classes merchants no longer lived above their businesses. Factory workers and clerks commuted to their workplaces. For the sweated worker, however, home and work occupied the same cramped space. The earlier model of apprenticeship in which boys boarded with their master in a house that was also a workplace was on the decline and would have been under particular pressure in London.
11. Booth records that engravers in offices were working around forty-eight hours a week, while those based in their own homes worked very irregular hours. Booth, *Life and Labour of the People in London*, 112.

12. William Linton estimated the cost of a kit including twelve gravers, a lamp, a globe, an eyeglass, and a sandbag at £1.5s in 1884. William Linton, *Wood-Engraving a Manual of Instruction* (London: G. Bell, 1884), 36. On equipment see also William Norman Brown, *A Practical Manual of Wood Engraving, with a Brief Account of the History of the Art* (London: Crosby, Lockwood and Co., 1886), and James Shirley Hodson, *A Historical and Practical Guide to Art Illustration in Connection with Books, Periodicals and General Decoration* (London: Sampson Low, 1884). The trade suppliers were all in Holborn, Clerkenwell, and Farringdon, close to the printing industries. As in other trades, the ownership of the tools gave the artisan a measure of independence.

13. The term office referred to the printing office rather than the business office.

14. In contrast to the sparseness of wood-engraving literature, over 70 instructional manuals on aspects of lithography, the second most widely used image technology, were published in the same period. The wood-engraving books were William Chatto and John Jackson, *A Treatise on Wood Engraving, Historical and Practical* (London: Charles Knight, 1839), which contains about 100 pages of technical information in addition to an extensive historical account written by Chatto, T. Gilks, *The Art of Wood-Engraving: A Practical Handbook* (London: Winsor and Newton, 1866), which is 57 pages in extent, C. W. Marx, *The Art of Drawing and Engraving on Wood* (London: Houlston and Co., 1881), 44 pages in extent, and Brown, *A Practical Manual of Wood Engraving, with a Brief Account of the History of the Art*, 70 pages in extent. W. J. Linton's *Wood-Engraving* is a vindication of his views on engraving as well as an instructional manual. In their exhaustive bibliography of printmaking Geoffrey Wakeman and Gavin Bridson suggest, "In the almost total absence of any English instructional texts we must assume that, if Papillon [J. B. M. Papillon's *Traité historique et pratique de la gravure en bois*, published in Paris in 1766, the first detailed account of wood engraving] was not consulted, the craft was taught entirely by example and learnt by experience." Geoffrey Wakeman and Gavin Bridson, *Printmaking and Picture Printing: A Bibliographical Guide to Artistic and Industrial Techniques in Britain, 1750–1900* (Oxford: Plough Press, 1984), 102. As a young engraver, Groves made extensive use of Chatto and Jackson's *Treatise*, borrowing it from the London Institution in Finsbury Circus. J. B. Groves, "Rambling Recollections and Modern Thoughts by an Old Engraver," Incomplete Manuscript (London: Punch Archive), 3.

15. There were, in fact, a number of well-known female engravers, including Mary Byfield and Eliza Thomson, and many of the manuals commend engraving as a trade suitable for women. The English engraver William Brown recommended it as a respectable and artistic occupation for women forced to face the world alone, as feminine fingers were particularly suited to its practice. Brown, *A Practical Manual of Wood Engraving, with a Brief Account of the History of the Art*. In the US at midcentury skilled wood engravers were in short supply. One of the early American instruction manuals was written in 1867 by the female engraver Sarah Fuller. She advised that the profession was not overcrowded and was suitable for women, due to its sedentary nature, although she cautioned that women should not work more than five or six hours a day, unlike men who worked an eight- or nine-hour day. Fuller asserted that pay rates were the same for both sexes, and so it was much more rewarding than other trades open to women such as millinery or sewing. S. E. Fuller, *A Manual of Instruction in the Art of Wood Engraving* (Boston: J. Watson, 1867). Though the apprentice system excluded women, many must have learned from manuals. William Linton maintained that engraving was the most suitable "artist work" for women, and stressed that all references in his

manual to "he" and "his" should also be read as "she" and "hers". Linton, *Wood-Engraving a Manual of Instruction*, 44. Not only was Linton a supporter of women's rights, he taught wood engraving to a women's class in New York, one of a number of venues in the US and England that offered engraving classes specifically for women. Helena E. Wright discusses the situation for women engravers in the US and notes that although there were many women in a trade that was a suitable area in which single women could support themselves, they were not well paid, and their situation was more precarious than their male counterparts. Helena E. Wright, *With Pen and Graver: Women Graphic Artists before 1900* (Washington: Smithsonian Institution, 1995), 6–7. Indeed, as women were excluded from the business networks provided by apprenticeship and the wood-engraving office, many female engravers were isolated freelancers. The illustrator Birket Foster recalled taking the block of a Barnaby Rudge illustration he had drawn as an apprentice to a female outworker, Miss Clint in Islington, so that she could engrave the easier parts of the block. Marcus Huish, "Birket Foster: His Life and Work", *Art Annual Xmas Number of the Art Journal*, 1890. Paul Martin, who worked as a wood engraver in the 1890s, claimed he had only ever heard of one female engraver. Paul Martin, *Victorian Wood Engraving* (London: Prints, Drawings and Paintings Collection).

16. Ruskin started teaching drawing at the Working Men's College in 1854 and published *The Elements of Drawing* (1857) and *The Elements of Perspective* (1859) based on his program. See Gillian Naylor, *The Arts and Crafts Movement* (Cambridge, MA: MIT Press, 1971). Groves stated that Ruskin's drawing classes at the Working Men's College were popular with engravers. Groves, "Rambling Recollections," 21. Indeed, the engraver Frederick Brigden, who underwent a thorough apprenticeship under Linton, also attended Ruskin's classes. Angela E. Davis, *Art and Work: A Social History of Labour in the Canadian Graphic Arts Industry to the 1940s* (Montreal: McGill-Queen's University Press, 1995), 30–32.

17. Gleeson White argued that while some artists complained there were many more who were satisfied with the reproduction and translation of their work. White, *English Illustration*, 175.

18. Baldry numbered George Pinwell, Frederick Walker, Arthur Boyd Houghton, Frederick Leighton, and John Everett Millais were among those who were inspired by the requirements of wood engraving to produce "virile design and direct draughtsmanship." A. L. Baldry, "The Future of Wood Engraving," *Studio* (June 1898), 10.

19. Gleeson White, *English Illustration*, 98.

20. On the development of more open styles for rapidly printed magazine work see J. Whitfield Harland, "The Prospects of Wood Engraving," *Printing Times and Lithographer*, (July 1892), 41. The metal presses developed in the nineteenth century were especially useful for the precise printing required for illustrations. These presses used dry paper and a light impression that were ideal for printing wood engraving. Howe suggests "It is probable, therefore, that the exact methods of presswork were not primarily evolved for the perfection of letterpress, but for obtaining the best possible results from white-line wood engravings, with their delicate incisions and variations of tone." Howe, *The London Compositor*, 295.

21. Landells was one of the founders of *Punch* and engraved its images for its first two volumes. See W. S. Hunt, "Concerning Some Punch Artists," *Magazine of Art*, 14 (1890), Spielmann, "Glimpses of Artist-Life. The Punch Dinner – the Diners and Their Labours," *The Magazine of Art* (1895).

22. Hartrick says that one of the reasons why there was friction between engravers and the "artist designer" was that in many cases the engravers were paid more than the artist. A. S. Hartrick, *A Painter's Pilgrimage through Fifty Years* (London: Cambridge University Press, 1939). On engravers being paid more than artists also see Gleeson White, *English Illustration*, 121.

23. George Stiff was an ex-*ILN* engraver who founded the hugely successful *London Journal* in March 1845. On Stiff and his publication see Andrew King, "A Paradigm of Reading the Victorian Penny Weekly: Education of the Gaze and the London Journal," *Nineteenth-Century Media and the Construction of Identities*. W. L. Thomas founded the *Graphic*, *ILN*'s major rival. Landells was a partner with Ingram in *ILN*. On Frank Leslie and *Frank Leslie's Illustrated Newspaper* see Madelaine B. Stern, *Purple Passage: The Life of Mrs Frank Leslie* (Norman: University of Oaklahoma Press, 1953), and Brown, *Beyond the Lines: Pictorial Reporting, Everyday Life, and the Crisis of Gilded Age America*.

24. On *ILN* see Symon, *The Press and Its Story*.

25. In order to be accepted into the home, periodicals had to make sure that their editorial content would not offend any members of the household, including women and children. Periodicals were often left in a prominent place in the public rooms of the house not only so that they could be read by the family but also that they could be seen by visitors. It was usual for the periodical to be lent to friends. In many cases families would eventually preserve the magazine in binders.

26. See Eric Hobsbawm and Terence Ranger, *The Invention of Tradition* eds Eric Hobsbawm and Terence Ranger (Cambridge: Cambridge University Press, 1983), in particular, Hobsbawm, "Introduction: Inventing Traditions," *The Invention of Tradition*, and Hobsbawm, "Mass-Producing Traditions: Europe, 1870–1914," *The Invention of Tradition*. David Cannadine notes the role of the mass-reproduced image in the press in the presentation of the monarchy in the 1890s Hobsbawm, "Mass-Producing Traditions: Europe, 1870–1914." David Cannadine, "The Context, Performance and Meaning of Ritual: The British Monarchy and the 'Invention of Tradition,' ca. 1820–1977," *The Invention of Tradition*, 123. Richard Terdiman states "A social formation depends for its stability on a relatively stable understanding of its past, consequently on a generalized assent to the structures and cultural discourses produced out of that past to regulate the present." Richard Terdiman, *Present Past: Modernity and the Memory Crisis* (Ithaca: Cornell University Press, 1993), 31. John Plunkett has examined the close relationship between the press and the monarchy in Victoria's reign. He shows how the press coverage by the illustrated press provided viewers with an intimate contact with the mobile Queen. The constant and regular coverage of the monarch was only possible in a format such as *ILN'S* and he suggests that the launch of the magazine was timed to coincide with the royal costume ball. Shortly after the launch the magazine provided extensive coverage of royal progress thorough Scotland with a total of 63 engravings of the tour. See Plunkett, "Queen Victoria's Royal Role," *Encounters in the Victorian Press: Editors, Authors, Readers*. For a more detailed analysis of the diffusion of the image of Victoria as a domestic sovereign, visible to her subjects, see John Plunkett, *Queen Victoria: First Media Monarch* (Oxford: Oxford University Press, 2003). The marriage of Princess Beatrice in 1885 was, according to Beetham, a visual milestone in the reporting of royalty as spectacle. Beetham, *A Magazine of Her Own?*, 98–99.

27. Walter Crane, *An Artist's Reminiscences* (London: Methuen and Co., 1907), 66.

28. Andrew King remarks, regarding the reproduction choices of the Sunday papers, "By markedly refusing culturally powerful styles available in magazines like *The Penny Magazine* in favour of non-naturalistic iconography linked to the older broadside, to the penny gaff and to melodrama they offered resistance to hegemonic culture." King, "A Paradigm of Reading the Victorian Penny Weekly: Education of the Gaze and the London Journal," 84. On Sunday papers in general, see Bourne, *English Newspapers: Chapters in the History of Journalism*, 121–24.

29. The *Penny Magazine* had already established the finer, more detailed codes of wood as genteel and respectable. It purported to appeal to a working-class readership interested in self-improvement and its use of wood engraving was intended to have an elevating influence on this readership. In fact its audience was lower middle class in nature. Wood engraving was also used to give a genteel apprearence to lower-class publications, such as the *London Journal*, that wished to link themselves to refined culture.

30. See Maidment for a discussion of the complex meanings of the wood engraving in the press. Maidment, *Reading Popular Prints, 1790–1870*, 145–48.

31. Henri Delaborde spoke of the engraver's role as a translator of paintings. "An engraver . . . will know how to modify certain details, attenuating or accenting the effect of certain tones, because the reduction of the proportions and the absence of color impose particular conditions of interpretation on the copy." Quoted in Elizabeth Anne McCauley, *Industrial Madness: Commercial Photography in Paris, 1848–1871* (New Haven: Yale University Press, 1994), 294. McCauley notes: "For Delaborde, the function of the copy of a painting is to reconstruct the experience of looking at the original, unlike our twentieth century expectation (perhaps even more naive) that the copy is identical to or congruent with the original." McCauley, *Industrial Madness*, 294. Delaborde's *Engraving: Its Origins, Processes and History* published in London in 1886 decried the public's taste for photography and photographic processes of reproduction. Delaborde blamed the decline of hand engraving on the public's "exaggerated confidence in the benefits of mechanical discovery." He spoke of the "ruthless imitiation," "stupid impartiality," and "unreasoning veracity" of process and contrasted this with the engraver's work of interpretation. The engraver used artistic feeling, intelligence and taste to translate color into monotone, to account for scale, to capture the overall effect of the original. In bringing out the character of the original selection, simplification, and in some cases exaggeration all were possible techniques for the engraver to use, but they were not possible with the camera, 286. Delaborde was speaking of metal engraving of fine-art images, but the concept of translation was usual in wood engraving also. Even when dealing with a small monochrome drawn image, rather than a large multicolored canvas the wood engraver still needed to adjust the original. As Hamber puts it: "While on the one hand there was the concept that the copyist could be able to mimic exactly the quintessential elements of the original, on the other there was the notion that the copyist could, indeed should, interpret and even improve on the original by correcting deficiencies." Hamber, *A Higher Branch of the Art: Photographing the Fine Arts in England 1839–1880*, 10. Trevor Fawcett discusses the adjustment and reversal of images in reproductions. Trevor Fawcett, "Graphic Versus Photographic in Nineteenth Century Reproduction," *Art History*, 9.2 (1986). The interpretive approach to the reproduction of images was the accepted norm in the press at midcentury when *ILN* was launched see John Tagg, "Movements and Periodicals: The Magazines of Art," *Studio International* (September/October 1976), 142.

32. Eldridge Kingsley, in 1889, in the *Century Magazine*, a home of high quality engraving, argued that the halftone might be mechanically exact, and that process might be suitable for line drawings but in tonal images the grid imposes a sameness that could not capture the multiple textures are inherent in nature. Every texture in nature was different, so how could it be transmitted via a mechanical, monotonous grid? "How can a harmony of many notes be best produced by a machine having only one note or texture? The result can only be a shadow of the original, a mere lifeless corpse." The feeling of the picture is destroyed as "It may be scientifically exact and yet have nothing in common with the original." Elbridge Kingsley, "Originality in Wood Engraving," *Century*: (August 1889), 578.
33. On the difficulties of facsimile see Hodson, *A Historical and Practical Guide to Art Illustration in Connection with Books, Periodicals and General Decoration*.
34. Bewick was central in asserting the interpretive approach, but in a letter of 1796 he offered to produce a facsimile of a client's drawing although he doubted the attractiveness of the result. Letter reproduced in *Cherryburn Times: The Newsletter of the Bewick Society*, 2.8 (Spring 1995). Linton cut images for *Hood's Comic Annual* in facsimile while working for Bonner. Mason Jackson, "The Book and Its Story 'The Memories of Mr. W. J. Linton,'" *Sketch* (April 10, 1895).
35. See Thomas Richards, *The Commodity Culture of Victorian England: Advertising and Spectacle, 1851–1914* (London: Verso, 1991), in particular "The Great Exhibition of Things," 17–72. On direct effects of the exhibition on wood engraving see Harland, "The Prospects of Wood Engraving," 41.
36. Apprenticeships became shorter and training became increasingly narrow and limited; "outdoor" apprenticeships, where the apprentice didn't board with the master, became the norm. In a time of rapid technological change apprenticeship was generally under threat as a means of passing on skills and controlling entry to trades. This move was a general one within Victorian manufacturing as trades were moving away from apprenticeships as they moved from hand to machine. Women and children were employed to undertake repetitive easily learned skills which could be mastered without an apprenticeship. For an overview, see T. A. Skingsley, "Technical Training and Education in the English Printing Industries: A Study in Late Nineteenth Century Attitudes. Part One: The Apprenticeship System," *Journal of the Printing Historical Society*, 13 (1978/1979), Skingsley, "Technical Training and Education in the English Printing Industries: A Study in Late Nineteenth Century Attitudes. Part Two: The Pressures of Change," *Journal of the Printing Historical Society*, 14 (1978/1979). The situation was similar in US where W. J. Rorabaugh claims that apprenticeship was "moribund" by 1865, having been "an empty facade" for some time before this date. W. J. Rorabaugh, *The Craft Apprentice: From Franklin to the Machine Age in America* (Oxford: Oxford University Press, 1986).
37. On the requirements of the interpretive approach see Ruskin, "Ariadne Florentina," 323.
38. Hodson, *A Historical and Practical Guide to Art Illustration in Connection with Books, Periodicals and General Decoration*, 111.
39. Groves, "Rambling Recollections," 38.
40. Ibid. 38.
41. Ibid. 15, 16. Groves worked for Swain cutting the heads for the engravings in *Punch*.
42. Crane, *An Artist's Reminiscences*, 48.
43. In metal engraving this type of specialization was also in place by the mid-1850s. The consequences in terms of de-skilling were the same in both industries.

Gordon J. Fyfe, "Art and Reproduction: Some Aspects of the Relations between Painters and Engravers in London 1760–1850," *Design and Aesthetics: A Reader*, eds Jerry Palmer and Mo Dodson (London: Routledge, 1996).

44. On the new structures of the industry see Gleeson White, *English Illustration*, 11–13.

45. Linton, "Art in Engraving in Wood," 707–09. Linton linked this mechanical approach not only to the splitting up of the block and the specialization of the engravers but to the use of photography on the block.

46. Gleeson White, *English Illustration*, 11–13. The following year Arthur Comfort, the chairman of the International Society of Wood Engravers, criticized these "illustration manufacturers." Arthur Comfort, "Letter from Arthur Comfort (Hon. Chairman of the International Society of Wood Engravers)," *Studio*, August 1898.

47. Originally titled "Lectures on Wood and Metal Engraving," they were published in 1876 as *Ariadne Florentina*.

48. Ruskin, "Ariadne Florentina," 296, 302.

49. On "The Nature of the Gothic," see Raymond Williams, *Culture and Society 1780–1950* (London: Chatto and Windus, 1958), 141.

50. The movements of the hand under the direction of the mind he terms "dexterity." For mere physical, habitual movements he suggests the term "sinisterity."

51. Ruskin, *Ariadne Florentina*, 299.

52. Ruskin, "Notes on the Present State of Engraving in England," *Proserpina*, 390–91.

53. According to Pennell the character of the engraving business rather than the artist or engraver dominated these productions, and he spoke of "the clever businessman who merged the individuality of all his artists and engravers into that of his own firm." Joseph Pennell, *The Illustration of Books: A Manual for the Use of Students, Notes on a Course of Lectures at the Slade School University College* (London: T. Fisher Unwin, 1896), 48. He also argued that these engravers became "supreme, autocratic, dictatorial, insufferable," 96.

54. Paul Fildes suggests that although jointed blocks were produced from the 1840s the bolted amalgamated block was not widely known even in 1873. He says that the date of their invention cannot be reliably established, but is later than 1860. Paul Fildes, "Phototransfer of Drawings in Wood-Block Engraving," *Journal of the Printing Historical Society*, 5 (1969), 97. Spielmann noted that when drawing the full page political cartoon for *Punch*, John Tenniel had to plan his image so that the faces didn't cross the joins in the block. Spielmann, "Glimpses of Artist-Life. The Punch Dinner – the Diners and Their Labours." Hartrick says that the foreman engraver would run through the joins on the block, showing the direction that the lines must follow before the image was broken up. Hartrick, *A Painter's Pilgrimage through Fifty Years*, 82, 83.

55. Anon, "The Manufacture of Bolted and Amalgamated Wood Blocks," *British and Colonial Printer and Stationer*, February 12, 1885, 102.

56. Lambert, *The Image Multiplied: Five Centuries of Printed Reproductions of Paintings and Drawings*, 108.

57. See Henry Vizetelly, *Glances Back through 70 Years: Autobiographical and Other Reminiscences*, vol. 1 (London: Kegan Paul and Co., 1893), 225–26. Claudet opened his studio in 1841 with Richard Beard, although he sold and imported daguerreotypes and equipment before this date; see Jager, "Discourses on Photography in Mid-Victorian Britain," *History of Photography*, 20.2 (1996).

58. John Ruskin, *The Stones of Venice*, vol. 2 (London: Smith, Elder & Co., 1853), 199.

59. Hamber notes "Photography brought about a fundamental re-evaluation of the form and purpose of reproduction, and introduced the concept of the 'absolute

facsimile.' This concept was at odds with the accepted aura, aesthetic and artistic spirituality of the manual reproduction." Hamber, *A Higher Branch of the Art: Photographing the Fine Arts in England 1839–1880*, 3. Fawcett, "Graphic Versus Photographic in Nineteenth Century Reproduction."

60. Walter Benjamin, "Daguerre or the Dioramas," *Charles Baudelaire: A Lyric Poet in the Era of High Capitalism* (London: New Left Books, 1973), 163.

61. Jussim, *Visual Communication and the Graphic Arts: Photographic Technologies in the Nineteenth Century*, 61, 255.

62. The first published account of an attempt to transfer a photograph onto a wood-block appeared in the *Magazine of Science* in 1839, and in 1854 the *Art Journal* published an engraving by Robert Langdon of an image which had been photo-graphically fixed on the block; see Anon, *Notes and Queries* (August 12, 1854). The earliest known French wood engraving from a daguerreotype appeared in *L'Ilustration* on July 8, 1848. From the mid-1850s photographs were used as the basis for images in *L'Ilustration* and *L'Artiste, Gazette Des Beaux Arts*. McCauley, *Industrial Madness*, 281. *Enoch Arden* by Tennyson, published by Moxon in 1866 and illustrated by Arthur Hughes was advertised at the time as the first successful attempt at photographing drawings onto wood. Gleeson White, *English Illustration*, 127.

63. G. Dalziel and E. Dalziel, *The Brothers Dalziel: A Record of Fifty Years' Work, in Conjunction with Many of the Most Distinguished Artists of the Day* (London: Methuen and Co., 1901), 42.

64. Hentschel, "Process Engraving." Bullock also gives 1866 as the date for the intro-duction of the technique. Bullock, J. M. "British Pen Drawings," *Modern Pen Drawings: European and American*, ed. Charles Holme (London: Studio, 1901), 12. W. T. Wilkinson gives a detailed description of the commercially used method for photographing on wood in 1893. W. T. Wilkinson, "Photographing Upon Wood," *British Journal Photographic Almanac*, 1893.

65. Paul Fildes says that the process camera used for photographing on the woodblock included a reversing prism in front of the lens. Fildes, "Phototransfer of Drawings in Wood-Block Engraving." *ILN* was quick to adopt the technology, and according to Rodney Engen, its first use of the technique was in 1861. Engen, *Pre-Raphaelite Prints*, 88. However, late in 1860 the magazine published Flaxman's "Deliver Us from Evil," which was engraved from a photograph on the block, *ILN*, 37.1067 (December 29, 1860), 618.

66. The difficulties included film that was too hard to engrave, film that stripped away from the block or softened the wood, chemicals that blunted engraving tools, but engravers simply had to put up with these difficulties as the procedure was economically advantageous. Wilkinson, "Photographing Upon Wood."

67. On distortions on the block see Hamerton, *Drawing and Engraving: A Brief Exposition of Technical Principles and Practice*, 61–62. Harper, *English Pen Artists of To-Day*, 291–94. Herkomer admitted that when facsimile wood engraving was cut in a hurry it had an awkward stiff appearance. Prof. Hubert Herkomer, "The Position of Wood Engraving," *Printing Times and Lithographer* (May 1894), 122. Linton says he had been informed by a number of American engravers including A. V. S. Anthony that their eyesight had been weakened through working on photo-graphic woodblocks. Linton, *Wood-Engraving a Manual of Instruction*.

68. On Tenniel and Swain see Spielmann, "Our Graphic Humorists: Sir John Tenniel," *Magazine of Art* (1895).

69. On photography enabling illustrators to ignore requirements of reproduction see Linton, *Wood-Engraving a Manual of Instruction*, Chapter 10, "On the Use and Abuse of Photography," 93–102.

70. Baldry, "The Future of Wood Engraving," 13.

71. Linton, *Wood-Engraving a Manual of Instruction*, 101. Hodson recorded that engravers worked on partly covered blocks to protect pencil lines from being rubbed by the graver. The paper was fixed to the sides of the block with wax and torn off bit by bit as the engraving was completed. Hodson, *A Historical and Practical Guide to Art Illustration in Connection with Books, Periodicals and General Decoration*, 100.

72. Frederick Juengling's images in *Scribner's* in March 1877 were important early images in establishing the style. See Frank Weitenkampf, *American Graphic Art* (New York: Henry Holt, 1912), Chapter 8, "The 'New School' of Wood-Engraving," 154–70.

73. William Ivins, *Prints and Visual Communication* (London: Routledge, 1953), 143, 144.

74. On the culture of these magazines and their attitudes to imaging, see Schneirov, *The Dream of a New Social Order: Popular Magazines in America, 1893–1914*, in particular, the section "Illustration, Photography and the 'Halftone Effect,'" 67–72.

75. On art paper and more accurate printing inspiring engravers to produce increasingly fine work, see Edwin Bale, "Mr. Timothy Cole and American Wood Engraving," *The Magazine of Art* (1893). On the influence on English engraving of the American School, see Martin, *Victorian Wood Engraving*, and Bale.

76. On journalistic ambivalence regarding the US, see Hampton, *Visions of the Press in Britain, 1850–1950*, 92–94.

77. Spielmann, "The New Robinson Crusoe," *Magazine of Art* (1892).

78. Linton, "Art in Engraving in Wood."

79. Vizetelly, *Glances Back through 70 years* (London: Kegan Paul and Co., 1893), 119.

80. Bale, "Mr. Timothy Cole and American Wood Engraving." Gleeson White also saw a connection between photography and the New School, and suggested that the soft qualities of the New School, and the change from the crisp linear contrasts of wood engraving were influenced by Pictorialist photography. Gleeson White, "Some Aspects of Modern Illustration." Walter Crane argued against what he saw as the degenerate influence of the New School on British engraving and saw that this tonal photographic tendency would lead to the triumph of photomechanical reproduction. Walter Crane, *On the Decorative Illustration of Books Old and New* (London: G. Bell, 1896), 148.

81. Linton, *Wood-Engraving a Manual of Instruction*, 101–02. Others also saw this as inevitable. Gleeson White suggested that a collection of Longfellow's poems illustrated by John Gilbert, engraved by the Dalziels, and published by Routledge in 1855 marked the beginning of the new tendency in engraving towards capturing tone, rather than line. "This tendency... in the seventies carried the technicalities of the craft to its higher achievement, or, as some enthusiasts prefer to regard it, to its utter ruin, so that the photographic process-block could beat it on its own ground." Gleeson White, *English Illustration*, 102. Walter Sickert also saw that the New School work was "destined perforce to be superseded by the camera." Walter Sickert, "Diez, Busch and Oberländer," *A Free House! Or, the Artist as Craftsman*, ed. Osbert Sitwell (London: Macmillan, 1947), 249. In the US Woodberry suggested that the New School approach debased wood engraving by making it simply "another mode of photography." Woodberry, *A History of Wood-Engraving*, 186.

82. Frederick E. Ives, *The Autobiography of an Amateur Inventor* (Philadelphia: Privately published, 1928).

83. C. S. Bierce stated that in the United States the wood-engraving trade was badly affected by the trade panic of 1893–1894 when price became a serious factor. C. S. Bierce, "Notes on Process Matters in the USA," *Process Photogram*, 7.75 (1900).

84. The Dalziels' publishing activities continued and they also diversified into process work. The *Photogram* reported in 1894, "Dalziel and Co., 110, High Street, Camden Town, NW, have just issued a sample book giving proofs of half-tone blocks in various degrees of fineness, and hard metal stereos from the same. When half-tones have to be reproduced we prefer these hard-metal stereos to the general run of electros, and the system has the advantage of being in the hands of a prompt and very reliable firm." Anon, "Process," *Photogram*, 1.7 (1894), 172.

85. See Jones, *Outcast London*, Chapter 1, "London as an Industrial Centre," 19–32, particularly 27–30, on the dominance of small-scale production and 22–23 on sweating as a particularly metropolitan phenomon relying on the mobility and availability of a fragmented urban labor force.

86. These ruling machines were used by engravers to produce parallel lines of varying widths and distances. They were especially useful for sky, buildings and machinery. The machines were extensively used in catalogue illustrations. See Henry Trueman Wood, *Modern Methods of Illustrating Books* (London: Elliot Stock, 1887), 226. According to Elliot the first machine was developed by an Englishman named Bellman in New York. Thomas W. Elliot, "Wood Versus Photo-Engraving," *Inland Printer*, May 1889.

87. Harland, "The Prospects of Wood Engraving," 41. Arthur Comfort said that the decline in the trade was due to the "illustration manufacturers" who wanted to turn out engravings quickly and splitting up images into sections in order to do so. This led to the specialization and isolation of the workers that Harland describes. Comfort, "Letter from Arthur Comfort (Hon. Chairman of the International Society of Wood Engravers)," 195.

88. Harland stated that prices were less than a third of what they had been in 1877. Harland's account echoes James Schmiechen's account of the clothing trade in *Sweated Industries and Sweated Labour: The London Clothing Trades 1860–1914*. In these trades tailors and seamstresses worked at home on a piece-work basis delivering fragmented elements of a garment to a central workshop for assembly. Employment took place in intense seasonal bursts of activity, against very tight deadlines, and often overnight. Exactly as Harland describes in engraving clothing employers "screwed down" workers' rates by telling them that other workers would do the job for less. As Schmiechen puts it: "One of the most notable features of the clothing trade labour force was its disorganisation and high degree of stratification. Indeed industrial disorganisation kept the workers apart. Based in intense labour competition, on the decentralised methods of production, and offering quasi capitalist status to many workers, outwork generated prejudices amongst workers and isolated them from the mainstream of the British labour movement. Outworkers were enemies of one another." Schmiechen, *Sweated Industries and Sweated Labour: The London Clothing Trades 1860–1914*, 189.

89. Booth, *Life and Labour of the People in London*, 113. On wood engravers pay and working conditions also see Bill Jay, *Victorian Candid Camera* (Newton Abbot: David and Charles, 1973), 14–15.

90. Charles Booth noted that process workers were drawn from many occupations, including engravers, lithographers, and photographers. Booth, *Life and Labour of the People in London*, 117.

91. John Swain Jr. learned photography at the age of 14 so that he could produce photography on wood for his father's process firm. F. G. Kitton, "The Art of Photo-Etching and Engraving," *The British Printer* (July–August 1894).

92. Paul Martin joined the engraving firm of R. and E. Taylor in E.C.1. in 1886. He was sent by his employer to take photographs of sites around London from which engravings were made. He left in 1897 when it became obvious that the trade was in decline. Like many other engravers he tried his hand as process, undertaking courses at Bolt Court from 1897 to 1898, but he didn't "take to" process. In 1899, in his mid-thirties, he set up a photographic firm in South London. Martin is now best known as one of the pioneers of street photography. See Jay, *Victorian Candid Camera*, and also Martin, *Victorian Wood Engraving*.
93. According to Booth these retouchers earned around forty shillings a week. Booth, *Life and Labour of the People in London*, 117. Various other methods in which wood engravings were imitated included "scratch out paper," a coated paper whose surface could be easily scraped away to produce an image which could be photographed to produce a line block. According to Harper some wood engravers adopted it as did Heywood Sumner and C. H. Shannon. Charles G. Harper, *A Practical Handbook of Drawing for Modern Methods of Reproduction* (London: Chapman and Hall, 1894), 82–84.

4 Process reproduction and the image assembly line

1. Ives, *The Autobiography of an Amateur Inventor*, 54.
2. Henry Fox Talbot, "Photographic Engraving," *The Athenaeum* (April 30, 1853), 533.
3. He is quoted in Hodson, *A Historical and Practical Guide to Art Illustration in Connection with Books, Periodicals and General Decoration*, 187–88.
4. Ives, *The Autobiography of an Amateur Inventor*, 48. He recalled that his early methods had "considerable use as substitutes for wood engravings in books and magazines of the highest character," 50. Most tellingly he referred to his technique as the "optical V" and stated that this was a reference to the "engravers' V tool."
5. An article in the *Inland Printer* in 1885 affirmed that wood engraving has established the criteria for reproduction that the new processes strove for. *Inland Printer*, 2.1 (1885), 32.
6. Pennell, *The Illustration of Books: A Manual for the Use of Students, Notes on a Course of Lectures at the Slade School University College*, 77.
7. Phillip Dennis Cate, "Printing in France, 1850–1900: The Artist and New Technologies," *The Gazette of the Grolier Club*, 28.29 (1978).
8. According to the *Photogram* Alexandre Zimmerman, the first photo etcher in London, had trained in Paris with Gillot before coming to England in 1875 at the age of 19. Anon, *Photogram*, 9.104 (1902), 126. However, Walter Boutall claimed that the first process workers in London were Frenchmen who arrived in 1871, fleeing from the political turmoil in Paris. Walter Boutall, "Technical Education in Relation to Process Engraving," *British Journal of Photography*, XLIV.1944 (1897), 506–507.
9. On the early years of process see Hentschel, "Process Engraving," and Hodson, *A Historical and Practical Guide to Art Illustration in Connection with Books, Periodicals and General Decoration*.
10. Gleeson White recalled that around 1874 the cliché industry really took off with many magazines suddenly switching to being illustrated by cheap images from overseas journals. He referred to these images as "that terrible microbe *the foreign cliché*" and it is likely that in some cases there were photorelief copies of wood engravings. Gleeson White, *English Illustration*, 66.

11. Gelatin was the basis of a number of line processes, based on the fact that it swelled when exposed to light. Gribayédoff writes that most of the American press had adopted zinco reproduction in preference to gelatin-based processes by the Presidential campaign of 1884. Gribayédoff, "Pictorial Journalism," *The Cosmopolitan*, (August 1891).

12. H. Baden Pritchard, *The Photographic Studios of Europe* (London: Piper and Carter, 1882), 110–13.

13. On these early processes, see Hamber, *A Higher Branch of the Art: Photographing the Fine Arts in England 1839–1880*, 168–76, and also Wright, "The Osbourne Collection of Photomechanical Incunabula," *History of Photography*, 24.1 (2000). For a contemporary technical account, see Wood, *Modern Methods of Illustrating Books*.

14. Pritchard, *The Photographic Studios of Europe*.

15. On early screen-based techniques, see M. Wolf, "The Line Screen Plates and their Uses." *British Journal of Photography*. 40. 1740 (1893): 574–76. British Journal of Photography

16. On Fox Talbot, Swan, and Meisenbach and their screens, see Charles Gamble, *Modern Illustration Processes: An Introductory Textbook for All Students of Printing Methods* (London: Sir Issac Pitman & Sons, Ltd., 1933), 136–39.

17. On screens and their manufacture, see Wolfe, 576.

18. On ruling machines see Elliot, "Wood Versus Photo-Engraving," *Inland Printer* (May 1889).

19. On Ives and the Levys, see Gamble, *Modern Illustration Processes: An Introductory Textbook for All Students of Printing Methods*, 139–41. On the high prices charged for process screens see George Hartnell Bartlett, *Pen and Ink Drawing* (Boston: Riverside Press, 1903), 141.

20. Kitton, "The Art of Photo-Etching and Engraving."

21. Anon, "The Future," *Process Photogram*, 2.1 (1895).

22. "In a very few offices the new conditions are comprehended more or less, but it is difficult to comply with them. The climate is against them. In summer it is seldom warm enough for the stiff ink necessary for best work to distribute well, and in winter the offices are not warmed, or not enough so to have effect on such ink, if it were used." Editor, "Photographic Engraving and the Work of Mr. Frederic Ives," *The British Printer* (July–August 1894).

23. Ibid.

24. On printing halftones see Frank Colebrook, "American and English Plate-Making," *Process Photogram*, 9.108 (1902).

25. Prices fell in the 1850s when mechanical methods of producing wood pulp were developed. By 1873 further price reductions were brought about by the introduction of chemically produced wood pulp. The periodical press led the way in the development of these new types of paper. Edward Lloyd, the radical publisher of *Lloyd's Weekly Newspaper* and the *Daily Chronicle* did much to develop paper-making in England, setting up his own mills in Sittingbourne in 1877, at the time the largest in the world. On paper, see Howe, *Newspaper Printing in the Nineteenth Century*; Colin Clair, *A History of Printing in Britain* (New York: Oxford University Press, 1966); and Joseph Hatton, *Journalistic London* (London: S. Low, Marston, Searle, & Rivington, 1882). On the numbers of paper mills, see David Reed, *The Popular Magazine in Britain and the United States, 1880–1960* (London: The British Library, 1997), 28. For a detailed account of the technical and human aspects of the US paper industry in the nineteenth century, see Judith A. McGaw, *Most*

Wonderful Machine: Mechanization and Social Change in Berkshire Paper Making, 1801–1885 (Princeton, NJ: Princeton University Press, 1987).

26. See Anon, "Journals and Journalists of Today, Messrs Girdlestone, Raven Hill and Pick Me Up," *Sketch* (April 3, 1895). On problems with printing halftones on both sides of the paper, see Shorter, "Illustrated Journalism: Its Past and Future," 18–20, 24–26.

27. On numbers of firms see Hentschel, "Process Engraving," 74.

28. W. Gamble, "The History of the Halftone Dot," *Photographic Journal*, NS 21.6 (1897).

29. Writing in 1960 Erwin Jaffe suggested that the most widely accepted and plausible theory was diffraction, but that workers were still on the whole unaware of the various theories and operated on a practical trial and error basis. Erwin Jaffe, *Halftone Photography for Offset Lithography* (New York: Lithographic Technical Foundation, 1960), 67–72.

30. There were no wood engraving trade magazines, there were no scientific theories to discuss, and perhaps just as important, there was not much equipment to advertise.

31. In the early days of process the equipment had to be made from scratch. When Charles Dawson set up a business with his brothers in 1874 they generated their own electricity and built their own apparatus. Charles E. Dawson, "Reminiscences of an Old Process Engraver," *Inland Printer* (February 1908).

32. See Ellen Mazur Thomson, *The Origins of Graphic Design in America* (New Haven: Yale University Press, 1997), Chapter 2, "Trade Journals," 36–59, on the role of trade journals in the new design and advertising professions in the USA.

33. This price of sixpence included the current issue of the *Photogram*.

34. The Wards were very interested in English literary history, particularly Dickens and Shakespeare. Catharine Weed Ward's photographs illustrated Henry's guides to literary England. For information on Catharine Weed Barnes see Peter Palmquist, *Camera Fiends and Kodak Girls: Fifty Selections by and About Women in Photography 1840–1930* (New York: Midmarch Arts Press, 1989), Peter Palmquist, *Catharine Weed Barnes Ward: Pioneer Advocate for Women in Photography* (Arcata CA: Peter Palmquist, 1992), also Naomi Rosenblum, *A History of Woman Photographers* (New York: Abbeville Press, 1994).

35. Henry Snowden Ward, "Trade Journals and Process Mongers," *Penrose Annual*, ed. William Gamble (London: A. W. Penrose and Co., 1896).

36. Anon, "The Future."

37. *Process Photogram*, 96.135.

38. Henry Snowden Ward and Catharine Weed Ward, *Photograms of the Year* (London: Iliffe & Sons, 1896).

39. Anon, *Photogram*, 13.147 (1906).

40. The Levy Business Papers at the Hagley Museum in Wilmington, Delaware contain correspondence between Penrose and the Levys regarding competing screens.

41. Gamble's *nom de plume*, which means author in German suggested that Germany was the source of photomechanical knowledge and also concealed Gamble's identity as Penrose's partner.

42. On early halftone process firms see Hentschel, "Process Engraving," and Bullock, "British Pen Drawings."

43. The 1912 edition of *The Halftone Process* lists the costs of a basic outfit including a camera at £27, but this does not include the screens, the major item of expenditure. Julius Verfasser, *The Halftone Process*, 5th ed. (Bradford and London: Percy Lund, 1912). On the size of blocks, see Henry Snowden Ward, Catharine

Weed Ward, *Photography for the Press* (London: Dawbarn and Ward, 1901), 14. The Wards list the sizes at which photographs would be reproduced as 4×3, 6×4, 7×9, 8×12.

44. Proofs that were carefully printed on a small specialist machine, looked much better than the printed image, and this led to many disagreements between printers and process houses. For a tour of Swain's offices see Kitton, "The Art of Photo-Etching and Engraving," 218–31.

45. These investors were Mr. Hanson, a printer, Edmund Johnson, a publisher, and Francis Logie Pirie, described in the register of companies as a "gentleman."

46. Advertisements would appear in newspapers offering huge returns on investments of between £50 and £1000. In some cases the firms placing the advertisements were "farmers," middle men who took orders from printers or publishers for blocks and "farmed them out" to process firms, having no equipment of their own. Potential investors were advised that there were indeed "young process businesses in which a man might think himself fortunate to secure a partnership, but nothing of this sort should be undertaken without the most searching investigation." Anon, "Flat-Catchers," *Process Photogram*, 2.14 (1895).

47. See Anon, *Process Photogram*, 57 (September 1898), 171.

48. Kitton, "The Art of Photo-Etching and Engraving." For an account of the acute air pollution in London in the 1890s, see Peter Brimblecombe, *The Big Smoke: A History of Air Pollution in London since Medieval Times* (London: Methuen, 1987), in particular Chapter 6, "Smoke and the London Fog," 108–35.

49. Anon, "Pictorial Reproduction Up-To-Date," *The British Printer*, 1900. Meisenbach's West Norwood factory in the southern suburbs of London was connected to the center by overground railway. By 1904 T. W. Lascelles, who supplied much of *ILN*'s engravings, had thirty employees based in Willesden Green. The firm was able to produce all of the illustrations for an issue of *ILN* in nine hours. Frank Colebrook, "A Palace of Paradox: A Morning Call at Maybury Studios," *Process Work and Electrotyping* (August–September 1904).

50. Kitton, "The Art of Photo-Etching and Engraving."

51. Anon, "An American Opinion," *Process Photogram*, 2.1 (1895).

52. Elbridge Kingsley, "Originality in Wood Engraving," *Century* (August 1889), 578.

53. See Whipp, "A Time to Every Purpose: An Essay on Time and Work."

54. Bierce, "The Executive or Office Department," *Process Photogram*, 4.43 (1897).

55. On the establishment of a "front office" at the Toronto Engraving Company, see Davis, *Art and Work: A Social History of Labour in the Canadian Graphic Arts Industry to the 1940s*, 72–73.

56. William Gamble, "Straight Talks to Practical Men, VI. Keeping Time," *Penrose and Co.'s Monthly Circular Process Work*, NS 6 (1899), 2. Gamble's thoughts on management were published in William Gamble, *Straight Talks on Business* (London: P. Lund, Humphries and Co., 1914).

57. Gleeson White, "Some Aspects of Modern Illustration," 352.

58. P. G. Hamerton, *The Art of the American Wood-Engraver* (New York: Charles Scribner's Sons, 1894), 14. Similar patterns were developing in other industries; McGaw's investigation of the paper industry in the United States shows a structure where workers became increasingly specialized and more distant from their employers, organized by a tier of supervisory staff. As worker knowledge became more limited, employers, through means such as trade magazines, were the only people with an overview of the process. McGaw, *Most Wonderful Machine: Mechanization and Social Change in Berkshire Paper Making, 1801–1885*, 125–27, 286–89, 303–04.

59. The firm had adopted Ives' methods that year, and brought him over to London the following year as their technical manager. This contact with the originator of the process gave the firm a competitive edge and they made much of their association with Ives. Editor, "Photographic Engraving and the Work of Mr. Frederic Ives," 65.

60. On Hentschel see Carl Hentschel, "A Process Autobiography," *Photogram* (November 1905); Anon, "Pictorial Reproduction Up-To-Date"; Anon, "A Notable Process Engraver–Mr. Carl Hentschel," *Printing World*, 5.6 (1897).

61. On August Hentschel, see Anon, *Publisher's Circular*, 63.1516 (1895), and Jerome K. Jerome, *My Life and Times* (London and New York: Harper Brothers, 1926), 111–14.

62. Hentschel, "A Process Autobiography."

63. The Dalziel Archive, vol. 34, the British Museum Department of Prints and Drawings.

64. By 1906 the firm was capitalized at £85,000. Anon, "Pictorial Reproduction Up-To-Date."

65. According to Jerome, his ambitions and his firm were ruined by competitors exploiting anti-German sentiment during the Great War. "The war brought him low. He was accused of being a German. As a matter of fact he was a Pole. But his trade rivals had got their chance, and took it." Jerome, *My Life and Times*, 111.

66. In 1894 his firm was producing the line blocks for Beardsley's *Yellow Book*. Possibly as a favor Beardsley designed the menu for The Playgoer's Club Tenth Annual Dinner at the Criterion on January 28, 1894. The menu features a photograph of Hentschel as the Hon. Treasurer. See Brian Reade, *Aubrey Beardsley* (Woodbridge: Antique Collectors Club, 1987), 335.

67. The street contained bric-a-brac stores and bookshops some of which sold pornographic books and photographs. On Hollywell Street and the Playgoer's Club, see Jerome, *My Life and Times*. On the shady nature of Hollywell Street, see Lynda Nead, *Victorian Babylon: People, Streets and Images in Nineteenth Century London* (New Haven: Yale University Press, 2000), 164–66.

68. Anon, *Printing World*, 5.6 (1897), 133.

69. Anon, "Pictorial Reproduction Up-To-Date," 227.

70. These illustrations included fashion images, book covers, and fiction illustrations. Anon, "Pictorial Reproduction Up-To-Date."

71. Hentschel, "Process Engraving."

72. For accounts of the firm, see Anon, "Commercial Marvels of Photography: The Illustration Process," *Photogram*, 13.147 (1906). The way-goose was a tradition that went back to the early days of printing in England. See Howe, *The London Compositor*, 26.

73. Many clerks were earning even less than artisans. Fifty percent of clerks were earning less than 31 shillings a week at the turn of the century. McLeod, "White Collar Values and the Role of Religion."

74. See George D. Richards, "Pictorial Journalism," *The World Today* (August 1905). William Gamble, "Process in Magazine and Book Illustration," *Penrose*, ed. W. Gamble (London: A. W. Penrose and Co., 1897).

75. Gamble, "Process in Magazine and Book Illustration."

76. Cycling was seen as a modern and liberating activity. For both sexes it connoted both physical and figurative mobility. Jackson, *The Eighteen Nineties*, 32. The association between the speed and modernity of cycling and the speed and modernity of the photograph was one that cycling magazines were keen to foster. *Cycling* had its own photographers who took snapshots at race meetings. These were processed

in the magazine's own zinco department. See Gamble, "Process in Magazine and Book Illustration," 14. There were many connections between cameras and cycling; indeed, cycles were produced with camera holders on their frames and the magazines for both cyclists and amateur photographs were widely distributed.

77. Anon, *Photographic Journal*, 21.4 (1897).
78. Anon, "At the Sign of King Lud," *Process Photogram*, 8.86 (1901). Charles Booth recorded that wood engravers at this time could earn £3 to £5 per week if fully employed but in practice very few earned more than 30 to 40 shillings. The ex-engravers who now worked as retouchers in process firms earned 40 shillings a week. Booth, *Life and Labour of the People in London*, 117.
79. Anon, "Max Levy and His Work," *Process Photogram*, 3.25 (1896).
80. Thos. G. Lee, *Process Photogram*, 3.26 (1896), 32.
81. Harland, "The Prospects of Wood Engraving,"(July 1892), 42.
82. A poem in the Penrose annual for 1900 commented sarcastically on the system of process firms producing free work for magazines in order to attract business. While the profits of the publishers of *ILN* soared the process man could not afford to eat.

 The honorary block-maker he smacked his shrunken thighs,
 As he read the *News*, a tear of pride rose in his deep shrunken eyes.
 "My customers, with profits high, their dividends maintain:
 Nay, they've increased! Now let me die I have not lived in vain."

 Frank Colebrook, "The Honorary Block-Maker," *Process Work Year Book* (London: A. W. Penrose and Co., 1900), 96.
83. On competition and the numbers of firms, see Hentschel, "Process Engraving," Chanan describes a similar pattern in the early British film sector where "the industry was plunged into a variety of price wars and trade combinations characteristic of capitalistic competition in a pre-monopoly stage." Chanan, *The Dream That Kicks: The Prehistory and Early Years of Cinema in Britain*, 192.
84. See Harper, *English Pen Artists of To-Day*; Blackburn, *The Art of Illustration*; and Hentschel, "Process Engraving."
85. Editor, "Photographic Engraving and the Work of Mr. Frederic Ives."
86. Maclean's survey of prices in 1896 puts line work at between two and sixpence per square inch, depending on the quality, with extra costs for hand work and applying tints. The minimum charge for a line zino was between two and four shillings. For halftone work he recorded that work for a sixpenny weekly would cost around eight pence per square inch with a minumum charge of five to ten shillings per block. Hector Maclean, *Photography for Artists* (Bradford: Percy Lund, 1896; New York: Arno Press, 1973), 119.
87. Shorter, "Illustrated Journalism: Its Past and Future."
88. Ives noted that *Harper's* would pay £15 for the re-engraving of a block. W. Cheshire, "On the Touching of Half-Tone Process Blocks," *Photographic Journal*, NS 20.7 (1896), 184.
89. *Process Photogram*, 3.25 (January 1896), 10.
90. The union also wanted prison authorities to stop the training of criminals in process work. Anon, *Process Photogram*, 2.1 (1895).
91. On *The Times* insert see Joseph Pennell, "Art and the Daily Newspaper," *Nineteenth Century* (October 1897), 657. The *Studio* regularly carried advertisements for German engraving companies.
92. Quoted in Stuart Macdonald, *The History and Philosophy of Art Education* (London: University of London Press, 1970), 293–94. See Macdonald, "The Philosophy of

the South Kensington Circle," 226–52, on the South Kensington system, and also, "From Applied Art to Design," 291–319.

93. Anon, *Photogram*, 1.2 (1894). On training, see Skingsley, "Technical Training and Education in the English Printing Industries: A Study in Late Nineteenth Century Attitudes. Part Two: The Pressures of Change," *Journal of the Printing Historical Society*, 14 (1978/1979).

94. Gamble had experience teaching at the People's Palace in the East End which in the 1890s provided a technical education to artisans and clerks in order to counter foreign competition. See Deborah E. B. Weiner, "The People's Palace," *Metropolis: London*, eds David Feldman and Gareth Stedman Jones (London: Routledge, 1989), 40–55.

95. Anon, "Art Notes," *Art Journal*, NS 48 (1896), 31.

96. In 1900 the average age of students at Bolt Court was 22. On the LCC and technical education, see W. Eric Jackson, *Achievement: A Short History of the London County Council* (London: Longmans, 1965), 23–24. On Bolt Court, see Anon, *Printing World*, 9.1 (1901), and Rupert Cannon, "Of Dragon's Blood and Bolt Court," *Penrose Annual 1981* (London: Northwood, 1981). For an overview of the London County Council Progressives and their attempts to modernize the capital, see also Pennybacker, *A Vision for London 1889–1914: Labour, Everyday Life and the LCC Experiment*.

97. Many print unions also opposed Technical Schools as they widened entry. See Skingsley, "Technical Training and Education in the English Printing Industries: A Study in Late Nineteenth Century Attitudes. Part Two: The Pressures of Change."

98. Anon, "The All-Round Man," *Process Work and the Printer*, 4.39 (1896).

5 The pictorial magazine and the city of leisure

1. Clement Shorter, "Small Talk," *Sketch* (February 6, 1895), 70.

2. On the new importance of leisure and the domestic sphere see Charles Ponce de Leon, *Self-Exposure: Human-Interest Journalism and the Emergence of Celebrity in America, 1890–1940* (Chapel Hill: University of North Carolina Press, 2002), 37–40.

3. Booth, *Life and Labour of the People in London*, quoted in Rose, *The Edwardian Temperament*, 166.

4. See Bailey, *Popular Culture and Performance in the Victorian City*, in particular, Chapter 1, "The Victorian middle class and the problem of leisure," 13–29, quotation page 29. On the legitimization of pleasure in the US among both middle and lower classes see Kathy Peiss, *Cheap Amusements: Working Women and Leisure in Turn-of-the-Century New York* (Philadelphia: Temple University Press, 1986), 34–76, 163–84. On working-class leisure in the US, see Roy Rosenzweig, *Eight Hours for What We Will: Workers and Leisure in an Industrial City, 1870–1920* (Cambridge: Cambridge University Press, 1983).

5. Anon, "What London Reads," *Sketch Literary Supplement* (December 4, 1895), 10.

6. Within the commodified theaters miscellaneous material was standardized in type and organization. The heterogeneity of the miscellany was compartmentalized into a "program." Improvisation and encores were curtailed, and performances were divided into numbered and timed segments. This strict temporal structure contained a mixture of eclectic material. A single Variety bill might include comic songs, opera, an instructional film, drama, ballet, folk songs,

freaks, jugglers, acrobats. See Bailey, " 'Naughty but Nice': Musical Comedy and the Rhetoric of the Girl, 1892–1914," 36–60.

7. On the middle-class audience see Bailey, *Popular Culture and Performance in the Victorian City*, 148. The Victorian editor T. H. Escott noted that the theater had became fashionable and accepted by the middle classes. "The integral part now occupied by the play in the life of the middle-class is shown by the spacious theaters that have lately risen in such decorous suburbs of the metropolis as Brixton." Escott, *Social Transformations of the Victorian Age: A Survey of Court and Country*, 218.

8. See Bailey, " 'Naughty but Nice': Musical Comedy and the Rhetoric of the Girl, 1892–1914," 53–54. "Little Eyolf," *Sketch* (December 2, 1896).

9. Shaw in the preface to Archer, *The Theatrical "World"* (London: W. Scott, 1894), xix. Each customer needed to pay five shillings according to Shaw.

10. Booth, *Theatre in the Victorian Age*, 13–16. Christopher Kent, "Image and Reality: The Actress and Society," *A Widening Sphere: Changing Roles of Victorian Women*, ed. Martha Vicinus (Bloomington: Indiana University Press, 1977).

11. Kent, "Image and Reality: The Actress and Society."

12. Walter Crane, "Modern Life and the Artistic Sense," *Cosmopolitan* (June 1892).

13. See Anon, "The Late Mr. J. L. Latey," *ILN* (January 10, 1891). Latey had been with the magazine since its founding and had been the "literary editor" since 1858. In an interview of 1895 Ingram stated that with the intense competition in publishing he needed younger up-to-date energetic men as editors, ideally men under 30. Without mentioning Shorter by name he noted that the "vigor" at *ILN* was due to younger men who had joined the staff. Anon, "The Illustrated London News," *Publisher's Circular Newspaper, Magazine and Periodical Supplement*, 9 (1895).

14. On Ingram's motivations see Shorter, *C.K.S. An Autobiography: A Fragment by Himself*, 63.

15. C. N. Williamson, "Illustrated Journalism in England: Its Development," *The Magazine of Art* (1890), 396.

16. The *Pall Mall Budget* was the most highly illustrated with process. Harper, *English Pen Artists of To-Day*, 262–65. Shorter had been helping to bring a new approach to the *Penny Illustrated Paper*. Shorter, *C.K.S. An Autobiography: A Fragment by Himself*, 53.

17. Shorter, *C.K.S. An Autobiography: A Fragment by Himself*, 53–59.

18. Ibid. 58.

19. The *ILN* commented on criticism that it was no longer a newspaper and had become simply a magazine. The magazine promised that it would continue to report on society and politics as it always had. A few years later the *Publisher's Circular* commented that illustrated papers such as *ILN* no longer covered the news as they had once done, and this was now being done by the *Daily Graphic* and budgets such as the *Pall Mall Budget*, *Publisher's Circular Newspaper, Magazine and Periodical Supplement*, 4 (1895). In the interview with *ILN*'s owner two months later the question was put to him, "I have heard it said, Sir William, that the *ILN* contains little news and deteriorated, in fact to a budget of pictures with a certain amount of letterpress – that is hardly the truth is it?" Ingram emphatically denied it and pointed to the expense the paper had gone to in illustrating the recent opening of the Baltic canal. Anon, "The Illustrated London News," 5.

20. See, for example Anon, "Pierrot: An Interview with Mdlle, Jane May," *ILN*, May 2, 1891.

21. In an interview with a trade paper Shorter said illustration was the key factor in the magazine's success. "Although Mr. Shorter takes the keenest interest in what might be called the pictorial side of his charge, he has tried to make the literary matter of equal excellence to the illustrations." Anon, "Prominent Pressmen 4: Clement King Shorter," *Printers' Register Supplement*, 1892. He later recalled that issues that featured images of royal weddings or funerals added thousands to the circulation, whereas securing a serial by a popular author did little to sales figures. On the editorial balance of illustration and literary contents see Shorter, *C.K.S. An Autobiography: A Fragment by Himself*, 84–87. There was a technical reason for this mixture of text and image, as large images could not be printed on both sides of the same sheet of paper.

22. Shorter, *C.K.S. An Autobiography: A Fragment by Himself*, 71. Shorter's ally at *ILN* was Henry Burt, who was in charge of the printing of the Ingram papers. As the printing of halftones was much more complex than printing wood engravings, his support would have been vital to the success of Shorter's plans.

23. Any attempt to go back to wood engraving would lead to the financial ruin of the paper that attempted it. Shorter, "Illustrated Journalism: Its Past and Future," 26.

24. The *ILN*, according to Hentschel, published its first halftone in 1887. Hentschel, "Process Engraving."

25. For positive comments on the use of process see, for example. Anon, "The Art Magazines," *ILN* (May 16, 1891).

26. Shorter, *C.K.S. An Autobiography: A Fragment by Himself*, 63.

27. Harland, "The Prospects of Wood Engraving."

28. In the January 3, 1891 issue there were 36 wood engravings and 4 process images. A year later, January 2, 1892, there were 21 wood engravings and 12 halftones. By 1895 the amount of process material had increased to 75 percent and by 1898 93 percent and by 1900 96 percent. Leo John De Freitas, "Commercial Engraving on Wood in England 1700–1880: An Economical Art," Ph.D. Royal College of Art, 1986.

29. Anon, "The Illustrated London News."

30. On Jackson's role on the magazine and on having to find employment for the engravers, see Shorter, "Illustrated Journalism: Its Past and Future," 69. Eight years after this date many of the wood engravers on the *Graphic, ILN*'s rival weekly, were redeployed working on retouching process plates, and it is probably that this was also the case with the *ILN*. Henry B. Wheatley, *Catalogue of the Loan Exhibition of Modern Illustration Comprising Typographical Reproductions and the Original Drawings Executed 1860–1900* (London: Victoria and Albert Museum, 1901), 19.

31. See chapter 6, for a discussion of the representation of the cockney in the music-hall and the press during this period.

32. This theatrical subject matter had been explored by artists over the last two decades. Sickert was influenced in his choice of imagery by his mentor Degas. Sickert, like Degas, and other French artists such as Lautrec, was fascinated by the modernity of the stage. He produced illustrations for the *Yellow Book*, the *Idler*, the *Savoy*, the *Pall Mall Budget*. On Sickert's intense interest in the music-hall, see William Rothenstein, *Men and Memories: Recollections 1872–1900* (London: Faber and Faber, 1931), 168–69. Rothenstein stated "for Sickert the music hall was a workshop, for the rest of us it was a pleasant dissipation," 23.

33. On Chevalier, see Gareth Stedman Jones, "The 'Cockney' and the Nation," *Metropolis: London.*

34. On the Empire see Chanan, *The Dream That Kicks: The Prehistory and Early Years of cinema in Britain*, 147, and Winter, *London's Teeming Streets 1830–1914*, 113. On bohemians and the Promenade see Rothenstein, *Men and Memories: Recollections 1872–1900*, 168–69. There continued to be a tension between the respectability needed to attract the new middle-class audiences of the nineties and the less salubrious and anarchic aspects of the halls. The Empire was closed down briefly in 1894 by the Licensing Committee of London County Council under Mrs. Chant in response to the prostitution in the Promenade. This was widely opposed by libertarians, trade unions, ordinary ratepayers; Winston Churchill and a group of his aristocratic friends rioted in the theater. Chanan, *The Dream That Kicks: The Prehistory and Early Years of Cinema in Britain*, 147. In a piece entitled "Disen-Chant-Ed," the *Sketch* defended the Empire promenade against charges of immorality. In such a mixture of people there would always be some who were "inclined to vice," and in any case it is usually "discreetly veiled." Anon, "Disen-Chant-Ed," *Sketch* (October 30, 1895).
35. A few sketches appeared in early issues but Shorter rapidly abandoned Ingram's idea.
36. The *Sketch* was a little smaller than *ILN*, at nine and a quarter inches wide by thirteen and a half inches high, as opposed to *ILN* at twelve inches wide by fifteen and a half high. *Punch* was eight inches by ten and a half inches.
37. Anon, "Our First Word," *Sketch* (February 1, 1893).
38. Shorter described Ingram as "an old fashioned capitalist." Shorter, *C.K.S. An Autobiography: A Fragment by Himself*. As I describe in chapter 4, the cost savings which process promised may have been eaten up in the costs of retouching, but it was the promise of savings that would have been attractive in the competitive world of periodical publishing.
39. Blackburn, *The Art of Illustration*, 160, stated that the *Sketch* was almost as popular as *ILN*. Wheatley, *Modern Illustration*, described the *Sketch* as the first sixpenny weekly to be entirely illustrated by process, Hentschel also acknowledged that the *Sketch* was the first weekly to be entirely illustrated by process, Hentschel, "Process Engraving." Given that some of the images in the *Sketch*'s early years look like wood engravings, Hentschel's view would support the notion that they were in fact process images in disguise.
40. A very different version of the genesis of the magazine is offered by J. D. Symon who claims that it was Ingram who had thought of the magazine. Symon, *The Press and Its Story*, 230. Symon was employed by Ingram so this may well have colored his account, and Shorter strenuously denied these claims, stating that they were made by parasites and sycophants. Shorter, *C.K.S. An Autobiography: A Fragment by Himself*, 73.
41. Shorter, *C.K.S. An Autobiography: A Fragment by Himself*, 73. The *Sketch* was, according to Shorter, immediately successful and quickly built a large circulation and attracted advertisers. In 1895 a Brixton newsagent stated that he sold twice as many copies of the *Sketch* as any other illustrated weekly "though that may be accounted for by the fact that a great many 'theatricals' reside in the neighborhood." "Our Leading Newsagents Number 1: Mr. T. Kitchenside, Brixton," *Publishers' Circular Newspaper, Magazine and Periodical Supplement* (Issue 3, March 23, 1895). No reliable British circulation figures for this period are available, but the magazine's approach in terms of appearance and content was influential and imitators swiftly appeared. The new *Pall Mall Budget* was an imitation of the *Sketch*, according to Bullock, as were *St. Paul's Magazine* and *St. James' Budget*. A downmarket penny weekly *Sketchy Bits* also copied elements of the *Sketch*.

Certainly Shorter's reputation was quickly established as an innovative editor. The American advertising pioneer John Morgan Richards rated Shorter highly, saying there was; "no more accomplished and able editor in illustrated journalism." Richards, *With John Bull and Jonathan: Reminiscences of Sixty Years of an American's Life in England and the United States*, 64. On his retirement in 1926 the *Newspaper World* described him as the father of pictorial journalism and noted that his appointment at *ILN* marked a new era for the press. Shorter saw the long-term impact of the *Sketch* in the daily press. He claimed that he suggested to his friend Alfred Harmsworth, over lunch at the Savoy, that Harmsworth use photomechanical photographs in his new venture the *Ladies' Mirror*. The title was a failure as a daily newspaper for women but it was hugely successful and influential when it was relaunched as the *Daily Mirror*. Shorter, *C.K.S. An Autobiography: A Fragment by Himself.*

42. See Jeannene M. Przyblyski, "Moving Pictures: Photographic Narrative and the Paris Commune of 1871," *Cinema and the Invention of Modern Life*. On the French press and *actualité* see Schwartz, *Spectacular Realities: Early Mass Culture in* Fin De Siécle Paris, 26–44.

43. Shorter, *C.K.S. An Autobiography: A Fragment by Himself*, 75.

44. Many Nonconformists were in the radical wing of the Liberal Party and later in the Labour Party. Young ex-chapel goers, were well educated and able to take part in a culture of free thinking, of socialism, of cycling, and "flouting the respectable norms." McLeod suggests these young people were particularly attracted to the music-hall. McLeod, "White Collar Values and the Role of Religion," 78.

45. There were more opportunities for university education in the 1890s, with the removal of restrictions on Nonconformists attending Oxford and Cambridge and the creation of new universities. However, only a very small proportion of the population studied at university in Britain in this period. Between 1861 and 1911 the percentage of university students in the population rose only from 0.02 to 0.06 in England and 0.1 to 0.07 in Scotland. See W. B. Stephens, *Education in Britain, 1750–1914* (Basingstoke: Macmillan Press, 1998), 119–20.

46. There were 1000 authors, editors and journalists listed in the London census of 1901, and many more part-timers. Rose, *The Edwardian Temperament*. Alan Lee suggests the world of journalism was attractive to "the rootless product of an expanding society and men seeking the upward mobility of the burgeoning professions in greater numbers than the professions could provide for them." Lee, *The Origins of the Popular Press*, 113. The Institute of Woman Journalists was founded in 1895. Beetham, *A Magazine of Her Own?*.

47. Jerome, *My Life and Times*, 58, 61.

48. On the *Star* see Martin Conboy, *The Press and Popular Culture* (London: Sage, 2002), 99–100. Margaret Beetham gives a concise definition encompassing the distinctive aspects of new journalism: "The personalised tone and stress on personalities in its reporting, the illustrated interview, the use of 'tit-bit' rather than the sustained argument, the competitions for readers, the reliance on advertisements and the steady increase in the importance of illustration as against letterpress...." Beetham, *A Magazine of Her Own?*, 187. According to Pennell the *Star* was backed by Coleman of Coleman's Mustard. Elizabeth Pennell, *The Life and Letters of Joseph Pennell*, vol. 1 (Boston: Little Brown, 1929), 199–200.

49. G. A. Cevasco, *The 1890s: An Encyclopaedia of British Literature, Art and Culture* (New York: Garland, 1993), 427. Speaking of the *Star* Raymond Williams wrote

"From now on the New Journalism began to look what it was." Williams, *The Long Revolution*, 221.
50. His column was entitled "Books and Bookmen." Margaret Beetham defines caus-erie as a regular column centered on the personality of the journalist, returning often to the same subject which offers readers not only information but "models of the self." Margaret Beetham, "The Sixpenny Reading Public in the 1890s," *Nineteenth-Century Media and the Construction of Identities*. Joseph Pennell, who replaced Shaw as the *Star's* art critic, claimed that the paper's success was due to its coverage of sport, in particular, Captain Coe's betting tips and the horse racing results.
51. On the American models for the *Star's* "make-up and its scare-heads," see Symon, *The Press and Its Story*, 154. He noted that although it was not aimed at the "educated classes" it devoted a lot of space to "culture" which did not effect its popularity. Also see John Goodbody, "The Star: Its Role in the New Journalism," *Victorian Periodical Review*, 20.4 (1987). The paper's radical stance changed in 1892 when it was forced by its backers to toe the Liberal party line. Most of the socialist journalists including Shaw and Massingham resigned. By then Shorter had already moved on to *ILN*.
52. The address is reprinted in Shorter, *C.K.S. An Autobiography: A Fragment by Himself*, 79–80.
53. See Vanessa R. Shwartz on the urban crowd and the "spectular realities" of Paris. Elizabeth Wilson notes that the *flâneur* was interested in "the trivial, fragmented aspects of street life" rather than official pomp. Elizabeth Wilson, *The Sphinx in the City* (Berkeley: University of California Press, 1991), 5, 54–56.
54. Symon noted that the photograph in the daily paper "has given the public an insight into what the French call in a special sense, *actualité*." Symon, *The Press and Its Story*, 238.
55. Ingram stated in an interview in the trade press that the *Sketch* was cheaper to produce than the *ILN* as it didn't require on-the-spot reporters. Anon, "The Illustrated London News."
56. That is not to say that the Empire and London's role and an imperial capital did not thoroughly infiltrate the *Sketch*, from the products it advertised to the entertainments it reviewed. After all, the magazine was inspired by a visit to the Empire Theater. On imperial entertainments, exhibitions, and spectacles such as the zoo, see Schneer, *London 1900: The Imperial Metropolis*, in particular, Chapter 5, "Popular Culture in the Imperial Metropolis," 93–118.
57. Alfred Baker, writing on journalistic genres in 1890, spoke of "The London Correspondent" column: "There is nothing that escapes that versatile flaneur, the London Correspondent." Columns of this type covered society matters as well as political events, music, art and this very varied gossipy material was reported in "crisp paragraphs." This approach, according to Baker, started the paragraphic style of journalism. Alfred Baker, *The Newspaper World: Essays on Press History and Work Past and Present* (London: Issac Pitman and Sons, 1890), 61.
58. On the tone of journalistic comment Jonathan Rose notes that the short items of causerie and gossip in the new journalism were relaxed, jocular, and conver-sational in tone. Writers such as Wilde, Beerbohm, Shaw, and Belloc made their serious points, in witty, flippant prose. Rose, *The Edwardian Temperament*, "The Gospel of Fun," 163–74.
59. An article in Beardsley's defense asked "Why break a butterfly upon a wheel?," and argued that Beardsley's images were no more decadent than those of William Morris. Anon, "The Truth About the Yellow Book," *Sketch* (February 20, 1895).

60. Anon, "Is the Public Taste in Literature Correct?" *The Idler* (November 1896).
61. The title is possibly a reference to Edmund Yates' "The Lounger at the Clubs" the columns for Vizetelly's *Illustrated Times* of the 1850s which were seen as the first examples of light paragraphic, gossipy journalism. On Yates see Salmon, "'A Simulacrum of Power': Intimacy and Abstraction in the Rhetoric of the New Journalism," 27.
62. Anon, "The Royal Academy," *Sketch* (May 15, 1895).
63. See in particular Alice Stronach, "The Slade School Revisited," *Sketch* (March 13, 1895).
64. On Blackburn see Kristine Ottesen Garrigan, " 'The Splendidest May Number of the Graphic': John Ruskin and the Royal Academy Exhibition of 1875," *Victorian Periodical Review*, 24 (1991), 27–28. In 1893 the *Art Journal* noted in reviewing Blackburn's record of the Summer Exhibition, "It is felt by many artists that the outlines made by expert draftsmen are really more acceptable as representations of the pictures than hastily produced and badly printed photographic reproductions." Anon, "Blackburn's Academy Notes," *Art Journal*, NS 45 (1893).
65. Anon, "Mr. Marks and the Editorial Parasite," *Sketch* (January 30, 1894). In an article published by the magazine in March 1897, Edwin Bale, the Art Manager of Cassels, noted that at Summer Exhibition time artists commonly send out photographs of their paintings offering free reproduction. The *Sketch* asserted that illustrated newspapers were constantly sent images of artworks as there were always exhibitions opening. Anon, "Mr. Justice Kekewich on Art Journalism," *Sketch* (March 31, 1897). See also Anon, *Art Journal*, NS 47 (1895). It was clear to many observers, as it was to many artists, that these reproductions added to rather than lessened the value of the originals. James Parton writing in the *Atlantic Monthly* in 1869 suggested that when most people had access to copies the possession of the original carried more cachet. Marien, *Photography and Its Critics: A Cultural History 1839–1900*, 178. For an interrogation of Benjamin's theories regarding the effect of mechanical reproductions and the death of the artistic aura see Jaquelynne Baas, "Reconsidering Walter Benjamin: 'The Age of Mechanical Reproduction' in Retrospect," *The Documented Image: Visions in Art History*, ed. Gabriel P. Weisberg (Syracuse: Syracuse University Press, 1987), 339–40.
66. See Pennell, *The Illustration of Books: A Manual for the Use of Students, Notes on a Course of Lectures at the Slade School University College*, 29. Pennell complained that these free reproductions took work away from illustrators. The painter William Rothenstein recorded that it was the usual practice for artists not to be paid for the reproduction of their paintings, even in specialist magazines such as the *Studio*. Rothenstein, *Men and Memories: Recollections 1872–1900*, 134.
67. Maclean, *Photography for Artists*, 49–51.
68. Chalaby notes that sports coverage, with its predictable events, strong visuals, clear narratives, lack of controversy, and opportunities for local and national pride, was an ideal element in the press from the nineteenth century to the present day. Chalaby, *The Invention of Journalism*, 90–94.
69. On the bicycle as a sign of gender mobility and independence in the illustrated press, see Elizabeth K. Menon, "Images of Pleasure and Vice," *Montmartre and the Making of Mass Culture*, ed. Gabriel P. Weisberg (New Brunswick: Rutgers University Press, 2001). On the English cycling boom of 1895, see Read, *England 1868–1914: The Age of Urban Democracy*.
70. Shorter, *C.K.S. An Autobiography: A Fragment by Himself*, xi. Given the number of magazines he was editing this method is not surprising.

71. Shorter, "Small Talk," *Sketch* (October 28, 1896).
72. On French metropolitan literature earlier in the century see Cohen, "Panoramic Literature and the Invention of Everyday Genres," *Cinema and the Invention of Modern Life*.
73. Judith R. Walkowitz, *City of Dreadful Delight: Narratives of Sexual Danger in Late-Victorian London* (Chicago: University of Chicago Press, 1992), 39.
74. Joyce, *The Rule of Freedom: Liberalism and the Modern City*, 193. Shorter, "Small Talk."
75. On this split see Rachel Bowlby, *Just Looking: Consumer Culture in Dreiser, Gissing and Zola* (New York: Methuen, 1985), 6.
76. Anon, "A Wonderful Invention: The Cinematographe of M. Lumiere," *Sketch* (March 18, 1896).
77. Anon, "What the 'Yellow Book' is to be: Some Meditations with Its Editors," *Sketch* (April 11, 1894). This promotional piece is framed by other commercial announcements with share offers for the D. H. Evans department store and the Birmingham Racecourse Company.
78. For an account of the *Yellow Book's* audience, see J. Bridget Elliot, "Sights of Pleasure: Beardsley's Images of Actresses and the New Journalism of the Nineties," *Reconsidering Aubrey Beardsley*, ed. Robert Langenfeld (Ann Arbor: UMI Research Press, 1989). Uncut edges were a signifier of an expensive collector's book. On Lane's reasons for using them in his inexpensive publications, see J. Lewis May, *John Lane and the Nineties* (London: Bodley Head, 1936), 201–03.
79. On the popularity of portraits on cartes de visite, mosaic cards and cabinet cards see Heinz K. Henisch, Bridget A. Henisch, *The Photographic Experience 1839–1914: Images and Attitudes* (University Park: Pennsylvania State University Press, 1994), 245–46, 343–47. Jerome K. Jerome recalled that on his first visit to the theater as a boy he was so smitten with the leading lady, Rose Massey, he bought her photograph the next day for ninepence and displayed it on the mantlepiece. Jerome, *My Life and Times*, 46.
80. "The Beauty" was by the 1830s a well-established genre in periodicals and books. Beetham, *A Magazine of Her Own?*, 39–40.
81. On Stead and the interview, see Bourne, *English Newspapers: Chapters in the History of Journalism*, 343. Bourne noted that New Journalism was originally called "The Americanisation of English journalism," 342–44.
82. Alan J. Lee notes the move towards the reproduction of oral forms in the press in the 1880s and 1890s. Lee, *The Origins of the Popular Press*, 130.
83. Charles Ponce de Leon, *Self-Exposure: Human-Interest Journalism and the Emergence of Celebrity in America, 1890–1940*, 41.
84. On the interviewing of artists and writers see Julie F. Codell, "Constructing the Victorian Artist: National Identity, the Political Economy of Art and Biographical Mania in the Periodical Press," *Victorian Periodicals Review*, 33.3 (2000), and Richard Salmon, "Signs of Intimacy: The Literary Celebrity in The 'Age of Interviewing,' " *Victorian Literature and Culture*, eds Michael Shortland and Richard Yeo (Cambridge: Cambridge University Press, 1997). Codell notes that artists strove via the presentation of themselves and their studios to create an image of the artist as a hard-working professional. Also see Giles Walkley, *Artists' Houses in London 1764–1914* (Aldershot: Scholar Press, 1994), on the symbolic role of the studio.
85. For an example, see *Sketch*, September 13, 1899, page 323, in which Miss Violet Vanburgh was photographed in the dressing room of her residence in Earl's Court Road.

86. See Tamar Garb, *Bodies of Modernity: Figure and Flesh in* Fin-De-Siècle *France* (London: Thames and Hudson, 1998), in particular, Chapter 4, "On images of the dressing room." On mirrors specifically see page 124. On the intimate tone of these reports see Bailey, " 'Naughty but Nice': Musical Comedy and the Rhetoric of the Girl, 1892–1914," 53.

87. It is clear from the comments of the American photographer George Rockwood in 1885 that the domestic background was seen as an accessible and meaningful place for the photograph. "People nowadays feel that their rooms are really a part of themselves, or rather they are part of their rooms, which ever you prefer. So now, instead of coming to the photographer, the photographer goes to them." Quoted in Michael L. Carlebach, *The Origins of Photojournalism in America* (Washington: Smithsonian Institution Press, 1992), 155.

88. Anon, "Our First Word." Anon, "Out-of-the-Way Interviews: 1. A Flower-Girl," *Sketch* (October 4, 1893).

89. Anon, "A Chat with Niagra," *Sketch* (November 13, 1895). On the early interview structured as a purportedly informal chat, see Salmon, " 'A Simulacrum of Power': Intimacy and Abstraction in the Rhetoric of the New Journalism," 31.

90. Joyce, *The Rule of Freedom: Liberalism and the Modern City.*

91. On women and matinees, see Susan Torrey Barstow, "Hedda is All of Us: Late-Victorian Women at the Matinee," *Victorian Studies*, 43.3 (2001).

92. Jerome, *My Life and Times*, 52. Jerome recalled that until the year of the Jubilee no respectable young woman went out after dusk without a housemaid. During the day a married woman could go shopping alone, provided she was back in time for tea.

93. Nead argues against the concept that women were passive victims of the male gaze. Nead, *Victorian Babylon: People, Streets and Images in Nineteenth Century London*, 69–71.

94. At the same time uncorseted aesthetic dress challenged conventional values, and although this was less visible on the fashion pages it did feature in the depictions of actresses who adopted this style, such as Mrs. Patrick Campbell. On shopping, fashion, and visibility in this period, see Bowlby, *Just Looking: Consumer Culture in Dreiser, Gissing and Zola.*

95. Margaret Beetham links fashion, the magazine, and the pleasure that could be found through expertise as a consumer. She states: "The novelty, whether a ribbon or a knick-knack, was a visible sign of a woman's skill as a purchaser and her up-to-date knowledge of the latest fashions, a knowledge that the paper provided. The reader could therefore not only regulate her own consumption to produce the right kind of home and self, she could also recognize and read the signs other women produced. This knowledge had constantly to be up-dated, since the 'novelty' was by definition always ceasing to be novel. Novelty and the periodical thus worked together to create a recurring pattern of consumption." Beetham, *A Magazine of Her Own?*, 96. Rachel Bowlby suggests that the individual became an "entrepeneur" who sold her or his image to an audience. Bowlby, *Just Looking: Consumer Culture in Dreiser, Gissing and Zola*, 68.

96. By 1900, Hentschel's, firm was producing 300 tonal fashion illustrations to every linear one. Whereas this area had been the province of the wood engraver, and later line, it was now tonal, either wash drawings or heavily retouched photographs. Anon, "Pictorial Reproduction Up-To-Date," *The British Printer*, 1900.

97. The blacking out of auditorium only became common after WWI. On the theater as a site of display, see Booth, *Theatre in the Victorian Age*, 62.

98. See Joel H. Kaplan and Sheila Stowell, *Theater and Fashion: Oscar Wilde to the Suffragettes* (Cambridge: Cambridge University Press, 1994); Chapter 1, "The Glass of Fashion," 8–44, discusses the relationship between the illustrated press and the theater. On dramatic reviewers' identification and marketing of dressmakers who went unnamed in the playbill, see pages 8–9.
99. Anon, *Sketch*, 1895.
100. "Our Ladies Pages: Fashions in the New St. James's Piece," *Sketch*, 210–13. On the theater as a site of commercial display posited on women as intensely visually aware consumers see Erika Rappaport, *Shopping for Pleasure: Women in the Making of London's West End* (Princeton, NJ: Princeton University Press, 2000), 184–87.
101. Monocle, "An Opinion of 'An Ideal Husband'," *Sketch* (January 9, 1895).
102. Archer, *The Theatrical "World"* (London: W. Scott, 1895), 173–74. George Bernard Shaw criticized the effects of what we would now call product placement when he spoke of one play as "a tailor's advertisement making sentimental remarks to a milliner's advertisement in the middle of an upholsterer's and decorator's advertisement." quoted in Kaplan, *Theater and Fashion: Oscar Wilde to the Suffragettes*, 11.
103. Anon, "Behind the Scenes at the Lyceum," *Sketch* (January 16, 1895), 548. See Robert L. Herbert, *Impressionism: Art, Leisure, and Parisian Society* (New Haven: Yale University Press, 1988), 103–07, on this backstage voyeurism in the French theater.
104. Lafayette of Dublin also provided images of actresses and beauties. Falk, a New York firm, supplied photographs, possibly in the form of electrotypes, which were considerably crisper than their English rivals.
105. Shorter, *C.K.S. An Autobiography: A Fragment by Himself*.
106. Ibid., 75.
107. Ibid., 102.
108. Symon notes that the risqué tone gradually quiet-down, and with the move to a more "artistic" theatrical costume it became more respectable. It was, in his opinion, one of the most attractive and entertaining weeklies. Symon, *The Press and Its Story*, 230. It is clear from a number of accounts that the magazine was one of the most successful weeklies.
109. Bailey suggests that this served to "sensationalize and contain sexual expression in a managable form." Bailey, " 'Naughty but Nice': Musical Comedy and the Rhetoric of the Girl, 1892–1914," 45.
110. See Garb, *Bodies of Modernity* on the intensity of vision and its relationship to gender in French culture during this period. 108.
111. Anon, "Our First Word."
112. Shorter, *C.K.S. An Autobiography: A Fragment by Himself*, 76. Dudley Hardy worked extensively for the theater on poster designs.
113. In the production stages of the illustrated magazine, text galleys and pictures were pasted down as "dummies" to serve as a guide to the printer. For a contemporary description of the magazine production process, see J. Davis, "How the Captain Is Printed," *The Captain*, 1901. This account states that the pictures were laid out first and the text arranged around them. Bullock later became the editor of the *Graphic*, and as an enthusiast for process illustration he contributed important articles on the subject such as, "Charles Dana Gibson," *Studio*, July 1896, and, "British Pen Drawings."
114. Gleeson White argued that in the sixties the weekly magazines were unimportant as sites of illustration, whereas in the nineties it is the weeklies that

produced the most important illustrations. Gleeson White, *English Illustration*, 94.

115. Shorter thought that Phil May's images had benefitted enormously from being seen in the *Sketch* instead of the cramped reductions that had been the case previously. Shorter, "Small Talk," (February 13, 1895), 118. The large-page format of the *Sketch* appealed to May, and his colleague Leonard Raven-Hill thought that it was possibly for this reason that May's work for the *Sketch* were his best pieces. They were collected in *Phil May's Sketch Book* published in 1895. James Thorpe, *Phil May: Master-Draughtsman and Humorist, 1864–1903* (London: G. Harrap and Co., 1932).

116. *Punch's* index listed these illustrations separately as "small engravings" and "large engravings." There was a clear difference between the importance that was placed on these two types of image.

117. Harper, *English Pen Artists of To-Day*, 165. *Pick-Me-Up's* images were much smaller than the *Sketch*. Gamble praised *Pick-Me-Up* as "the sprightliest of our modern humour periodicals" that only used process. Gamble, "Process in Magazine and Book Illustration," *Penrose*. Ingram Brothers took over *Pick-Me-Up*, and Shorter became its editor.

118. Shorter, *C.K.S. An Autobiography: A Fragment by Himself*, 70. Schneirov notes that editors of the American illustrated magazines of the nineties separated their personal political convictions from their magazine's content, though sometimes these opinions were expressed in the editorial of the magazine. Schneirov, *The Dream of a New Social Order: Popular Magazines in America, 1893–1914*, 101, 116–17.

119. Shorter regretted the lack of political coverage in the daily press and read Hansard to get the full picture. His politics were most definitely left wing and he flew the Irish Tricolor outside his home "Knockmaroon" in Great Missenden. Shorter, *C.K.S. An Autobiography: A Fragment by Himself*, xviii.

120. Chalaby, *The Invention of Journalism*, 76–78, 111–14.

121. Anon, "Our First Word." On the role of photography in the spectacularization of the political in the illustrated magazine of the 1930s, see Siegfried Kracauer's classic essay "Photography."

122. See White, *Women's Magazines 1693–1968*, on the encouragement to consume in women's magazines of the period. Although the ad wrappers have been removed from bound copies of the *Sketch* it seems to have had a robust advertising content within its editorial pages. The issue for June 14, 1893, for example, contains sixteen pages of advertisements interspersed through a forty-four page issue. The 1894 edition of Blackburn's *The Art of Illustration* contained an analysis of the *Sketch* as having thirty editorial pages and ten pages of ads. The 1901 edition of the same book lists the *Sketch* as having forty editorial pages and fourteen pages of advertisements.

123. See Helen Damon-Moore, *Magazines for the Millions: Gender and Commerce in the "Ladies Home Journal" and the "Saturday Evening Post"* (Albany, New York: State University of New York Press, 1994). She terms this a "superstructure of consumption," 54. This study examines the gendering of magazine editorial content.

124. An advertisement captioned "In the Studio," features an illustration by Fred Pegram that shows an artist urging his coughing model to take Geraudels. It is placed at the end of the "Light Side of Nature" section. Fred Pegram, "In the Studio," *Sketch*, December 26, 1894.

125. Anon, "An Apostle of the Grotesque," *Sketch*, (April 10, 1895).

126. For L. F. Austin's advice on night clubs, see L. F. Austin, "Impressions of Paris," *Sketch* (February 20, 1895).
127. There was a well-recorded growth in the number and size of women's magazines in this period, and these publications were leaders in the incorporation of illustration and advertising. Indeed, the weekly *Lady's Pictorial* which emphasized its illustrations and attracted a large number of advertisements was seen by many as the best illustrated paper. Shorter claimed that *Lady's Pictorial* was the first newspaper to use studio photographs in any number and the first to use process to make blocks from them. Shorter, *C.K.S. An Autobiography: A Fragment by Himself*, 7.
128. Beetham, *A Magazine of Her Own?*, 125–26. For a discussion of gendered consumption in the periodical see Hilary Fraser, "Gender, Commodity and the Late Victorian Periodical," *Gender and the Victorian Periodical*, eds Hilary Fraser, Stephanie Green, and Judith Johnston (Cambridge: Cambridge University Press, 2003). On American advertisers' problems in targeting male consumers see Roland Marchand, *Advertising the American Dream: Making Way for Modernity, 1920–1940* (Berkeley: University of California Press, 1986), 66–69, 167–88, and also Jackson Lears, *Fables of Abundance: A Cultural History of Advertising in America* (New York: Basic Books, 1994), 118–20, 209.
129. Austin, "At Random," *Sketch* (August 4, 1897). The *Sketch* was very positive regarding the role of press advertisements and connected the growth of the advertisement to that of the pictorial magazine from the *ILN* onwards, Anon, "Pictorial Advertisements," *Sketch* (April 1, 1896). In the United States the publisher McLure promoted the value of ads in his editorials as a means of keeping up with the business world and with contemporary society. On the mixture of the literary see Bowlby, *Just Looking: Consumer Culture in Dreiser, Gissing and Zola*, 85. See also Schneirov, *The Dream of a New Social Order: Popular Magazines in America, 1893–1914*, 92, 176.
130. Shorter eventually puts his reader's complaint down to jealously: "Her lips with a scornfulness pout/At the medley of maidens I etch;/Ah – you've been left out; that's the reason no doubt,/there is nothing to read in the *Sketch*." Shorter, "To a Lady Who Says That There's Nothing to Read in the *Sketch*," *Sketch* (March 3, 1897).
131. Bowlby, *Just Looking: Consumer Culture in Dreiser, Gissing and Zola*, 6. On the aesthetic of abundance in the department store as a means of legitimizing purchase without need see also Miles Orvell, *The Real Thing: Imitation and Authenticity in American Culture 1880–1940* (Chapel Hill: University of North Carolina Press, 1989), 42–43.
132. On the entomology of *magazine* see Robert L. Patten, "Dickens as Serial Author: A Case of Multiple Idenities," *Nineteenth-Century Media and the Construction of Identities*. On the theatricalization of the department store see Bailey, " 'Naughty but Nice': Musical Comedy and the Rhetoric of the Girl, 1892–1914," 40–44. On the concealment of production in the display of goods see Crane, "Modern Aspects of Life and the Sense of Beauty," 207–19, 210, discussed in chapter 1.
133. The machines were mainly used for newspaper work in the provinces, where unions were not able to resist the change. The first use of the Linotype in England was at the *Newcastle Chronicle* in 1889. The *Globe* was the first London paper to use the Linotype at the end of 1893 followed by the *Financial Times*. By the middle of 1894, Linotypes were in use at half-a-dozen offices including the *Daily Telegraph*. Soon after this all the London dailies were set by Linotype. On the history of mechanical typesetting, see Howe, *The London Compositor*, and *Newspaper Printing in the Nineteenth Century*, Clair, *A History of Printing in Britain*.

134. For further discussion of Simmel's point see chapter 1.

135. Crane, *On the Decorative Illustration of Books Old and New*, 165.

136. On let-in blocks, see Howe, *The London Compositor*.

137. Anon, "The Monotype," *Sketch* (October 20, 1897).

138. On the cropping of images, see A. Horsley Hinton, "Photography for Illustration," *Photogram* (September, October 1894), also Peter Penciller, "Constructive Criticism No. 12: A Word About Trimming," *Process Photogram*, 4.38 (1897).

6 The illustration of the everyday

1. Emily Soldene, "How the Alhambra was Shut," *Sketch* (January 30, 1895).

2. James Hall suggested that pen-and-ink harmonized well with type and made a much-needed contrast with the photograph in the press. James Hall, *With Pen and Ink*, 2nd ed. (New York: Prang, 1913), 5.

3. Walter Crane, *The Bases of Design* (London: Bell, 1898), 290. Wright suggests that there was a very direct photographic influence on the tonal wash images of events which weeklies printed in large numbers. He notes that these illustrations became increasingly photographic in their aesthetic with a blurring of their background and a more detailed approach to their foregrounds. Jeffrey Wright, "The Origins and Development of British Press Photography, 1884–1914," Swansea: MSc Thesis, University College, 1982, 79.

4. Blackburn, *The Art of Illustration*, 108. The result of this craze was, Blackburn asserted, that "several thousand blocks are made in London alone every week," 108. Pennell's canon extends back to the 1880s but its most dramatic growth was in the 1890s. His wife Elizabeth Pennell in her review of the Paris Salons of 1893 suggested that, spurred on by competition from photography, black and white artists were producing the most original and exciting work of the day. Matthew Sturgis, *Aubrey Beardsley* (London: Harper Collins, 1999), 140.

5. Joseph Gleeson White, "At the Sign of the Dial: Mr. Ricketts as a Book-Builder," *Magazine of Art* (April 1897), quotation, 307.

6. White, "The Editor's Room. New Publications," *Studio* (1895).

7. Ibid.

8. Harry Barnett, "The Special Artist," *Magazine of Art* (1883): 166.

9. Brown, *Beyond the Lines: Pictorial Reporting, Everyday Life, and the Crisis of Gilded Age America*, 68, also see pages 32–34, on illustrators' methods of assembling images from verbal and written reports collated after the event.

10. The system only changed when magazines such as *Life* were able to produce narratives via very carefully arranged juxtapositions of text and photographs.

11. Harper, *English Pen Artists of To-Day*, 2.

12. On French realist drawing see Petra ten-Doesschate Chu, "Into the Modern Era: The Evolution of Realist and Naturalist Drawing," *The Realist Tradition: French Painting and Drawing 1830–1900*, ed. Gabriel P. Weisberg (Cleveland: Cleveland Museum of Art, 1980). For a technical survey of Impressionist sketching methods see Bernard Dunstan, *Painting Methods of the Impressionists* (London: Pitman, 1976).

13. On Hamerton's critical standing see *Art Journal*, NS 46 (1894), 377.

14. See "The Law of Progress in Drawing," in Hamerton, *Drawing and Engraving: A Brief Exposition of Technical Principles and Practice*, 59–60. On the Victorian love of detail see John Fiske, "Popular Discrimination," *Modernity and Mass Culture*,

eds James Naremore and Patrick Brantlinger (Bloomington: Indiana University Press, 1991). For Whistler's criticism of the desire for detail of the masses see Brian Lukacher, "Powers of Sight: Robinson Emerson and the Polemic of Pictorial Photography," *Pictorial Effect Naturalistic Vision: The Photographs and Theories of Henry Peach Robinson and Peter Henry Emerson*, ed. Ellen Handy (Norfolk, VA: The Chrysler Museum, 1994), 144.

15. Bullock, "British Pen Drawings," 14.
16. J. G. Reid, *At the Sign of the Brush and Pen: Being Notes on Some Black and White Artists of Today* (London: Simpkins and Marshall, 1898), 16.
17. Harper, *English Pen Artists of To-Day* 4.
18. Holme noted that this work was ephemeral, thrown aside by the reader. Frank Holme, "The Training of an Illustrator," *British and Colonial Printer* (August 17, 1899).
19. Spielmann, "Our Graphic Humourists: L. Raven Hill," *Magazine of Art* (1895–1896), 494.
20. Gleeson White, "Some Aspects of Modern Illustration," 352. On the theories of Helmholtz and photography see Mark Durden, "Peter Henry Emerson: The Limits of Representation," *History of Photography*, 18.3 (1994). As a knowledgeable critic of Pictorialist photography Gleeson White would have been aware of these theories, either directly or via Emerson's *Naturalistic Photography for Students of the Art* published in 1889.
21. Gleeson White, "The Taste for Trifles," *Studio* (January 1894).
22. Christopher Campos in his introduction to Holbrooke Jackson's *The Eighteen Nineties* points out that the characteristic art forms of the period were short. He cites as examples short stories, brief poems, essays, cartoons, and anecdotes. Jackson, "The Eighteen Nineties," ed. Christopher Campos (Brighton: Harvester Press, 1976).
23. David Kunzle, *The History of the Comic Strip: The Nineteenth Century* (Berkeley: University of California Press, 1990), 377.
24. The author of one very popular French manual stated "let it be clearly understood that the simplest expression is the best, but also the most difficult; it would almost be safe to say that the less facts are stated the better the sketch." G. Fraipont, *The Art of Making and Using Sketches* (London: Cassell and Co., 1892), 13.
25. Anon, "Reviews of Recent Publications: The Alhambra," *Studio* (February 1897).
26. Harper, *English Pen Artists of To-Day*, 4, 282–83.
27. J. M. Bullock, "Charles Dana Gibson," *Studio* (July 1896), 80. In fact Gibson's drawings were, according to Pennell, reproduced by halftone and then hand engraved to remove the tonal areas. Pennell, *The Illustration of Books*, 91. Pennell, an enthusiast for printmaking thought that the results looked like etchings. Also see Raven-Hill's comment on the use of hand engraving to produce more faithful reproductions of his drawings. L. Raven-Hill, "An Artist's Opinion on Drawing for Reproduction," *Studio* (1893), 69.
28. Harris, "Pictorial Perils: The Rise of American Illustration," *Cultural Excursions*, 348.
29. See Susan Meyer, *America's Great Illustrators* (New York: Harry N. Abrams, 1978), 24.
30. Holme, "The Training of an Illustrator."
31. Newspaper illustrators could earn up to £10 a week. W. Gamble, "Newspaper Portraits," *Process Work* (1898).

32. For Whistler's high opinion of May see Jackson, *The Eighteen Nineties*, 287, and Rothenstein, *Men and Memories: Recollections 1872–1900*, 58. See Franklyn, *The Cockney*, on May's identification with cockneys, his intention to entertain, and his depictions of cockneys as happy, resilient, and philosophical about their lot. 206–08. In fact, *Punch* initially considered May too vulgar for its pages. Hartrick, *A Painter's Pilgrimage through Fifty Years*, 104.

33. Hartrick, *A Painter's Pilgrimage through Fifty Years*, 100.

34. May described himself as a guttersnipe, however, Thorpe argued that though the family had come down in the world it was still respectable. Thorpe, *Phil May: Master-Draughtsman and Humorist, 1864–1903*, 89. For details of May's life also see Simon Houfe, *Phil May: His Life and Work 1864–1903* (Aldershot: Ashgate, 2002), Spielmann, "Our Graphic Humorists: Phil May," *Magazine of Art* (1894), and Anon, "The Life and Genius of the Late Phil May," the *Studio*, 29.126 (1903).

35. Jackson, *The Eighteen Nineties*, 350.

36. Spielmann, "Our Graphic Humorists: Phil May." In a review of "Phil May's Illustrated Winter Annual," in the *Magazine of Art* the reviewer noted that although the printing of the annual was not all that it should be, May's style "is so admirably adapted to the exigencies of ill-printing that it is pre-insured against failure on this account." Anon, "Phil May's Illustrated Winter Annual," *Magazine of Art* (1896–1897), 287.

37. On May in Paris see Rothenstein, *Men and Memories: Recollections 1872–1900*, 57–58, 62–63. Thorpe, *Phil May: Master-Draughtsman and Humorist, 1864–1903*, 29–31.

38. On May's personality see Hartrick who described him as melancholic and unable to be alone Hartrick, *A Painter's Pilgrimage through Fifty Years*, 104.

39. May often used tints to differentiate between the figures in his images. Interestingly middle- and upper-class figures were often defined by flat tints or by simple empty outlines. The working class often were covered in pen scribbles. On Gillot paper and other French methods of placing a mechanical tint on a line drawing see Cate, "Printing in France, 1850–1900: The Artist and New Technologies." The use of these tints was not always popular with critics. In reviewing Daniel Vierge's illustrations for *Pablo De Segovia* the *Art Journal* noted "We wonder, however, that in several of the designs he has allowed his photo-engraver to reproduce his effects by that unpleasantly mechanical dotted surface, which is, so far, the most objectionable feature of process work." Anon, "Art Gossip and Reviews," *Art Journal*, NS 44 (1892), 384.

40. Rev. Joseph Slapkins, *The Parson and the Painter* (London: Central Publishing and Advertising Company, 1891).

41. Crane, *The Bases of Design*, 286. On the French influence on May see Frederick Wedmore, "Expressive 'Line,'" the *Studio*, 14.65 (1898).

42. Anon, "Reviews of Recent Publications," the *Studio*, 9.45 (1896), quotation, 216. Sturgis notes that May, like Beardsley, adapted "Japanese conventions to a modern sensibility." Sturgis, *Aubrey Beardsley*, 299.

43. As a test May was given snapshots of a seaside resort that he transformed into drawings. As Hartrick recalled "The monotony of the snapshots had disappeared, the subjects had become varied and the incidents made clear in line and embellished with humour." Hartrick, *A Painter's Pilgrimage through Fifty Years*, 100.

44. H. Arthur Lawrence, "Mr. Phil May at Home," the *Idler*, December 1896. Final quotation Reid, *At the Sign of the Brush and Pen*, viii. On May's methods see also E. J. Sullivan, *The Art of Illustration* (London: Chapman and Hall, 1921), 109–10.

45. Jackson, *The Eighteen Nineties*, 351.

46. Thorpe, *Phil May: Master-Draughtsman and Humorist, 1864–1903*, 36–37.
47. In 1893, the *Sketch* published thirty-five full-page images by May, the following year fifty-nine, and the following year thirty. The number of images dropped as May began to publish sketches in *Punch*.
48. As John Carey notes the widespread intellectual characterization of the popular press as insubstantial in its content was blind to the quality of the literary material it actually contained. John Carey, *The Intellectuals and the Masses: Pride and Prejudice among the Literary Intelligentsia, 1880–1939* (London: Faber and Faber, 1992), 108–09.
49. Alexandre, Spielmann, Bunner, and Jaccaci, *The Modern Poster*, 99. There were eleven *Phil May* winter annuals and seven summer annuals. The annuals were popular and critical successes and a review in the *Magazine of Art* noted that *Phil May's Illustrated Winter Annual* was "a masterpiece of art" in which many of the drawings were "of a very high achievement and interest." Anon, "Phil May's Illustrated Winter Annual."
50. Aubrey Beardsley adopted the same hairstyle. Beardsley's friend Haldane Macfall remarked that the distinctive Beardsley fringe was in fact "very much in the style of Phil May." Haldane Macfall, *Aubrey Beardsley: The Man and His Work* (London: John Lane, 1928), 34.
51. May took on the "the appearance of a groom." Thorpe, *Phil May: Master-Draughtsman and Humorist, 1864–1903*, 61. Houfe suggests that this loud clothing was an aspect of his shyness and reticence. Houfe, *Phil May: His Life and Work 1864–1903*.
52. "In our peregrinations from pub to pub everybody knew Phil and everybody wanted to shout for him. Americans who recognized him by his portraits would introduce themselves and say: 'Ah must have a drink with Mr. Phil May.' A. B. "Banjo" Paterson, *Happy Dispatches* (http://www.uq.edu.aumlwhambanjohappy_dispatchesphil_may.html). May's theatrical experiences may have been a factor in his projection of a distinctive personality. Like many of his peers, he bridged the worlds of theater and illustrated journalism. Julian Franklyn noted that May "belonged to the bohemian world where studio and stage mingled." Franklyn, *The Cockney*, 210.
53. Baudelaire, "The Painter of Modern Life," *The Painter of Modern Life and Other Essays*. Edgar Allen Poe, "The Man of the Crowd," *Tales of the Grotesque and Arabesque* (Philadelphia: Lea and Blanchard, 1840). Anon, "Phil May's Illustrated Winter Annual." Sullivan, *The Art of Illustration*, 118.
54. Anon, "The Life and Genius of the Late Phil May," 282.
55. Sullivan, *The Art of Illustration*, 120.
56. On the brevity of May's captions see Sullivan, *The Art of Illustration*, 113.
57. Bullock, "Charles Dana Gibson." Bullock returned to these themes in an article in the *Sketch* in which he noted that May's world was "animated by the most primitive instincts and emotions." Yet, as with many of the middle class, Bullock characterized the "lower orders" as being more in touch with their passions, "when 'Lizer becomes struck with 'Enry 'Awkins, she obeys the impulse and mates straight away. She satisfies herself." Gibson's women, in contrast, were torn between "instinct and intelligence." J. M. Bullock, "The Nether World and Mr. Phil May: The Upper World and Mr. C. D. Gibson," *Sketch* (November 25, 1896). May, in fact, depicted all of the classes, and his middle-class figures are, if anything, drawn more simply than his representations of the working class (see note 37).

58. Anon, "The Life and Genius of the Late Phil May," 285. Frank Emanuel commented on J. L. Forain's "La Comédie Parisienn," which showed sexually charged scenes. "They are snap shots of propitious moments; but taken by an artist's eye in place of a photographic lens, and an artist's science to display what is necessary and to discard what is unnecessary for the illustration of the point at issue." Frank L. Emanuel, *The Illustrators of Montmartre* (New York: Charles Scribner's Sons, 1906), 68.

59. Jones, "The 'Cockney' and the Nation," *Metropolis: London*, 300.

60. Anon, "The Art of the Day," *Sketch* (June 5, 1895), 307. Margaret Armour, "Aubrey Beardsley and the Decadents," *Magazine of Art* (November 1896). Anon, "Phil May's Illustrated Winter Annual." According to his biographer Thorpe, May captured the working class's "boisterous enjoyment of life." Thorpe, *Phil May: Master-Draughtsman and Humorist, 1864–1903*, 84.

61. On middle-class views of the working class see Winter, *London's Teeming Streets 1830–1914*. On Henry Mayhew's vision of the "lower orders" see Gertrude Himmelfarb, *The Idea of Poverty: England in the Early Industrial Age* (New York: Knopf, 1983).

62. Charles Baudelaire, "On the Essence of Laughter," *The Mirror of Art: Critical Studies* (London: Phaidon, 1955), quotations, 143, 153.

63. Seth Koven's investigation of slumming reveals the contradictions and complexities of the bourgois and upper-class involvement with the East End of London, from fashionable tourists to social reformers. Seth Koven, *Slumming: Sexual and Social Politics in Victorian London* (Princeton: Princeton University Press, 2004).

64. Jones, "The 'Cockney' and the Nation," 300.

65. Spielmann, "Our Graphic Humorists: Phil May," 351.

66. Thorpe, *Phil May: Master-Draughtsman and Humorist, 1864–1903*, 86.

67. Sullivan, *The Art of Illustration*, 119. Maidment, *Reading Popular Prints, 1790–1870*, 91.

68. On Phil May's cartoon suggesters, see Paterson, *Happy Dispatches*. In an interview with Arthur Lawrence, May claimed he wrote his own jokes on the whole, although people did give him suggestions. Lawrence, "Mr. Phil May at Home." For a detailed description of the *Punch* system of joint authorship see Spielmann, "Glimpses of Artist-Life. The Punch Dinner – the Diners and Their Labours," *The Magazine of Art* (1895). In discussing Daumier's work Terdiman notes the "multiple authorship" which was practiced by Daumier and his caption writers. He notes that these collaborations have not been valorized by scholars who tend to strip these political, textual, and visual artifacts of both their letterpress text and their political purpose. The caricatures thereby become largely aesthetic and the work of Daumier alone. Terdiman, *Discourse/Counter Discourse: The Theory and Practice of Symbolic Resistance in Nineteenth Century France*, 180–83.

69. Blackburn, *The Art of Illustration*, 171–72. The *Sketch* praised pen-and-ink as the art of the day, in which, every month a new artist was discovered and quickly publicized by process. Anon, "The Art of the Day: Certain Summaries of Victorian Art," *Sketch* (January 12, 1898). The illustrator Louis Wain maintained that black-and-white illustration should enter into all of the crazes of the age. Roy Compton, "Canine and Sublime: A Chat with Mr. Louis Wain," the *Idler* (January 1896).

70. On the spreading of stylistic influence through the press see Bullock, "Charles Dana Gibson."

71. Anon, *Studio* (October 1893). On Birmingham see Wallace Lawler, "Romance in Black and White: A Chat with Mr. H. Miller," the *Idler* (October 1895). Anon, "The Birmingham Municipal School of Art," *Studio* (November 1893).

72. Anon, "Editorial," *Publishers' Circular: Newspaper, Magazine and Periodical Supplement* (June 15, 1895), 4.

73. On Westminster see Stronach, "London Art Schools: The Westminster School of Art," *Sketch* (May 1, 1895). Sturgis, *Aubrey Beardsley*. D. S. MacColl, "Professor Brown: Teacher and Painter," *Magazine of Art* (1894). *The Magazine of Art* noted that "as a teacher in enforced connection with South Kensington he had, in disregard of the system cherished and rewarded there, trained his pupils to draw..." 403. Brown left for the Slade in 1894 but the school continued to offer twice weekly classes in black-and-white illustration.

74. Blackburn, *The Art of Illustration*, xiv Henry Blackburn died in 1897 and his *Art of Illustration* was published in a revised edition in 1901 with revisions by J. S. Eland.

75. Compton, "Half and Hour with Mr. Fred Pegram," the *Idler* (June 1897), reveals that Pegram has no formal training beyond studying with Fred Brown and working in Paris for three months. These claims paralleled the avant-garde's attempts to establish itself outside of the academy. On photography in France and Nadar's claims to innate genius, and its relationship to the avant-garde see McCauley, *Industrial Madness*, 121.

76. For critical opinions of May see Spielmann, "Our Graphic Humorists: Phil May." On May's social contacts with artists see Macfall, *Aubrey Beardsley: The Man and His Work*, 69, and the many references in Rothenstein, *Men and Memories: Recollections 1872–1900*. From 1892 to 1896 May's studio was at 9 Holland Park Road. Hartrick, *A Painter's Pilgrimage through Fifty Years*, 102. He then moved to Medina Place in St. John's Wood, an area of London where other artists also lived and worked, Thorpe, *Phil May: Master-Draughtsman and Humorist, 1864–1903*, 45–46. Victorian artists were careful to establish studios near other artists in areas where potential collectors lived. Walkley, *Artists' Houses in London 1764–1914*.

77. The *Sketch*, reviewing his exhibition at the Fine Art Society insisted that the images were more than humorous cartoons. "But it is more than merely this, for Mr. May is one of the very few English artists who knows the value of line, of selection, and of rejection. With the smallest number of strokes possible, this artist is easily able to produce the maximum of effect." Anon, "The Art of the Day," 307.

78. Jussim discusses the use of Japan paper to print New School engravings, lightweight paper that allowed for the printing of very fine detail and for them to be sold as artistic prints. Jussim, *Visual Communication and the Graphic Arts: Photographic Technologies in the Nineteenth Century*, 94.

79. Prof. Sir Hubert Von C. V. O. Herkomer, *My School and My Gospel* (London: Archibald Constable and Co., 1908), 29. On the new subject matter in the *Graphic* see J. Saxona Mills, *Life and Letters of Sir Hubert Herkomer C.V.O., R. A.: A Study in Struggle and Success* (London: Hutchinson, 1923), 59–60.

80. For a discussion of Ruskin's reaction see Garrigan, " 'The Splendidest May Number of the Graphic': John Ruskin and the Royal Academy Exhibition of 1875," *Victorian Periodical Review*, 24 (1991).

81. Anne Hollander, *Moving Pictures* (Cambridge, MA: Harvard University Press, 1986), 336–38.

82. On illustrators' desire for independence see N. N. Feltes, *Modes of Production of Victorian Novels* (Chicago: University of Chicago Press, 1986), 69–73. On illustrators' choice of less dramatic incidents see Staley, *The Post-Pre-Raphaelite Print*, 37–38.

83. Maclean, *Photography for Artists*, 10, 16.

84. Painters also made extensive use of photography as reference, a sketching tool, as inspiration and as a means of promoting their work. As Staley noted photography impinges on the work of virtually every Victorian artist in countless ways. Staley, *The Post-Pre-Raphaelite Print*, 133. On the use of photography by French painters see Dunstan, *Painting Methods of the Impressionists*, 13; also see Hamber, *A Higher Branch of the Art: Photographing the Fine Arts in England 1839–1880*, 187–98. On Rosetti's knowledge of and frequent use of photography see Alicia Craig Faxon, "D. G. Rosetti's Use of Photography," *History of Photography*, 16.3 (1992).

85. Blackburn, *The Art of Illustration*, 171.

86. On illustration as the equivalent of theatrical performance see Brown, *Beyond the Lines: Pictorial Reporting, Everyday Life, and the Crisis of Gilded Age America*, 72. See Wynne, *The Sensation Novel and the Victorian Family Magazine*, 127–28, on the use of theatrical poses in du Maurier's illustrations for *Once a Week* in 1863.

87. Gleeson White, "Some Aspects of Modern Illustration," 350.

88. Major John Fortune Nott, "Photography and Illustrated Journalism," *British Journal of Photography* (1891).

89. Crane, *On the Decorative Illustration of Books Old and New*, 178. For more on Crane's opinions on photography see Crane, *The Bases of Design*, 290.

90. On illustrators working as teams on images see Richards, "Pictorial Journalism," *The World Today*, August 1905. A very similar system was developed in the United States. For a contemporary account of a system similar to the *Daily Graphic* see Will Jenkins, "Illustration of the Daily Press in America," *Studio* (May, September 1902). Jenkins notes the use of teams of artists with an interchangeable style working on photographs. For further accounts of press practices in the US see Felice Jo Lamden, "Newspaper Illustration 1890–1910," *City Life Illustrated: 1890–1940* (Delaware: Delaware Art Museum, 1980). Rebecca Zurier points out that the sketch styles that were developed for press work conveyed a sense of immediacy and presence even when they illustrators had not witnessed the events they drew. Rebecca Zurier, *Metropolitan Lives: The Ashcan Artists and Their New York* (New York: Norton, 1995), 60–61.

91. For a personal recollection of the *Daily Graphic*'s illustration system see Hartrick, *A Painter's Pilgrimage through Fifty Years*, 63–83.

92. J. Gleeson White, "Drawing for Reproduction," *Practical Designing*, ed. J. Gleeson White (London: George Bell and Sons, 1897), 188.

93. T. C. Hepworth, "How to Make Pen and Ink Drawings for Process Work," British Journal of Photography, 40 (January 6, 1893). Charles Harper gave directions for a method that was popular in the US, although Harper advised illustrators not to simply follow the "inartistic surface of the photograph" with its excess of detail. "Still, admirable results have been obtained in this way by artists who know and practice the very great virtue of reticence." Harper, *A Practical Handbook of Drawing for Modern Methods of Reproduction*, 116.

94. Spielmann, "Our Graphic Humorists: Linley Sambourne," *The Magazine of Art* (1893), 333–34. Sambourne's archive of photographs contains over 15,000 items. On other *Punch* artists, use of photography see Spielmann, "Our Graphic

Humorists: Sir John Tenniel," *Magazine of Art* (1895). On artists' use of photography see Eliza Putnam Heaton, "Woman and the Camera," *British Journal of Photography*, 38 (1892). Joseph Pennell, "Photography as a Hindrance and a Help to Art," *British Journal of Photography*, 38 (1891). Hector Maclean's *Photography for Artists* provided a guide on how to use photographs surreptitiously. The *Sketch* in reviewing the book noted that it offered artists "numerous and easy facilities for hiding their own use of photography" so there is no longer any need for an artist to admit that they do make use of it. *Sketch* (June 10, 1896), 276.

95. Spielmann, "Our Graphic Humorists: Linley Sambourne." Crane suggested that he was influenced by photography in his treatment of light and shade. Crane, *The Bases of Design*, 287.

96. Sickert, "Diez, Busch and Oberländer," *A Free House! Or, the Artist as Craftsman*, 248–49. Blackburn, *The Art of Illustration*. Elliot also maintained that drawing for process is harder than for wood engraving. Elliot, "Wood Versus Photo-Engraving," *Inland Printer* (May 1889). Drawing for facsimile wood engraving was said to be more difficult and time consuming for artists and Hodson noted a link between the line drawn for facsimile engraving and the line drawn for line process, both needing to be clear and definite with strong blacks. Hodson, *A Historical and Practical Guide to Art Illustration in Connection with Books, Periodicals and General Decoration*, 198.

97. Another reason for using bristol board was that it protected the work when it was at the printers. Reade, *Aubrey Beardsley*. Herkomer quote A. L. Baldry, *Hubert Von Herkomer, RA: A Study and a Biography* (London: George Bell and Sons, 1901), 76. On the unpredictability of line process see Pennell, "Art and the Daily Newspaper." Pennell, *The Illustration of Books*.: Holme, "The Training of an Illustrator."

98. Blackburn, *The Art of Illustration*, 91. On Baudelaire's criticism of debased *chic* illustration which is based on formula rather than memory see Hannoosh, *Baudelaire and Caricature*, 97.

99. Raven-Hill, "An Artist's Opinion on Drawing for Reproduction."
100. Gleeson White, "Drawing for Reproduction."
101. Armour, "Aubrey Beardsley and the Decadents."
102. "The Chronicle of Art August Reviews," *Magazine of Art*, 19 (1896), 422. Anon, "Mr. Christopher Dean, Designer and Illustrator," *Studio*, 12.57 (1897), 183. There are varying accounts of this period; for some commentators it seemed that the profession was already crowded some years earlier. In 1893 T. C. Hepworth warned that illustration for the press was already an overcrowed profession. "How to Make Pen and Ink Drawings for Process Work." The same year Charles Harper lamented that most illustrators were a "manufacturing army of frantic draughtsmen." *A Practical Handbook of Drawing for Modern Methods of Reproduction*, viii. For the situation in the United States see Bogart, *Advertising, Artists and the Borders of Art*. She suggests that after a fairly prosperous period in the 1890s the profession became increasingly overcrowded as illustrators were attracted by the promise of the huge wages earned by the high-profile stars. By 1910 it was very difficult to make a regular income as an illustrator, see "The Problem of Status for American Illustrators," 15–78.

103. Pennell, *The Illustration of Books*, 11.
104. H. W. Bromhead, "Some Contemporary Illustrators: Max Cowper, Stephen Reid, Claude Shepperson," *The Art Journal*, NS 60 (1898).

7 The photograph on the page

1. H. Lamont Brown, "Facts Versus Art," *Penrose Annual, Volume 4, 1898*, ed. William Gamble (London: Lund Humphries, 1898), 43.
2. Horgan, "Photography and the Newspapers," *Photographic News*, 38.1348 (1884), 428.
3. Anon, "Red Prints for the Draughtsman," *Amateur Photographer*, 2.49 (1885).
4. Anon, *British and Colonial Printer*, 1887, quoted in Jeffrey Wright, "The Origins and Development of British Press Photography, 1884–1914".
5. Carmichael Thomas, "Ilustrated Journalism," *Journal of the Society of Arts*, 39.1993 (1891), 178.
6. The editor Clifford-Weblyn saw the art editor and the advertising manager as the key figures in the success of an illustrated paper. Anon, "Journals and Journalists of Today Xl: Mr. Clifford Weblyn and 'the Illustrated Sporting and Dramatic News,'" *Sketch* (May 22, 1895).
7. Shorter criticized Thomas of the *Graphic* for being almost too concerned with the artistic quality of the magazine, given his background as a wood engraver. Shorter, "Illustrated Journalism: Its Past and Future."
8. Ibid. On need for a new type of editor also see Townsend, "Modern Developments in Illustrated Journalism."
9. On the art editor's duties see "How Popular Periodicals Are Produced," St. Brides Printing Library, London, n. d. and Davis, "How the Captain is Printed," *The Captain*, 1901. On magazine production schedules and deadlines see Henry Snowden Ward, Catharine Weed Ward, *Photography for the Press*, 45–48.
10. On the chaos that process reproduction brought to the art magazine see Fawcett, Trevor, and Clive Phillpot, *The Art Press: Two Centuries of Art Magazines* (London: The Art Book Company, 1976).
11. Individuals with long experience of image publication commented on the uncertainty brought by the photomechanical techniques. Henry Blackburn noted that publishers were "deprived of the fostering care of the master wood engraver" and therefore should have in-house experts in the new reproduction methods. Blackburn, *The Art of Illustration*, 213. Phillip Hamerton also remarked on the need for careful editorial supervision of process images. Hamerton, *The Art of the American Wood-Engraver*, 15.
12. Keller notes that "Trivial incidents made an appearance in force only around 1900 and they have stayed with us ever since, underscoring once more that this is the period from which modern photojournalism should be dated." Ulrich F. Keller, "Photojournalism around 1900: The Institutionalization of a Mass Medium," *Shadow and Substance*, ed. Kathleen Collins (Bloomfield Hills, Michigan: Amorphous Institute, 1990), 200. The example of "trivial" photography that Keller cites, a photograph of a small girl feeding a pigeon in Central Park, was a continuation of the genre of sentimental pictures of children and animals that had been a staple of the illustrated press since the 1840s.
13. Keller finds "a clear aesthetic deficit" in early photojournalism. He describes it as relatively unsophisticated and puts this down to the poor pay and status of the job failing to attract the more talented. Keller, "Photojournalism around 1900: The Institutionalization of a Mass Medium," 290. Keller is certainly correct on the low status of the press photographer, but I would suggest that the photographers, rather than simply lacking talent were also working within expectations. Would-be photographers were advised to study magazines to see the types of image and story that they already contained. Ward, *Photography for the*

Press, 2–6. Wright also notes that in Britain press photography operated in the same fashion as wood engraving both formally and in terms of its content. He sees this situation changing, slightly, toward the end of the century. Wright, "The Origins and Development of British Press Photography, 1884–1914, 78–82." Griselda Pollock notes the emergence of press photography from within existing approaches to image making, but she sees the photomechanical image as an effective one. "Building on a range of pictorial traditions photojournalism endowed the visual display of power with the aura of authenticity, objectivity and immediacy, while also mobilizing fantasy, desire, and pleasure to glamorize the objects of study." Griselda Pollock, "The Dangers of Proximity: The Space of Sexuality and Surveillance in Word and Image," *Discourse*, 16.2 (1993), 9.

14. The term *cut* developed from woodcut and it became the generic word for any type of reproduction. On printer's cuts see Clair, *A History of Printing in Britain*, 231.

15. Nops were agents for *ILN*, the *Strand*, *Lady's Pictorial*, the *Graphic*, and *Black and White*, as well as a number of German and Italian magazines. They also offered an image production service, making drawings from photographs or roughs supplied by clients. See advertisement in *Printing Times and Lithographer*, NS 1.1 (1892).

16. Throughout the nineteenth century there had been proposals for the creation of encyclopedic collections of photographs for educational purposes. On this see Marien, *Photography and Its Critics: A Cultural History 1839–1900*, 125–29. This came to fruition, in a way, with magazines' visual archives.

17. Illustrations of the 1903 wedding of German royal family were based almost entirely on 1881 images of the Kaiser's wedding. Richards, "Pictorial Journalism," *The World Today*, August 1905. In the US the prominent periodical publisher Frank Leslie preserved engravings that were indexed and carefully stored for reuse. "Cuts were stored and indexed in a separate building, where a custodian could produce any desired cut at a moment's notice." Stern, *Purple Passage: The Life of Mrs Frank Leslie*, 107.

18. On early photo-graphic agencies in London see Helmut Gernsheim, *The History of Photography* (London: Thames and Hudson, 1968), 454–55.

19. On the supply of electrotypes by magazines see Henry Snowden Ward, *The Index of Standard Photograms* (New York: Tennant and Ward, 1901).

20. On the early days of Underwood see Michael L. Carlebach, *American Photojournalism Comes of Age* (Washington: Smithsonian Institution Press, 1997), 35–37.

21. The Wards operated the Illustrated Press Bureau, which acted as an agent for placing photographs, and conducted searches for editors for free relying on fee from the photographer. They claimed to be able to provide photographs on commission from anywhere in the world. Ward, *Photography for the Press*, 19–21. On the role of the photo agency see Keller, "Photojournalism around 1900: The Institutionalization of a Mass Medium," 290–93.

22. Orvell, *The Real Thing: Imitation and Authenticity in American Culture 1880–1940*, 95.

23. Nott, "Photography and Illustrated Journalism."

24. Orvell examines Jacob Riis's work in which the photographer and his subjects collaborated to construct a generalized truth about life in the slums of New York. Orvell, *The Real Thing: Imitation and Authenticity in American Culture 1880–1940*, 96–97. On Jacob Riis using the existing narrative conventions of the pictorial press see Maren Stange, *Symbols of the Ideal Life: Social Documentary Photography in America, 1890–1950* (Cambridge: Cambridge University Press, 1989), 1–26.

On the staging of events for photographic press coverage in France see Donald E. English, *Political Uses of Photography in the Third French Republic, 1871–1914* (Ann Arbor: UMI Research Press, 1984), 204–07.

25. Ward, *Photography for the Press*, 18.

26. There was no copyright on photographs used in American magazines, and only the more respectable magazines who had offices in the UK would pay. Anon, "The Illustrated Papers and Copyright Photographs," *British Journal of Photography*, 40.1750 (1893). In the same issue W. Vick of Ipswich wrote that he had scores of photos copied by editors who bought the print and believed it was acceptable to reproduce it without paying further fees.

27. Other prices were one guinea for a six by four (the size of a woodblock) two guineas to three guineas for a half page, and five to ten guineas for a full page. A front cover image was three guineas for a portrait, two guineas for an inside portrait. A double page image would fetch fifteen guineas. Better class journals paid five guineas for a series of images on one page. Advertising images could fetch from one guinea to forty guineas, posters from five guineas upwards. Ward, *Photography for the Press*, 14–17.

28. The book went through at least four editions. The revised 1914 edition still deals mainly with weeklies rather than daily papers. Only three daily papers are listed: the *Daily Graphic*, the *Daily Mirror*, and the *Daily Sketch*. The prices photographers were advised to charge were actually less than in 1901. F. J. Mortimer, *Photography for the Press and Photography for Profit*, 4th ed. (London: Hazell, Watson and Viney, 1914). The next detailed treatment of press photography to be published in England was Bell R. Bell, *The Complete Press Photographer* (London: Sir Issac Pitman, 1927). This was also addressed to amateurs who were looking to do occasional freelance for the press.

29. *The Index of Standard Photograms*, was expensive, 5 shillings in the UK and $6 in the US. The editors sent forms to 10,000 photographers in the UK and 500 in the US. The index also covered exhibitors of magic lantern slides and kinematographs. See Henry Snowden Ward and Catharine Weed Ward, "Golden Opportunities," *Photogram*, 7.1 (1900).

30. Listings from the index include: "Johnston, Miss Francis B., 1332 V. Street Washington DC. A notable collection of work specially prepared for illustrated press purposes, dealing very comprehensively with the Government Departments at Washington, buildings, staff, the President, interiors of homes of notable Americans." On Johnston see Keller, "Photojournalism around 1900: The Institutionalization of a Mass Medium," 295–96. The Tonnessen Sisters of Chicago, who were among the first advertising photographers, offered: "Great series of genre and figure studies, effects, etc. especially prepared for advertising purposes." Zaida Ben-Yusuf of New York produced illustrations for books and posters. Ellen Mazur Thomson suggests that advertising and editorial photography was an area that attracted economically secure American women. They were able to undertake work of an artistic nature that did not disrupt the ideal of respectable middle class domesticity. Ellen Mazur Thomson, "Alms for Oblivion: The History of Women in Early American Graphic Design," *Design History: An Anthology*, ed. Dennis P. Doordan (Cambridge: MIT Press, 1995).

31. There were, however, more portraits of clergymen than there are for sportsmen.

32. Ward and Ward, "Golden Opportunities." Indeed, Joseph Elliot, a prominent portrait photographer, made £2004 in the first six months of 1900. This was largely due to his portraits of officers who were fighting in the South African War., "Copyright and the American Photographer," *The Photo Beacon*, October

1900. Wright estimates that there were over 100 photographers whose work regularly appeared in periodicals. Wright, "The Origins and Development of British Press Photography, 1884–1914," 57, 192. One factor that makes it difficult to be precise on figures was the practice of not crediting freelance photographers. Editors often preferred that photographs were not credited so that they would appear to be the work of staff photographers. On this practice see Mortimer, *Photography for the Press and Photography for Profit*.

33. Anon, "Camera Club Conference," *Journal of the Camera Club*, 5 (1891).

34. Nott, "Photography and Illustrated Journalism."

35. Thomas, *Journal of the Society of Arts*, 53.2720, 2721 (1905), 152.

36. Carlebach, *American Photojournalism Comes of Age*, 22.

37. On the snapshot in the evening papers see Welford, "The Influence of the Hand Camera."

38. Eight by ten cameras were popular until 1898 and the introduction of the Graflex camera, which used four by six or five by seven film. Carlebach, *American Photojournalism Comes of Age*. For early advice on press cameras for amateurs see Nott, "Photography and Illustrated Journalism," and Ward, *Photography for the Press*. Ward recommends a five by four "Correspondent's Camera." Although some photographers were using smaller format cameras magazines still expected to be supplied with ten by eight prints. The Wards stated that photographer must decide whether to comply by using a large camera or by producing enlargements. They suggest that the advantage is with using a smaller, more portable camera and then making either an enlarged negative with which to make a contact print, or making an enlarged print. Ward, *Photography for the Press*, 27. It is only with the use of smaller cameras that the enlargement of negatives becomes an issue.

39. Welford, "The Influence of the Hand Camera," 280. On another occasion Welford stated that "To pictorially represent England as she is now we do not want a complicated apparatus; it takes people all their time to fix in their mind what to get, and then go and get it." Anon, "Camera Club Conference," 86. Walter Kilbey speaks of the camera's "quickening influence on the hand and eye." Walter Kilbey, "Hand Camera Work," *Photogram*, 9.104 (1902), 226.

40. Stephen Kern, *The Culture of Time and Space 1880–1918* (London: Weidenfield and Nicholson, 1983), 111.

41. See chapter 8, on these theories and their relationship to the image in particular.

42. On Pearson see Peter Johnson, *Front Line Artists* (London: Cassell, 1978). On Publishers' Exaggerated claims regarding number of correspondents see Estelle Jussim, "The Tyranny of the Pictorial: American Photojournalism from 1880 to 1920," *Eyes of Time: Photojournalism in America*, ed. Marianne Fulton (New York: New York Graphic Society, 1988), 64.

43. Advertisement in the *Black and White Budget*, Saturday, January 6, 1900. Barnett was a photographer and Bull was a well known illustrator and photographer.

44. *ILN* assistant editor J. D. Symon recalled that photographic agents came into being with the South African War. Symon, *The Press and Its Story*, 239–40. Ward, *Photography for the Press*, 19–21.

45. On May 12 the paper stated that the photographs it had promised a week earlier could not appear as they had gone down in a shipwreck.

46. Ward, *The Index of Standard Photograms*.

47. Photogram, "Reinhold Thiele: A Man of Genius and Enterprise," *Photogram*, 1899.

48. The Editor, "Commercial and Press Photography," *Penrose Annual 1903–4* (London: Lund Humphries, 1903–1904), 111.
49. On the lowly status of the early press photographer see Carlebach, *American Photojournalism Comes of Age*. Keller notes the professional identity and loyalties of the press photographer were established in the early 1900s. Keller, "Photo-journalism around 1900: The Institutionalization of a Mass Medium," 298.
50. On the initial difficulties in getting photographs see Anon, "Obtaining Portraits for Papers," *Photographic News*, XXIX.1396 (1885). On the changing situation in the US see Gribayédoff, "Pictorial Journalism," *Cosmopolitan*, August 1891.
51. Ward, *Photography for the Press*, 2.
52. See Plunkett, *Queen Victoria: First Media Monarch*, 208–09, 217–19.
53. Shorter, "Illustrated Journalism: Its Past and Future."
54. Ibid., 26.
55. On the origins of the vignette in the picturesque see King, "A Paradigm of Reading the Victorian Penny Weekly: Education of the Gaze and the London Journal," *Nineteenth-Century Media and the Construction of Identities*. On the wood-engraved vignette see Maidment, *Reading Popular Prints, 1790–1870*, 165–66.
56. On borders on the image see Anon, "Pictorial Reproduction Up-To-Date," *The British Printer*, 1900.
57. A. Horsley Hinton, "Photography for Illustration," *Photogram* (September, October 1894), 234.
58. The cropping or "trimming" of an image was often done on the original photo-graph with a pair of scissors before the plate was made. For a discussion of trimming photographic prints see Penciller, "Constructive Criticism No. 12: A Word About Trimming," *Process Photogram*, 4.38 (1897).
59. Anon, "The Future," *Process Photogram*, 2.1 (1895), 13.
60. This approach continued well into the twentieth century. On use of cutouts and geometric shapes in *Look* magazine in the late 1930s see Cara Finnegan, "Doing Rhetorical History of the Visual: The Photograph and the Archive," *Defining Visual Rhetorics*, eds C. Hill and M. Helmers (Manwah, NJ: Lawrence, 2003), 204–05.
61. On use of vignettes on halftones see Bierce, "Notes on Process Matters in the USA," 41. Walter Crane criticized the artificiality of the "card basket style" where images overlapped each other and edges appeared to be turned over. Crane, *On the Decorative Illustration of Books Old and New*, 165–66. Gretton suggests that these collaged layouts suggested both the multiplicity of the reproduced image and at the same time the attempt to rescue specific images from ephem-erality. He relates the practice to domestic scrapbooks. Tom Gretton, "Signs for Labour-Value in Printed Pictures after the Photomechanical Revolution: Main-stream Changes and Extreme Cases around 1900," *Oxford Art Journal*, 28.3 (2005), 378–80.
62. Phenol, "The Combination of Line and Half-Tone," *Process Photogram*, 7.6 (1900).
63. Ward, *Photography for the Press*.
64. Jenkins, "Illustration of the Daily Press in America," *Studio* (May, September 1902), 281, 284, 287.
65. Horgan, "Photography and the Newspapers," 428.
66. "Fifty Years of Art," *Art Journal*, NS 61 (1899), 56, speaks of the growth of etchings, mezzotints, photogravures, and other "semi-mechanical" methods of reproduction.

67. Ernest C. Morgan, "Retouching," British Journal of Photography, 40 (1893). Also see W. H. Fairbairns, "On Retouching," The Process Year Book, ed. William Gamble (London: A. W. Penrose and Co., 1901). There were a number of popular American manuals that went into many editions; Anon, The Modern Practice of Retouching Negatives Practiced by French, German, English and American Experts, 7th ed. (New York: Scoville and Adams Company, 1890), J. P. Ourdan, The Art of Retouching, 4th ed. (New York: E. & H. T. Anthony and Co., 1900). Clara Weisman, an instructor in retouching at the Illinois College of Photography, provided very thorough instructions in Clara Weisman, A Complete Treatise on Artistic Retouching (St. Louis: H. A. Hyatt, 1903).

68. George E. Brown, Finishing the Negative (London: Dawbarn and Ward, 1901), 102. For a fascinating discussion of the extensive retouching on photographs of Queen Victoria see Plunkett, Queen Victoria: First Media Monarch, 186–94.

69. Finishing the Negative, edited by George Brown, one of the editors of The Photogram contains very thorough instructions for retouching. The author of the chapter "Retouching Portrait Negatives" stated "The brutal realism of the photographic image is not to be tolerated, and it falls to the retoucher to remedy the defect to just that nicety that there is no undue prominence of the unpleasing feature, nor yet that entire removal of it which will at once make it conspicuous by its very absence." Brown, Finishing the Negative, 91.

70. Booth, Life and Labour of the People in London, 116.

71. The job required training at an art school followed by a year's experience in technical drawing at a process house. Then wages were £100 to £120 a year. Anon, "Fine Etching for Women," Process Photogram, 4.39 (1897). William Gamble noted that in the USA fine etching was call "staging" and that in some firms as many as thirty young women were employed as fine etchers. Women were preferred as they worked for lower wages than men. William Gamble, "Halftones in 'News' Printing," Process Photogram and Illustrator (August 1905).

72. Alfred Seymour, "Pictorial Expression: Chapter 5. Illustrated Journalism," British Printer (1900), 292.

73. Ward, Photography for the Press, 27.

74. Ibid., 24.

75. Ibid., Page 6 is captioned "Funeral of Queen Victoria. King and Kaiser entering Hyde Park. From the original snap-shot, with 'N. & G.' camera and 'Planar' lens, by T. W. Dorrington, for J. Bulback & Co." Page seven is captioned "Funeral of Queen Victoria. King and Kaiser entering Hyde Park. Reduced from enlargement of snap-shot on page 9. Enlarged negative was slightly worked up, and prints from it were taken by all the leading papers" The final version on page 9 is captioned "Funeral of Queen Victoria. King and Kaiser entering Hyde Park. From a worked-up print made from the photogram on page 7" This print, which is deemed suitable for high-class magazine reproduction, is almost completely redrawn.

76. See Joseph Pennell, "The Illustration of Books," Art Journal, NS 47 (1895).

77. On etching procedures and retouching see Kitton, "The Art of Photo-Etching and Engraving," 230.

78. The article described the laborious fine etching of a portrait in which every area of the face and hair was etched in with a brush. Parry Wager, "On Fine Etching," The Process Year Book.

79. On the use of "routers," "scoopers," "roulettes," and "burnishers" see Maclean, Photography for Artists, 118, 119.

80. Booth puts the wages of process camera operators at 36 shillings to 80 shillings a week, etchers could earn 30 shillings to 50 shillings, and the engravers who worked on blocks 40 shillings. In contrast the women who developed the negatives earned 18 shillings a week.

81. On the difficulties and methods of stereotyping and printing halftone illustrations on rotary presses see Moran, *Printing in the Twentieth Century*, 125–26.

82. In the US Bierce noted that halftones were vignetted, tooled, and line engravings were grained, to produce wood-engraving effects. The article predicted that wood engraving would continue as clients would become tired of the halftone. Bierce, "Notes on Process Matters in the USA." The editor Wallace Crowdey disapproved of the obvious retouching which appeared in *ILN* but was in favor of the use of the roulette. Wallace L. Crowdy, "Process Reproduction from an Editor's Point of View," *Photographic Journal*, NS 22.7 (1898). On burnishers see Seymour, "Pictorial Expression: Chapter 5. Illustrated Journalism," 292. "In many cases where very fine book illustrations are made the engraver will spend from thirty to fifty hours in this work." Bartlett, *Pen and Ink Drawing*, 197. On retouching on the block also see Kitton, "The Art of Photo-Etching and Engraving," 228. Pennell recorded that wood engravers "remedy the imperfections of the photograph and the mistakes of the etcher. That is, whites may be cut, blacks toned down, lines thinned, or large spaces on the block may be left for the engraver to work upon." Pennell, "The Illustration of Books," 362.

83. On the use of in-house engravers on process plates see Gamble, "Process in Magazine and Book Illustration," *Penrose* annual, 3. On wages of re-engravers see Booth, *Life and Labour of the People in London*, 117.

84. Hamerton speaks of "workmen who are paid to imitate engravings for the purposes of photographic reproductions." Phillip Gilbert Hamerton, *The Graphic Arts: A Treatise on the Varieties of Drawing, Painting and Engraving in Comparison with Each Other and with Nature* (London: Seeley, Jackson and Halliday, 1882), 63.

85. See William A. Hinners, "Re-Engraving of Half-Tones," *Inland Printer* (October 1900).

86. H. Lamont Brown, "Engraved Half Tones," *Penrose Annual* (London: A. W. Penrose and Co., 1896), 71.

87. Gamble, "Process in Magazine and Book Illustration," 3.

88. On the problems of retouching see Editorial, "Photographic Versus Hand Engraving," *British Journal of Photography*, 38 (1891). The director of a leading process house stated that profits were eaten up by the hand retouching that was needed; a block which cost ten shillings to engrave might involve retouching by hand which could cost fifty shillings. The originals therefore needed to be specially prepared: "The most successful half tone blocks at the present time in use are those from pictures in mono that are specially worked for the purpose, many of these are enlarged photos, highly finished in 'black and white' and reduced to the size desired." Cheshire, "On the Touching of Half-Tone Process Blocks."

89. Anon, "Pictorial Reproduction Up-To-Date," 255.

90. Blackburn, *The Art of Illustration*, 183. Blackburn died in 1897 and the introduction is not by him.

91. Ives clearly knew a good deal of this combined technique and told a meeting of the Royal Photographic Society that the hand engraving on a block in *Harper's* could cost £15. He also admitted that he had recently changed his mind in favor of retouching. Cheshire, "On the Touching of Half-Tone Process Blocks," 184.

From the perspective of process firms anything which made their blocks more attractive was a good thing. Hentschel, "Process Engraving."

92. See Peter Conrad, *The Victorian Treasure-House* (London: Collins, 1973), 106–33, for a discussion of detail in Victorian art. Also see Dianne Sachko Macleod, *Art and the Victorian Middle Class: Money and the Making of Cultural Identity* (New York: Cambridge University Press, 1996), 15–16, on the middle class love of mimesis.

93. Carl Hentschel spoke of "hand tooling" in which "wonderfully beautiful effects are being wrought." Anon, "A Notable Process Engraver – Mr. Carl Hentschel," *Printing World*, 5.6 (1897).

94. See Cheshire, "On the Touching of Half-Tone Process Blocks," 183.

95. The art editor tested the ability of firms to work to facsimile by supplying the same image to four process houses. His instructions were "fac-simile reproduction, as near as possible, with no hand engraving, and the smallest possible amount of fine etching." All the blocks added contrast and the results were widely varying, the most expensive block at 12 shillings was the least accurate. As with the Wards' images of Victoria's funeral the most expensive was the more retouched and the least "accurate." An Art Editor, "Fac-Sim by an Art Editor," *Process Photogram* (April 1901). Vincent quote, Anon, "Fac-Simile Reproduction: Views of Another Art-Editor and a Practical Process Worker," *Process Photogram*, 8.89 (1901), 70.

96. "Modern Illustration," *Process Photogram* (February 1901). Wheatley, *Catalogue of the Loan Exhibition of Modern Illustration Comprising Typographical Reproductions and the Original Drawings Executed 1860–1900*, 19. Wheatley stated that many of the wood engravers at the *Graphic* had been redeployed on this retouching of halftones.

8 Learning to read the halftone

1. Henry Peach Robinson, *Photographic News*, 1894, quoted in Jeffrey Wright, "The Origins and Development of British Press Photography, 1884–1914," 72.

2. Spielmann stated that process was a quarter the cost of wood engraving. M. H. Spielmann, *The History of Punch* (London: Cassell and Company, 1895), 251.

3. The magazine editor Clifford Weblyn also thought that photography was being overused, and that it was a temporary fad that the public would eventually tire of. Anon, "Journals and Journalists of Today Xl: Mr. Clifford Weblyn and 'The Illustrated Sporting and Dramatic News,'" *Sketch* (May 22, 1895). Even in the 1920s Clement Shorter forecast that there would be a reaction against the photograph and a resurgence of the illustrator, and even the wood engraving. Shorter, *C.K.S. An Autobiography: A Fragment by Himself*, 92.

4. At the time this form of assembly-line production was known as "sectioned." Anon, "Pictorial Reproduction Up-To-Date," *The British Printer*, 1900.

5. W. C. Eddington, "Successful Half-Tone Illustration," *Photographic Journal*, NS 21.4 (1896).

6. For this argument see James Bell, "Pictures and Print," *Good Words*, 33.52 (1892). Matthew Surface gathered positive opinions on the important role of the image in Matthew Surface, "When Nature Fails, Then Art Steps In," *Penrose Annual 1896* (London: Lund Humphries, 1896).

7. Henry Cole, a key figure in art and design education, acknowledged *ILN*'s role in spreading the taste for art. On Cole's praise for *ILN* see Hamber, *A Higher Branch of the Art: Photographing the Fine Arts in England, 1839–1880*, 113; see pages 109–18 for a general discussion of art reproduction in newspapers and magazines.
8. On art as a filler in the press see Hamber, *A Higher Branch of the Art: Photographing the Fine Arts in England 1839–1880*, 113, and see the discussion of art in the press in chapter 5.
9. On Reith's distrust of "frivolous" popular culture and his agenda at the BBC see LeMahieu, *A Culture for Democracy: Mass Communication and the Cultivated Mind in Britain between the Wars*, 141–54.
10. On the challenge of the image Neil Harris states, "All of these forms of expression shared was a diversion of authority away from its orthodox sources and traditional methods, in favor of new and apparently untried techniques. Ingenious, aggressively original, or incompetent illustrators could challenge the authority of the storyteller, as letter writers pointed out; cartoonists could challenge the honesty, patriotism, and, even more seriously, the dignity of pillars of the establishment, and so undermine their authority as setters of standards; . . . But pictures were subversive, most of all, because they presented a new and apparently uncontrollable set of sources to the larger public." Harris, "Iconography and Intellectual History: The Halftone Effect," 347–48.
11. George du Maurier, "The Illustrating of Books: From the Serious Artist's Point of View," *The Magazine of Art* (1890). On the highly pictorial theater of the 1890s see Booth, *Theatre in the Victorian Age*, 95–98. Erika Rappaport notes the close connections between these visually seductive theatrical presentations and the visual display of commerce. Rappaport, *Shopping for Pleasure: Women in the Making of London's West End*, 184–87.
12. Shorter, "Illustrated Journalism: Its Past and Future."
13. William Wordsworth, "Illustrated Books and Newspapers," *Poetical Works* (Oxford: Oxford University Press, 1969).
14. See Barbara Stafford on the origins of these attitudes in Plato and in the eighteenth-century Protestant distrust of the image, in which the word was associated with rational thought and empiricism, and the image with emotion. Barbara Maria Stafford, *Good Looking: Essays on the Virtue of Images* (Cambridge, MA: MIT Press, 1996), in particular, "Display and the Rhetoric of Corruption," 42–52. For twentieth-century reactions to mass reproduction and visual culture see Daniel Boorstin, *The Image: Or, What Happened to the American Dream* (New York: Atheneum, 1961), and also Neil Postman, *The Disappearance of Childhood* (New York: Delacorte Press, 1982). For French intellectual reactions to the visual see Martin Jay, *Downcast Eyes: The Denigration of Vision in Twentieth-Century French Thought* (Berkeley: University of California Press, 1993).
15. Roy Porter, "Seeing the Past," *Past and Present*, 118.1 (1988), 188–89.
16. Sinnema, *Dynamics of the Pictured Page: Representing the Nation in the Illustrated London News*, see in particular Chapter 4, "Representing the Railway," 116–41, in which Sinnema suggests that the visual depictions of railway accidents remained within the traditions of the picturesque and in doing so softened the impact of these potentially very disturbing events.
17. Anon, "Preface to Volume 1, 1842," *Illustrated London News* (January 6, 1843).
18. Gamble, "Newspaper Portraits," *Process Work*, 1898.
19. Anon, "Editorial," *Under the Union Jack* (July 21, 1900).
20. Matthew Arnold, "Up to Easter," *Nineteenth Century*, XXI (1887), quoted in Tulloch, "The Eternal Recurrence of New Journalism," *Tabloid Tales: Global Debates over Media Standards*.

21. From *New Grub Street*, 1891, quoted in Beetham, *A Magazine of Her Own?*, 120. Whelpdale's magazine was *Chit-Chat*, a parody of *Tit-Bits*.
22. Dicey, "Journalism Old and New," *Fortnightly Review*, 83 (1905), 917.
23. On criticisms of new journalism see Kate Campbell, "Journalistic Discourses and Constructions of Modern Knowledge," *Nineteenth-Century Media and the Construction of Identities*. On concerns regarding shortening attention spans see Harold Innis, *Changing Concepts of Time* (Toronto: University of Toronto Press, 1952), 93–94, 102.
24. LeMahieu, *A Culture for Democracy: Mass Communication and the Cultivated Mind in Britain between the Wars*, 106–07.
25. On class, gender and the emotional appeal of illustration see Wilke, *Advertising Fictions*, 161–62, and on concerns about the vulnerability of women to visual display see Nead, *Victorian Babylon People*, 186–88. Dr. R. S. Marsden addressed the Sanitary Conference in Leeds in 1896 on "Some Sanitary Aspects of Advertising" on the dangers of imagery in posters. Whereas the "well conditioned mind" reacted to sensational posters with disgust, the less well educated, the "ignorant and emotional classes" were easily influenced by them. Marsden claimed that most violent crimes could be traced back to the influence of posters. Anon, "Those Wicked Posters," *Printing World*, 5.1 (1897).
26. Carey, *The Intellectuals and the Masses: Pride and Prejudice among the Literary Intelligentsia, 1880–1939*.
27. LeMahieu, *A Culture for Democracy: Mass Communication and the Cultivated Mind in Britain between the Wars*, 107–11.
28. Anon, "Up-To-Date Journalism," *Process Work and the Printer*, 4.40 (1896).
29. Anon, "The Use and Abuse of Illustration," *Process Worker and the Printer*, 4.39 (1896).
30. Matthew Surface, "The Daily Graphic," *Process Work and the Printer*, 6 (1898).
31. Harper, *English Pen Artists of To-Day*, 288.
32. For critics of industrialism the soulless photograph was an emblem of all that was wrong with society. See McCauley, *Industrial Madness in*, "Art Reproduction for the Masses," 225–300.
33. In his discussion of French critical reaction to photography Allan Sekula points out: "The complaints against the emergent 'democratic' media are couched in aesthetic terms but devolve, almost always, into a schizophrenic class hatred aimed at both the middle and working classes coupled with a hopeless fantasy of restoration." Alan Sekula, "On the Invention of Photographic Meaning," *Thinking Photography*, 95.
34. Morris and Crane did accept photography's practical applications in reproduction, and Morris certainly used photography as a tool, just as Ruskin had done. Crane approved of photography's reproductive role but decried its other influence on illustration and its use as a substitute for illustration, see Crane, *The Bases of Design*, 290.
35. Joseph Pennell, *Modern Illustration*, Ex Libris, ed. Gleeson White (London: George Bell, 1895), 45.
36. Quoted in T. C. Hepworth, *The Camera and the Pen* (Bradford: Percy Lund, 1897).
37. George Sala, *The Life and Adventures of George Augustus Sala, Written by Himself* (New York: C. Scribner's Sons, 1895), 202.
38. Horgan noted that a finer screen or "grating" was more difficult to electrotype. S. H. Horgan, "To Avoid the 'Screeny Effect' in Half Tone Work," *Penrose 1896* (London: Lund Humphries, 1896).

39. Addressing a meeting of the Royal Photographic Society in 1896, W. Cheshire stated that he thought the screen in process work was so prominent that "one thought of it more than the picture." Cheshire, "On the Touching of Half-Tone Process Blocks."

40. Sullivan, *The Art of Illustration*, 196.

41. For further discussion of Ivins see chapter 1.

42. Crowdy, "Process Reproduction from an Editor's Point of View," 211. The engraver Charles Dawson also criticized the harsh mechanical effect produced through the new methods of printing on art paper, see Dawson, "Reminiscences of an Old Process Engraver." Also see Gleeson White, "Drawing for Reproduction," 207. The rough, off-white, handmade papers espoused by William Morris were the antithesis of these smooth, consistent, industrial papers. Publishers who wanted to appeal to an Arts and Crafts audience often used mass-produced papers that imitated the imperfections of the handmade.

43. Anon, "Reaction Against Glazed Printing Paper," *Process Photogram*, 7 (1900). Indeed, paper had gradually become whiter as bleached wood-pulp paper replaced the blue or gray tints of the rag papers of the earlier part of the century.

44. J. Comyns Carr, "Book Illustration Old and New," *Journal of the Society of Arts*, 30.1560, 1561 (1882), 1055.

45. Gretton, "Signs for Labour-Value in Printed Pictures after the Photomechanical Revolution: Mainstream Changes and Extreme Cases around 1900," *Oxford Art Journal*, 28.3 (2005).

46. Editor, "The Vile Process," *Process Work* (October 1897).

47. For debates on the halftone in magazines in the US see Schneirov, *The Dream of a New Social Order: Popular Magazines in America, 1893–1914*, in particular the section "Illustration, Photography and the 'Halftone Effect,' " 67–72.

48. Blackburn, *The Art of Illustration*, 140, 213–14. Blackburn had relied on line illustration in his popular annual Academy guides and also ran a school of press illustration. He cautioned that in the rush to process a great deal of reproductive expertise was being cast aside in favor of an uncertain and rather crude new technology.

49. For Whistler's criticism of the desire for detail of the masses in *The Gentle Art* see Lukacher, "Powers of Sight: Robinson Emerson and the Polemic of Pictorial Photography," 144.

50. Anon, "Newspaper Pictures," *The Nation* (April 1893): 307. On criticisms of over-illustration in the US see Carlebach, *American Photojournalism Comes of Age*, 11–14.

51. Hamerton, *The Art of the American Wood-Engraver*, 10.

52. Ibid., 79–80.

53. See Wynne, *The Sensation Novel and the Victorian Family Magazine*, 43–50, 84–97, on the Victorian obsession with nervous debilities and concerns over the pace of modern life and health. Journalists were seen as particularly prone to nervous afflictions due to the pace of the business. The reporter George Lynch writes of an American journalist friend who had to hire a boy to accompany him home over the Brooklyn Bridge as he could not face the journey alone. Nine other journalists in his office were also suffering from nervousness. George Lynch, *Impressions of a War Correspondent* (London: George Newnes, 1903), 160. See Kern, *The Culture of Time and Space, 1880–1918*, in particular, "Speed," 109–31, on anxieties on the pace of life, and 124–30, on theories of degeneration and speed.

54. On Nordau see William Greenslade, *Degeneration, Culture and the Novel, 1880–1940* (Cambridge: Cambridge University Press, 1994), 120–27. Greenslade calls Nordau's book "risable" yet "strangely compelling." "The project was certainly

a brilliant vindication of the conventional and philistine attitude to art and the artist," 122–23. His ideas were widely criticized in more progressive circles.

55. Max Nordau, *Degeneration*, 2nd ed. (London: Heinemann, 1895), 9–11, 21, 39, 42.
56. Symon, *The Press and Its Story*.
57. Joseph Pennell, "A New Illustrator," *Studio*, 1.1 (1893), 14.
58. Quoted in Sturgis, *Aubrey Beardsley*, 180. The *Chap Book*, published in the USA by the Beardsley imitator Will Bradley, claimed Beardsley's style was a mixture of Egyptian, French and Japanese influences, "His chief delight is a Parisian Monsieur in an Egyptian attitude." Gleeson White, "The Lay Figure at Home," *Studio*, 3 (1894), xxii.
59. H. M. Spielmann, "Posters and Poster Designing in England," *Scribner's* (July 1895).
60. Armour, "Aubrey Beardsley and the Decadents," *Magazine of Art* (November 1896), 10.
61. See Gamble, *Modern Illustration Processes: An Introductory Textbook for All Students of Printing Methods*, 54. The American Frank Weitenkampf's assessment was that process allowed any "half-realized daub" to be printed. Frank Weitenkampf, "The American Illustrator" (New York: New York Public Library, 1955), 14.
62. Jerome K. Jerome, "To the Reader of the Idler," *The Idler* (August 1895), 98.
63. Anon, "The Illustrated London News," *Publisher's Circular Newspaper, Magazine and Periodical Supplement*, 9 (1895).
64. Editorial, "The Illustrated Press and Photography," *British Journal of Photography*, XLII.1833 (1895).
65. His "Ex-Libris Series" of books on the art of the book included both Pennell's *Modern Illustration* and Crane's *The Decorative Illustration of Books*. Other books in the series included books on type, printers' marks and book bindings. His own books included Gleeson White, "Drawing for Reproduction." Gleeson White, *English Illustration "the Sixties" 1855–70*.
66. Gleeson White, "The National Competition: South Kensington," *Studio*, 8.42 (1896), quotation, 224.
67. For example see White, "New Publications," *Studio*, 2.10 (1894), Gleeson White, "Afternoons in Studios: A Chat with Mr. G. H. Boughton, A.R.A.," *Studio*, 3.17 (1894), 135, Gleeson White, "Photographic Portraiture: An Interview with Mr. H. H. Hay Cameron," *Studio*, 2.8 (1893).
68. Photogram, "In Memory of Gleeson White," *the Photogram* (December 1898).
69. Gleeson White, "Some Aspects of Modern Illustration," 350.
70. *Publisher's Circular*, 1495 (February 23, 1895), 205.
71. Harper, *A Practical Handbook of Drawing for Modern Methods of Reproduction*, 151.
72. Hamerton, *The Art of the American Wood-Engraver*, 20–21, 28–29. Biscombe Gardner noted that even in line work poor process either thickened or weakened the lines in the original. W. Biscombe Gardner, "The Present and Future of Wood Engraving," *Magazine of Art* (1895–1896).
73. McCauley, *Industrial Madness*, 294.
74. Frank Weitenkampf, "The Significance of Process," *Process Photogram* (June 1907), 126.
75. H. W. Bromhead, "Some Contemporary Illustrators," *The Art Journal* (1898), 270, 303, 304.
76. Verfasser, *The Halftone Process*, 372.
77. Gamble, *Modern Illustration Processes: An Introductory Textbook for All Students of Printing Methods*, 87, viii.

78. Bullock, "British Pen Drawings," 16.
79. LeMahieu, *A Culture for Democracy: Mass Communication and the Cultivated Mind in Britain between the Wars*, 69.
80. For an early discussion of this see Simon Esterson, "Could This be the Death of the Dot?," *Eye*, 1994. The halftone dot is now no longer a technical necessity but an aesthetic choice, available as a PhotoShop filter. Ellen Lupton traces the ways in which, during the early decades of the 20th century, avant-garde designers highlighted and imitated the methods of mechanical production in a modernist celebration of the new printing technologies. "Design and Production in the Mechanical Age," *Graphic Design in the Mechanical Age: Selections from the Merrill C. Berman Collection*. Ed. Deborah Rothschild, Ellen Lupton, and Darra Goldstein (New Haven: Yale University Press, 1998), 50–81.
81. Even the commercial wood-engraving trade survived through the 1920s as it produced images in mail order cataloguess. The woodcut produced finer images than the process block on the thin papers that had to be used for these bulky items. See Davis, *Art and Work: A Social History of Labour in the Canadian Graphic Arts Industry to the 1940s*.
82. Joyce, *The Rule of Freedom: Liberalism and the Modern City*, 201.
83. Chalaby, *The Invention of Journalism*, 190–91.
84. Shorter, *C.K.S. An Autobiography: A Fragment by Himself*, 79–80.

Bibliography

Victorian periodicals and journals

Amateur Photographer
Art Journal
Black and White Budget
British and Colonial Printer and Stationer
British Printer
The Idler
Illustrated London News
Inland Printer
Journal of the Camera Club
Journal of the Society of Arts
The King
The Magazine of Art
Newspaper Owner and Manager
Penrose Annual: The Process Work Year Book
Photogram
Photographic Journal
Photographic News
Printers' Register
Printing Times and Lithographer
Printing World
Process Photogram
Process Work and Electrotyping
Process Work and the Printer
Publishers' Circular
Sketch
Sphere

Books and journal articles

Alexandre, Arsene. M. H. Spielmann, H. C. Bunner and August Jaccaci. *The Modern Poster*. New York: Scribner, 1895.

Altick, Richard. *The English Common Reader: A Social History of the Mass Reading Public, 1800–1900*. Chicago: University of Chicago Press, 1957.

——. *The Presence of the Present: Topics of the Day in the Victorian Novel*. Columbus: Ohio University Press, 1991.

Anderson, Benedict. *Imagined Communities: Reflections on the Origin and Spread of Nationalism*. London: Verso, 1983.

Anderson, Patricia. *The Printed Image and the Transformation of Popular Culture, 1790–1860*. Oxford: Oxford University Press, 1991.

Anon. "A Notable Process Engraver–Mr. Carl Hentschel," *Printing World*. 5.6 (1897): 132–133.

——. "A Wonderful Invention: The Cinematographe of M. Lumiere," *Sketch*. 13.164 (March 18 1896): 323.

——. "An American Opinion," *Process Photogram*. 2.1 (1895): 52.
——. "An Apostle of the Grotesque," *Sketch*. 9.115 (April 10 1895): 561–562.
——. "Art Gossip and Reviews," *Art Journal*. NS (1892): 383–384.
——. "Art Notes," *Art Journal*. NS 48 (1896): 31–62.
——. "At the Sign of King Lud," *Process Photogram*. 8.86 (1901): 5.
——. "Behind the Scenes at the Lyceum," *Sketch*. 8.103 (January 16 1895): 548.
——. "Blackburn's Academy Notes," *Art Journal*. NS 45 (1893): 252.
——. " 'Bon Voyage' to Phil May: A Chat with the Popular Artist," *Sketch*. 1.9 (March 29 1893): 552.
——. "Camera Club Conference," *Journal of the Camera Club*. 5 (1891): 73.
——. "Commercial Marvels of Photography: The Illustration Process," *Photogram*. 13.147 (1906): 85–88.
——. "Disen-Chant-Ed," *Sketch*. 12.114 (October 30 1895): 6.
——. "Editorial," *Publishers' Circular: Newspaper, Magazine and Periodical Supplement*. 9 (June 15 1895): 4
——. "Editorial," *Under the Union Jack*. 3.37 (July 21 1900): 3.
——. "Fac-Simile Reproduction: Views of Another Art-Editor and a Practical Process Worker," *Process Photogram*. 8.89 (1901): 68–70.
——. "Fine Etching for Women," *Process Photogram*. 4.39 (1897): 10–11.
——. "Flat-Catchers," *Process Photogram*. 2.14 (1895): 23.
——. "In Memory of Gleeson White." *Photogram*. 5.60 (1898): 371–374.
——. "Is the Public Taste in Literature Correct?," *The Idler*. 10.4 (November 1896): 560–567.
——. "Journals and Journalists of Today XL: Mr. Clifford Weblyn and 'The Illustrated Sporting and Dramatic News'," *Sketch*. 10.121 (May 22 1895): 205–206.
——. "Journals and Journalists of Today, Messrs Girdlestone, Raven Hill and Pick Me Up," *Sketch*. 9.114 (April 3 1895): 527.
——. "Little Eyolf," *Sketch*. 16.197 (December 2 1896): 213.
——. "Max Levy and His Work," *Process Photogram* 3.25 (January 1896): 10.
——. "Modern Illustration." *Process Photogram*. 8.86 (February 1901): 25–26.
——. "Mr. Justice Kekewich on Art Journalism," *Sketch*. 17.218 (March 31 1897): 417.
——. "Mr. Marks and the Editorial Parasite," *Sketch*. 9.105 (January 30 1895): 45.
——. "Newspaper Pictures," *The Nation*. 56.1452 (April, 1893): 306–307.
——. "Obtaining Portraits for Papers," *Photographic News*. XXIX.1396 (June 5 1895): 368.
——. "Our First Word," *Sketch*. 1.1 (February 1 1893): 3.
——. "Our Leading Newsagents Number 1: Mr. T. Kitchenside, Brixton," *Publishers' Circular Newspaper, Magazine and Periodical Supplement*. Issue 3, March 23, 1895.
——. "Out-of-the-Way Interviews: 1. A Flower-Girl," *Sketch*. 3.36 (October 4 1893): 515–516.
——. "Phil May's Illustrated Winter Annual," *Magazine of Art*. 20 (1896–1897): 287.
——. "Pictorial Advertisement," *Sketch*. 13.166 (April 1 1896): 436.
——. "Pictorial Reproduction Up-to-Date," *The British Printer*. (1900): 223–231.
——. "Pierrot: An Interview with Mdlle, Jane May," *Illustrated London News*. 98.2715 (May 2 1891): 567.
——. "Preface to Volume 1, 1842," *Illustrated London News*. (January 6 1843): iii, iv.
——. "Process," *Photogram*. 7 (1894): 171–172.
——. "Prominent Pressmen 4: Clement King Shorter," *Printers' Register Supplement*. (September 6 1892): 41.
——. "Reaction Against Glazed Printing Paper," *Process Photogram*. 7 (September 1900): 130.

——. "Red Prints for the Draughtsman," *Amateur Photographer*. 2.49 (September 11 1885): 364.

——. "Reinhold Thiele: A Man of Genius and Enterprise," *Photogram*. 6.72 (1899): 356–360.

——. "Reviews of Recent Publications," *Studio*. 9.45 (December 1896): 215–216.

——. "Reviews of Recent Publications: The Alhambra," *Studio*. 10.47 (February, 1897): 63–64.

——. "The All-Round Man," *Process Work and the Printer*. 4.39 (August 1896): 103.

——. "The Art Magazines," *Illustrated London News*. 98.2717 (May 16 1891): 662.

——. "The Art of the Day," *Sketch*. 10.123 (June 5 1895): 307.

——. "The Art of the Day: Certain Summaries of Victorian Art," *Sketch*. 20.259 (January 12 1898): 477.

——. "The Birmingham Municipal School of Art," *Studio*. 2.8 (November 1893): 90–98.

——. "The Encroachment of the Advertisement," *Process Work and the Printer*. 6 (1897): 106.

——. "The Future," *Process Photogram*. 2.1 (February 1895): 13.

——. "The Illustrated London News," *Publisher's Circular Newspaper, Magazine and Periodical Supplement*. 9 (June 1895): 4–5.

——. "The Illustrated Papers and Copyright Photographs," *British Journal of Photography*. 40.1750 (November 1893): 732.

——. "The Late Mr. J. L. Latey," *Illustrated London News*. 98.2699 (January 10 1891): 38.

——. "The Life and Genius of the Late Phil May," *Studio*. 29.126 (1903): 280–287.

——. "The Manufacture of Bolted and Amalgamated Wood Blocks," *British and Colonial Printer and Stationer*. 14.7 (February 12 1885): 102.

——. "The Monotype," *Sketch*. 19.247 (October 20 1897): 548.

——. "The Royal Academy," *Sketch*. 10.120 (May 15 1895): 138.

——. "The Truth About the Yellow Book," *Sketch*. 9.108 (February 20 1895): 166.

——. "The Use and Abuse of Illustration," *Process Worker and the Printer*. 4.39 (August 1896): 121.

——. "Those Wicked Posters," *Printing World*. 5.1 (January 1897): 242.

——. "Up-To-Date Journalism," *Process Work and the Printer*. 4.40 (September 1896): 148.

——. "What London Reads," *Sketch Literary Supplement*. 12.149 (December 4 1895): 8–10.

——. "What the 'Yellow Book' is to be: Some Meditations with Its Editors," *Sketch*. 5.63 (April 11 1894): 557–8.

——. *Illustrated London News Her Majesty's Glorious Jubilee 1897: The Record Number of a Record Reign*. St. Albans: Oxford Smith and Co., 1897.

Archer, William. *The Theatrical "World."* London: W. Scott, 1896.

Armour, Margaret. "Aubrey Beardsley and the Decadents," *Magazine of Art*. 20 (November 1896): 9–12.

Ashbee, Charles. *Caricature*. London: Chapman and Hall, 1928.

Austin, L. F. "At Random," *Sketch*. 19.236 (August 4 1897): 56.

——. "Impressions of Paris," *Sketch*. 9.108 (February 20 1895): 164.

Baas, Jaquelynne. "Reconsidering Walter Benjamin: 'the Age of Mechanical Reproduction' in Retrospect." *The Documented Image: Visions in Art History*. ed. Gabriel P. Weisberg. Syracuse: Syracuse University Press, 1987.

Bailey, Peter. " 'Naughty but Nice': Musical Comedy and the Rhetoric of the Girl, 1892–1914." *The Edwardian Theatre*. eds Michael R. Booth and Joel H. Kaplan. Cambridge: Cambridge University Press, 1996.

———. *Popular Culture and Performance in the Victorian City.* Cambridge: Cambridge University Press, 1998.

Baker, Alfred. *The Newspaper World: Essays on Press History and Work Past and Present.* London: Issac Pitman and Sons, 1890.

Baldry, A. L. "The Future of Wood Engraving," *Studio.* 14.63 (June 1898): 10–16.

Bale, Edwin. "Mr. Timothy Cole and American Wood Engraving," *The Magazine of Art.* 16 (1893): 138–39.

Bann, Stephen. *Parallel Lines: Printmakers, Painters and Photographers in Nineteenth-Century France.* New Haven: Yale University Press, 2001.

Barstow, Susan Torrey. "Hedda Is All of Us: Late-Victorian Women at the Matinee," *Victorian Studies.* 43.3 (2001): 387–411.

Barthes, Roland. "The Photographic Message." *Image – Music – Text.* 1964. ed. Stephen Heath. London: Fontana/Collins, 1977.

Bartlett, George Hartnell. *Pen and Ink Drawing.* Boston: Riverside Press, 1903.

Baudelaire, Charles. "The Painter of Modern Life." *The Painter of Modern Life and Other Essays.* ed. Jonathan Mayne. London: Phaidon, 1965.

Beetham, Margaret. *A Magazine of Her Own?* London: Routledge, 1996.

———. "The Sixpenny Reading Public in the 1890s." *Nineteenth-Century Media and the Construction of Identities.* ed. Laurel Brake. Basingstoke: Palgrave, 2000.

Bell, James. "Pictures and Print," *Good Words.* 33.52 (November 1892): 249–252.

Benjamin, Walter. "Daguerre or the Dioramas." *Charles Baudelaire: A Lyric Poet in the Era of High Capitalism.* London: New Left Books, 1973.

Bhabha, Homi. *The Location of Culture.* London: Routledge, 1994.

Bierce, C. S. "The Executive or Office Department," *Process Photogram.* 4.43 (July 1897): 99–101.

———. "Notes on Process Matters in the USA," *Process Photogram.* 7.75 (March 1900): 43–45.

Biscombe Gardner, W. "The Present and Future of Wood Engraving," *Magazine of Art.* 19 (1895): 7–63.

Blackburn, Henry. *The Art of Illustration.* London: W. H. Allen, 1894.

———. *The Art of Illustration.* 2nd ed. Edinburgh: John Grant, 1901.

Bogart, Michele H. *Advertising, Artists and the Borders of Art.* Chicago: University of Chicago Press, 1995.

Boorstin, Daniel. *The Image: Or, What Happened to the American Dream.* New York: Atheneum, 1961.

Booth, Charles. *Life and Labour of the People in London.* London: Macmillan, 1903.

Booth, Michael. *Theatre in the Victorian Age.* Cambridge: Cambridge University Press, 1991.

Bowlby, Rachel. *Just Looking: Consumer Culture in Dreiser, Gissing and Zola.* New York: Methuen, 1985.

Brimblecombe, Peter. *The Big Smoke: A History of Air Pollution in London since Medieval Times.* London: Methuen, 1987.

Bromhead, H. W. "Some Contemporary Illustrators: Max Cowper, Stephen Reid, Claude Shepperson," *Art Journal.* NS 60 (1898): 268–272.

Brown, H. Lamont. "Engraved Half Tones," *Penrose Annual.* London: A. W. Penrose Co., 1896.

———. "Facts Versus Art," *Penrose Annual.* London: Lund Humphries, 1898.

Brown, Joshua. *Beyond the Lines: Pictorial Reporting, Everyday Life, and the Crisis of Gilded Age America.* Berkeley: University of California Press, 2002.

Brown, William Norman. *A Practical Manual of Wood Engraving, with a Brief Account of the History of the Art.* London: Lockwood, 1886.

Bullock, J. M. "Charles Dana Gibson," *Studio.* 8.40 (July 1896): 75–80.
——. "The Nether World and Mr. Phil May: The Upper World and Mr. C. D. Gibson," *Sketch.* 16.200 (November 25 1896): 190–91.
——. "British Pen Drawings," *Modern Pen Drawings: European and American.* ed. Charles Holme London: Studio, 1901.
Burgin, Victor. "Looking at Photographs," *Thinking Photography.* ed. Victor Burgin London: Macmillan, 1982.
Calder, Jenni. *The Victorian Home.* London: Batsford, 1977.
Campbell, Kate. "Journalistic Discourses and Constructions of Modern Knowledge." *Nineteenth-Century Media and the Construction of Identities.* ed. Laurel Brake. Basingstoke: Palgrave, 2000.
Cannadine, David. "The Context, Performance and Meaning of Ritual: The British Monarchy and the 'Invention of Tradition,' c. 1820–1977." *The Invention of Tradition.* eds Eric Hobsbawm and Terence Ranger. Cambridge: Cambridge University Press, 1983.
Cannon, Rupert. "Of Dragon's Blood and Bolt Court," *Penrose Annual 1981.* London: Northwood, 1981.
Carey, John. *The Intellectuals and the Masses: Pride and Prejudice among the Literary Intelligentsia, 1880–1939.* London: Faber and Faber, 1992.
Carlebach, Michael L. *The Origins of Photojournalism in America.* Washington: Smithsonian Institution Press, 1992.
——. *American Photojournalism Comes of Age.* Washington: Smithsonian Institution Press, 1997.
Carr, J. Comyns. "Book Illustration Old and New," *Journal of the Society of Arts.* 30.1560, 1561 (October 1882): 1035–1040, 1045–1053.
Cate, Phillip Dennis. "Printing in France: 1850–1900, The Artist and New Technologies." *The Gazette of the Grolier Club.* 28/29 (1978): 57–73.
Cevasco, G. A. *The 1890s: An Encyclopaedia of British Literature, Art and Culture.* New York: Garland, 1993.
Chalaby, Jean K. *The Invention of Journalism.* Basingstoke: Macmillan Press, 1998.
Chanan, Michael. *The Dream That Kicks: The Prehistory and Early Years of Cinema in Britain.* 2nd ed. London: Routledge, 1996.
Chatto, William and John Jackson. *A Treatise on Wood Engraving, Historical and Practical.* London: Charles Knight, 1839.
Cheshire, W. "On the Touching of Half-Tone Process Blocks," *Photographic Journal.* NS 20.7 (March 1896): 181–186.
Chu, Petra ten-Doesschate. "Into the Modern Era: The Evolution of Realist and Naturalist Drawing," *The Realist Tradition: French Painting and Drawing 1830–1900,* ed. Gabriel P. Weisberg. Cleveland: Cleveland Museum of Art, 1980.
Clair, Colin. *A History of Printing in Britain.* New York: Oxford University Press, 1966.
Codell, Julie F. "Constructing the Victorian Artist: National Identity, the Political Economy of Art and Biographical Mania in the Perodical Press." *Victorian Periodicals Review.* 33.3 (2000): 283–316.
Cohen, Margaret. "Panoramic Literature and the Invention of Everyday Genres." *Cinema and the Invention of Modern Life.* eds Leo Charney and Vanessa R. Schwartz. Berkeley: University of California Press, 1995.
Colebrook, Frank. "A Palace of Paradox: A Morning Call at Maybury Studios," *Process Work and Electrotyping.* 7 N.S. (August 1904): 4.
——. "American and English Plate Making," *Process Photogram.* 9.108 (December 1902): 179–182.

——. "The Honorary Block-Maker," *Process Work Year Book*. London: A. W. Penrose and Co., 1900.

Comfort, Arthur. "Letter from Arthur Comfort (Hon. Chairman of the International Society of Wood Engravers)," *Studio*. 14.65 (August 1898): 195.

Compton, Roy. "Canine and Sublime: A Chat with Mr. Louis Wain," *The Idler*. 8.48 (January, 1896): 550–555.

——. "Half and Hour with Mr. Fred Pegram," *The Idler*. 11.5 (June, 1897): 672–683.

Conboy, Martin. *The Press and Popular Culture*. London: Sage, 2002.

Conrad, Peter. *The Victorian Treasure-House*. London: Collins, 1973.

Crane, Walter. "Modern Life and the Artistic Sense." *Cosmopolitan*. 13.2 (June 1892): 152–56.

——. *On the Decorative Illustration of Books Old and New*. London: G. Bell, 1896.

——. *The Bases of Design*. London: Bell, 1898.

——. *Line and Form*. London: George Bell and Sons, 1900.

——. *An Artist's Reminiscences*. London: Methuen and Co., 1907.

——. "Modern Aspects of Life and the Sense of Beauty." *William Morris to Whistler*. ed. Walter Crane. London: G. Bell and Sons, 1911.

Crossick, Geoffrey. "The Emergence of the Lower Middle Classes in Britain," *The Lower Middle Class in Britain 1870–1914*, ed. Geoffrey Crossick London: Croom Helm, 1977.

Crowdy, Wallace L. "Process Reproduction from an Editor's Point of View," *Photographic Journal*. NS 22.7 (March 1898): 211.

Dalziel, G. and E. Dalziel. *The Brothers Dalziel: A Record of Fifty Years' Work, in Conjunction with Many of the Most Distinguished Artists of the Day*. London: Methuen and Co., 1901.

Damon-Moore, Helen. *Magazines for the Millions: Gender and Commerce in the "Ladies Home Journal" and the "Saturday Evening Post"*. Albany, NY: State University of New York Press, 1994.

David, Vincent. *Literacy and Popular Culture*. Cambridge: Cambridge University Press, 1989.

Davis, Angela E. *Art and Work: A Social History of Labour in the Canadian Graphic Arts Industry to the 1940s*. Montreal: McGill-Queen's University Press, 1995.

Davis, J. "How the Captain is Printed," *The Captain*. 4 (1901): 397.

De Freitas, Leo John. "Commercial Engraving on Wood in England 1700–1880: An Economical Art." London: Ph.D Thesis, Royal College of Art, 1986.

De Weese, Trueman A. "The Magazine in National Advertising," *The Library of Advertising*. vol. 1. ed. A. P. Johnson. Chicago: Cree, 1911.

Delaborde, Henri. *Engraving: Its Origins, Processes and History*. London: Cassell, 1886.

Dicey, Edward. "Journalism Old and New," *Fortnightly Review*. 83, (1905): 904–918.

Dobraszczyk, Paul. "Sewers, Wood Engraving and the Sublime: Picturing London's Main Drainage System in the Illustrated London News, 1859–62." *Victorian Periodical Review*. 38.4 (2005): 349–378.

du Maurier, George. "The Illustrating of Books: From the Serious Artist's Point of View," *Magazine of Art*. 13 (August 1890): 349–353.

Dunstan, Bernard. *Painting Methods of the Impressionists*. London: Pitman, 1976.

Durand, Régis. "How to See (Photographically)." *Fugitive Images*. ed. Patrice Petro. Bloomington: Indiana University Press, 1995.

Eddington, W. C. "Successful Half-Tone Illustration," *Photographic Journal*. NS 21.4 (December 1896): 81–87.

Editor, "Commercial and Press Photography," *Penrose Annual 1903–4*. London: Lund Humphries, 1903–1904.

——. "Fac-sim by an Art Editor," *Process Photogram*. 8.88 (April 1901): 52–54.

——. "Photographic Engraving and the Work of Mr. Frederic Ives," *The British Printer*. 7 (1894): 65–68.

——. "The Vile Process," *Process Work*. 5.53 (October 1897): 144.

Editorial. "Photographic Versus Hand Engraving," *British Journal of Photography*. 38 (April 1891): 224–225.

——. "The Illustrated Press and Photography," *British Journal of Photography*. 42 (June 1895): 387.

Edwards, Elizabeth and Janice Hart. "Introduction: Photographs as Objects." *Photographs Objects Histories: On the Materiality of Images*. eds Elizabeth Edwards and Janice Hart. London: Routledge, 2004.

Elliot, Bridget, J. "Sights of Pleasure: Beardsley's Images of Actresses and the New Journalism of the Nineties." *Reconsidering Aubrey Beardsley*. ed. Robert Langenfeld. Ann Arbor: UMI Research Press, 1989.

Elliot, Thomas W. "Wood Versus Photo-Engraving," *Inland Printer*. 6.8 (May 1889): 645–647, 829–832.

Engen, Rodney. *Pre-Raphaelite Prints*. London: Lund Humphries, 1995.

English, Donald E. *Political Uses of Photography in the Third French Republic, 1871–1914*. Ann Arbor: UMI Research Press, 1984.

Emanuel, Frank L. *The Illustrators of Montmartre*. New York: Charles Scribner's Sons, 1906.

Escott, T. H. S. *Social Transformations of the Victorian Age: A Survey of Court and Country*. London: Seeley and Co., 1897.

——. "The Past, Present and Future of the Middle Classes," *Fortnightly Review*. NS 88 (1907): 109–121.

Esterson, Simon. "Could This be the Death of the Dot?," *Eye*. 14 (1994): 87–88.

Fairbairns, W. H. "On Retouching," *The Process Year Book*. ed. William Gamble. London: A. W. Penrose and Co., 1901.

Fawcett, Trevor. "Graphic Versus Photographic in Nineteenth Century Reproduction." *Art History*. 9.2 (1986): 185–211.

Fawcett, Trevor and Clive Phillpot. *The Art Press: Two Centuries of Art Magazines*. London: The Art Book Company, 1976.

Faxon, Alicia Craig. "D. G. Rosetti's Use of Photography," *History of Photography*. 16.3 (1992): 254–262.

Feltes, N. N. *Modes of Production of Victorian Novels*. Chicago: University of Chicago Press, 1986.

Fildes, Paul. "Phototransfer of Drawings in Wood-Block Engraving," *Journal of the Printing Historical Society*. 5 (1969): 87–97.

Finnegan, Cara. "Doing Rhetorical History of the Visual: The Photograph and the Archive," *Defining Visual Rhetorics*. eds C. Hill and M. Helmers. Manwah, NJ: Lawrence, 2003.

Fiske, John. "Popular Discrimination." *Modernity and Mass Culture*. eds James Naremore and Patrick Brantlinger. Bloomington: Indiana University Press, 1991.

Fox Bourne, H. R. *English Newspapers: Chapters in the History of Journalism*. London: Russell and Russell, 1887.

Fraipont, G. *The Art of Making and Using Sketches*. London: Cassell and Co., 1892.

Franklyn, Julian. *The Cockney*. London: Andre Deutsch, 1953.

Fraser, Hilary. "Gender, Commodity and the Late Victorian Periodical." *Gender and the Victorian Periodical*. eds Hilary Fraser, Stephanie Green and Judith Johnston. Cambridge: Cambridge University Press, 2003.

Friederichs, Hulda. *The Life of Sir George Newnes Bart.* London: Hodder and Stoughton, 1911.

Fuller, S. E. *A Manual of Instruction in the Art of Wood Engraving.* Boston: J. Watson, 1867.

Fyfe, Gordon J. "Art and Its Objects: William Ivins and the Reproduction of Art." *Picturing Power: Visual Depiction and Social Relations.* eds Gordon Fyfe and John Law. London: Routledge, 1988.

——. "Art and Reproduction: Some Aspects of the Relations between Painters and Engravers in London 1760–1850." *Design and Aesthetics: A Reader.* eds Jerry Palmer and Mo Dodson. London: Routledge, 1996.

Gamble, Charles. *Modern Illustration Processes: An Introductory Textbook for All Students of Printing Methods.* London: Sir Issac Pitman & Sons, Ltd., 1933.

Gamble, William. "Halftones in 'News' Printing," *Process Photogram and Illustrator.* 12.136 (August 1905): 138–9.

——. "Newspaper Portraits," *Process Work.* 6 (1898): 2–30.

——. "The History of the Halftone Dot," *Photographic Journal.* NS 21.6 (February 20 1897): 126–136.

——. "Process in Magazine and Book Illustration," *Penrose.* ed. William. Gamble London: A. W. Penrose and Co., 1897.

——. "Straight Talks to Practical Men VI. Keeping Time," *Penrose and Co.'s Monthly Circular Process Work.* NS 6 (September 1899): 1–2.

Garb, Tamar. *Bodies of Modernity: Figure and Flesh in Fin-De-Sièclè France.* London: Thames and Hudson, 1998.

Garrigan, Kristine Ottesen. " 'The Splendidest May Number of the Graphic': John Ruskin and the Royal Academy Exhibition of 1875." *Victorian Periodical Review.* 24 (1991).

Gernsheim, Helmut. *The History of Photography.* London: Thames and Hudson, 1968.

Gilks, T. *The Art of Wood-Engraving: A Practical Handbook.* London: Winsor and Newton, 1866.

Gleeson White, Joseph. "Afternoons in Studios: A Chat with Mr. G. H. Boughton, A.R.A.," *Studio.* 3.17 (1894): 131–136.

——. "At the Sign of the Dial: Mr. Ricketts as a Book-Builder," *Magazine of Art.* 20 (April 1897): 304–309.

——. "Drawing for Reproduction." *Practical Designing.* ed. J. Gleeson White. London: George Bell and Sons, 1897.

——. *English Illustration "the Sixties:" 1855–70.* London: Archibald Constable and Co., 1897.

——. "Mr. Christopher Dean, Designer and Illustrator," *Studio.* 12.57 (December 1897): 183–187.

——. "New Publications," *Studio.* 2.10 (January 1894): 143–46.

——. "Photographic Portraiture: An Interview with Mr. H. H. Hay Cameron," *Studio.* 2.8 (November 1893): 84–89.

——. "Some Aspects of Modern Illustration," *Photographic Journal.* NS 19.11 (January 1895): 350–353.

——. "The Editor's Room. New Publications," *Studio.* 4 (1895): xix, xxxi.

——. "The Lay Figure at Home," *Studio.* 3 (1894): xxii.

——. "The Lay Figure Speaks," *Studio.* 1.7 (October 1893): 76.

——. "The National Competition: South Kensington," *Studio.* 8.42 (1896): 224–237.

——. "The Taste for Trifles," *Studio.* 2.10 (January 1894): 131.

Goodbody, John. "*The Star*: Its Role in the New Journalism." *Victorian Periodical Review.* 20.4 (1987): 141–150.

Green-Lewis, Jennifer. *Framing the Victorians*. Ithaca: Cornell University Press, 1996.

Greenslade, William. *Degeneration, Culture and the Novel, 1880–1940*. Cambridge: Cambridge University Press, 1994.

Gretton, Tom. "Signs for Labour-Value in Printed Pictures after the Photomechanical Revolution: Mainstream Changes and Extreme Cases around 1900." *Oxford Art Journal*. 28.3 (2005): 371–190.

Gribayédoff, Valerian. "Pictorial Journalism," *The Cosmopolitan*. 11.4 (August 1891): 471–481.

Groves, J. B. "Rambling Recollections and Modern Thoughts by an Old Engraver." Manuscript. London: Punch Archive, n.d.

Hall, James. *With Pen and Ink*. New York: Prang, 1913.

Hamber, Anthony J. *A Higher Branch of the Art: Photographing the Fine Arts in England 1839–1880*. Amsterdam: Gordon and Breach, 1996.

Hamerton, P. G. *The Graphic Arts: A Treatise on the Varieties of Drawing, Painting and Engraving in Comparison with Each Other and with Nature*. London: Seeley, Jackson and Halliday, 1882.

——. *Drawing and Engraving: A Brief Exposition of Technical Principles and Practice*. London: Adam and Charles Black, 1892.

——. *The Art of the American Wood-Engraver*. New York: Charles Scribner's Sons, 1894.

Hammond, Anne Kelsey. "Aesthetic Aspects of the Photomechanical Print." *British Photography in the Nineteenth Century: The Fine Art Tradition*. ed. Mike Weaver. Cambridge: Cambridge University Press, 1989.

Hampton, Mark. *Visions of the Press in Britain, 1850–1950*. Urbana: University of Illinois Press, 2004.

Hannoosh, Michele. *Baudelaire and Caricature*. University Park: Penn State University Press, 1992.

Harland, J. Whitfield. "The Prospects of Wood Engraving," *Printing Times and Lithographer*. 1.1 (July 1892): 41–42.

Harper, Charles G. *English Pen Artists of To-Day: Examples of Their Work with Some Criticisms and Appreciations*. London: Percival and Co., 1892.

——. *A Practical Handbook of Drawing for Modern Methods of Reproduction*. London: Chapman and Hall, 1894.

Harris, Neil. "Iconography and Intellectual History: The Halftone Effect." *Cultural Excursions*. Chicago: University of Chicago Press, 1990.

——. "Pictorial Perils: The Rise of American Illustration." *Cultural Excursions*. Chicago: University of Chicago Press, 1990.

Hartrick, A. S. *A Painter's Pilgrimage through Fifty Years*. London: Cambridge University Press, 1939.

Hatton, Joseph. *Journalistic London*. London: S. Low, Marston, Searle, & Rivington, 1882.

Heaton, Eliza Putnam. "Woman and the Camera," *British Journal of Photography*. 38 (January 1892): 8–9.

Henisch, Heinz K and Bridget A. Henisch. *The Photographic Experience 1839–1914: Images and Attitudes*. University Park: Pennsylvania State University Press, 1994.

Hentschel, Carl. "Process Engraving," *Journal of the Society of Arts*. 49.2474 (April 20 1900): 463–474.

——. "A Process Autobiography," *Photogram*. 12.137 (November 1905): 174–175.

Hepworth, T. C. "How to Make Pen and Ink Drawings for Process Work," *British Journal of Photography*. 40 (January 6 1893): 5–6.

——. *The Camera and the Pen*. Bradford: Percy Lund, 1897.

Herbert, Robert L. *Impressionism: Art, Leisure, and Parisian Society*. New Haven: Yale University Press, 1988.

Herkomer, Prof. Hubert. "The Position of Wood Engraving," *Printing Times and Lithographer*. (May 1894): 121–122.

Hewitt, Martin. *The Emergence of Stability in the Industrial City: Manchester, 1932–67*. Aldershot: Scolar Press, 1996.

Hill, L. Raven. "An Artist's Opinion on Drawing for Reproduction," *Studio*. 1.2 (May 1893): 69.

Himmelfarb, Gertrude. *The Idea of Poverty: England in the Early Industrial Age*. New York: Knopf, 1983.

Hinners, William A. "Re-Engraving of Half-Tones," *Inland Printer*. 26.1 (October, 1900): 64–65.

Hobsbawm, Eric. *Industry and Empire: The Making of Modern English Society from 1750 to the Present Day*. New York: Pantheon, 1968.

Hobsbawm, Eric and Terence Ranger. *The Invention of Tradition*. Cambridge: Cambridge University Press, 1983.

Hodson, James Shirley. *A Historical and Practical Guide to Art Illustration in Connection with Books, Periodicals and General Decoration*. London: Sampson Low, 1884.

Hollander, Anne. *Moving Pictures*. Cambridge, MA: Harvard University Press, 1986.

Holme, Frank. "The Training of an Illustrator," *British and Colonial Printer*. 45.7 (August 1899): 10.

Horgan, S. H. "Photography and the Newspapers," *Photographic News*. 38.1348 (1884): 427–428.

——. "To Avoid the 'Screeny Effect' in Half Tone Work," *Penrose 1896*. London: Lund Humphries, 1896.

Horsley, Hinton, A. "Photography for Illustration," *Photogram*. 1.9–10 (September–October 1894): 205, 234.

Houfe, Simon. *Phil May: His Life and Work 1864–1903*. Aldershot: Ashgate, 2002.

Howe, Ellic. *Newspaper Printing in the Nineteenth Century*. London: Printed Privately, 1943.

——. *The London Compositor*. London: The Bibliographical Society, 1947.

Huish, Marcus. "Birket Foster: His Life and Work," *The Art Annual*. London: J. S. Virtue, 1890.

Hungerford, Constance Cain. "Charles Marville, Popular Illustrator: The Origins of a Photographic Sensibility," *History of Photography*. 9.3 (1985): 227–246.

Hunt, W. S. "Concerning Some Punch Artists," *Magazine of Art*. 14 (1890): 296–297.

Ives, Frederick E. *The Autobiography of an Amateur Inventor*. Philadelphia: Privately published, 1928.

Ivins, William. *How Prints Look*. New York: Metropolitan Museum of Art, 1943.

——. *Prints and Visual Communication*. London: Routledge, 1953.

Jackson, Holbrooke. *The Eighteen Nineties*. ed. Christopher Campos. Brighton: Harvester Press, 1976.

Jackson, Holbrooke. *The Eighteen Nineties*. London: Grant Richards, 1913.

Jackson, Kate. *George Newnes and the New Journalism in Britain, 1880–1910: Culture and Profit*. Aldershot: Ashgate, 2001.

Jackson, Mason. *The Pictorial Press: Its Origins and Progress*. London: Hurst and Blackett, 1885.

Jackson, Mason. "The Book and Its Story: 'The Memories of Mr. W. J. Linton,'" *Sketch*. 9.115 (April 10 1895): 570.

Jaffe, Erwin. *Halftone Photography for Offset Lithography*. New York: Lithographic Technical Foundation, 1960.

Jäger, Jens. "Discourses on Photography in Mid-Victorian Britain." *History of Photography*. 19.4 (1995): 316–321.

Janzen Kooistra, Lorraine. *Christina Rossetti and Illustration*. Athens Ohio: Ohio University Press, 2002.

Jay, Bill. *Victorian Candid Camera*. Newton Abbot: David and Charles, 1973.

Jay, Martin. *Downcast Eyes: The Denigration of Vision in Twentieth-Century French Thought*. Berkeley: University of California Press, 1993.

Jenkins, Will. "Illustration of the Daily Press in America," *Studio*. 25–26, 110–114 (May, September 1902): 254–261, 281–287.

Jerome, Jerome K. *My Life and Times*. London and New York: Harper Brothers, 1926.

Jerome, Jerome K. "To the Reader of the Idler," *The Idler*. 8.43 (August 1895): 97–100.

Johannesson, Lena. *Pictures as News, News as Pictures: A Survey of Mass-Reproduced Images in 19th Century Sweden*. Uppsala: Acta Universitatis Upsaliensis, 1984.

Jones, Gareth Steadman. *Outcast London*. Oxford: Clarendon Press, 1971.

Jones, Gareth Stedman. "The 'Cockney' and the Nation." *London: Metropolis*. eds David Feldman and Gareth Stedman Jones. London: Routledge, 1989.

Joyce, Patrick. *Democratic Subjects: The Self and the Social in Nineteenth-Century England*. Cambridge: Cambridge University Press, 1994.

——. *The Rule of Freedom: Liberalism and the Modern City*. London: Verso, 2003.

Jussim, Estelle. *Visual Communication and the Graphic Arts: Photographic Technologies in the Nineteenth Century*. New York: Bowker, 1974.

——. "The Tyranny of the Pictorial: American Photojournalism from 1880 to 1920." *Eyes of Time: Photojournalism in America*. ed. Marianne Fulton. New York: New York Graphic Society, 1988.

Kaplan, Joel H. and Sheila Stowell. *Theater and Fashion: Oscar Wilde to the Suffragettes*. Cambridge: Cambridge University Press, 1994.

Keller, Ulrich F. "Photojournalism around 1900: The Institutionalization of a Mass Medium." *Shadow and Substance*. ed. Kathleen Collins. Bloomfield Hills, Michigan: Amorphous Institute, 1990.

Kent, Christopher. "Image and Reality: The Actress and Society." *A Widening Sphere: Changing Roles of Victorian Women*. ed. Martha Vicinus. Bloomington: Indiana University Press, 1977.

Kern, Stephen. *The Culture of Time and Space 1880–1918*. London: Weidenfield and Nicholson, 1983.

Kilbey, Walter. "Hand Camera Work," *Photogram*. 9.104 (August 1902): 225–228.

King, Andrew. "A Paradigm of Reading the Victorian Penny Weekly: Education of the Gaze and the London Journal." *Nineteenth-Century Media and the Construction of Identities*. ed. Laurel Brake. Basingstoke: Palgrave, 2000.

Kingsley, Elbridge. "Originality in Wood Engraving," *Century*. 38.4 (August 1889): 576–583.

Kitton, F. G. "The Art of Photo-Etching and Engraving," *British Printer*, 7.40 (July–August, 1894): 218–231.

Knight, Charles. *Passages of a Working Life During Half a Century*. vol. 3. London: Bradbury & Evans, 1865.

Koven, Seth. *Slumming: Sexual and Social Politics in Victorian London*. Princeton: Princeton University Press, 2004.

Kracauer, Siegfried. "Photography." *The Mass Ornament*. ed. Thomas Y. Levin. Cambridge, MA: Harvard University Press, 1995.

Kunzle, David. *The History of the Comic Strip: The Nineteenth Century*. Berkeley: University of California Press, 1990.

Lambert, Susan. *The Image Multiplied: Five Centuries of Printed Reproductions of Paintings and Drawings*. London: Trefoil, 1987.

Lamden, Felice Jo. "Newspaper Illustration 1890–1910," *City Life*. Illustrated: 1890–1940. Delaware: Delaware Art Museum, 1980.

Lawler, Wallace. "Romance in Black and White: A Chat with Mr. H. Miller," *The Idler*. 8.45 (October 1895): 228–236.

Lawrence Arthur, H. "Mr. Phil May at Home," *The Idler*. 10.5 (December 1896): 632–648.

Lears, Jackson. *Fables of Abundance: A Cultural History of Advertising in America*. New York: Basic Books, 1994.

Lee, Alan J. *The Origins of the Popular Press*. London: Croom Helm, 1976.

Lee, Thos. G. *Process Photogram*. 3.26 (1896): 32.

LeMahieu, D. L. *A Culture for Democracy: Mass Communication and the Cultivated Mind in Britain between the Wars*. Oxford: Clarendon Press, 1988.

Linton, William. *Wood-Engraving a Manual of Instruction*. London: G. Bell, 1884.

Linton, William J. "Art in Engraving in Wood," *Atlantic Monthly*. 43 (June, 1879): 705–715.

Loeb, Lori Anne. *Consuming Angels: Advertising and Victorian Women*. Oxford and New York: Oxford University Press, 1994.

Lupton, Ellen. "Design and Production in the Mechanical Age," *Graphic Design in the Mechanical Age: Selections from the Merrill C. Berman Collection*. ed. Deborah Rothschild. Ellen Lupton and Darra Goldstein. New Haven: Yale Unversity Press, 1998.

Lynch, George. *Impressions of a War Correspondent*. London: George Newnes, 1903.

MacColl, D. S. "Professor Brown: Teacher and Painter," *Magazine of Art*. 17 (1894): 403–409.

Macfall, Haldane. *Aubrey Beardsley: The Man and His Work*. London: John Lane, 1928.

Maclean, Hector. *Photography for Artists*. Bradford: Percy Lund, 1896.

Macleod, Dianne Sachko. *Art and the Victorian Middle Class: Money and the Making of Cultural Identity*. New York: Cambridge University Press, 1996.

Maidment, Brian. *Reading Popular Prints, 1790–1870*. Manchester: Manchester University Press, 1996.

Marchand, Roland. *Advertising the American Dream: Making Way for Modernity, 1920–1940*. Berkeley: University of California Press, 1986.

Marien, Mary Warner. *Photography and Its Critics: A Cultural History, 1839–1900*. Cambridge: Cambridge University Press, 1997.

Martin, Paul. "Victorian Wood Engraving." Manuscript. London: Victoria and Albert Museum, Prints, Drawings and Paintings Collection, n.d.

Marx, C. W. *The Art of Drawing and Engraving on Wood*. London: Houlston and Co., 1881.

May, J. Lewis. *John Lane and the Nineties*. London: Bodley Head, 1936.

McCauley, Elizabeth Anne. *Industrial Madness: Commercial Photography in Paris 1848–1871*. New Haven: Yale University Press, 1994.

McClure, S. S. *My Autobiography*. New York: Frederick A. Stokes Company, 1914.

McGaw, Judith A. *Most Wonderful Machine: Mechanization and Social Change in Berkshire Paper Making, 1801–1885*. Princeton, NJ: Princeton University Press, 1987.

McLeod, Hugh. "White Collar Values and the Role of Religion." *The Lower Middle Class in Britain 1870–1914*. ed. Geoffrey Crossick. London: Croom Helm, 1977.

Menon, Elizabeth K. "Images of Pleasure and Vice," *Montmartre and the Making of Mass Culture*. ed. Gabriel P. Weisberg New Brunswick: Rutgers University Press, 2001.

Miller, J. Hillis. *Victorian Subjects*. Durham, NC: Duke University Press, 1991.

Mills, J. Saxona. *Life and Letters of Sir Hubert Herkomer C.V.O., R. A.: A Study in Struggle and Success*. London: Hutchinson, 1923.

Mitchell, Rosemary. *Picturing the Past: English History in Text and Image, 1830–1870*. Oxford: Clarendon Press, 2000.

Mitchell, W. J. *The Reconfigured Eye: Visual Truth in the Post-Photographic Era*. Cambridge, MA: MIT Press, 1992.

Monocle, "An Opinion of 'An Ideal Husband'," *Sketch*. 8.102 (January 9 1895): 496.

Moran, James. *Printing in the Twentieth Century*. London: The Times Printing Company, 1930.

Morgan, Ernest C. "Retouching," *British Journal of Photography*. 40 (May 1893): 280–282.

Mortimer, F. J. *Photography for the Press and Photography for Profit*, 4th ed. London: Hazell, Watson and Viney, 1914.

Mortimer, James. "A Chat with Niagara," *Sketch*. 12.146 (November 13 1895): 141–144.

Naylor, Gillian. *The Arts and Crafts Movement*. Cambridge, MA: MIT Press, 1971.

Nead, Lynda. *Victorian Babylon: People, Streets and Images in Nineteenth Century London*. New Haven: Yale University Press, 2000.

Nevett, Terry. *Advertising in Britain: A History*. London: Heinemann, 1982.

——. "Advertising and Editorial Integrity in the Nineteenth Century." *The Press in English Society from the Seventeenth to Nineteenth Centuries*. eds Michael Harris and Alan Lee. London: Associated University Presses, 1986.

Nordau, Max. *Degeneration*. Germany: 1892. 2nd ed. London: Heinemann, 1895.

Nott, Major John. "Photography and Illustrated Journalism," *British Journal of Photography*. (June 26 1891): 376–377.

Ohmann, Richard. *Selling Culture: Magazines, Markets, and Class at the Turn of the Century*. London: Verso, 1996.

Orvell, Miles. *The Real Thing: Imitation and Authenticity in American Culture, 1880–1940*. Chapel Hill: University of North Carolina Press, 1989.

Palmquist, Peter. *Camera Fiends and Kodak Girls: Fifty Selections by and About Women in Photography 1840–1930*. New York: Midmarch Arts Press, 1989.

Palmquist, Peter. *Catharine Weed Barnes Ward: Pioneer Advocate for Women in Photography*. Arcata, CA: Peter Palmquist, 1992.

Peiss, Kathy. *Cheap Amusements: Working Women and Leisure in Turn-of-the-Century New York*. Philadelphia: Temple University Press, 1986.

Penciller, Peter. "Constructive Criticism No. 12: A Word About Trimming," *Process Photogram*. 4.38 (February 1897): 49–53.

Pennell, Elizabeth. *The Life and Letters of Joseph Pennell*. vol. 1. Boston: Little Brown, 1929.

Pennell, Joseph. "A New Illustrator," *Studio*. 1.1 (April 1893): 14–18.

——. "Art and the Daily Newspaper," *Nineteenth Century*. (October 1897): 653–657.

——. *Modern Illustration*. ed. Joseph Gleeson White. London: George Bell, 1895.

——. "Photography as a Hindrance and a Help to Art," *British Journal of Photography*. 38 (1891): 294–296.

——. "The Illustration of Books," *Art Journal*. NS 47, (1895): 361–362.

——. *The Illustration of Books: A Manual for the Use of Students, Notes on a Course of Lectures at the Slade School University College*. London: T. Fisher Unwin, 1896.

Plunkett, John. *Queen Victoria: First Media Monarch*. Oxford: Oxford University Press, 2003.

Phenol, "The Combination of Line and Half-Tone," *Process Photogram*. 7.6 (1900): 50.

Plunkett, John. "Queen Victoria's Royal Role," *Encounters in the Victorian Press: Editors, Authors, Readers*. eds Laurel Brake and Julie F. Codell Basingstoke: Palgrave, 2005.

Ponce de Leon, Charles *Self-Exposure: Human-Interest Journalism and the Emergence of Celebrity in America, 1890–1940.* Chapel Hill: University of North Carolina Press, 2002.

Pollock, Griselda. "The Dangers of Proximity: The Space of Sexuality and Surveillance in Word and Image," *Discourse.* 16.2 (1993): 3–50.

Pope, Daniel. *The Making of Modern Advertising.* New York: Basic Books, 1983.

Porter, Bernard. "The Edwardians and Their Empire." *Edwardian England.* ed. Donald Read. London: Croom Helm, 1982.

Porter, Roy. "Seeing the Past," *Past and Present.* 118.1 (1988): 186–205.

Postman, Neil. *The Disappearance of Childhood.* New York: Delacorte Press, 1982.

Pritchard, H. Baden. *The Photographic Studios of Europe.* London: Piper and Carter, 1882.

Przyblyski, Jeannene M. "Moving Pictures: Photographic Narrative and the Paris Commune of 1871." *Cinema and the Invention of Modern Life.* eds Leo Charney and Vanessa R. Schwartz. Berkeley: University of California Press, 1995.

Rappaport, Erika. *Shopping for Pleasure: Women in the Making of London's West End.* Princeton, NJ: Princeton University Press, 2000.

Read, Donald. *England 1868–1914: The Age of Urban Democracy.* London: Longman, 1979.

Reade, Brian. *Aubrey Beardsley.* Woodbridge: Antique Collectors Club, 1987.

Reed, David. *The Popular Magazine in Britain and the United States, 1880–1960.* London: British Library, 1997.

Reid, J. G. *At the Sign of the Brush and Pen: Being Notes on Some Black and White Artists of Today.* London: Simpkins and Marshall, 1898.

Reid, Wemyss. Sir, "Some Reminiscences of English Journalism," *Nineteenth Century.* XLII.CCXLV, (July 1897): 55–66.

Richards, George D. "Pictorial Journalism," *The World Today.* 9 (August 1905): 845–52.

Richards, John Morgan. *With John Bull and Jonathan: Reminiscences of Sixty Years of an American's Life in England and the United States.* New York: Appleton and Company, 1906.

Richards, Thomas. *The Commodity Culture of Victorian England: Advertising and Spectacle, 1851–1914.* London: Verso, 1991.

Roberts, Helene E. *Art History through the Camera's Lens.* Amsterdam: Gordon and Breach, 1995.

Rorabaugh, W. J. *The Craft Apprentice: From Franklin to the Machine Age in America.* Oxford: Oxford University Press, 1986.

Rose, Jonathan. *The Edwardian Temperament.* Columbus: Ohio State University Press, 1986.

Rosenzweig, Roy. *Eight Hours for What We Will: Workers and Leisure in an Industrial City, 1870–1920.* Cambridge: Cambridge University Press, 1983.

Rothenstein, William. *Men and Memories: Recollections, 1872–1900.* London: Faber and Faber, 1931.

Ruskin, John. "Ariadne Florentina: Six Lectures on Wood and Metal Engraving Given before the University of Oxford at Michaelmas Term 1872." *Proserpina.* Boston: Dana Estes and Co., 1872.

——. "Notes on the Present State of Engraving in England." *Proserpina.* Boston: Dana Estes and Co., 1876.

——. *The Stones of Venice.* vol. 2. London: Smith, Elder & Co., 1853.

Salmon, Richard. "Signs of Intimacy: The Literary Celebrity in the 'Age of Interviewing'." *Victorian Literature and Culture.* eds Michael Shortland and Richard Yeo. Cambridge: Cambridge University Press, 1997.

——. " 'A Simulacrum of Power': Intimacy and Abstraction in the Rhetoric of the New Journalism." *Nineteenth-Century Media and the Construction of Identities.* ed. Laurel Brake. Basingstoke: Palgrave, 2000.

Sahlins, Marshall. "La Pensée Bourgeoise: Western Society as Culture," *Culture and Practical Reason.* Chicago: University of Chicago Press, 1976.

Sala, George. *The Life and Adventures of George Augustus Sala.* Written by Himself. New York: C. Scribner's Sons, 1895.

Schmiechen, James A. *Sweated Industries and Sweated Labour: The London Clothing Trades 1860–1914.* London: Croom Helm, 1984.

Schneer, Jonathan. *London 1900: The Imperial Metropolis.* New Haven: Yale University Press, 1999.

Schneirov, Matthew. *The Dream of a New Social Order: Popular Magazines in America, 1893–1914.* New York: Columbia University Press, 1994.

Schwartz, Joan M. "Un Beau Souvenir Du Canada." *Photographs Objects Histories: On the Materiality of Images.* eds Elizabeth Edwards and Janice Hart. London: Routledge, 2004.

Schwartz, Vanessa R. *Spectacular Realities: Early Mass Culture in Fin De Sièclè Paris.* Berkeley: University of California Press, 1998.

Sekula, Alan. "On the Invention of Photographic Meaning," *Thinking Photography.*

Sennett, Richard. *The Fall of Public Man.* Cambridge and New York: Cambridge University Press, 1976.

Seymour, Alfred. "Pictorial Expression: Chapter 5. Illustrated Journalism," *British Printer.* (1900): 290–293.

Shorter, Clement. *C.K.S. An Autobiography: A Fragment by Himself.* ed. J. M. Bullock. London: Privately Printed, 1927.

——. "Illustrated Journalism: Its Past and Future," *The Newspaper Owner and Manager.* (April 1899): 18–20, 24–26.

——. "Small Talk," *Sketch.* 9.106 (February 6 1895): 70.

——. "Small Talk." *Sketch.* 16.196 (October 28 1896): 7–13.

——. "To A Lady Who Says That "There's Nothing To Read In The 'Sketch.' " *Sketch.* 17.214 (March 3 1897): 234.

Sickert, Walter. "Diez, Busch and Oberländer." *A Free House! Or, the Artist as Craftsman.* ed. Osbert Sitwell London: Macmillan, 1947.

Sinnema, Peter. *Dynamics of the Pictured Page: Representing the Nation in the Illustrated London News.* Aldershot: Ashgate, 1998.

Skingsley, T. A. "Technical Training and Education in the English Printing Industries: A Study in Late Nineteenth Century Attitudes. Part One: The Apprenticeship System." *Journal of the Printing Historical Society.* 13 (1978/1979): 1–26.

——. "Technical Training and Education in the English Printing Industries: A Study in Late Nineteenth Century Attitudes. Part Two: The Pressures of Change." *Journal of the Printing Historical Society.* 14 (1978/1979): 58.

Slapkins, Rev. Joseph. *The Parson and the Painter.* London: Central Publishing and Advertising Company, 1891.

Slater, Don. "Domestic Photography and Digital Culture," *The Photographic Image in Digital Culture.* ed. Martin Lister. London: Routledge, 1995.

Smith, Wareham. *Spilt Ink.* London: E. Benn, 1932.

Soldene, Emily. "How the Alhambra was Shut." *Sketch.* 9.105 (January 30 1895): 53.

Southward, John. *Progress in Printing and the Graphic Arts During the Victorian Era.* London: Simpkins, Marshall, Hamilton, Kent and Co., 1897.

Spielmann, M.H. "Glimpses of Artist-Life. The Punch Dinner – The Diners and their Labours." *Magazine of Art.* 18 (1895): 89–94.

——. "Our Graphic Humorists. Sir John Tenniel." *Magazine of Art.* 18 (1895): 201–207.

——. "Our Graphic Humorists: Phil May." *Magazine of Art.* 17 (1894): 348–353.

——. "Posters and Poster Designing in England," *Scribner's.* (July, 1895): 34–47.

——. *The History of Punch.* London: Cassell and Company, 1895.

——. "The New Robinson Crusoe." *Magazine of Art.* 15 (1892): 47–51.

Stafford, Barbara Maria. *Good Looking: Essays on the Virtue of Images.* Cambridge, MA: MIT Press, 1996.

Staley, Allen. *The Post-Pre-Raphaelite Print: Etching, Illustration, Reproductive Engraving, and Photography in England in and around the 1860s.* New York: Columbia University Press, 1995.

Stange, Maren. *Symbols of the Ideal Life: Social Documentary Photography in America, 1890–1950.* Cambridge: Cambridge University Press, 1989.

Stephens, W. B. *Education in Britain, 1750–1914.* Basingstoke: Macmillan Press, 1998.

Stern, Madelaine B. *Purple Passage: The Life of Mrs Frank Leslie.* Norman: University of Oaklahoma Press, 1953.

Stronach, Alice. "London Art Schools. The Westminster School of Art." *Sketch.* 10.18 (May 1 1895): 21–23.

——. "The Slade School Revisited." *Sketch.* 9.110 (March 13 1895): 367–369.

Sturgis, Matthew. *Aubrey Beardsley.* London: Harper Collins, 1999.

Sullivan, E. J. *The Art of Illustration.* London: Chapman and Hall, 1921.

Surface, Matthew. "The Daily Graphic," *Process Work and the Printer.* 6 (1898): 92.

——. "When Nature Fails, Then Art Steps In," *Penrose Annual 1896.* London: Lund Humphries, 1896.

Swan, *Progress of British Newspapers in the Nineteenth Century.* London: Simpkins, Marshall, Hamilton and Kent, 1901.

Symon, J. D. *The Press and Its Story.* London: Seeley, Service and Co., 1914.

Tagg, John. "Movements and Periodicals: The Magazines of Art." *Studio International.* 193.983 (September/October 1976): 136–144.

Talbot, Henry Fox. "Photographic Engraving," *The Athenaeum.* 1331 (April 30 1853): 532–533.

Tarde, Gabriel. *Gabriel Tarde: On Communication and Social Influence.* ed. Terry N. Clark. Chicago: University of Chicago Press, 1969.

Terdiman, Richard. *Discourse/Counter Discourse: The Theory and Practice of Symbolic Resistance in Nineteenth Century France.* Ithaca: Cornell University Press, 1985.

——. *Present Past: Modernity and the Memory Crisis.* Ithaca: Cornell University Press, 1993.

Thomas, Carmichael. "Ilustrated Journalism," *Journal of the Society of Arts.* 39.1993 (January 1891): 173–178.

——. "The Production of an Illustrated Newspaper," *Journal of the Society of Arts.* 53.2720, 2721 (January 1905): 151–53, 177–179.

Thomson, Ellen Mazur. "Alms for Oblivion: The History of Women in Early American Graphic Design," *Design History: An Anthology.* ed. Dennis P. Doordan. Cambridge: MIT Press, 1995.

Thomas, Julia. *Pictorial Victorians: The Inscription of Values in Word and Image.* Athens Ohio: Ohio University Press, 2004.

Thompson, E. P. "Time, Work Discipline and Industrial Capitalism." *Essays in Social History.* eds M. W. Flinn and T. C. Snout. Oxford: Clarendon Press, 1974.

Thomson, Ellen Mazur. *The Origins of Graphic Design in America.* New Haven: Yale University Press, 1997.

Thornton, R. K. R. *The Decadent Dilemma.* London: E. Arnold, 1983.

Thorpe, James. *Phil May: Master-Draughtsman and Humorist, 1864–1903.* London: G. Harrap and Co., 1932.

Townsend, Horace. "Modern Developments in Illustrated Journalism," *Journal of the Society of Arts.* 42.2152 (February 1894): 233–246.

Tucker, Jennifer. *Nature Exposed: Photography as Eyewitness in Victorian Science.* Baltimore: Johns Hopkins University Press, 2005.

Tulloch, John. "The Eternal Recurrence of New Journalism." *Tabloid Tales: Global Debates over Media Standards.* eds John Tulloch and Colin Sparks. Laneham, Maryland: Rowman and Littlefield, 2000.

Turner, Mark. "St. Paul's Magazine and the Project of Masculinity." *Nineteenth-Century Media and the Construction of Identities.* ed. Laurel Brake. Basingstoke: Palgrave, 2000.

Turner, Mark. "Towards a cultural critique of victorian Periodicals." *Studies in Newspaper and Periodical History 1995 Annual.* eds Michael Harris and Tom O' Malloy (Westport, CT: Greenwood Press, 1997).

Verfasser, Julius. *The Halftone Process.* 5th ed. London: Percy Lund, 1912.

Vizetelly, Henry. *Glances Back through 70 Years: Autobiographical and Other Reminiscences.* London: Kegan Paul and Co., 1893.

Wager, Parry. "On Fine Etching," *The Process Year Book.* ed. William Gamble, London: A. W Penrose and Co., 1901.

Wakeman, Geoffrey and Gavin Bridson. *Printmaking and Picture Printing: A Bibliographical Guide to Artistic and Industrial Techniques in Britain, 1750–1900.* Oxford: Plough Press, 1984.

Walkowitz, Judith R. *Prostitution and Victorian Society.* Cambridge: Cambridge University Press, 1980.

——. *City of Dreadful Delight: Narratives of Sexual Danger in Late-Victorian London.* Chicago: University of Chicago Press, 1992.

Walter, Benjamin. "The Work of Art in the Age of Mechanical Reproduction," in *Illuminations.* London: Fontana, (1973).

Ward, Henry Snowden. *The Index of Standard Photograms.* New York: Tennant and Ward, 1901.

Ward, Henry Snowden and Catharine Weed Ward. "Golden Opportunities," *Photogram.* 7.1 (January 1900): 3.

Ward, Henry Snowden. "Trade Journals and Process Mongers," *Penrose Annual.* ed. William Gamble. London: A. W. Penrose and Co., 1896.

Ward, Henry Snowden and Catharine Weed Ward. *Photograms of the Year.* London: Iliffe & Sons, 1896.

——. *Photography for the Press.* London: Dawbarn and Ward, 1901.

Wechsler, Judith. *A Human Comedy: Physiognomy and Caricature in 19th Century Paris.* Chicago: University of Chicago Press, 1982.

Wedmore, Frederick. "Expressive 'Line,'" *Studio.* 14.65 (August 1898): 171–181.

Weisman, Clara. *A Complete Treatise on Artistic Retouching.* Saint Louis: H. A. Hyatt, 1903.

Weiner, Deborah E. B. "The People's Palace," *Metropolis: London.* eds David Feldman and Gareth Stedman Jones. London: Routledge, 1989.

Weitenkampf, Frank. *American Graphic Art.* New York: Henry Holt, 1912.

——. "The American Illustrator," Unpublished Manuscript. New York: New York Public Library, 1955.

——. "The Significance of Process," *Process Photogram.* 14.162 (June 1907): 126–126.

Welford, W. D. "The Influence of the Hand Camera," *British Journal of Photography.* XL, (May 1893): 279–280.

Wheatley, Henry B. *Catalogue of the Loan Exhibition of Modern Illustration Comprising Typographical Reproductions and the Original Drawings Executed 1860–1900.* London: Victoria and Albert Museum, 1901.

Whipp, Richard. "A Time to Every Purpose: An Essay on Time and Work." *Historical Meanings of Work.* ed. Patrick Joyce. Cambridge: Cambridge University Press, 1987.

White, Cynthia L. *Women's Magazines 1693–1968.* London: Michael Joseph, 1970.

Wilke, Jennifer. *Advertising Fictions.* New York: Columbia University Press, 1988.

Wilkinson, W.T. "Photographing upon Wood." *British Journal Photographic Almanac.* (1893): 606–607.

Williams, Raymond. *Culture and Society 1780–1950.* London: Chatto and Windus, 1958.

———. *The Long Revolution.* London: Chatto and Windus, 1961.

Williamson, C. N. "Illustrated Journalism in England: Its Development," *Magazine of Art.* 13 (1890): 297–301, 334–340, 391–396.

Wilson, Elizabeth. *The Sphinx in the City.* Berkeley: University of California Press, (1991).

Winter, James. *London's Teeming Streets 1830–1914.* London: Routledge, 1993.

Wolfe, M. "The Line Screen Plates and Their Uses." *British Journal of Photography.* 40. 1740 (September 1893): 574–576.

Wood, Henry Trueman. *Modern Methods of Illustrating Books.* London: Elliot Stock, 1887.

Woodberry, George E. *A History of Wood-Engraving.* New York: Harper & Brothers, 1883.

Wordsworth, William. "Illustrated Books and Newspapers," *Poetical Works.* ed. Ernest De Selincourt. Oxford: Oxford University Press, 1969.

Wright, Helena E. *With Pen and Graver: Women Graphic Artists before 1900.* Washington: Smithsonian Institution, 1995.

———. "The Osbourne Collection of Photomechanical Incunabula." *History of Photography.* 24.1 (2000): 42–46.

Wright, Jeffrey. "The Origins and Development of British Press Photography, 1884–1914." Swansea: MSc. Thesis, University College, 1982.

Wynne, Deborah. *The Sensation Novel and the Victorian Family Magazine.* Basingstoke: Palgrave, 2001.

Zurier, Rebecca. *Metropolitan Lives: The Ashcan Artists and Their New York.* New York: Norton, 1995.

Index

illustration – *continued*
 influences on, 149, 154
 manuals on, 138–9
 minimalism/fragmentation of, 138,
 153, 156
 mixtures of styles in, 202–3, 272n58
 in monthlies/weeklies, 133
 and multiple authorship, 149
 need for, 189–90
 and numbers of illustrators, 158–9,
 260n102
 and pen-and-ink sketch, 136–8,
 257n69
 and photorelief reproduction, 131–2,
 136, 139, 152, 153–7, 253n2–n4,
 258–9n84, n94, 260n96
 positioning/layout of, 161–3
 provision of, 160
 and quality of paper, 78–9, 258n78
 realist/decorative, 132–3
 and retouching of photographs, 134–5
 and Special Artists, 133–6
 style associations, 131–2
 and team work, 156, 259n90
 temporal aspects, 134, 253n9
 training in, 149–51, 257–8n73, n75
 and use of bold lines, 157–8, *see also*
 mass image; process reproduction;
 text/image relationship; urban
 images; wood engraving
Index of Standard Photograms (Ward &
 Ward), 167
Ingram Brothers, 38, 79, 91, 102, 104
Ingram, Herbert, 53, 54, 62
Ingram, William, 102, 104, 105, 196,
 203, 243n38, 244n40
Inland Printer, 235n5
Irving, Henry, 101, 190
Irving, Washington, *The Alhambra*, 139
Ives, Frederick, E., 44, 72–3, 76, 183,
 234n4, 267n91
Ivins, William, 11, 67, 197,
 213–14n34

Jackson, Holbrooke, 18, 141, 143
Jackson, Mason, 37, 104, 161, 243n30
Jaffe, Erwin, 236n29
Jerome, Jerome K., 88, 103, 106, 107,
 118, 203, 238n65, 248–9n92
Johannesson, Lena, 212n24

Jones, Henry Arthur, 120
Joyce, Patrick, 113, 208, 217n72
Judy, 44, 61
Juengling, Frederick, 65, 232n72
Jussim, Estelle, 63, 214n34

Keene, Charles, 19, 52, 124
Keller, Ulrich, F., 261–2n12, n13
Kelmscott Press, 133
Kelvin, Lord, 198
King, 171–2
King, Andrew, 228n28
Kingsley, Eldridge, 229n32
Kipling, Rudyard, 102
Knight, Charles, 3
knowingness
 and advertising, 24, 217n76, n81
 articulation/circulation of, 23–4
 characterization of, 21–2
 communal/pleasurable aspects, 22, 26
 definition, 21
 and mixing of diverse imagery, 26
 photograph/sketch relationship,
 22–3, 26
 and publication/reader bond, 26
 and social caricature, 22–3
 and theatre/music hall performance,
 21–2, 24–6, 217n72, n82
 and topicality, 26, 217n83
 urban, 22, 217n73
Kodak, 167–8
Kunzle, David, *The History of the Comic
 Strip*, 138

Ladies Field, 167
Lady's Newspaper, 53
Lady's Pictorial, 44, 119, 120, 162, 167,
 185, 251n127, 262n15
Landells, Ebenezer, 53, 61, 227n21, n23
Lang, Andrew, 103
Langdon, Robert, 231n62
Lascelles, T. W. (engraver), 71, 237n49
Latey, John, 102, 241n13
Lautrec, Henri Toulouse, 141, 152,
 243n32
Lawrence, D. H., 194
Le Chat Noir, 142
Le Courrier Française, 142
Le Gallienne, Richard, 108, 144
Leavis, F. R., 194

Walker, Frederick, 61
Walter Hill and Company, 164
Ward, Catharine Weed, 79, 80, 82, 166,
 171, 173, 236n34, 262n21
Ward, Henry Snowden, 79, 80, 82, 166,
 171, 173, 262n21
Way, T. R., 96
Wayside Posies (1867), 61
Webb, Sidney, 95, 108
Weblyn, Clifford, 261n6, 268n3
Wechsler, Judith, 18, 219n20
Welford, W. D., 168–70
Wells, Charles, 62
Wells, H. G., 102, 144, 192
Westminster Gazette, 42, 168, 222n47,
 222n49
Westminster Review, 223n57
Westminster School of Art, 136, 151
Wheatley, H. B., 244n39
Whipp, Richard, 85
Whistler, Laurence, 140, 152, 184, 195,
 202
Wilde, Oscar, "An Ideal Husband," 121
 "The Importance of Being Earnest,"
 120–1
Salome, 202
Wilke, Jennifer, 217n76
Willette, Adolphe, 141
Williams, Raymond, 6, 215n49, 222n42
Williamson, Charles, 102
Williamson, David, 123
Wilson, Elizabeth, 245n53
Wolf, Henry, 65
Woman at Home, 167
women
 and consumption, 126–7, 251–2n122,
 n124, n127–n131
 elite view of, 194
 as magazine readers, 7, 211n20,
 215n53
 as process retouchers, 178, 266n71
 representations of, 117–23,
 248–9n92–n104, 250n108–n110
 specialist publications for, 44, 223n54
 as wood engravers, 51–2, 225–6n15
wood engraving, 8, 14, 134, 160
 advantages of, 162
 apprenticeship system, 51–2, 56,
 226n16, 229n36
 boundaries of image, 174

and breaking up of reproduction
 trade, 61–2
decline in, 64–5, 69–71, 233–4n88,
 n92
development of, 49–53, 224–7n7–n22
economic effects on, 69, 233n83–n85
facsimile work, 58–60, 62–4, 689
female engravers, 51–2, 225–6n15
in *ILN*, 53–5
in-house craftsmen, 182
interpretive approach, 58, 229n37
mechanical/pictorial split, 58–61,
 230n43, n45, 46
mechanization of, 69
methods used, 56, 228–9n31–n34
and middle-class consciousness, 55–6
New School of, 65–8, 232n72, n80
origination of image, 52, 226n17
pace of production, 52–3, 226–7n20
pictorial conventions, 48, 223–4n2
and process reproduction, 47, 48–9,
 62–4, 73, 188, 197, 224n4–n6,
 231–2n59, n62, n65–n67, n69,
 234n4, 235n5
and rise of halftone, 68–9
Ruskin's reaction to, 47, 60–1
and spatial fragmentation/worker
 isolation, 69, 233n87
suitability of, 48
transformation of, 47, 56–61
and use of blocks, 62, 71, 230–1n54,
 232n66, n67, 234n93
and wood-cut finish, 182
Wood, Henry Trueman, 68
Woodberry, George E., 233n81
Woodbury, Walter, 75
Woodville, Caton, 134
Woodward, Alice, 151
Wordsworth, William, "Illustrated Books
 and Newspapers," 190–1
Working Men's College, 52
World newspaper, 173
W. P. D. Press Agency, 164
Wright, Jeffrey, 253n3
Wright, Seppings, 133
Wyndham, Charles, 101

Yellow Book, 87, 110, 114–15, 203,
 238n66

Zimmerman, Alexandre, 235n8